ECCE HOMO

THE MALE-BODY-IN-PAIN

ECCE HOMO

AS REDEMPTIVE FIGURE

KENT L. BRINTNALL

The University of Chicago Press
CHICAGO AND LONDON

Kent L. Brintnall is assistant professor in the Depart-
ment of Religious Studies and affiliate professor in
the Women's and Gender Studies Program at the
University of North Carolina at Charlotte.

The University of Chicago Press, Chicago 60637
The University of Chicago Press, Ltd., London
© 2011 by The University of Chicago
All rights reserved. Published 2011
Printed in the United States of America

20 19 18 17 16 15 14 13 12 11 1 2 3 4 5

ISBN-13: 978-0-226-07469-6 (cloth)
ISBN-13: 978-0-226-07470-2 (paper)
ISBN-10: 0-226-07469-2 (cloth)
ISBN-10: 0-226-07470-6 (paper)

Library of Congress Cataloging-in-Publication Data

Brintnall, Kent.
 Ecce homo : the male-body-in-pain as redemp-
 tive figure / Kent Brintnall.
 p. cm.
 Includes bibliographical references and index.
 ISBN-13: 978-0-226-07469-6 (cloth : alk. paper)
 ISBN-10: 0-226-07469-2 (cloth : alk. paper)
 ISBN-13: 978-0-226-07470-2 (pbk. : alk. paper)
 ISBN-10: 0-226-07470-6 (pbk. : alk. paper)
 1. Suffering in art. 2. Masculinity in art. 3. Vio-
 lence in art. 4. Sex in art. 5. Redemption in art.
 I. Title.
 N8251.S567B75 2011
 704.9'423—dc22

 2010048792

⊗ The paper used in this publication meets the mini-
mum requirements of the American National Stan-
dard for Information Sciences—Permanence of Pa-
per for Printed Library Materials, ANSI z39.48-1992.

for Loki
2002–2009
faithful companion
you are missed

Contents

Figures

Acknowledgments

*These notes link me to my fellow humans ... though I wouldn't have
wanted friends reading them.... I'd like to be published when I'm dead ...
only there's the possibility I'll live a long time, and publication will be in
my lifetime. The idea makes me suffer.*

GEORGES BATAILLE

This book was conceived during my time at Emory University. With
their encouragement, numerous colleagues helped bring it into existence:
Brooke Campbell, Wendy Farley, Emily Holmes, Nina Martin, Shelly
Rambo, and Don Saliers.

This book relies on images to make its argument. I am grateful to the
museums that have given me access to their collections, with special grati-
tude to those that have allowed me to reproduce images. I am also grateful
to Art+Commerce, the Mapplethorpe Foundation, and the Francis Bacon
estate for their assistance.

This book was completed during my first three years at the University of
North Carolina at Charlotte. I am grateful for financial assistance from the
university, including the Carol Douglas Endowment, which helped defray
costs of reproducing images, and to my colleagues—especially Joe Win-
ters, David Mozina, Jeremy Schott, and Sean McCloud—for the less tan-
gible, but more essential, gift of enthusiasm. It has not escaped my delight
in irony that I am a public employee in a state that repeatedly reelected Jesse
Helms, and am publishing a book that recommends Robert Mapplethorpe's
photographs as a resource for transforming Christianity's cultural opera-
tion. Time is often justice's greatest ally.

This book was improved by my participation in the Carpenter Founda-
tion Research Seminar in Religion and Sexuality in June 2009. For their
help in thinking through the book's formal problems, I extend warm af-
fection to the seminar's members, with particular gratitude to Lynne

Huffer, Joe Marchal, and Heather White. The book has also benefited from the generosity and bountiful humor of Jeremy Biles and Karmen Mac-Kendrick.

This book found its home at the University of Chicago Press because of my editor, Doug Mitchell. I am immensely grateful for the invaluable contributions of the Press's editorial and production staff, the people whose names I know and those I do not. I also appreciate the encouraging and critical words from the Press's anonymous readers.

This book would never have begun without the inspiration of two mentors. I owe enormous intellectual debts to Karla Oeler. I hope one day to be a scholar with half her acumen, knowledge, and decency. Mark Jordan has unfailingly treated me as both colleague and friend, calling me into a grander vision of myself as both scholar and person. While I will never be his true intellectual peer, I will forever aspire to his curiosity, humility, and delight in a well-crafted sentence. He will always be, in my mind, a "poet, priest of nothing, legend."

This book would never have reached fruition without the steadfastness of two dear friends. I will not try to capture in words my gratitude for their presence in my life. Lynn Huber has provided unflagging and unflappable support, especially in the final stages of revision. Lynne Gerber has been a stalwart champion of my most radical claims and a keen editor of my greatest stylistic excesses.

Finally, this book would have been impossible without my canine companions, who continually remind me that the quality of a day is not measured in pages written or read.

Abbreviations

AM Kaja Silverman, *The Acoustic Mirror: The Female Voice in Psychoanalysis and Cinema* (Indianopolis: Indiana University, 1988)

ASI Georges Bataille, *The Accursed Share: An Essay on General Economy*, trans. Robert Hurley, vol. 1, *Consumption* (New York: Zone Books, 1991)

ASII–III Georges Bataille, *The Accursed Share: An Essay on General Economy*, trans. Robert Hurley, vols. 2, *The History of Eroticism*, and 3, *Sovereignty* (New York: Zone Books, 1993)

Éc Jacques Lacan, *Écrits: The First Complete Edition in English*, trans. Bruce Fink (New York: Norton, 2006)

Er Georges Bataille, *Erotism: Death and Sensuality*, trans. Mary Dalwood (San Francisco: City Lights Books, 1986)

G Georges Bataille, *Guilty*, trans. Bruce Boone (San Francisco: Lapis, 1988)

IE Georges Bataille, *Inner Experience*, trans. Leslie Anne Boldt (Albany: State University of New York, 1988)

LE Georges Bataille, *Literature and Evil*, trans. Alastair Hamilton (New York: Marion Boyars, 1973)

Lx Georges Bataille, *Lascaux, or The Birth of Art*, trans. Austryn Wainhouse (Lausanne, Switzerland: Skira, 1955)

ME Georges Bataille, *Madame Edwarda*, in *My Mother/Madame Edwarda/The Dead Man*, trans. Austryn Wainhouse (New York: Marion Boyars, 1995)

MS Kaja Silverman, *Male Subjectivity at the Margins* (New York: Routledge, 1992)

ON Georges Bataille, *On Nietzsche*, trans. Bruce Boone (New York: Paragon House, 1992)

SE Sigmund Freud, *The Standard Edition of the Complete Psychological Works of Sigmund Freud*, trans. James Strachey (London: Hogarth, 1966)

SEc Amy Hollywood, *Sensible Ecstasy: Mysticism, Sexual Differ-ence, and the Demands of History* (Chicago: University of Chicago Press, 2002)

SIII Jacques Lacan, *The Seminar of Jacques Lacan*, book 3, *The Psychoses, 1955–56*, trans. Russell Grigg (New York: Norton, 1993)

SXI Jacques Lacan, *The Seminar of Jacques Lacan*, book 11, *The Four Fundamental Concepts of Psychoanalysis*, trans. Alan Sheridan (New York: Norton, 1978)

SXX Jacques Lacan, *The Seminar of Jacques Lacan*, book 20, *On Feminine Sexuality, the Limits of Love and Knowledge, 1972–73*, trans. Bruce Fink (New York: Norton, 1998)

StE Georges Bataille, *Story of the Eye*, trans. Joachim Neugroschel (San Francisco: City Lights Books, 1987)

TE Georges Bataille, *The Tears of Eros*, trans. Peter Connor (San Francisco: City Lights Books, 1989)

TR Georges Bataille, *Theory of Religion*, trans. Robert Hurley (New York: Zone Books, 1992)

PRELUDE

*It is necessary to give words the power to open eyes.... To use words ...
no longer [to] serve the ends of knowledge but of sight ... as if they were no
longer intelligible signs but cries.*

GEORGES BATAILLE

In the concluding paragraphs of the final chapter of his last book, Georges Bataille ruminated on photographs of a Chinese man undergoing *lingchi*, a form of public execution accomplished by severing limbs and ripping flesh from the victim's body. "The world evoked by this straightforward image of a tortured man . . . is, to my knowledge, the most anguishing of worlds accessible to us through images captured on film" (*TE* 205). The largest photo in the English translation shows an emaciated young man gazing skyward, arms tied to a stake behind his back, surrounded by a crowd of people who watch and facilitate his death (*TE* 204). Large swaths of flesh have been excised from his chest, revealing ribs, heart, and lungs. The wounds' jagged edges make it appear that the skin has been torn rather than cut. Rivulets of blood streak his abdomen, drawing attention to his genitals. In the foreground, someone leans in to saw away his leg, while members of the crowd strain to see the action.

The text records that "this photograph had a decisive role in [Bataille's] life" (*TE* 206). He had "never stopped being obsessed by this image of pain, at once ecstatic (?) and intolerable," since receiving it as a gift from his psychoanalyst, Adrien Borel, almost forty years earlier (*TE* 205–6). Due to the unexpected and admittedly atypical ecstasy spurred by the photograph's "insane . . . [and] shocking form," Bataille discerned "a fundamental connection between religious ecstasy and eroticism—and in particular sadism" (*TE* 206):

What I suddenly saw, and what imprisoned me in anguish—but which at
the same time delivered me from it—was the identity of these perfect con-
traries, divine ecstasy and its opposite, extreme horror. *And this is my inevi-
table conclusion to a history of eroticism.* But I should add: limited to its own do-
main, eroticism could never have achieved this fundamental truth divulged
in *religious eroticism*, the identity of horror and the religious. . . . Only an in-
terminable detour allows us to reach that instant where the contraries seem
visibly conjoined, where the religious horror disclosed in sacrifice becomes
linked to the abyss of eroticism, to the last shuddering tears that eroticism
alone can illuminate. (*TE* 207)

This photograph reveals, according to Bataille, an intimate connection be-
tween religious and erotic experiences, an ecstatic rupture both blissful and
horrific.

In a recent study of the practice of *lingchi* in China and representations
of *lingchi* in European scholarship, the authors fault Bataille for imposing a
"mask of ecstatic suffering . . . [that] burdens the tortured person, in effect
concealing him."[1] Focusing on "the distinction between 'person' and 'per-
sona,'" they seek "to recover . . . the history" Bataille purportedly obscures
(236, 223). The caption in *Tears of Eros*, they explain, mistakenly identifies
the person in the photograph (225).[2] Yet, with or without Bataille's imposi-
tion, the photograph's subject remains anonymous: his name, date of birth,
crime, time of death, aspirations, and disappointments are simply unknow-
able given the state of the historical record. These authors are wrong to
blame Bataille, rather than the archive, for the torture victim's anonymity.

But even if this person's identity were known or accessible, it would be a

1. Brook, Bourgon, and Blue, *Death by a Thousand Cuts*, 223.
2. The authors point out other factual errors in the photograph's caption (224–25)
and challenge the claim that Bataille received a copy of the photograph from Borel
in 1925 (230–34). They even question whether Bataille authored *Tears of Eros*, sug-
gesting that his editor, Joseph Marie Lo Duca, might have written "the entire book,"
or at least "stitched together various drafts . . . while adding various 'hooks' here
and there to hold the whole thing together" (235–36). In partial defense of this last
claim, the authors rely on a quote from *Guilty* to argue that "Bataille constructed a[n
impassable] gulf" between mysticism and eroticism in his early work; "to suppress
it," as *Tears of Eros* purportedly does, "is to misread him and throw his oeuvre out of
joint" (235). This gulf's existence would likely surprise readers of *The Accursed Share*,
Lascaux, and *Erotism*. It also runs counter to another of Bataille's statements, in *On
Nietzsche*, written shortly after *Guilty*: "There is no wall between eroticism and mys-
ticism!" (*ON* 131). Insofar as the authors of *Death by a Thousand Cuts* make claims that
require knowledge of Chinese history, I concede their expertise; insofar as they make
claims that require familiarity with Bataille's corpus, I find their scholarship wanting.

mistake to accuse Bataille of imposing a persona on him.[3] Bataille rejects the notion that any simple or singular meaning can be assigned to the victim's facial expression: for Bataille, the expression's indecipherability heightens the viewer's anguish. The photograph in *Tears of Eros* "was [formerly] reproduced in 1923 in Georges Dumas's *Traité de psychologie*" (*TE* 205). With an ironic exclamation point, Bataille notes his astonishment that Dumas uses the photo

> as an example of *horripilation*: when one's hair stands on end . . . ! Dumas insists upon the ecstatic appearance of the victim's expression. There is, of course, something undeniable in his expression, no doubt due at least in part to the opium [administered to the condemned man], which augments what is most anguishing about this photograph (*TE* 205).[4]

Although Bataille reports Dumas's assessment, he does not advance his own interpretation of the victim's expression, and the parenthetical question mark he places after the word "ecstatic" just a few sentences later distances him from Dumas's specific adjective and overall perspective.[5] Not only is the person—the historical subject—unknown, but, according to Bataille, his persona—the supposed mask—is unknowable.

After summarizing Dumas's interpretation, the text describes Bataille's experience: how he obtained the photograph, obsessed about it, wondered what the Marquis de Sade would make of it, and, through meditation on it, "reached the point of ecstasy" (*TE* 206).[6] Bataille acknowledges that *Tears of Eros* "is not written from within the limited experience of most" people;

3. While *Death by a Thousand Cuts* claims that attributing the "notion of 'ecstatic suffering' . . . to Bataille is dubious," this aside depends on the hypothesis that Bataille's editor authored *Tears of Eros*. At the beginning and end of the relevant chapter, the authors critique Bataille for hiding the torture victim behind a "visible mask of ecstatic suffering" (223, 239–41).

4. *Death by a Thousand Cuts* points out that the victim's bristling hair resulted from prisoners' grooming habits rather than any physical response to torment (237–38). While this error might be attributable to Dumas, Bataille neither endorses Dumas's observation nor makes horripilation central to his analysis.

5. *Death by a Thousand Cuts* contends that the "ecstatic" characterization is Bataille's alone (237). Whether or not *Tears of Eros* accurately represents Dumas, it distances Bataille from the claim of ecstasy. As Jeremy Biles observes, even if the "question mark could be read as disingenous . . ., [it] points, finally, to Bataille's ambivalence and uncertainty" (*Ecce Monstrum*, 10–11). For a similar understanding, see *SEc* 303n2; for a contrary understanding, see Connor, *Georges Bataille*, 3.

6. *Death by a Thousand Cuts* suggests that the discussion of Sade and the language of "voluptuous effect" is inconsistent with Bataille's earlier comments that he took no pleasure in the Chinese man's suffering (234). Referencing Sade is not, however, a

what is unclear is whether the more expansive experience is that of the Chinese man's torture, documented by the photograph, or Bataille's ecstasy, triggered by it (*TE* 206). The text moves from Bataille's stunned reaction (his experience), to his interest in illustrating the "connection between religious ecstasy and eroticism" (his reaction, possibly based on the Chinese man's), to the experience from which the book is written (either his or the Chinese man's), to its culminating revelation (definitely Bataille's experience). This raises rather than resolves the question of whether the person or the image is central to Bataille's account.

At the beginning of this final section of *Tears of Eros*, Bataille proposes to "dwell upon some fairly unknown contemporaries, whom I know only through photographs. . . . The first is a voodoo *sacrificer*. The second is a victim of Chinese torture" (*TE* 185). This seems to indicate that Bataille is interested in persons, even though the clause about knowing these contemporaries only through photographs complicates the matter. But Bataille continues, "The game I am setting up for myself is to represent what they were living at the moment the lens fixed their image" (*TE* 185). This could be read as a desire to recover the person's experience, but calling it a "game," a game "for myself," a game focused on representation, distances Bataille's mode of proceeding from any typical understanding of historical inquiry.

When the text turns to photographs of the voodoo sacrificer, it begins by characterizing the sacrificer's experience and then suggests the relevant images provide access to the sacrificer's world (*TE* 199). Bataille appears to speak for the historical subject, but the text also comments on the relation between the reader and the photograph:

> Across time, the blood sacrifice opened [our] eyes to the contemplation of the vexing reality completely outside daily reality, which is given in the religious world this strange name: the *sacred*. We can give no justifiable definition of this word. But some of us can still imagine (try to imagine) what *sacred* means. And no doubt such readers of this book, faced with these photographs, will try to relate this meaning to the image of what the bloody reality of the sacrifice represents to them, the bloody reality of the animal's death in sacrifice. To the image, and perhaps to the troubled feeling where a vertiginous horror and drunkenness come together, where the reality of death itself, of the sudden coming of death, holds a meaning heavier than life, heavier—and more glacial. (*TE* 199)

confession of sadistic desire. Bataille distances himself from the Sadean perspective throughout his corpus; his surmises in *Tears of Eros* do nothing to alter that.

The text and its readers are now several steps removed from the unknown contemporary upon whom Bataille initially proposed to dwell. The text introduces images, ideas, and representations to describe—and invoke—an experience of the now increasingly unavailable sacred.

Having conjured this fantastic mixture of elements, the text moves on to Bataille's second contemporary, characterizing "the world evoked by this straightforward image of a tortured man" as "the most anguishing of worlds accessible to us through film" (*TE* 205). Given how the text has shifted from person, to objective experience, to image, to subjective experience, it is at least an open question how we should interpret its claims about persons and worlds to which photographs give access. What kinds of worlds are accessible to us through these images? The execution square, or the viewer's psyche? *Tears of Eros* does not seek to discover and document the consciousness of historical subjects, but rather to provoke a particular awareness in its reading subjects (*TE* 162–65, 173). The images reproduced in the text—most of them fabricated (paintings, pottery, statuary), rather than documentary—are presented not as evidence of events, but as opportunities for experience.

Some commentators contend that Bataille's use of a torture *photograph*, in light of the photograph's indexical relation to reality, does irreparable damage to *Tears of Eros* and its argument about religious ecstasy, erotic abandon, and transgressive art.[7] Yet, rather than insisting on a radical difference between the book's reproductions of paintings and reproductions of photographs, it is just as plausible to understand the fabricated images—and the viewer's meditative engagement—as interacting with, and perhaps overrunning, the photographic "reality," demonstrating that a range of artifacts has the capacity to generate similar kinds of awareness. As already noted, Bataille strives to foster a new perception, rather than describe photographed events. This may appear to confirm *Death by a Thousand Cuts'* claim that Bataille imposes a falsifying construction on the photographed subject. But he is interested in neither the person nor the persona in the image. His concern is with the image's viewer.

7. Brook, Bourgon, and Blue, *Death by a Thousand Cuts*, 228–29; Elkins, "Very Theory"; Millett, *Politics of Cruelty*, 155–61. *Death by a Thousand Cuts* suggests that reproducing the images in *Inner Experience* and *Guilty* "would fatally show up [Bataille's mystical] exercise as a purely literary artifice" (242). Although the photographs are undoubtedly more disturbing than a written description, Bataille's statements that an image of torture is "beautiful" and erotically intoxicating (*IE* 119–20), that it generates a sense of friendship and harmony (*G* 46), are also jarring. The difference between the illustrated and unillustrated texts is one of degree, not kind.

My insistence that Bataille is interested in the image and its effects, rather than the person/a and his identity, is supported by his earlier accounts of meditating on this image. In *Inner Experience*, published in 1943, Bataille mentions the photograph while discussing Ignatius's *Spiritual Exercises* and their call to "dramatize . . . the torture to which Christ is led" (*IE* 119). According to Bataille, this dramatization of pain, violence and impending death breaks the bonds of discursive thought "to attain non-discursive experience." Just as Christian mystics rely on the drama of crucifixion, Bataille "had recourse to upsetting images" of the Chinese torture victim (*IE* 119).[8] As a consequence of this exercise, "the young and seductive Chinese man of whom I have spoken . . . communicated his pain to me . . ., and it was precisely that which I was seeking, not so as to take pleasure in it, but in order to ruin in me that which is opposed to ruin" (*IE* 120). Although this language could be read as implying communication between persons, in the larger context of the Ignatian model that depends upon "theatrical representation," it seems as plausible to conclude that Bataille understands that this communication is an act of fantasy.[9] Like Ignatius, Bataille counsels his reader to rely on images of violated bodies to experience feelings that will alter conscious awareness of the world, the other, and one's relation to both.

The character and purpose of this meditative practice is most clearly expressed in *Guilty*, written at the same time Bataille was working on *Inner Experience*:

> I wanted to speak as clearly as possible about the "means of ecstasy." I haven't succeeded very well, but I've tried. . . . Chancing on an image of torture, I can turn away in fright. But if I look I'm *beside myself*. . . . A sight of torture opens my individual being violently, lacerates it. . . . Instead of avoiding laceration I'd deepen it. . . . Cruelly, I stretch the laceration out— in that instant attaining ecstasy. *Compassion*, pain, and ecstasy connive with each other. (*G* 36–37; third ellipsis in original)

Bataille's interest in the photograph is not macabre curiosity. As Jeremy Biles importantly notes, the photograph's

8. On Bataille's reliance on this photograph as an object of "religious devotion," see Brook, Bourgon, and Blue, *Death by a Thousand Cuts*, 240–42; Connor, *Georges Bataille*, 5; *SEc* 73; Nikolopoulou, "Elements of Experience," 101; Stoekl, *Bataille's Peak*, 69–70.

9. This provides the beginning of a response to Amy Hollywood's question about the possibility of communicating with "the image of a man who is dead" and to her concern that Bataille's understanding of communication requires the actual suffering of other human beings (*SEc* 15, 57).

revelation does not occur without regard for the plight of the victim. . . . [It] is possible only so long as the element of excessive horror remains intolerable—that is, so long as the horror is preserved *as* horror, so long as it is not overcome, interpreted, given a definitive meaning, or converted into a purely conceptual form. . . . Across the decades in which Bataille contemplates this photo, it never stops obsessing him, never ceases to be excessive. . . . Bataille, in short, never masters the image that he confronts.[10]

Bataille is not inadvertently or lazily foregoing historical inquiry; he is not avoiding "the Chinese judicial archives" to keep the "mystic illusion" of his "literary artifice" in place.[11] He is, rather, showing how certain kinds of historical contextualization, in an effort to understand, explain, and master the past, serve to justify, flatten, or dampen horrific events (*SEc* 83−84).[12] He challenges his reader to imaginatively encounter the anguish, terror, and ecstatic self-loss of catastrophic violence without the protective shield of historical narratives to contain the cataclysm.

As historians and sinologists, the authors of *Death by a Thousand Cuts* want to locate the person; they want to peel back representation and uncover reality. The erasure of history, for these authors, is an extension of the eradicating violence of *lingchi*. This violent erasure, as their book exhaustively and importantly documents, is both effect and cause of the imperial and colonial devastation of actual human bodies. "What does it mean to publish a photograph of an unknown torture victim whose name and personal history are unknown? Does that not amount to exhibiting a blank, empty mask, to brandishing a fake icon in which there simply is *no one* there" (242)? Or could it be an intervention that seeks to rupture the logic of independent, autonomous, rational selves that makes imperial and colonial power seem natural, inevitable, and morally good? Could it be an attempt to insist on an identification between self and other that acknowledges a shared vulnerability, fragility, and mortality? By reproducing this image, meditating on it, and writing about it, Bataille seeks to create an awareness of the ubiquity, senselessness, and radical contingency of catastrophic violence.[13] He is trying to foster an experience of intimacy and

10. Biles, *Ecce Monstrum*, 11−12.

11. Brook, Bourgon, and Blue, *Death by a Thousand Cuts*, 242.

12. See also Connor, *Georges Bataille*, 161−62.

13. Hollywood importantly notes that "it is not clear that *who* suffers is in fact so radically contingent. Rather, differences in race, class, gender, sexuality, and ethnicity make it more likely that members of one or another particular group will be the subject of physical torture and thus serve as the noncontingent means through which the contingency of human bodily experience finds expression" (95).

communication that can be secured only through sacred violence. This is a fundamentally different project than the historically minded inquiry of *Death by a Thousand Cuts*. In order to provoke an experience of ecstatic conflagration that can serve as the affective foundation of an alternative political imaginary, Bataille must privilege representation over reality, photograph over person, image over history. The *reality* of violence may, just possibly, be critiqued, resisted, and prevented by attending to *representations* of violence in particular ways.

<p style="text-align:center">★ ★ ★</p>

In the closing section of the final chapter of his first book, Jeremy Biles suggests that "reading—and writing on—Bataille really begins when it no longer seeks to explain Bataille, but rather puts him to work . . . in a way that contradicts and critiques the existing order—of scholarship, of literature, of art—while also refusing to let Bataille's writings become merely an element in that order, or an order unto themselves" (Ecce Monstrum, 167). *Without laying claim to Biles's imprimatur, I offer this book mindful of his vision. Although I spend time in this text explaining my understanding of Bataille's ideas, and how my understanding relates to others' interpretations, I do so in pursuit of a larger project of thinking about the political operation of representation, spectacle, and interpretation. This book performs readings of representations of the male body to show how they might be productive for feminist and queer theories and politics. It relies on Bataille's texts as lodestars, mindful of their complicated representation of gender and sexuality. Inspired by Bataille, I argue that certain ways of representing the male-body-in-pain have the capacity—not without complexity, not without risk, but the capacity nonetheless—to disrupt cultural fantasies of masculine plenitude that ground the social orders of masculine power and privilege.*

I take seriously Bataille's notion that certain forms of artistic production, including writing, operate sacrificially—that is, they compel an encounter with the permeability and incoherence of the self—and that this operation creates the possibility of greater intimacy, decency, and generosity between human beings by undoing illusions of self-sufficiency, autonomy, and hermeticism that perpetuate alienation, anxiety, and violence. I am persuaded that experiences of fragmentation and laceration are essential to opening the subject to the other in ways that foster nondamaging, nonlethal violence between persons. To render these claims plausible, I offer a plurality of voices and images, each addressing—in ways that both reveal and conceal—the self-shattering encounter with the eroticized, sacred body theorized and described in Bataille's texts.

This book is intentionally polyphonic, even cacophanic: the prelude and postlude provide a base line (or, perhaps, a melody), while the remaining chapters are variations on a (set of) theme(s). The chapters—which treat, in turn, Hollywood action films, psychoanalytic accounts of masochistic desire, photographs by Robert Mapplethorpe,

and paintings by Francis Bacon—have been crafted with an ear for echoes and reso-
nances capable of producing a fundamental harmonics. (For this reason, they could be
read in any order, but taking them out of order will diminish the experience I hope to
foster in the reader.) The argument is also kaleidoscopic: it jumbles and rearranges a
limited number of colored fragments. With Bataille's suspicion of discursive speech in
mind, I have intentionally excised connective tissue from the chapters. The text's per-
suasive force, if any, comes from repetition and accumulation rather than didactic ap-
peal. In many ways, the text's most Bataillean feature is the risk borne by the trust
I place in you, my reader. My Bataillean faith, however, is that no idea can be ade-
quately communicated and no person authentically known without such risk.

<p style="text-align:center">★ ★ ★</p>

At the beginning of the final chapter of *Tears of Eros*, Bataille writes that
conscious awareness is essential for human beings to reach the height of
their potential (*TE* 173). The effort to experience such awareness is, unfor-
tunately, "futile," because it "is possible only at a level where consciousness
is no longer an operation whose outcome implies duration, that is, at the
level where clarity, which is the effect of the operation, is no longer given"
(*TR* 57). This *impossible* consciousness, however fleetingly and imperfectly it
appears, must be connected to the ability to "let go" (*TE* 162):

> Here's something to express forcefully, to keep clearly in mind—that
> there's no truth when people look at each other as if they're separate in-
> dividuals. Truth starts with conversations, shared laughter, friendship and
> sex, and it only happens *going from one person to another*. I hate the thought of
> a person being connected to isolation. . . . As I picture it, the world doesn't
> resemble a separate or circumscribed being but *what goes from one person to*
> *another* when we laugh or make love. When I think this is the way things
> are, immensity opens and I'm lost. How little *self* matters then (*G* 44–45)!

Bataille characterizes our typical consciousness of ourselves as separate, iso-
lated individuals as problematic. A different perception of self and other is
possible, but it must be experienced, rather than expressed propositionally.

Why do we perceive ourselves as discontinuous beings? What are the
consequences of this perception? How do we change it? Bataille's answers
to these questions turn on his understanding of the relation between work
and human subjectivity. For Bataille, "work, beyond all doubt, is the foun-
dation of the human being as such" (*TE* 39). Work is the source of the in-
tellectual and practical achievements that found humanity's sense of dig-
nity and worth; it also isolates, alienates, and renders anxious, creating a
sense of separation from self, other human beings, and the world as well as

an awareness of temporality and mortality (*ASII–III* 61, 213–14; *Er* 31, 40; *TE* 40–42).

"The introduction of *labor* into the world replaced intimacy, the depth of desire and its free outbreaks, with rational progression, where what matters is no longer the truth of the present moment, but, rather, the subsequent result of operations" (*ASI* 57). Work necessarily creates an awareness of time, some conception of a future for and toward which one is striving. Just as work creates an awareness of time, the instrument of labor—the tool—introduces a conception of subject and object (*ASII–III* 213–14; *TR* 27–30). The tool is subordinated to the worker's intentions and valued wholly for its instrumentality; the worker's relation to the tool is the precursor for similarly instrumentalizing and subordinating relations that typify many human interactions (*AS I* 132; *IE* 132–33; *TR* 27–32, 39–40). Ultimately, the worker becomes a tool. "The grain of wheat *is* a unit of agricultural production; the cow is a head of livestock . . ., and the farmer . . ., during the time [he is] working . . ., is not a man: he is the plow of the one who eats the bread" (*TR* 41–42; see also *ON* xxvi–xxvii).

But work produces not only alienation, objectification, and subordination. By projecting the laborer into the future, it also generates anxiety. After all, the future is uncertain:

> Might we not imagine . . . that work—and the anticipation of its result— are at the basis of the knowledge of death . . . ? How, if I had not begun a project, a task, unsatisfying in itself, perhaps arduous, but whose result I look forward to, how could I continue, as I do, to anticipate the authentic being which I never am in the present time and which I place in the time to come? But the fact is that death threatens to forestall me, and to steal away the object of my anticipation. (*ASII–III* 82–83; see also *ASII–III* 218; *Lx* 29; *TR* 51–52)

Work, then, is double. On the one hand, it gives rise to the unique capacities that characterize humanity. Through both manual and intellectual labor, and by foregoing immediate pleasure for delayed gratification, human beings have accomplished astonishingly creative and inventive feats. On the other hand, labor alienates us from ourselves, transforms our bodies into tools and our fellow travelers into objects. The capacities that allow us to create inventively enable us to destroy expansively, and the subject-object consciousness legitimizes and renders invisible practices of dehumanizing subordination. By working to cultivate crops, build shelter, and marshal resources, we stave off mortality and keep the fear of death at bay. At the same time, the experience of labor, an activity that requires duration, creates an awareness of, and a sensitivity to, the ravages of time.

Finally, work requires self-control, regulation of desire, and restraint of "wild impulses" (*Er* 41). Taboos and prohibitions protect the world of work (*ASII–III* 82–83; *Er* 68; *Lx* 37). By guaranteeing the conditions that make labor efficient and productive, they provide the "cornerstone of humanized patterns of behavior" (*Lx* 31; see also *ASII–III* 339–40; *Er* 83). Although genuinely human existence requires work, labor, and project, human beings struggle to find the balance between the rational order and passionate abandon (*ASII–III* 342; *Er* 40; *TR* 53). Just as prohibitions and taboos protect the world of work, they also mark the exuberance beyond work as alluring and desirable: they point to experiences capable of relieving the alienating, subordinating, objectifying, anguish-inducing effects of profane existence (*ASII–III* 124–26; *Er* 35–39; *TE* 66–67). "There is no prohibition that cannot be transgressed. Often the transgression is permitted . . ., even prescribed" (*Er* 63). The calendar of celebrations, festivals, and rites is regulated with as much precision as the work day, if not more. Because efficient labor requires prohibitions, it necessarily generates the very means for its disruption. Paradoxically, the final achievement of the profane order is evocation of its opposite, the sacred.

"In a basic sense, what is *sacred* is precisely what is *prohibited*" (*ASII–III* 92; *Er* 68). Through festivals, games, and rituals, the sacred disrupts the conditions that make productive labor possible, consumes the products of human work, and creates a space to indulge the passions that must be held in check to accomplish projects. Work is about restraint, concern for the future, and individual existence; the sacred is characterized by excessive abandon in the present moment that reconnects the individual to community. The sacred, like project, but for different reasons, also causes anguish: insofar as work provides a sense of security against impending mortality and sustains the familiar feeling of discontinuous existence, the sacred confronts the individual with the possibility of death and troubles the boundaries of self and other. Like work, the sacred is double: while it enables humans to "[detach] . . . from the poverty of *things*, and . . . [restore] the *divine* order" of intimacy, continuity, and community lost through the alienation, objectification, and separation demanded by the profane order of work, labor, and project (*ASI* 57–58; *TR* 54–57), precisely because such experiences rupture what is familiar, safe, and secure, the sacred is unsettling and disturbing (*ASII–III* 214–16; *Er* 68–69; *TE* 70–72; *TR* 52–53). Both profane and sacred worlds cause human beings anguish, but their respective anguishes have markedly different consequences for how human beings think of themselves and their relation to others and the world.

The sacred, like project, takes a number of forms. For Bataille, "sacri-

fice . . . is the religious act above all others" (*Er* 81).[14] It is also "the antith-esis of production" (*TR* 49; see also *IE* 136–37). Whether it be a handful of grain, a bull, or a human slave, sacrifice requires the removal of a *useful* ob-ject from production (*ASI* 58–59; *TR* 43–44, 48–50, 59–60). Because of the sacrificer's identification with the sacrificial victim, the spectacle of destruc-tion restores the sacrificer's relation to the intimate order, suspending her or his relation to the world of things (*ASI* 55–59; *Er* 22; *IE* 153; *ON* 44; *TR* 43–44, 50–52). Sacrifice, then, is a consumptive practice that fosters identi-fication with death and destruction, an identification that ruptures the au-dience's relation to time and bounded existence.[15]

Eroticism, like religion, is a search for lost continuity (*Er* 15). As Bataille writes in *Tears of Eros*, "The meaning of eroticism escapes anyone who can-not see its *religious* meaning! Reciprocally, the meaning of religion in its to-tality escapes anyone who disregards the link it has with eroticism" (*TE* 70; see also *Er* 7–9). Eroticism's religious dimension is signaled primarily by its "quest for continuity" (*Er* 16).[16] "The whole business of eroticism is to de-stroy the self-contained character of the participators as they are in their normal lives. . . . Erotic activity, by dissolving the separate beings that par-ticipate in it, reveals their fundamental continuity, like waves of a stormy sea" (*Er* 17, 22).

The meaning of eroticism also escapes anyone who equates it with the sexual act itself. Unlike sexual acts that have reproduction as their goal, and are therefore fully consistent with utilitarian aims, eroticism is pro-hibited conduct that seeks consumptive pleasure (*ASII–III* 83, 123–24; *Er* 49–51, 79–80, 156–58, 170, 256; *TE* 20, 23). "Work is . . . the desire to ac-quire something," eroticism the desire to lose it (*TE* 45). Unlike productive labor, "in the fever of sexual passion . . . we lose substantial amounts of en-ergy without restraint and without gain" (*ASII–III* 177; see also *ASII–III*

14. See also Bataille, "Jesuve," 73.

15. Consistent with his understanding that a prohibition sometimes mandates its own violation, Bataille claims that "sacrifice . . . [is] a suspension of the commandment not to kill" (*Er* 81; see also *G* 65; *IE* 137; *ON* 20). Although not all sacrifice, as Bataille acknowledges, entails killing, it always involves wasteful expenditure, which violates the mandate for productive labor.

16. Bataille sometimes describes the shift from separation to merger at the level of sperm and egg (*Er* 12–14), but it is difficult to square this with his interest in the sub-jective, rather than objective, dimension of eroticism. In addition, this would seem to restrict erotic experiences to heterosexual couplings, even though Bataille notes that consideration of homosexuality would "[contribute] only odd variants, of second-ary importance," to a history of eroticism (*ASII–III* 437n2). He does suggest, how-ever, that sex difference heightens the sense of loss in eroticism and more fully brings the experience of continuity to the surface (*Er* 99).

16–18; *Er* 170). Unlike sexual activity, eroticism has both a corporeal and a psychological dimension (*Er* 11, 29, 102). Bataille considers "objective" inquiries into eroticism of secondary importance; rather, he focuses on the "inner life . . ., [the] religious life, if you like" (*Er* 31). Because erotic experience depends on a certain consciousness, it is uniquely human conduct; *erotic* actors must be aware they are violating the imperative for productive behavior and must experience a disruption of their discontinuity.

Expenditure of self in passionate abandon links eroticism to sacrifice. Just as the sacrificer's identification with the victim creates awareness of continuity through violent spectacle, desire for and identification with the erotic object culminates in dissolution of the self's physical and psychological boundaries, giving rise to an experience of intimacy through and with the other (*Er* 16–24; *ON* 98). In language reminiscent of his description of sacrificial expenditure, Bataille writes in *Guilty*, "Eroticism is the brink of the abyss. I'm leaning out over deranged horror. . . . From this comes a 'questioning' of everything possible. This is the stage of rupture, of letting go of things, of looking forward to death" (*G* 109).[17] Eroticism is "the disequilibrium in which the being consciously calls his own existence in question. In one sense, the being loses himself deliberately" (*Er* 31). Abandoning oneself to desire for the other, making vulnerable one's body through both nakedness and interpenetration, and expending vast amounts of energy solely in pursuit of pleasure stand in stark contrast to the self-sufficient, circumscribed, future-oriented existence demanded by the world of work. Because erotic experience is so markedly different from the profane experience of productive labor, it—like sacrifice—produces anguish; an ecstatic terror accompanies the slipping away of one's self and the dissolution of the other in one's presence. But the "warmth of pleasure and sensuality" accompanies this anguish, both suspending and intensifying it: Bataillean anguish, in both sacrificial and erotic violence, is never in complete opposition to, or wholly separate from, happiness.[18]

Like sacrifice and eroticism, art is a form of transgressive expenditure. Where this spirit of transgression—a spirit that ruptures the day-to-day reality of labor, alienation, objectification, and subordination—is "faint or

17. Bataille, like many others, ruminates on the significance of orgasm's being colloquially referred to as the "little death" (*Er* 100; *TE* 20). Bataille also explains eroticism's connection to death by discussing how awareness of the uncertainty that life will issue forth from sexual conduct gives rise to a sense of the contingency of one's own existence (*IE* 69). Because this conflates reproductive sexuality and eroticism, contrary to Bataille's insistence on their separation elsewhere, and restricts eroticism to a heterosexual context, which Bataille repudiates elsewhere, I do not discuss it in detail.
18. Bataille, "Happiness," 188–89.

barely present," the work of art is "mediocre" (*Lx* 39). Artistic production, while a kind of work, is "wealth expended without utility."[19] But it is not just the squandering of time and material resources. Certain artistic forms undo the systems of reason and thought that make productive labor possible. Poetry, for example, is a "sacrifice in which words are victims" (*IE* 135). Words advance knowledge, convey information, articulate plans—they are tools of thought (*IE* 135–36). But poetry "tear[s] words from these links in a delirium . . ., detach[ing them] from interested concerns" (*IE* 135).[20] Poetry "is the *cry* of what, within us, cannot be reduced; what, within us, *is stronger than us*."[21] (Can the strength of this cry ruin that within us that is opposed to ruin?)

The delirious cries of literature and poetry, like those of eroticism and sacrifice, put the self in question. Like erotic play, aesthetic contemplation loosens the self's boundedness. This is surely part of what we mean when we talk about identifying with a character in a novel, being transported by a melody, becoming absorbed in a painting, or forgetting one is watching a film. This experience is magnified when the artwork in question involves risk, loss, or death:

> The charm of a novel is linked to the misfortunes of a hero, to the threats that hang over him. Without troubles, without anguish, his life would have nothing that captivates us, nothing that excites us and compels us to live it with him. Yet the fictional nature of the novel helps us bear what, if it were real, might exceed our strength and depress us. We do well to live vicariously what we don't dare live ourselves. (*ASII–III* 105–6)

Bataille's celebration of the "popular detective novel" sits oddly alongside his championing of experimental poetry, but each type of literature, in its own way, disrupts and disturbs the reader's subjectivity in a manner akin to religious ritual (*LE* 84).[22] Like the religious and erotic quests for intimacy and continuity, art can have a mournful air. In his discussion of the privileging of animal forms over human faces in the Lascaux cave paintings, Bataille suggests the images ruminate on the price paid to become human, the cost of being goal-oriented laborers. For Bataille, this prehistoric art is a *memento mori* to the tragic loss entailed in be(com)ing human (*Lx* 11,

19. Bataille, "Lecture," 101.

20. See also Bataille, "From the Stone Age," 138–39; Bataille, "Notion of Expenditure," 120.

21. Bataille, "From the Stone Age," 138.

22. For Bataille on the detective novel, see *ASII–III* 105–6, 435n8; *Er* 86–87; on poetry, "From the Stone Age," 138–39; on the relation between poetry and mysticism, *LE* 25–26.

115–16).[23] As with sacrifice and eroticism, aesthetic pleasure is bound up with anguish.

By representing risk, tragedy, loss, and death, by disturbing the viewer's sense of boundedness, by presenting an experience contrary to profane reality, art and literature "[continue] the game of religions of which [they are] the principal heir." Literature "has received sacrifice as a legacy: at the start, this longing to lose, to lose ourselves and to look death in the face, found in the ritual of sacrifice a satisfaction it still gets from the reading of novels" (*ASII–III* 106; see also *Er* 87; *LE* 69, 84). [24] But it is not only a relation of succession: "In a sense, sacrifice was a novel, a fictional tale illustrated in a bloody manner. A sacrifice is no less fictional than a novel; it is not a truly dangerous, or culpable, killing; it is not a crime but rather the enactment of one; it is a game" (*ASII–III* 106; see also *Er* 87).

When I read that sacrifice is not deadly but merely a form of playful theater, I experience a shock not unlike that caused by Bataille's description of the Chinese torture photo. Bataille undoubtedly has in mind his notion that a prohibition sometimes mandates its own violation. Sacrifice enacts a crime rather than commits one because it is a form of destruction with as much imperative fervor as murder's prohibition. "Thou shalt not kill"—except, of course, when thou shalt: on the battlefield, in the slaughterhouse, at the altar. Bataille is fully aware that sacrifice destroys its victim, but his interest here is with the audience of the sacrificial spectacle. By describing sacrifice as a novel written in blood, Bataille forces us to consider the relation between representation and event.

Bataille is clear that sacrifice can, and should, no longer occur (*ON* 32).[25] But when he writes, "Nowadays sacrifice is outside the field of our experience and imagination must do duty for the real thing" (*Er* 92), he means something more than that sacrifice no longer happens or is now ethically objectionable. If today an animal or a person were killed in the presence of most people, they would not be able to experience it as an avenue to the sacred. The sacred dimension of violent spectacle—the inexplicable and inexpressible admixture of horror and joy, terror and bliss—has fallen outside our experience because we can see only the brutality (or comedy, or entertainment) without moving through it to anguished ecstasy. Unlike sacrificial cultures that revere and make sacred the objects, animals, and humans that will be sacrificed, contemporary practices mark those entities

23. See also Bataille, "Passage from Animal to Man," 74–80.
24. Bataille also notes a connection between literature and eroticism. See *Er* 25; *TE* 19.
25. See also Bataille, "Sacrifice," 61. Near the beginning of *Inner Experience*, Bataille notes the importance of moving from the external form of sacrifice to the internal form of inner experience (*IE* 11).

and bodies that are legitimate targets of violence as wholly and completely other. A human being's violent death is caught up in a different system of signification for the average twenty-first-century urban dweller than it was for the average fourteenth-century Aztec warrior.

Artistic representations can perform a sacrificial function if and only if they provide a legible experience of anguished ecstasy. But both anguish and ecstasy are part of the formula: the representation cannot be a watered-down, cruelty-free attempt to shock and titillate, nor can it be a scene of brutality with no frame of reference other than its own sadistic frenzy. In a cultural context where the truth and self-evidence of individual autonomy is virtually unassailable, spectacles that strive to expose vulnerability, fragility, and mortality face enormous obstacles in being read as a revelation of the shared possibility of loss and death rather than as horrific violence or spectacular entertainment. No single representation, or single type of representation, will be capable of doing this for all viewers, in all contexts, across all times. However, if "art alone . . . inherits . . . the *delirious* role and character of religions," if art alone is capable of "gnaw[ing] at and transfigur[ing] us," then artistic representations *must* perform this sacred task in order to preserve a source of disruptive transgression that can breach the alienated subjective experience demanded by the world of work.[26] Work, through subject-object relations, produces its own kind of violence. In order to avoid it, we must be shocked, shattered, and shaken up so we can, however fleetingly and imperfectly, have a brief moment of clarity about the intimate connection between self, other, and world. On Bataille's understanding, violence is inevitable; we can only influence its form. To put it in the starkest terms: we must choose between poetry and war.

The choice of poetry over war is not only ethically advisable: it is only through representation, rather than event, that we attain the experience that sacrifice, eroticism, and art proffer. In order to alter the alienating conditions that haunt human life, in order to establish a new form of awareness, the anguished confrontation with death that disrupts the subject's sense of self must be a *conscious* one. In other words, I cannot be caught up in a chaotic, conflagrational event—like war—that provides no distance for reflection. "Only the fictitious approach of death, through literature or sacrifice, points to the joy that would fully gratify us, if its object were real . . ., if we were dead we would no longer be in a condition to be gratified" (*ASII–III* 109).[27] Not only does representation provide us with a vantage

26. Bataille, "Letter to René Char," 35.
27. See also *Er* 141; Bataille, "Hegel, Death and Sacrifice," 287–89; Bataille, "Teaching of Death," 119, 123–24; *TR* 103–4.

point from which we can both *have* and *retain* the experience of death, thus reaping its benefits, it may even be superior to the event in some circumstances. When discussing Sade's novels, for example, Bataille observes that "the true nature of the erotic stimulant can only be revealed by literary means, by bringing into play characters and scenes from the realm of the *impossible*" (*ASII–III* 177). Although Bataille condemns the actions depicted in Sade's novels, he argues that the novels themselves perform an unassailable function. Representations of sacrificial violence or erotic anguish may, in certain circumstances, be better able to produce the disturbing, unsettling, blissful, ecstatic anguish that Bataille has in mind— precisely because they are distanced from the real. Bataille's fascination with violent spectacle is not fed by an interest in fostering cruelty, acting violently, or causing suffering. His call for sacrificial violence, in substitutionary form, is neither homicidal nor suicidal. Just the opposite. Bataille argues that violent spectacle has the capacity to shatter the very conceptions that cause human beings to injure, destroy, and oppress one another.[28]

Bataille suggests that art—like rational thought and the awareness of death—is a defining feature of humanity.[29] Along with the tool, creation of the art object is a "capital [event] in the course of human history" (*Lx* 27). But art—as a form of expenditure, of sacrifice—stands in opposition to work. More important than our capacity for labor is our facility to "change work into play," and art is the best example of this capacity (*TE* 47; see also *Lx* 38). Bataille acknowledges that the Lascaux cave paintings were likely produced, in part, as talismans of sympathetic magic intended to influence the success of the hunt—just as he acknowledges that sacrifice and sexual activity have utilitarian dimensions. At the same time, he draws attention to the paintings' breathtaking beauty (*Lx* 34). Bataille notes that reaction to these prehistoric paintings is quite different from reaction to prehistoric tools; we are captivated by their rich colors and bold painterly gestures. They rival and compete with contemporary visual artifacts at the level of aesthetic pleasure (*Lx* 129–30). Given this experience, we must concede the images are not *solely* utilitarian. No

28. Why, then, use a *photograph* as a meditation image? To have a photograph of torture, some body had to undergo torture. Bataille's reliance on this image does not produce the violence; nor can either consideration or ignorance of it alleviate the pain of the person *in this particular photograph*. The best that can be hoped for is that consideration of images of violence—fictional or documentary—will prevent future acts of violence.

29. See *Lx* 7, 11; Bataille, "Cradle of Humanity," 144–45; Bataille, "Lecture," 89, 97; Bataille, "Passage from Animal to Man," 58–60.

matter how much their creators hoped to achieve a successful hunt as a result of painting them, they also partook in the joy of artistic creation. Their beauty is, in the final analysis, pointless: as with an afternoon in bed, a night in a bar, or a weekend in a casino, the world of work counsels against such frivolous exercises. Art, as a squandering of resources and a useless application of technical skill, is a protest against the tool's profanity (*Lx* 27).

This feature of artistic practice—its status as a form of work, its ability to transform work into play—illustrates the fundamental instability of the profane world, the sacred world, and human identity itself. As Bataille notes, "The word *human* never denotes . . . a stabilized position, but rather an apparently precarious equilibrium that distinguishes the human quality. The word . . . is always connected with an *impossible* combination of movements that destroy one another" (*ASII–III* 342). The laborer tries to secure stability through "efficacious activity," whereas the sacrificer willingly enters and remains "*in the storm*" (*ASII–III* 342–43). Because of this necessary oscillation between profane solidity and sacred rupture, human beings are faced with the problem of complete alienation on the one hand and utter destruction on the other.

The world of work generates the capacities that make human beings qua human possible: conceptual thought is the very foundation of human consciousness; without it, we cease being aware of ourselves at all. Taboos and prohibitions may constrain and confine, but they create the conditions whereby productive labor can happen, so that food, shelter, and clothing are available. But this pursuit of project casts us into the future, where death awaits, terrorizing us. Human labor requires tools, which create a distinction between me and not-me. This awareness—extended beyond the flint knife to my body, my lover, my employees, my livestock, my resources—funds acts of cruelty, dehumanization, and subjugation. Various means exist to disrupt this conception of the world. Sacrifice returns me to the present moment through its violent consumption but has the capacity to create a stable of sacred things that strive, but fail, to secure the rupture that it introduced. By externalizing intimacy, the sacred object, used like a tool, quells the violent force of religious ritual, by making it a kind of labor (*ASI* 189; *TR* 77). Eroticism ruptures my sense of separation and discontinuity through corporeal and psychic interpenetration, but it quickly gives way to the work of sexual reproduction, tamed by the commitments of marriage and family (*Er* 109–12). Art, poetry, and literature wastefully expend time and resources, and represent risk, tragedy, and death in ways that call the self into question. But the author's language can easily become discur-

sive; the artist's creation quickly becomes a commodity.[30] And, of course, we must eventually leave the festival. Just as the world of work cannot completely satisfy us, the sacred realm cannot perpetually sustain us. Consumption requires production; expenditure requires labor. To lose oneself in ecstatic abandon, one must first—at some place, in some way—have a sense of self. Humans seek intimacy through religion, eroticism, and art, but this means that one must be human—alienated, objectified, and servile—to sense that intimate communication with the other has value or worth. Work generates the means for its disruption; sacrifice, eroticism, and art have no single, predictable effect. On both sides of transgression, then, instability and uncertainty reigns.

<p style="text-align:center">★ ★ ★</p>

Near the middle of his essay distinguishing the "text" from the "work," Roland Barthes asks, "How do you classify a writer like Georges Bataille? Novelist, poet, essayist, economist, philosopher, mystic?" ("From Work to Text," 157). He suggests that Bataille did not write texts in a variety of genres so much as he "wrote . . . continuously one single text" (157). According to Barthes, the text has a "subversive force" that goes "to the limit of the rules of enunciation." It produces an irreducible plurality that will not answer to interpretation, but requires rather "a dissemination" (157–59).

With this in mind, I approach Bataille's writings with an eye for what they do, in an effort to trace the shift of consciousness they attempt—sometimes through analysis and sometimes through affect. Bataille has a strong critique of work, of project, of rational knowledge, of discursive language, of goal-oriented activity of all kinds, but recognizes their inevitability and necessity. Bataille is clear that humans cannot fully and completely overcome project (and remain human); they can only interrupt it— and they can interrupt it only through project. He insists on the paradox of overcoming project through project, of revealing the shortcomings of discursive thought through language, of arguing for the superiority of silence with words, of eradicating the desire for power by striving for sovereignty. Bataille's goal is to dispel fascination with goal-oriented activity. With this as my inspiration, I insist on the promise of the instability and ambiguity found in representations of masculine subjectivity.

I bring Bataille into the conversation about masculinity not because he had much to say about it explicitly, but because his interest in disturbing our sense of ourselves as separate, isolated, autonomous, self-contained individuals necessarily requires a chal-

30. On poetry, see Bataille, "From the Stone Age," 147; on art, Bataille, "Notion of Expenditure," 121–25.

lenge to dominant fantasies of masculine identity. Just as Bataille argues that produc-
tive work eventually produces its opposite, the consumptive festival, I show how fan-
tasies of masculine plenitude inevitably contain the seeds of their own destruction—or,
at least, betray their perpetual grasping for power and privilege. While my interpreta-
tion of suffering male bodies depends, in part, on Bataille's specific claims about sacri-
fice, eroticism, and artistic representation, I rely as much, if not more, on his general
method of pursuing doubleness, undecidability, and juxtaposition.

According to Barthes, "Discourse on the Text should be nothing other than
text. . . . The theory of the Text can coincide only with a practice of writing" (164).
When considering Bataille's texts, such an imperative is intimidating to say the least.
To engage them, must I produce a text comparable to them? Perhaps, thankfully, the
bar is not quite so high. "The Text requires that one try to abolish . . . the distance
between writing and reading" (162). Reading the text should not be a form of con-
sumption aimed at deciphering meaning, but rather a kind of play that "open[s] it out,
set[s] it going" (163). The reader should play the text like a game or a musical score:
"the Text . . . asks of the reader a practical collaboration" (161–63).

In this book, I seek to collaborate with Bataille by reading the male-body-in-pain
with and through the violent, sacrificial expenditure central to his textual practice. I
hope to show how such images and discourses pierce the fantasy of autonomous, self-
sufficient subjectivity that grounds claims of masculine power and privilege. Represen-
tations of the suffering male body seek their audiences' practical collaboration. They
strive to enlist viewers and readers in the fantastic work of valorizing triumphant hero-
ism as the meaning of masculine subjectivity and the criterion of human dignity. My
playful (re-)reading/writing of these representations should sound as alternate mel-
odies in a Bataillean key. My engagement is, undeniably, collaborative; it depends
heavily on these representations' affective power, while opening them up to other pos-
sible significations, setting them going in new directions. To state all of this in another
way: I have sought to produce a Bataillean text not by mimicking his writing (the
Text, after all, resists "passive," mimetic reduction [162]), but by pursuing a practice
of reading that insists, with Bataille, on the political and ethical promise of moments of
rupture, especially the rupture of the male body.

<p style="text-align:center">★ ★ ★</p>

In the closing paragraphs of the chapter on Bataille in *Death by a Thousand
Cuts*, the authors fault Bataille—and others—who liken *lingchi* victims to
Christ figures because the frame of Christian suffering obscures "the real
tortured Chinese, whose expression and feelings are still, and will remain,
beyond our reach" (240):

> In substituting an anonymous bleeding corpse for the figure of Christ cru-
> cified, Bataille meant to substitute humanity for divinity, thereby enlarg-

ing the meaning of sacrifice. He failed to realize that by dissolving the historicity of the torture victim into his own religious abstraction, he might have sacrificed that very meaning. *Ecce homo*: the phrase is usually used in reference to the image of the suffering and humiliated Christ wearing the crown of thorns. But literally it means: "Here he is." That is, it designates the person of Jesus Christ: his identity, his history; his name, origins, and personal connections; his words, his acts, and his death—not as the tortured person, nor as pure suffering, but as event: trial, date, place, deeds, words. . . . What would one make of a Christ about whom nothing was known except Calvary, or whose image was reduced to a mask of his last moments (241–42)?

With this meditation on the phrase *ecce homo*, the authors intend to show how a "mask of suffering" prevents suffering from being meaningful. What they demonstrate instead is that one inevitably chooses between masks. To identify the historical person of Jesus with the Christ of theology is to impose a mask (which, in turn, requires choosing among the various Christ masks on display in the Christian theological warehouse). To assume that Jesus's words (insofar as they can be known to history independent of traditions of faith) are as relevant as his suffering is to impose a mask. The same can be said about his deeds. To assume that the relevant event is something more than Jesus's suffering imposes a mask.

Unlike the authors of *Death by a Thousand Cuts*, Bataille proceeds in accord with the literal meaning of *ecce homo*. Here he is: a brutalized, beaten, battered body on the precipice of death. And, lest we forget, a male body. Confronted with a male-body-in-pain—and, in the case of Jesus, a male-body-in-pain named by the Christian tradition as (the revelation of) God—what sense can one make? Does *ecce homo* even try to make sense? Or is it a performative utterance, the linguistic equivalent of a pointing finger? Once one begins to make sense, whatever sense one makes, one forges masks and imposes personae. Bataille obsessively breaks, shatters, and undoes the sense we have of ourselves as autonomous, separate, isolated, discontinuous individuals. He confronts his readers with the anguished ecstasy that comes from non-sense and un-knowing. He connects this experience to an awareness of shared vulnerability and mutual laceration. In order to make this particular kind of (non-)sense, an anonymous victim of brutality might do. As with their earlier insistence that there is only one question to be asked of the torture photograph (236), the authors of the *lingchi* study assume that there is only one way to be interested in the bloody, soon-to-be corpse of Jesus.

Bataille is more than satisfied with a Jesus reduced to Calvary; for him,

the most valuable aspect of Christianity is "the Son of God's ignominious crucifixion."[31] The crucifixion wounds God and, like the mutual laceration of erotic intimacy, makes communication possible (G 31). The crucifixion, as a form of sacrifice, demonstrates God's vulnerability; it shows that nothing is exempt from loss, violence, and death. Because the spectacle of crucifixion pierces the fantasy of impermeability that fosters our sense of discontinuity, we should, according to Bataille, imitate the great cry of forsakenness—*lama sabachthani*—that sounds from Golgotha (*IE* 47).[32] Yet, just as most human beings flee the anguish of sacrifice and eroticism for the comforts of sacred objects and reproductive sex, Christians have fled from the abyss opened by nails and spear for the saner, safer religious imaginary of salvation. Rather than claiming the crucifixion as the primal human transgression of murdering God, they proclaim the cross as the gracious self-offering of divine love. Associated only with that which is good and beneficent, the sacred loses its connection to danger and risk, stripping the holy of its terror, of its ability to disturb the profane world (*ASII–III* 132–34; *Er* 118–21; *TR* 69–71). Consequently, Christianity can no longer access the sacred; it is now "the least religious of . . . all" religions (*Er* 32; see also *ASII–III* 132–34; *Er* 118–21; *TR* 69–71).

Without the horrifying spectacle of crucifixion as a teeming wound, without the haunting peals of *lama sabachthani*, Christianity becomes profane. As the cross is transformed from crime to crutch, salvation becomes the focus of religious life. And salvation is, ultimately, a form of work, "the summit of all possible project" (*IE* 47; see also *ASI* 120; *TE* 79). Whether understood as the result of merit or grace, salvation projects the subject into the future and makes the present less relevant in a manner fully consistent with other forms of labor (*TR* 87). Moreover, salvation is sometimes imagined as the "prolongation of every individual soul. . . . Chosen and damned . . . bec[o]me impenetrable fragments, forever divided, arbitrarily distinct from each other, arbitrarily detached from the totality of being with which they must nevertheless remain connected" (*Er* 120). Even God, imagined as a person, becomes a separate and discontinuous being, a divine thing, as distinct and instrumentally valuable as any other thing (*Er* 102; *TR* 33–34, 88). Christianity becomes irredeemably profane due to its "inevitable obsession with a *self*" (*G* 115; see also *G* 45).

Undoubtedly, Bataille's understanding of both the promise and profanity of Christianity must be nuanced in light of the variety of theological

31. Bataille, "Notion of Expenditure," 119; see also *Er* 89, 120–27; *ON* 18.
32. See also Bataille, "Sacrifices," 133–34.

voices and visions that comprise Christian traditions.[33] But his analysis of Christianity reveals its instability. In Christianity, project and transgression compete for ascendance. To distinguish those features of the Christian theological imaginary that might "reduc[e] this world of selfish discontinuity to the realm of continuity afire with love" (*Er* 118) from those that foster division and separation, Bataille, to my eyes, rightly focuses on bodily violation, subjective rupture, and self-loss. In *Guilty*, Bataille writes that "the God of theology is only a response to a nagging urge of the self to be finally *taken out of play*. Theology's God, reason's god, is never brought into play." But "the unbearable self we are comes into play endlessly. 'Communication' brings it into play endlessly" (*G* 85). The soul-searing, subject-rending cry of self-loss is the beginning of any authentic communication.

Contrary to assertions in *Death by a Thousand Cuts*, historical specificity does not, in all cases, foster identification. Historical specificity, contextual detail, identifying features—these do not bind me to the victim of torture, but provide a means to distinguish myself: *I am not vulnerable in that way. I can avoid that kind of pain. I will be able to stay safe, whole, the invulnerable person I am, unaffected and uninfected by the traumas that afflict others, if I do not go to that place, engage in that activity, join that group.* Pity, yes; identification, no—the gesture might seek to comfort, but still it distances; its reach extends to that which is understood as outside of, distinct from, external to my self. It is fully consonant with the subject-object distinction of profane reality. And this distancing gesture that begins as compassionate easily becomes self-protective and, often unwittingly, culminates in a violent blow.

Discourses of history can easily build walls—impose masks—that separate human beings from each other. The details of time and place that give a person an identity necessarily give that person a *discrete* identity, a discontinuous identity. Historical specificity can just as easily prevent as promote identification. For this reason, Bataille replaces the suffering body of Jesus with the photograph of an unidentified Chinese torture victim. "Jesus" is simply bound up in too much signification, too much historical chatter. His death can no longer be my death. To reopen the sacred abyss at the heart of the Christian imaginary, we need to remember that it circles around a broken, suffering, and dying male body without immediately thinking of that

33. Hollywood's discussion of Bataille's relation to Angela of Foligno and Mechtild of Magdeburg as well as his own invocation of Angela of Foligno, John of the Cross, and Teresa of Avila show that there are resources within the Christian tradition for a Bataillean religious experience. On this issue, it is also important to consider the relation between Bataille and Simone Weil. See Biles, *Ecce Monstrum*, 95–123; Irwin, *Saints of the Impossible.*

body as an atoning sacrifice, a loving redeemer, a sign of God's solidarity, or a reminder of political tyranny. What do we make—what *can* we make—of an anonymous martyr, an unknown saint, an unidentified victim?

Representations of the suffering body per se are a screen, a surface burnished by history's erasure, that can reflect the viewer's and the victim's shared capacity for pain, trauma, and suffering. Of course, representations of violated bodies do not always function this way—cruelty, humor, voyeurism, and indifference often intervene. Mirrors warp. But *histories* of violated bodies, which are only another manner of representing them, also misfire—the desire to explain is often a desire to explain away, to justify, to diminish horror. Narratives distort. What Bataille helps us see—besides the fact that intervening in cultural fantasies that perpetuate humanity's inhumanity, one to another, is no easy matter—is that representations that foster unease, discomfort, nausea, and terror may, ultimately, issue forth not only in ecstasy but in a different way of perceiving one another and a different way of living together. This transformation comes neither from the articulation of nor the assent to a new set of principles, but rather flows out of a new awareness of what it means to be human, beginning with an experience of one's own nearness toward death. The poetic cry of *lama sabachthani* loses none of its anguish with this realization—indeed, the moment the anguish is lost, the cry is no longer poetic—but when the cry becomes a chorus, anguish becomes the foundation of recognition, an ecstatic encounter with the other across the dizzying, terrifying loss of self.

SUFFERING TRIUMPH

Modern audiences are trained to read violence not in a religious context, but in an action-hero, injury and revenge context.

SARAH HAGELIN

Film masochism ... is, in effect, emblematic of masculinity, not its opposite.

JEFFREY BROWN

When I heard that [Mel] Gibson would direct a film adaptation of the life of Jesus, my first thought was, "What took him so long?"

ELVIS MITCHELL

Just days after Hitler invaded Poland and France declared war on Germany, Georges Bataille penned the following: "The date I start (September 5, 1939) is no coincidence. I'm starting because of what's happening, though I don't want to go into it. I'm writing it down because of being unable *not* to. . . . No more evasions! I have to say things straight out . . ." (G 11; final ellipsis in original). Subsequent journal entries and philosophical fragments, written between 1939 and 1943 from the relative security of the French countryside, would become the second volume of Bataille's ever-evolving, always incomplete *Summa atheologia*. Despite its intention "to say things straight out," the resulting text is anything but straightforward. As Denis Hollier observes, "*Guilty* isn't actually a book, and . . . it isn't what is conventionally known as a journal either. Rather, it's an experimental document: a record of . . . experiences whose waves or turbulence Bataille felt in the course of the war years."[1]

Guilty also quickly distances itself from the events that motivated its inception. In the sixth paragraph, Bataille declares, "I won't speak of war, but of mystical experience" (G 12). But he mentions air-raid sirens (G 12), refers to German troop movements (G 51), and comments on the devastation he sees (G 52, 56). More puzzling than his breaking of this self-imposed vow of silence is his motivation for taking it in the first place. From the time it was published to the present, critics have characterized *Guilty* as an irre-

1. Hollier, "Tale of Unsatisfied Desire," vii.

sponsible retreat from the political, especially given the trauma of war that was its context and Bataille's prewar criticism of fascism.

Although he was more explicit about the relation between war and mysticism in unpublished writings from this period, Bataille hints at his understanding of their relation in *Guilty*:

> I saw in the war something ordinary life lacked—something that causes fear and prompts horror and anguish. I turned to it to lose my thinking in horror—for me, war was a torment. . . . I despise the boorishness of people drawn to the combat aspect of war; it attracted me by provoking anguish. War professionals, so called, are unfamiliar with these feelings. War is an activity that answers their needs. They go to the front to avoid anguish. Give it your all! That's what they think counts. (G 56)

In his exceptionally lucid and enormously helpful study of Bataille's wartime writings, Alexander Irwin notes that

> Bataille was for violence, and . . . against war only because and to the extent that war failed to be the kind of violence he considered most extreme and liberating. . . . War engendered mass death stripped of the "deep meaning" that could only be given to death (and therefore to life) through the work of consciousness, the long and patient labor of sacrifice. . . . War and its underlying logic, then, were to be contested in the name not of pacifism or resignation, but of a higher violence.[2]

Bataille recognizes war's seductive allure—it provides "something ordinary life lack[s]"—but locates it solely in the "anguish" and "torment" fostered in the subject, rejecting conquest and the infliction of harm.

Following the popular German author and World War I soldier Ernst Jünger, Bataille equated battlefield trauma with mystical rapture, but he distanced himself from Jünger by pointing out that the instrumental violence demanded by the logic of victory lessens war's horror by providing it with a justification.[3] Bataille also argued that war's mystical dimension can never be experienced in the moment. As Irwin explains:

> War can know itself only if it is not fought, but written. To "deepen" the experience of horror that combat offers him, the soldier would have to stop being a soldier and become, like Jünger, a writer. Perhaps all soldiers *should* become writers (or mystics). But until they do, to treat actual warfare lyrically, as an affair of depth, is to indulge in an irresponsible literary redemption or recuperation of human pain. (142)

2. Irwin, *Saints of the Impossible*, 159–60.
3. See Hussey, *Inner Scar*, 133–35; Irwin, *Saints of the Impossible*, 136–46.

For Bataille, written meditations on war's conflagration can generate self-shattering violence without warfare's material consequences. His point is not to avoid all forms of traumatizing experience but rather to avoid actual, physical devastation. To celebrate combat per se as a mystical experience is monstrous—to Bataille and to his critics.

Guilty does not directly criticize war's devastation, or fascism's aggression, or France's capitulation. Rather, it encourages internalizing the violence of ecstatic abandon in order to lacerate the self and open it to the lacerated other (e.g., G 30–31). This violence trades in the glory of war without replicating its logic of "friend and enemy, victor and vanquished, slayer and slain."[4] In an essay written a few months before beginning *Guilty*, Bataille declared, "I MYSELF AM WAR."[5] This evocation of and identification with war was offered as a possible mystical exercise, imaginatively directing war's violence against the meditating subject:

> I AM joy before death . . . ceaselessly destroying and consuming myself in myself in a great festival of blood.
>
> I imagine the gift of an infinite suffering, of blood and open bodies, in the image of an ejaculation cutting down the one it jolts and abandoning him to an exhaustion charged with nausea.
>
> I imagine myself covered with blood, broken but transfigured and in agreement with the world, both as prey and as a jaw of TIME, which ceaselessly kills and is ceaselessly killed.[6]

Bataille equates war and mysticism to harness war's splendor and redirect it for different ends. He does not retreat from war, but surveys it from the distance that representation allows in order to transvalue the violence it bears. Bataille attempts to capture the affective dimension of war's violence in textual stylization to prevent the physical carnage of its empirical expression.

Motivated by a similar spirit, this chapter attends to representations of violence—specifically, violence generated by and directed against male bodies—in Hollywood action films. Linking the "violence" of action films with the trauma of war, however tangentially, may appear as obscene and problematic as Bataille's celebratory turn to mystical self-annihilation in the midst of World War II, but I see a connection between the action genre's pleasures and those "drawn [from] the combat aspect of war" (G 56). The male action hero is motivated by the "Give it your all!" attitude Bataille

4. Irwin, *Saints of the Impossible*, 145.
5. Bataille, "Practice of Joy," 239.
6. Ibid., 238–39.

repudiated. The genre's ever-victorious protagonist bears a family resemblance to the "war professional" Bataille criticized. The action film's triumphant narrative seeks to assuage the anxieties related to mortality, limitation, and vulnerability that Bataille sought to intensify. More importantly, in ways similar to the sacrificial and erotic self-abandon Bataille championed, action films' representations of violated bodies sometimes instantiate values that run counter to the goal-oriented triumphalism of their overarching narratives. This chapter, then, considers some of the clearest examples of the male-body-in-pain's ambiguity. Featuring narratives of the suffering but triumphant hero, and containing spectacular displays of the male body, action films present all the issues and questions that motivate this study.

★ ★ ★

Action films are typically composed of images of spectacular violence that show the male body's ability to overcome an astonishing degree of peril, suffering, and pain. They tell stories featuring a hero (usually male) who is both linked to institutional authority (law enforcement, the armed services) and alienated from it. This hero is a highly competent manipulator of the various tools of violence (knives, guns, explosives), as well as a master of his body's violent potential. He usually operates in a setting, such as an urban or natural jungle, that circumscribes his range of vision and bodily motion; his capacity for swift, graceful, and efficient action allows him to overcome these limitations. After facing a series of potentially deadly encounters, and sustaining some degree of physical injury or loss (comrades-in-arms, family members), he manages not simply to subdue the opposing force but to eradicate it. The hero's use of violence, virtually identical in scope and content to his enemy's—if not greater—is marked as morally legitimate; his foe's, whatever its motivation, as morally reprehensible.[7]

What distinguishes the action genre is not its representation of violence, nor its construction of a world of starkly contrasted good and evil, nor even its obsession with "real men." It is action itself: violent, spectacular, stylized.[8] Frenetic fight scenes, high body counts, rapid-fire weapons, car chases, and other physical and pyrotechnical displays are emphasized, while

7. For a similar description, see Lichtenfeld, *Action Speaks Louder*, 17–18.
8. Caldwell, "Muscling In," 137–39; Gallagher, "I Married Rambo," 206–7; Lichtenfeld, *Action Speaks Louder*, 59–60; Neale, *Genre and Hollywood*, 52; Prince, *New Pot of Gold*, 184; Tasker, "Introduction," 5–6; Webb and Browne, "Big Impossible," 81–82; Welsh, "Action Films," 169–70. The action film's most apparent generic precursor is the Western. Hoberman, "Fascist Guns in the West," 42. Lichtenfeld characterizes the genre as a reconsideration of the Western in light of film noir anxieties (*Action Speaks Louder*, xv–xvi). See also Gallagher, *Action Figures*, 47. Like the melodrama's

narrative exposition and character development are minimized. The hero hurtles through a series of exceedingly tense, visually interesting, physically demanding predicaments, overcoming or evading increasingly dire threats.[9]

This excess secures the genre's central message: the bigger the explosion, the more impressive the hero's escape. While there is little genuine doubt that the hero will endure, his survival remains the chief narrative obsession. In the course of a single film and across the genre as a whole, the degree of risk the hero faces and the level of ingenuity he requires steadily escalate. For all its special-effects wizardry, the action film is essentially an ordeal narrative: Will our hero prove his manhood by surviving?[10] The genre almost always answers in the affirmative. Its spectacular visual display—cataclysmic violence alongside indestructible male bodies—establishes ever-renewable power and strength as the chief characteristic of the masculine subject.[11]

The hero's body is a key feature of the film's visual display. While buildings explode and helicopters spiral to the ground, the hero's iconic corporeal form remains. Action films from the 1980s and early 1990s celebrated oversized, exaggerated, near-caricatured visions of muscular masculinity—the era's stars were Arnold Schwarzenegger, Sylvester Stallone, and Jean-Claude Van Damme. Following the success of *Die Hard* (1988), starring the much smaller and trimmer Bruce Willis, the spectacle of the male body diminished, without an overall reduction in visual excess. As the spectacle of corporeal display decreased, spectacular physical destruction increased, reaching a level previously seen only in the disaster film.[12]

heroine, the action hero proves his goodness and exemplary status, in part, through his response to suffering. Gallagher, *Action Figures*; Gledhill, "Rethinking Genre"; Williams, "Melodrama Revisited."

9. See Schubart, "Passion and Acceleration."

10. Gallagher, "I Married Rambo," 210; Marchetti, "Action-Adventure," 187–88; Schatz, *Hollywood Genres*, 34. Heroic status is open to female characters if they succeed on the genre's terms. See Brown, "Gender, Sexuality and Toughness"; Inness, *Tough Girls*; O'Day, "Beauty in Motion"; Tasker, *Spectacular Bodies*, 14–34, 132–52; Vares, "Action Heroines."

11. Brown, "Tortures of Mel Gibson," 131; Gallagher, "I Married Rambo," 199, 204; Lichtenfeld, *Action Speaks Louder*, 59; Neale, *Genre and Hollywood*, 56.

12. See Lichtenfeld, *Action Speaks Louder*, 197; Schneider, "With Violence If Necessary," 11n5. Although there are various industrial explanations for these shifts, the genre also had to negotiate growing cultural awareness regarding (homo)erotic contemplation of the male body. As gay male desire became a more explicit dimension of "mainstream" culture, it became more difficult to disavow the erotic allure of the action hero's body. Because I am interested in how representations of the male body shape, secure, and subvert cultural understandings of masculine subjectivity, I focus on films that feature corporeal display as a primary iconographic element. I neither

Action films, then, are constructed through the juxtaposition of spectacular violence and the spectacle of the male body.[13] A suffering male body can potentially signify vulnerability, limitation, and lack, in contrast to dominant cultural myths about masculine identity. The muscular action hero, on the other hand, exemplifies the cultural standard of the solid and impenetrable male body. If even that body can be wounded, the mythic frame of masculine superiority is potentially shaken. The action hero's suffering body, however, bears its injuries not as a sign of weakness but as the mark of invulnerability. Scenes of danger, destruction, and devastation provide a stage on which the hero performs acts of strength and bravery.[14] Insofar as his body is in pain during the performance of these Herculean feats, its suffering evinces his heroic stature: this male body (or, *the* male body) deserves admiration and veneration because it emerges victorious even though it has been beaten, bruised, made to bleed. The body's suffering, then, does not necessarily open a space in which the action genre's alliance with hegemonic masculinity can be fruitfully resisted and renegotiated.

To establish the body's invulnerability to injury, assault, and destructive forces, the body must be displayed. The ambiguity of this display is key to any critical intervention in the genre's ideological project. The muscular male body on display—especially when shown performing acts requiring strength, skill, and speed—unquestionably signifies masculine power. This body's beauty and grace, as much as its efficiency and potency, make masculine power attractive, alluring, enticing. Thus, the muscular male body on display—even when shown performing acts requiring strength, skill, and speed—is also an object of erotic contemplation. While its sexual charge does not cancel its ability to signify power, it complicates its relationship to hegemonic norms of masculine identity. According to normative understandings, the masculine subject is an agent of desire, not its object. When the masculine body becomes desire's object—and a fabricated object at that—the relation between that body and dominant fantasies of masculinity is significantly altered. Moreover, the erotic patina raises questions about the body's motivation: does the display merely accompany heroic acts, or does the hero actively elicit desire?

Cyborg (1989) illustrates well both how the male hero's suffering legiti-

intend nor attempt to provide an analysis of the action genre as a whole. For further discussion of the genre, see Gallagher, *Action Figures*; Greven, *Manhood in Hollywood*; Jeffords, *Hard Bodies*; Lichtenfeld, *Action Speaks Louder*; Tasker, *Spectacular Bodies*.
13. Fradley, "Maximus Melodramaticus," 239; Willis, *High Contrast*, 40.
14. Brown, "Tortures of Mel Gibson," 129–30; Gallagher, *Action Figures*, 56; Hoberman, "Fascist Guns," 44–45; Marchetti, "Action-Adventure as Ideology," 191.

mates his claim to power and how the suffering body becomes an erotic object. In the film, Jean-Claude Van Damme plays Gibson Rickenbacker, a mercenary guardian who, wandering the plague-ravaged landscape of a near-future America, witnesses an attack on a team of cyborgs who are trying to find a cure for the plague. One of the cyborgs is kidnapped by a band of "land pirates," led by Fender, a long-haired mass of a man with eerily light-blue eyes.

Rickenbacker suffers a brutal beating at Fender's hands that ends with a shot of Van Damme's face, covered with blood, sweat, and sand—and a quick cut to black. The next scene opens with Fender's gang standing together, looking up. The camera follows their gaze to reveal Van Damme's blood-spattered body hanging from a beached ship's masthead.[15] As they depart, a young woman lingers at the foot of this makeshift cross, fingering the pendant hanging around her neck. As Rickenbacker hangs on the cross, his past is made fully comprehensible. The film repeats flashbacks that have previously received only fleeting attention. While Rickenbacker suffers, the sequence is put in order, extended slightly, and completed. While guarding a young mother and her children, the flashbacks reveal, he fell in love. After their initial sexual encounter (depicted with rapt attention to Van Damme's beauty), Fender's gang invaded their pastoral retreat and hung the woman, one of her children, and Rickenbacker over the opening of a well. Fender gave the woman's youngest daughter a cord of barbed wire, telling her she could save them if she held on tightly.

The weight proved too much for the girl: her family fell; her hands were shredded. This girl is the woman who recognizes the man on the cross, the fingered pendant a gift from him. The flashbacks are punctuated by glimpses of Rickenbacker's body in the present. Enraged by the memory of Fender's evil deeds, he kicks at the cross, splinters the wood, and, in a momentary nod to empirical veracity, quickly tires. At the climax of the flashback sequence, he climbs out of the well—the fall's sole survivor—collapses to his knees, and emits a guttural scream. This resurrection in the past gives Rickenbacker newfound energy in the present; the force of his cry enlivens his feet and he shatters the masthead on which he has been left to die. *Cyborg* narratively coalesces all of the hero's injury, grief, and trauma into a single moment that culminates in the generation of self-resurrecting power. As he suffered and triumphed in the past, so will he suffer and tri-

15. Crucifixion scenes also appear in *Conan the Barbarian* (1982) and *Rambo: First Blood II* (1985). For discussion of action films' Christian iconography, see Boer, "Christological Slippage"; Schubart, "Passion and Acceleration."

umph in the present, in order to suffer and triumph in the future (a victory over Fender at the film's conclusion). His suffering both explains and justifies his desire for revenge.

With its display of Van Damme's nearly naked body, *Cyborg* exemplifies how the male body's suffering and its erotic allure are virtually inseparable in the action film's representational logic. The hero's crucified body may be cosmetically bloodied, but the camera lingers on his bulging pectoral muscles, well-defined torso, and massive arms. When, in flashback, Rickenbacker scrambles out of the well, the drenched fabric of his pants clings tightly to his massive thighs, water glistens across his broad chest, and an anguished cry clenches his six-pack abs. This body may suffer (temporary) defeat, but it never loses its appeal. The suffering body is a beautiful body.

A similar sequence is found midway through *Rambo III* (1988). The backdrop for this installment of the series is the Soviet occupation of Afghanistan. Stallone's character, Vietnam vet John Rambo, enters the fray to rescue his mentor, Colonel Trautman. During his first attempt, Rambo is shot through the abdomen, literally pierced in the side, while attempting an act of redemption. Alone in the Afghan desert, he pushes his thumb into his torn flesh and manually expels the projectile. With a gunpowder charge on the tip of his iconic knife, he cauterizes the wound. For a moment, a tongue of flame licks at each opening. Rambo cries out, lurches forward, and clenches a rock, gasping for breath. Predictably, he recovers quickly and returns triumphantly to the prison.[16]

Rambo's ingenious self-repair allows the camera to attend to Stallone's sculpted body. Illuminated by flickering firelight, his pecs, abs, biceps, and triceps are etched in chiaroscuro. The scene begins with Rambo ripping open his shirt to reveal both a bloody wound and a taut, sweat-drenched stomach. To tend to his injury, Stallone must twist in ways that tighten, stretch, and pose his muscular frame. Once again, the hero demonstrates his ability to withstand and overcome suffering. Once again, suffering overcome energizes the hero. Once again, the suffering male body, represented with allusions to Jesus's crucified body, is contemplated erotically.

In his essay "Masculinity as Spectacle," Steve Neale nuances Laura Mulvey's observation that "the male figure cannot bear the burden of sexual objectification."[17] While acknowledging mainstream cinema's reluctance to consider the male body erotically, he demonstrates that it occurs frequently, albeit surreptitiously. "In a heterosexual and patriarchal society

16. The thematic of self-repair runs across the *Rambo* trilogy. It also appears in films featuring cyborgs, such as *Universal Soldier* (1992) and the *Terminator* series.
17. Mulvey, "Visual Pleasures," 20.

the male body cannot be marked explicitly as the erotic object of another male look: that look must be motivated in some other way, its erotic component repressed."[18] In other words, erotic contemplation of the male body takes place under conditions of plausible deniability: ask an average theatergoer why the hero is nearly naked, with his glistening sculpted frame on display, and he will always be able to offer a reason other than the pleasure derived from gazing upon the actor's beauty. Neale contends that narratives of suffering provide the primary alternative motivation for displaying the male body (284).[19] In her analysis of the male gaze and classic Hollywood cinema, Mulvey observes that "sadism demands a story."[20] To Mulvey, this explains mainstream films' fascination with the punishment and humiliation of women. With respect to the spectacular male body, the statement must be modified: homoeroticism demands a sadomasochistic story. The male body's frequent display evinces its sexual allure and the ubiquity of a desire to gaze upon it. The coincidence of suffering and spectacle, then, can be understood as one strategy of managing the undercurrent of homoeroticism that is the constant—albeit disavowed—companion of displays of masculine power.[21]

Even without the complication of eroticization, the male body's display is indeterminate with respect to masculine power. The action film attempts to give masculine domination a natural foundation by grounding it in the male body. But the action star's hyperdeveloped musculature alone exposes the body's artifice.[22] In addition, action film narratives show the male body acquiring its power through training and preparation, usually portrayed in extended montage sequences. In Van Damme's films, for example, significant screen time is given to disciplining and perfecting his body. He must learn to perform the tasks of masculinity, skills that are not intrinsic to him. This training reveals the protagonist's endurance, stamina, and strength. In *Bloodsport* (1988), Van Damme is initially clumsy and inept; only slowly does he develop corporeal prowess. This process is literally painstaking: his body undergoes injury, stress, and humiliation. The ordeal justifies showing his

18. Neale, "Masculinity as Spectacle," 281.
19. See also Brown, "Tortures of Mel Gibson," 129–30; Gallagher, "I Married Rambo," 208; Mitchell, "Violence in the Film Western," 177; Tasker, *Spectacular Bodies*, 125. The male body's athletic prowess is another strategy for displaying and disavowing erotic allure. See Dyer, "Don't Look Now," 274–75; Savran, *Taking It Like a Man*, 202–4; Tasker, *Spectacular Bodies*, 77–80.
20. Mulvey, "Visual Pleasures, 22.
21. Neale, "Masculinity as Spectacle," 286.
22. Caldwell, "Muscling In," 135–37; Gallagher, "I Married Rambo," 212; Tasker, *Spectacular Bodies*, 9, 18, 105, 119.

body sweating, straining, and stretching in ways that reveal its contours.[23] And as Van Damme's body becomes more skilled, it sheds clothing. The body ready for battle is a near-naked body.

One of the most blatant revelations of the masculine body's fabrication is found in *Commando* (1985). Just before he storms his archenemy's compound to rescue his daughter, Arnold Schwarzenegger prepares for battle. After he has carefully adorned his face and body with camouflage greasepaint, an extended montage of extreme close-ups of his arms, hands, face, and weaponry dissects and reassembles him. Schwarzenegger's body and arsenal—the sources of his masculine splendor—are constructed by the editing.[24] This stylized spectacle situates the viewer in contradictory spaces. As Mark Gallagher observes, "Though at some level action films require viewers to take male performance seriously (seriously enough to generate suspense), on another level the films allow viewers to enjoy the artifice of men masquerading as supermen."[25] The spectacle that intends to secure the film's underlying ideological message illuminates that project's very mechanism.

The parodic potential of the male body's stylization can perhaps best be understood by considering the treatment of Schwarzenegger's body in the *Terminator* films. Because he portrays an existentially distinct cyborg in each film of the series, it is not his character, the cyborg model T-101, but Schwarzenegger himself—his body, star persona, and performance style— who is the central source of pleasure. This investment in Schwarzenegger's body is indicated by the similarity in his wardrobe, movement, and conduct across the films. Through costume and narrative, his body is marked as an exemplar of the hegemonic masculine ideal. Schwarzenegger's body is immense, hard, and well-defined; it is outfitted in militaristic jackets, heavy boots, and dark sunglasses. Although subjected to numerous assaults from a wide variety of implements, this body endures.

While Schwarzenegger's physicality and the films' narratives emphasize his deep reserves of masculine power, his body's presentation complicates its relation to the masculine ideal. This can be seen in a moment depicted in each of the first three *Terminator* installments: the T-101's arrival from the future. Because only living tissue can pass through the time portal, the T-101 always arrives nude. In the first film, he stands proudly, faces the camera squarely, and strides forward to survey Los Angeles. Schwarzenegger's broad shoulders, massive thighs, and sculpted buttocks are framed by

23. Similar sequences appear in the *Rocky* films, the most excessive example, especially for its eroticism, is the *Rocky IV* (1985) montage.

24. Similar scenes appear in Schwarzenegger's *Predator* (1987) and *Raw Deal* (1986), Stallone's *Rambo* films, and Gibson's *Lethal Weapon* series.

25. Gallagher, "I Married Rambo," 213.

the nighttime skyline in an alignment between male beauty and potential power that would make Leni Riefenstahl weep.[26] The display marks Schwarzenegger's body as alluring and authoritative, worthy of veneration both as an object of contemplation and as a subject of command. This corporeal grandeur is further emphasized when the human soldier from the future—portrayed by the much lither Michael Biehn—arrives, shivering, in a fetal position.

Because he is naked, the T-101's first order of business is the acquisition of clothes. In the first film, he does this quickly and matter-of-factly. In the second, he wanders into a biker bar and demands a patron's boots, jacket, and motorcycle. The biker refuses and laughs, until the T-101 throws him across the room. When he exits the bar clad in motorcycle leathers, the camera slowly climbs his body, starting at his boot-shod feet—a gesture similar to the adoration of his naked form in the first film, but also reminiscent of the female starlet reveal in classic Hollywood cinema. The visual inspection of his manly costuming is accompanied by George Thorogood and the Destoyers' song "Bad to the Bone." The soundtrack could be interpreted as either emphasizing the "badness" of Schwarzenegger's attire or signaling its near-drag excess with neocamp riffs. Lest the audience miss the importance of apparel to masculine badness, the T-101, confronted by the bar owner carrying a shotgun, quickly and efficiently disarms him, then steps forward ominously, only to remove sunglasses from the owner's shirt pocket, completing his outfit. Although I interpret this scene as a parodic interrogation of gendered self-presentation, signaling masculinity's status as a form of bodily stylization, Schwarzenegger's impressive and intimidating figure astride a motorcycle decreases the legibility of the parodic gesture.

The parody shifts from plausibly deniable to arguably heavy-handed by the third film. Once again, the nude T-101 walks into a bar to acquire clothes. This time, however, he arrives on "ladies night" and takes the costume of a male stripper dressed as a biker and coded as gay. His exit is accompanied by diegetic music: the Village People's "Macho Man." While the apparel he obtains in the second and third films is virtually identical, the musical accompaniments have radically disparate cultural significations. The third film complicates the simple equation between biker gear and normative masculinity upon which the second film depends. The shift from the first film's neofascistic celebration to the second's ambiguous representation

26. Schwarzenegger's body demonstrates its power while being at rest and on display. This troubles the strong relation Mulvey wants to establish between activity and masculinity, spectacle and femininity ("Visual Pleasures," 19–20).

to the third's blatant send-up indicates how virtually identical iconographies can generate markedly different meanings.[27] By repeating the clothes-acquisition type-scene, the films, perhaps unwittingly, expose the machinery for constructing and portraying Schwarzenegger—and his action-hero compatriots—as a masculine ideal of a particular type. Despite the impressive character of Schwarzenegger's body, the loving attention paid to its costuming demonstrates that masculinity is secured as much through careful styling as natural endowment.

The action film's spectacular display of the male body generates complex and contradictory significations. Although suffering can signify vulnerability, weakness and limitation, enduring pain and injury signifies resilience. Similarly, while display of the male body can both render it an object of erotic contemplation and reveal the fabrication of the masculine ideal, it can also mark the body *as* ideal, worthy of attention and admiration. This allure can, at the same time, make the masochistic trial itself appealing. The action film's display of the male body thus both substantiates myths of masculine power and privilege and provides material for subverting those myths.

Dominant fantasies of masculine power depend on the display of the male body to secure their claim to truth, but display of the male body also reveals the striving behind this ideological construction. The deep instability of such display means that virtually any representation—including the suffering male body, which primarily signifies vulnerability, or the strong male body, which primarily signifies invulnerability—is open to another reading, another deployment, another signification. This slipperiness can be a source of great pessimism and despair: almost any image can be recuperated to serve the prevailing system. Or, it can be a source of optimism and hope: almost any image can be interpreted to expose the lie of the dominant fiction. What remains true across the analyses, however, is that no representation is pure, no image has a unitary meaning, no depiction has a single effect. Any depiction must be examined on its own terms and, insofar as possible, reinscribed in service of the project of dismantling hegemonic masculinity.

27. The third film's reversals extend to the T-101's fondness for sunglasses. Reaching into the stripper's jacket, he pulls out a pair of sunglasses with star-shaped, rose-colored lenses and silver sequined frames. After wearing them just long enough for the audience to laugh at their juxtaposition with his clothing, the T-101 drops them and crushes them underfoot. Fortunately for his gendered presentation and iconographic consistency, he finds a suitable pair of rectangular, black sunglasses on the dashboard of the truck he steals from the bar's parking lot.

* * *

The ambiguity of the male-body-in-pain deepens when looking at the films of Mel Gibson. As both actor and director, Gibson has perfected the art of securing masculine presence through masochistic performance.[28] In addition, *The Passion of the Christ* (2004) illustrates how action genre codes interact with the Christian imaginary.

In *Mad Max* (1979), the film that secured his international status as a brooding sex symbol, Gibson's character suffers enormous personal loss at the hands of a roving band of highway marauders.[29] A highway patrolman in a near-future wasteland, Max sees his partner captured and set on fire. The film cuts from the image of Goose in flames to Max, dressed in black leather, racing down an all-white hospital corridor. The chromatic contrast, along with the pace of the editing and the jarring soundtrack, magnify Max's revulsion and grief upon seeing his friend's charred hand fall out from under the sheet covering his body. When the same gang abducts Max's wife and son, the horror is amplified by the narrative sequence: the kidnapping follows an extended sequence showing Max and his wife enjoying a lush countryside quite unlike the harsh concrete highways that are the film's primary backdrop. Unlike the attack on Goose, the killing of Max's wife and son is elegiacally implied by the silent, mournful bounce of one of his son's toys across a deserted highway. In the second and third films in the series, Max is depicted as a brooding loner lacking either the capacity or the desire for relationship.

Personal loss also haunts Martin Riggs, the character Gibson played to great commercial success in the *Lethal Weapon* films. In the first film, Riggs teeters on the brink of suicide following his wife's death. He is first seen seated on the floor of his ramshackle trailer, sobbing, half-naked, with empty beer cans scattered around him. With tears streaming down his face, he mumbles forlornly about how much he misses his wife and then places a gun in his mouth. For several tense seconds, Riggs struggles to pull the trigger, but eventually he jerks the gun out of his mouth, releases a gut-wrenching wail, and collapses in body-wracking sobs, apologizing to his wife for being unable to effect his self-immolation. The setting's destitution, Riggs's physical and emotional vulnerability and the threat of

28. My analysis of Gibson's masochistic masculinity relies on Brown, "Tortures of Mel Gibson," and Luhr, "Mutilating Mel." Both essays were published prior to the release of *The Passion of the Christ.*
29. For discussion of the "multiple-orientation appeal" of Gibson's star personna, see DeAngelis, *Gay Fandom*, 119–77.

imminent violence generate a mood that is unusually complex in a genre typified by psychological shallowness.[30]

These characters' punishment extends to their bodies. Max is chased, shot at, punched, stabbed, and run over by a motorcycle. This final assault snaps his leg, leaving him with a limp for the trilogy's subsequent installments. In addition to the threat of self-inflicted harm, Riggs is shot at, kicked, punched, suspended from a meat hook, hit by a car, and nearly drowned.[31] True to the generic context, Riggs is tortured shirtless and soaking wet. The scene shows Riggs's strength and Gibson's beauty. When jumper cables touch his body, its writhing tightens his muscles highlighting their definition, and his facial expressions suggest orgasmic satisfaction.[32]

Gibson's films use stories of loss and images of pain not only to illustrate the durability and desirability of the male body, but also to evoke sorrow over the loss of certain forms of masculinity.[33] The mournful air is especially pronounced in Gibson's directorial debut, *Man without a Face* (1993). Set in the late 1960s, the film opens with its protagonist, a fourteen-year-old boy named Charles Norstadt, dreaming about his graduation from military school and longing for a glimpse of his absent father's face. Charles inhabits a world of women: his family consists of two sisters and his mother. The latter's current suitor disapproves of Charles's desire to become a pilot because of his opposition to the Vietnam War. He also repudiates the "power trip" of formality by insisting that Charles call him by his first name and addressing the boy with the diminutive "Chuck."

Justin McLeod, played by Gibson, enters Charles's world as a reluctant tutor for the military-school entrance exam, unwittingly providing the masculine presence that helps Charles flourish. McLeod represents a traditional model of masculinity that the film endorses and celebrates. His

30. On the connection between Riggs's physical and emotional vulnerability, see DeAngelis, *Gay Fandom*, 168. As in other action-film series, the hero's vulnerability and fragility is progressively erased. In *Lethal Weapon*, he is brooding and self-destructive. By *Lethal Weapon 2* (1989), he has become a fun-loving, sarcastic scamp. In *Lethal Weapon 3* (1992), he has recovered from the loss of his wife, leaving him free to fall for a female officer, whom he contemplates marrying in *Lethal Weapon 4* (1998). See Burnett, "Characterization of Martin Riggs," 251–52.

31. In *Payback* (1999), Gibson's character undergoes torture involving toes and hammers. The scene appears neither in the source novel nor in prior screen adaptations and was included, by all reports, on Gibson's insistence over the director's strong objections; the film's depiction of retaliatory violence is likewise grander than in previous versions. See Brown, "Tortures of Mel Gibson," 123–24.

32. DeAngelis observes that Gibson's body is on display more in *Lethal Weapon* than in any of his prior films (*Gay Fandom*, 166).

33. Luhr, "Mutilating Mel," 234.

home epitomizes spartan order. His life consists of stereotypically masculine pursuits. He demands unconditional obedience, absolute respect, and utter formality. He teaches Charles to swim and ride horses and introduces him to poetry and Shakespeare. (The poem is about a jet; the plays are *Julius Caesar* and *The Merchant of Venice*.) When Charles learns of his father's alcoholism and mental illness, he turns to McLeod. In the film's final scene, one of several deviations from Isabel Holland's novel, McLeod watches Charles's graduation from afar, providing the longed-for paternal visage. In another deviation, to be discussed more fully below, the relationship between McLeod and Charles is forcibly terminated. McLeod, then, embodies the lost masculine ideal and figures its loss.[34]

In *Braveheart* (1995), Gibson uses the story of Scottish freedom fighter William Wallace to present his vision of masculinity. According to historian Colin McArthur, Wallace is the "most venerated icon" in Scotland: "The very meagreness of historical evidence provide[s] the *tabula rasa* on which diverse groups write their versions of Wallace."[35] In Gibson's version, Wallace's fight for Scotland is admirable because it is fought with a singular commitment to an idealistic vision. Suffering is not shameful, Gibson's movie suggests, as long as one dies well.

Braveheart's world is overwhelmingly male. Except for the spouses of Wallace, Edward II, and two minor characters, none of the men's wives appear on-screen. After a brief glimpse of Wallace's mother at the film's beginning, mothers are neither seen nor mentioned. Wallace's love interests appear only briefly and serve mainly to forward the plot. During the film's first third, Wallace refuses to fight the English; he works his farm and nurtures his family. But when his wife is killed after refusing a British soldier's sexual advances, Wallace launches his military campaign. His grief motivates him for the remainder of the film. Sent as an emissary by her father-in-law, the king of England, Isabelle becomes Wallace's lover. She desires Wallace because he is more honorable than the king and more manly—that is, heterosexual—than her husband, the king's son.

Although other male characters dominate the film, they fall below the

34. The theme of fatherhood—its loss and its importance—is a frequent thematic in action films. Indeed, the genre could productively be examined as a site through which the complexities of father-son desire and identification are negotiated. In *The Passion of the Christ*, longing for the absent father is a strong narrative strain. Satan's attack on Jesus at the beginning of the film turns on the suggestion that Jesus has been abandoned by his father; near the film's close, after Jesus has breathed his last, the camera rapidly ascends to a heavenly perspective and a single rain- or teardrop falls, creating a storm and earthquake to evince the father's sorrow.

35. McArthur, Brigadoon, Braveheart *and the Scots*, 124, 157.

standard of masculinity set by Wallace.[36] His fighting companions, while courageous and fierce, lack his skill and canniness. The peasant-farmers treat him as a mythic father figure and swear unwavering loyalty. The Scottish noblemen reject his vision of a united, liberated Scotland. Robert the Bruce greatly admires Wallace but is conflicted about his duties as a member of the nobility and bullied by his father. Edward Longshanks, the king of England, is depicted as conniving, cruel, and underhanded, in contrast to Wallace's strategic and virtuous use of violence for the good of the community.

The starkest "juxtaposition of competing masculinities" is that between Wallace's "raw manhood" and the "stereotypical and negative portrayal" of Edward II's homosexuality.[37] Introduced at his wedding to Isabelle, Edward II glances mournfully toward his male lover; this, along with the narrator's voice-over, indicate that he is not happy about his marriage. His nuptial sorrow stands in sharp contrast to Wallace's aggressive courting of Murron and their clandestine, nighttime wedding, which culminates in passionate love-making. While Wallace longs first for Murron and then for Isabelle, Edward II disdains all women, especially his bride. Edward II dresses in silk and brocade, styles his hair and paints his face, often with more makeup than his wife, while Wallace, perpetually muddy and bloodstained, wears tattered clothes and lets his long, matted hair hang loose. Wallace paints his face only in preparation for battle. While Wallace is a brilliant military strategist and a highly competent soldier, Edward II, in his father's absence, does nothing to stop the insurgent's rampages and, upon his father's return, offers ridiculously naïve suggestions for dealing with him. In a moment consistently cheered by audiences, Edward II watches, helpless and horrified, as his father throws his male lover from a window.[38] Wallace's liaisons with Isabelle result in her impregnation, displacing Edward II as both biological father to his heir and symbolic father to England's future. Wallace's heterosexual virility eradicates Edward II's homosexual vice.

As much as *Braveheart* wants Wallace to embody the new-old masculine

36. The father-son relationships in *Braveheart* are fraught with loss and disappointment. Wallace's father is killed early on, and Robert the Bruce's father is withering away from a disfiguring skin disease. When the senior Bruce uses his son in a plot to betray Wallace, his son expresses his desire for his father's death. Edward II is clearly terrified of, and a complete disappointment to, his father.

37. Keller, "Masculinity and Marginality," 149–50.

38. DeAngelis, *Gay Fandom*, 120. Equally disturbing is how this death positively changes the relationship between Edward II and his father. The erasure of the (explicit) homoerotic love object produces a closer bond between father and son.

ideal, it faces the thorny historical problem of his having been executed before he could win Scotland's freedom.[39] The film does not skirt the issue: Gibson presents Wallace's torture and execution with an unflinching attention to detail. Although "it is unusual for a film to make its culminating spectacle the hero's death agonies," Wallace's suffering is represented in a manner fully consonant with *Braveheart*'s ideological project.[40] As film scholar Jeffrey Brown concludes, "*Braveheart* shows what it takes to be a man. . . . Wallace's resistance . . . is the point of masculinity." For Gibson, masculinity is primarily masochistic rather than sadistic in orientation.[41]

Once captured, Wallace refuses to affirm his loyalty to the king. Isabelle visits Wallace while he awaits execution and offers him a narcotic potion. A chivalrous lover to the end, he pretends to imbibe but spits it out after she has gone. As he is wheeled to the scaffold, Wallace silently endures the crowd's taunts, spittle, and hurled garbage. Upon his refusal of the executioner's initial offer of mercy, he is suspended by the neck from a scaffold. He chokes, turns red, and kicks the air. After struggling for several moments, he is dropped on the platform and given another chance to beg for mercy. Still coughing and gagging, Wallace struggles to his feet. This refusal earns him the honor of being stretched. Bound hand and foot, his body is pulled taut. After several shots of Wallace's overextended arms, the horses' laboring against the ropes, and the strain on the apparatus itself, Wallace's body once again crashes down on the platform.

For the final act in this liturgy of pain, Wallace's body is laid out on a cross-shaped platform. A scythe-bearing henchman slices open his shirt and then moves below his waist (and out of frame) where he proceeds to, apparently, remove Wallace's genitals. Wallace is given one last opportunity to beg for mercy. With glazed eyes, bulging veins, and clamped lips, he remains silent—crying out neither in pain nor for death. Struggling to catch his breath, he begins to form a word; the executioner silences the crowd so the prisoner may speak. Mustering every ounce of remaining strength, Wallace bellows, "F-R-E-E-D-O-M!" Strings swell and the executioner's ax descends in a graceful, slow-motion arc.

Wallace's stoicism converts torture into triumph. Standing on the platform as his ordeal commences, Wallace exchanges glances and smiles with a boy in the crowd. He appears to endure brutality, in part, for the child's sake, both as martyr and moral exemplar. After he cries out, the camera slowly pans the crowd, which looks on, transfixed, in stunned silence. The

39. McArthur, Brigadoon, Braveheart *and the Scots*, 157.
40. Luhr, "Mutilating Mel," 227.
41. Brown, "Torures of Mel Gibson," 135–36.

execution is intercut with scenes from Longshanks's deathbed; Wallace's death coincides with the king's. Isabelle tells the king that the child she carries is Wallace's: Longshanks's legacy dies with him, while Wallace's will survive. As the final sequence reveals, Wallace's scream becomes Scotland's battle cry. *Braveheart* depicts Wallace's life—or rather, death—as possessing transformative power. His suffering gives birth to a nation.[42]

Braveheart goes to great lengths to present Wallace as a crucified figure. When wheeled into the courtyard, he kneels in the cart with his hands tied to a crossbeam on either side of his head; with only his face and arms framed in close-up, he appears affixed to a cross. Strapped down during his torture, with the camera above him, he again appears to be hanging on a cross. When Wallace prays in his cell, he is shot from below, and a stream of sunlight pours through the iron-barred window. With this allusion to the spirit descending on Jesus after his baptism or to Jesus's experience in Gethsemane, the scene establishes a religious frame for understanding Wallace's subsequent ordeal. When stretched, his body is primarily shot from below, framed against the clear, too-blue sky, as if he had already ascended to heaven.

Gibson's Jesus, like Gibson's Wallace, undergoes torture willingly, but not passively. As with Wallace's story, the Passion is a historical *tabula rasa* that allows for authorial imprint—and it also presents difficulties for those who would understand it as something other than defeat. Gibson's Jesus, like Gibson's Wallace, demonstrates his superiority over the circumstances of his execution. Although resurrection narratives serve as the final response to—and repudiation of—Jesus's death, the representation of suffering can also reframe its meaning.

The strength of Gibson's Jesus is apparent from *The Passion*'s opening. Jesus prays alone in a gloomy, moonlit garden, evincing an anxiety that his disciples find uncharacteristic. Satan taunts Jesus, mocking his idea that he is God's son and his notion that his death can redeem humanity. Seemingly overwhelmed, Jesus lies prostrate. When a snake slithers from under Satan's robe, however, Jesus shows his true colors: he stands and stomps the snake's head, killing the satanic familiar.[43] During his scourging, while chained to a post and literally whipped to the ground, he once again lies prostrate, a close-up on his trembling, shackled hands evincing his trauma. Glimps-

42. Recollections of Max in the closing scenes of *Mad Max: Beyond Thunderdome* (1985) function similarly in the narrative.

43. In *Inside the Passion*, John Bartunek, a Catholic priest who was on set during the making of the film, describes these opening moments as fusing "the rich streams of Christian reflection on Christ's suffering in Gethsemane into two evocative images, both of which share a common denominator: combat" (17).

ing his mother, however, Jesus struggles to his feet and presents his body for another round of blows. The soldiers express shock at his capacity, and willingness, to endure more. Later, taking up his cross, Jesus kisses it; falling under its weight, he announces, "Behold, I make all things new!" Like Gibson's Wallace, Gibson's Jesus actively participates in his torture, humiliation and death, maintaining his vision and integrity until the end. The story "follows the masculine contours of Hollywood cinema: Jesus dies hardest."[44]

As with the films discussed earlier, *Braveheart* eroticizes Wallace's body. Gibson employs familiar strategies that inevitably—if unintentionally—make Wallace an erotic object. The stripping of his body, visually echoing his wedding night, accompanied by a focus on his genitals, through implied castration, infuse the torture with sexual energy. The strain on his body emphasizes its musculature. His facial expressions could indicate extreme pain, sexual ecstasy, or both. Wallace's torture also reunites him with the women he loves. Just after his dying exclamation, Wallace sees a vision of his wife moving in the crowd. With crosscuts to her teary-eyed face, the film also situates his lover Isabelle as a witness to his execution.

At the same time, Gibson's films demonstrate a phobia about the relationship between homoeroticism and masculinity that exceeds that of other action films.[45] In *Braveheart*, Edward II—portrayed as weak, silly, ineffectual, without redeeming or admirable traits—embodies homoerotic desire. By ridiculing Edward II, the film critiques any homoerotic desire experienced in relation to Wallace's body.

Gibson, however, cannot contain the homoeroticism generated by his celebration of masculine prowess. Throughout the movie, Wallace firmly grasps a handkerchief given to him by his dead wife. During his torture, he drops the cloth and scrambles to pick it up. As the ax swings toward his neck, the camera cuts to the handkerchief again falling from his hand. In the final scene, Robert the Bruce, who has miraculously retrieved the cloth, strokes it absentmindedly, mustering courage for battle. This final appearance complicates both the handkerchief's meaning and the film's erotic dynamics. If Wallace cherished the cloth as a reminder of his wife, what is its significance to Robert? The handkerchief undoubtedly reminds him of Wallace's courageous struggle, but does it continue to bear its erotic significance? Do Robert's tender strokes explain his conflicted, but constant,

44. Vander Stichele and Penner, "Passion for (the) Real?," 26.

45. For a discussion of how action films in general manage this relationship, see Holmlund, "Masculinity as Multiple Masquerade." On the *Lethal Weapon* films, see Tasker, *Spectacular Bodies*, 45–47; Willis, *High Contrast*, 28–29.

fascination with Wallace? Do they underscore Wallace's desirability as absent ideal, illustrating the unstable relationship between a subversive homoeroticism and a hegemonic worship of masculinity? And how does Robert's retrieval of the handkerchief relate to its earlier transfers between Robert and Wallace as a pledge of their political fidelity to one another? The handkerchief's circulation from graveside to wedding to scaffold to battlefield, signifying both honor between men and love between a woman and a man, suggests, at the very least, a permeable boundary between identification and desire.

The phobic gesture in *Man without a Face* is more extreme. Although not an action film, it is, in Gibson's hands, the tale of a suffering hero. Its ideological project is revealed in its deviation from Holland's novel. In both novel and film, McLeod has a face disfigured in a fiery car crash. In both, the town's residents gossip about him. Holland's McLeod is explicitly identified as homosexual, and Norstadt's affection for him finds sexual expression. Their relationship is brief; it ends when Norstadt enters military school. The novel effects an ultimate separation with McLeod's death, but—in a final paternal gesture—he bequeaths his property to Norstadt. Norstadt's step-father, who knew McLeod prior to his accident and seems aware of his sexual identity, describes him as a good man, opining that Norstadt was lucky to have known him. In the film, a false rumor of a prior pedophilic relationship gives rise to a similar accusation regarding Norstadt, but Gibson's McLeod is decidedly not homosexual. Norstadt's mother, with the help of the legal system, forbids McLeod from seeing her son. At a hearing, Gibson's McLeod dresses down the liberal establishment—including, presumably, the novel's author—for their inability to distinguish intimate male friendship from homosexual desire.

The novel tells the story of a young boy's self-discovery through homoerotic desire.[46] The film instead depicts a destructive and misdirected witch hunt for the predatory homosexual. Gibson's heroes' suffering indicts the social order that abuses them.[47] Altering a story that would challenge the equation of homosexuality and pedophilia, Gibson elegizes a lost masculinity and repudiates even the possibility of homoerotic desire. The audience's revulsion at the false accusation against McLeod and their sorrow over the relationship it destroys generates sympathy for the hero and his values. The

46. In light of the note that McLeod leaves for Norstadt stating he should not worry about the significance of their sexual relationship, a legitimate reading of the novel would be that Norstadt is not gay but merely had a homosexual encounter with positive psychological benefits.

47. Luhr, "Mutilating Mel," 229.

torture scenes in *Braveheart* and *The Passion* function similarly: brutality directed toward the hero generates sympathy for him and antipathy for his tormentors.

The Passion also reveals a skittishness regarding homoeroticism. Unlike the sources on which it allegedly draws, it refuses to depict a naked male body. When John flees the garden upon Jesus's arrest, a guard rips off his cloak but does not strip him naked, contrary to scriptural warrant (Mark 14:51–52). During his flogging and crucifixion, Jesus is not naked, contrary to historical warrant.[48] Like *Braveheart*'s Edward II, *The Passion*'s Herod, an enemy of the virtuous protagonist, is coded as homosexual. And Satan's androgyny links gender fluidity with evil.[49]

Yet like *Braveheart*, *The Passion* cannot fully exclude homoerotic desire from its system of signification. The film's flashbacks show Jesus in his unmarred state. Because Jim Caviezel, who portrays Jesus, is classically handsome, because the flashbacks are warmly lit, and because they provide welcome relief from the film's brutality, Jesus's physical beauty dominates them. *The Passion*'s John possesses a desiring male gaze. Although the film does not depict him (or anyone else) reclining on Jesus's breast during the Last Supper (contrary to scriptural warrant; John 13:23–25), it frequently lingers on his deep brown eyes as he looks upon his dying friend. This gaze finds its most significant deployment during the crucifixion. For most of the film, women's reactions to Jesus's torture are the primary cues for interpreting events. During the trial before the Sanhedrin, the trial before Pilate, the flogging scene, and the walk to Golgotha, women's faces provide the vast majority of the reaction shots. While Jesus is being nailed to the cross, however, things change. The film flashes back to the Last Supper, an event that, according to Gibson, was attended solely by male disciples. As Jesus proclaims that his body is the bread of life and lifts the loaf to break it, the film cuts to the cross lifting Jesus's broken body. At this moment—and for the first time—John's gaze links the images; women momentarily disappear from the frame. John becomes the privileged spectator; the women who walked the *via dolorosa* are literally cut out of the picture. When it is time to understand Jesus's suffering theologically and reenact it

48. Walsh, "Wrestling," 7. This choice, like the decision to have Jesus carry the entire cross rather than merely the crossbeam, was probably motivated by a desire to remain faithful to familiar visual depictions. See Bartunek, *Inside the Passion*, 110–11.
49. Crossan, "Hymn to a Savage God," 20; Freeland, "Women Who Loved Jesus," 152–53; Powell, "Satan and the Demons," 71–74; Walsh, *Male Trouble*, 45–48. For a contrary view, see Miles, "Art of *The Passion*," 14–15. Gibson has explained that he understands evil to be a distortion of what is good and beautiful and pure. Neff, "Passion of Mel Gibson," 32.

liturgically, the spectatorial economy is exclusively male. This male-to-male theological exchange is made, however, between two astonishingly beautiful actors—Caviezel and Hristo Jivkov—their warm eyes and luminous faces expressing sorrow, longing, and deep connection. This moment that excludes women for what are most likely conscious theological reasons (homo)eroticizes the crucifixion, the eucharist, and the exclusively male coterie of liturgical experts surrounding both, exposing the gendered and erotic dynamics that fund the central Christian ritual.[50] Gibson's depiction of Jesus's suffering is undoubtedly constructed to inspire adoration, but the character of that veneration, once elicited, cannot be controlled or contained.

Gibson's work as actor and director extends and magnifies the features it shares with the action genre. His heroes not only suffer tremendous pain and injury—graphically presented—but often succumb to the violence directed against their bodies. Their suffering does not merely justify revenge but indicts the tormentors and exonerates the hero. Gibson does not merely disavow the male body's erotic allure, he explicitly raises the issue of homoeroticism so that it can be denounced, rejected, and vilified. As his films show, representations of masochism, homoeroticism, and masculinity are tightly bound, even if their relation is complex and uncertain.[51]

<p style="text-align:center">★　★　★</p>

Is it absurd to worry about the ideological effect of action films? After all, they are consumed (and critiqued) as escapist fantasy. And their political commitments are hardly subtle. Given their narrative implausibility, how likely is it that audiences will be taken in by their representations? Every fan—and every detractor—likely has a favorite example of the genre's most fantastic depiction: the hero who takes repeated blows to his rib cage with only a grunt and grimace; the hero knocked unconscious who regains

50. See Jordan and Brintnall, "Mel Gibson."

51. In *Apocalypto* (2006), Gibson's directorial follow-up to *The Passion*, the film's protagonist endures and escapes violent threats to his life. Graphic, sacrificial violence occupies a great deal of screen time. And more than a fair amount of male flesh is on display. The most intriguing aspect of the film is its depiction of sacrificial violence as a politically motivated ritual gesture without legitimate religious significance. While fans of *The Passion* would likely distinguish Christian and Aztec sacrifices on theological grounds, critiques launched, much like desires elicited, are difficult to control and contain. Also, *Apocalypto*'s final scene, which depicts the main character successfully eluding his Aztec pursuers only to witness the landing of Spanish conquistadors, operates as an anti-resurrection scene that suggests perpetual violence defines human existence.

full mental acuity and physical capacity the moment he awakes; the hero who walks away, without a scratch, after jumping from an airplane without a parachute. Given their deviations from empirical reality, it seems fair to conclude that these films' creators do not intend to represent the world accurately and that audiences seek different pleasures than those available in documentary films. Yet action films do adhere to the formal and narrative conventions established by their genre. By insisting on their failure as empirically mimetic documents—by emphasizing their escapism, their excess—one can lose sight of the reality the genre constructs and the ideological values it conveys. Action films shape their audience's fantastic investments by providing spectacular, emotionally charged displays of heroic derring-do, reality be damned.

To clarify what is gained analytically by distinguishing between the events depicted and the depiction's formal devices, I rely on Steve Neale's discussion of cultural and generic verisimilitude.[52] Cultural verisimilitude is the degree to which a film accurately reflects social, historical, and psychological details related to the events it depicts. Evaluation of an action film's cultural verisimilitude would turn on whether the devices used by characters could accomplish the tasks for which they are used or how closely the urban environments characters inhabit resemble the places they claim to be. Generic verisimilitude is the degree to which a film conforms to the genre conventions it invokes. Evaluation of an action film's generic verisimilitude would turn on whether its characters' behavior and dialogue are consistent with that in previous action films. In terms of cultural verisimilitude, car axles should snap after long-distance jumps, and guns should run out of ammunition; in terms of generic verisimilitude, vehicles and weapons have the same staying power as the hero's body—unless, of course, the plot demands otherwise. Genre films "are made in imitation not of life but of other films."[53] "It is only in an ultimate sense," Robert Warshow elaborates, "that the type appeals to its audience's experience of reality; much more immediately, it appeals to previous experience of the type itself: it creates its own field of reference."[54]

Distinguishing cultural and generic verisimilitude with precision is further complicated by the fact that generic worlds influence perception of the "real" world. Genre functions intracinematically to provide viewers cues

52. Neale, *Genre and Hollywood*, 32–36; Neale, "Questions of Genre," 161–63.
53. Sobchack, "Genre Film," 105; see also Gallagher, *Action Figures*, 50. Generic norms, of course, are hardly ironclad: "Not all genre films relate to their genre in the same way or to the same extent." Altman, "Semantic/Syntactic Approach," 34.
54. Warshow, "Gangster as Tragic Hero," 100.

from which they can predict and interpret narrative trajectories, character behavior, and plot resolutions. It functions extracinematically to make certain configurations of activity, motivation, and desire plausible and intelligible. Genre formulas thus become pervasive and persuasive points of reference for assessing competing representations of cultural and social phenomena. Through cumulative exposure, they establish visions of ethnic subcultures, historical periods, gender norms, and familial configurations; a genre becomes a heuristic through which similar depictions—as well as real-life situations—are interpreted and organized. Generic verisimilitude can overtake and displace cultural verisimilitude to the extent that a genre's narrative and iconographic features establish criteria for what will count as true and accurate in representations of actual phenomena. As any police academy trainer would no doubt attest, a cop's day-to-day work is rarely as exciting as a film detective's life. Professors of American history could most likely point out similar discrepancies between life on the Western frontier and its depiction in cinematic Westerns. And who among us does not bear scars left by the mismatch between our dating lives and romantic-comedy tropes?

The significance of the oscillation between generic and cultural verisimilitude is especially pronounced when the phenomena in question are solely representational. Where details can be evaluated by referring to photographs, documentary evidence, or firsthand accounts—as when a genre represents historical events or the physical world—generic frames can only establish presumptions. For example, the sound of gunfire in news footage always rings false to me, because movie soundtracks have established the norm for its sonic representation. Because I understand the difference between news footage and an action film, I do not conclude that the images on CNN are fabricated, but I always notice the difference, and some conscious attention is required to privilege the newscast.

A film, however, is more than an attempt to record the profilmic world. A film comprises not only sets, costumes, narrative formulas, and character types; it also includes a scheme of values about human interactions, motivations, and desires. As Robin Wood observes, different genres "represent different strategies for dealing with the same ideological tensions."[55] Codes of generic verisimilitude are not principally noteworthy because they displace empirical referents but because they offer fantastic representations and resolutions of cultural conflicts—conflicts related to gender, class, race, sexuality, and other signifiers of power and powerlessness—that are always

55. Wood, "Ideology, Genre, Auteur," 63.

already fantastic.[56] Action films, insofar as they provide a compelling vision of masculine subjectivity that includes the use of violence to resolve disputes, create a presumption about the meaning of masculinity and the legitimacy of violence. Because competing accounts cannot claim an evidentiary status equivalent to the recorded sound of gunfire, this presumption has a greater likelihood of becoming the "truth."

Masculinity has no empirical referent; it is only ever representational, fantastic and mythic. The action genre's narrative implausibility, then, need not undercut its ideological credibility. Indeed, the action genre, through its violent spectacles and its configuration of the spectacular male body, conforms to the prevailing understanding of masculine power. What action films lack in terms of mimetic representation, they make up for in psychological reassurance. In other words, action films—along with other genre offerings—can abandon cultural verisimilitude without relinquishing cultural influence.

The word "realism" can denote a reflection of the lived world, but it also names a representational style. The distinction between cultural and generic verisimilitude often gets collapsed in discussions of realism because the term can be applied to either. Robert Ray severs the connection between realism and empirical veracity when he notes that "realism is merely an effect produced by aesthetic convention to which an audience has grown accustomed."[57] A film is experienced as realistic not because it accurately depicts the world, but because it uses stylistic devices that conform to audience expectation. Documentary films comprised entirely of newsreel footage can seem fantastic if they are formally experimental; science-fiction films heavily dependent on digital animation can seem virtually photographic if they are highly conventional. Slawomir Idziak, cinematographer for Ridley Scott's *Black Hawk Down* (2001), a film about the failed US mission in Somalia during the Clinton presidency, intentionally copied the lighting schemes, color tonalities, and editing techniques used by CNN

56. Altman, *Film/Genre*, 42; Klinger, "'Cinema/Ideology/Criticism' Revisited," 76–80; Marchetti, "Action-Adventure," 187; Ray, *Certain Tendency*, 15–16, 32–34; Schatz, *Hollywood Genres*, 21–24, 31. In *Film/Genre*, Rick Altman argues that each genre—horror films, gangster movies, teen comedies—offers a particular transgressive pleasure; their narrative resolutions, however, always reinforce regnant norms (154–155). Following Altman, the generic pleasure of action films could be understood as the rupturing of masculine plenitude and the shattering of masculine power, but the restoration of the male hero at narrative's end returns the film's audience to a place that feels familiar and safe.

57. Ray, *Certain Tendency*, 35.

reporters and reality-television producers to make the film appear realistic to its audience.[58] His reliance on the aesthetics of both news broadcasts and entertainment-oriented television shows to make his images seem "realistic" reflects the fact that a viewer's sense of realism depends on formal convention rather than conformity to fact. My ability to meaningfully describe realism as an *audience experience* points to its status as an aesthetic style, rather than a fixed relation between cinematic image and profilmic world.

The relations between cinematic style, generic verisimilitude, and ideological effect can be illuminated by considering claims of realism made about *The Passion of the Christ*. Mel Gibson and his marketing team promoted the film as the most historically and biblically accurate cinematic depiction ever of Christ's Passion.[59] They promised a realistic film, with realism here denoting both cultural verisimilitude and theological fidelity. As critics noted, for *The Passion* to be historically, biblically, and theologically accurate would be virtually impossible; the biblical accounts not only deviate from historical sources but also fail to speak with one voice.[60] Citing Gibson's numerous deviations from the historical and biblical records—often in deference to his true muse, the nineteenth-century visionary-nun Anne Catherine Emmerich—most commentators rejected the film's claim to realism.[61]

Fans, however, could not say enough about the film's accuracy.[62] Their statements, curiously, often appeared alongside acknowledgments of the film's deviations from the biblical record, Gibson's reliance on Christian art rather than historical evidence when deciding how to represent certain details, and the influence of visionary texts, as well as praise of Gibson's directorial skill in shaping the film's mood, style, and message. If even those who championed the film's realism acknowledged its divergence from the biblical and historical record, its artistic and visionary borrowings, and Gibson's aesthetic predilections, how are we to understand their use of the words "realistic" and "accurate"? As Vincent Miller suggests, realism is, at

58. Gallagher, *Action Figures*, 22.
59. Bartunek, *Inside the Passion*, 88; Caldwell, "Selling *Passion*," 211–24; Levine, "Mel Gibson," 137–49; Silk, "Almost a Culture War," 23–34.
60. On the film's relation to the biblical and historical record, see Corley and Webb, *Jesus and Mel Gibson's* The Passion, and Fredriksen, "Gospel Truths."
61. For a discussion of Gibson's dependence on Emmerich, see Boyer, "Jesus War," 70–71; Jordan and Brintnall, "Mel Gibson"; Miller, *Theology of* The Passion, 83–108; Webb, "*The Passion* and the Influence."
62. See Brintnall, "Pursuing *The Passion*'s Passions"; Brown, Keeler, and Lindvall, "Audience Responses"; Deacy, *Faith in Film*, 107–33; Woods, Jindra, and Baker, "Audience Responds."

its root, polemical; as a cinematic style and a critical category, it attempts to elide the distinction between event and representation, historical fact and narrative rendition.[63]

When examining the film's popularity among evangelicals, Leslie Smith found that they "gauged *The Passion*'s accuracy not by measures of specific historicity but rather by the emotions the film evoked."[64] *The Passion* was championed as realistic because it *felt* genuine. Smith explains the value assigned to affective experience with reference to the history of revivals in evangelical culture and the importance placed on the subjective experience of conversion (52). While this is a persuasive account of why an emotionally gripping depiction of Christ's Passion would resonate with evangelicals, it does not explain why *The Passion* is emotionally compelling in the first place. The affective experience of a film—or, more to the point, the affective *legibility* of a film—depends on the intelligibility of its form, images, and narrative.[65] For a film to strike its audience as compelling, it must first be comprehensible. Fans' sense of *The Passion*'s accuracy, while undoubtedly related to their theological commitments, was also shaped by prior exposure to systems of cinematic signification. Because the film made a *theological* argument, it had to conform to certain doctrinal strictures; because a *film* made this theological argument, it had to conform to certain cinematic conventions. If *The Passion* had deviated too sharply from either set of normative constraints, the audience would have been unable to connect with it as powerfully as they did.[66]

In a characteristically insightful analysis, Stephen Prince outlines how *The Passion* could, at the same time, be factually inaccurate, stylistically excessive, and experienced as realistic.[67] He argues that the film's aestheticized display of graphic violence provided the film's sense of realism. Although Prince does not discuss the film's deviation from biblical materials, he questions its empirical veracity.[68] For example, the film never shows Jesus bleeding. The blow of a whip and the penetration of a nail cause blood to spurt, but it never flows. When presented to the crowd after his flagellation, Jesus's body is covered by dozens of deep lacerations, but it does not bleed.

63. Miller, "Contexts," 47–49.

64. Smith, "Living *in* the World," 51.

65. See Walsh, "Wrestling," 4.

66. My experience teaching Pier Paolo Pasolini's *The Gospel according to St. Matthew* (1964), which the vast majority of students dislike strongly because of its style, bears this out.

67. For an equally insightful discussion of these issues, see Vander Stichele and Penner, "Passion for (the) Real?"

68. Prince, "Beholding Blood Sacrifice," 18–19.

During the crucifixion scene, Prince notes, neither Jesus nor the men with whom he is crucified have trouble conversing with each other or members of the crowd, even though crucifixion kills by asphyxiation. Moreover, except for the single instance of a crow pecking out the unrepentant thief's eye, the men on the crosses are not bothered by birds, insects, or other vermin.

Prince also documents the film's reliance on special-effects technology. The film includes 135 digital-effects shots as well as a large number of other effects (15).[69] In the scourging scene, actors held only wooden handles and mimed the process of flagellation (16–17). Wounds and blood sprays were also digital enhancements. During the crucifixion scene, where Gibson's hand holds the spike being driven into Jesus's palm—a detail focused on by fans as evidence that Gibson counted himself among those responsible for Jesus's death—the image is a complicated combination of prosthetics, real action, digital enhancement, blue-screen technology, animation, and painted detail (18–19).[70] These moments, identified by fans as the most significant because most "real," are the moments most dependent on cinematic artifice. Audiences were undoubtedly aware that actual damage was not being inflicted on actual bodies, and few would insist on that as a standard for realistic violence. But it bears repeating that movies are artistic representations: the viewer's experience of authenticity depends on the image's formal organization rather than its indexical relation to an event.[71] "Realism" is read off the film's surface—the product of technical and aesthetic sophistication—and substantiated by the viewer's affective response.

Viewers' claims that *The Passion* accurately depicted the events of Jesus's death raise the question of what standards guided their assessment. As Prince notes, most American film audiences have very little unmediated exposure to physical violence. While some viewers have been punched, stabbed, or shot, the magnitude of the action genre's violence—automatic gunfire, cataclysmic explosions, crashing planes, collapsing buildings—is foreign to most audience members' experience. This is even more emphatically the case with *The Passion*. While some viewers may have undergone torture or extensive physical brutality, no one watching the movie had a personal, unmediated experience of Roman scourging or crucifixion. While the film's presentation of a sacrificial understanding of atonement undoubtedly made it seem true to viewers who shared its theological per-

69. See also Bailey and Pizzello, "Savior's Pain"; Duncan, "Passion Play."
70. See also Duncan, "Passion Play," 32–33.
71. As Prince notes, "One would not know [based on reviews] that *The Passion of the Christ* is a digital effects–intensive film" ("Beholding Blood Sacrifice," 14). I would add, based on my review of fan websites, that unlike fans of typical special effects–laden fare, *The Passion*'s fans are silent on the film's technical sophistication.

spective, its reliance on well-known images from painters like Caravaggio, Grünewald, Mantegna, and Rembrandt—which gave it an "already seen" quality—also played a role.[72] And, as Prince argues, the film relied on codes from the contemporary action genre:

> The staging of the action, with its blood spurts, prosthetic wounds, and slow-motion inserts, places the violence in a cinematic vernacular that is immediately familiar and accessible to modern viewers. In this sense, there is more of cinema style than of "realism" to the film. However, because the style is familiar, it may help to foster a viewer's sense that Gibson has achieved a higher degree of realism than have other films depicting these events. Because the style is so contemporary, it may seem inherently true for viewers. (19)[73]

The Passion was experienced as authentic not because viewers compared it to either personal experience or historical knowledge, but because it conformed to prior representations and interpretations of similar events.[74]

Concluding his discussion of *The Passion* by returning to more general questions about the effect of cinematic style, Prince states that "the act of viewing cinema entails the transformation of style into content" (21). This work of translation "remains a latent one for viewers—but latent in a very Freudian way, exerting a determinative influence on their experience while going relatively unrecognized as a key constituent of response" (22). As most audience research shows, viewers are typically unable to report on

72. Apostolos-Cappadona, "On Seeing *The Passion*," 100–101; Denton-Barhaug, "Bloodthirsty Salvation," par. 9; Goa, "*The Passion*," 153; Morgan, "Catholic Visual Piety," 85–86. René Girard asserts that Gibson's film is realistic in the same manner as a Caravaggio or Mantegna painting without reflecting on the fact that, like *The Passion*, such paintings are highly stylized representations.

73. Many fans of *The Passion* reported an admiration for Gibson's prior work, whereas several critics decried his action-film roots. To understand reactions to the film, it might be more useful to inquire after viewers' genre preferences than their religious affiliations.

74. Like numerous action films, *The Passion* shows violence directed against Jesus's body primarily in extreme close-up, accompanied by both quick reaction shots and an overwrought score. It edits blows to Jesus's body into multiple shots. It records physical damage in slow motion. It is the film's excessive stylization, rather than its deviation from historical and biblical accounts, that makes fans' vociferous insistence on realism puzzling to me. Despite strong aversion to the film's theological claims, I admire Gibson's talent as a visual rhetorician. Not to attend to the film's style is to do Gibson a disservice as a filmmaker. More importantly, not to attend to the ways in which *The Passion*'s style influences reception is to miss something important about the cultural work of representation.

a film's stylistic conventions, such as editing or camera movement, unless they are conspicuously foregrounded (21). One way to foreground style, of course, is to deviate sharply from audience expectation. Or, the corollary: to make stylistic choices invisible, they should conform to familiar conventions.[75] When a film adheres to audience expectations at the level of both content and form, it will usually strike viewers as plausible, credible, and authoritative.

The affective importance of style is evidenced by Robbert Veen's discussion of *The Passion*. Veen praises its graphic violence, arguing that unlike typical Hollywood fare, *The Passion* shows brutality's horrific consequences.[76] He credits the film for indicting the inhumanity it depicts. Veen's analysis of the film's style is worth quoting in its entirety:

> The emotional impact of *The Passion* differs from the effect of other images of horror. It was not the same as the deep sense of horror that I felt when I saw the first images of the terrorists' attack on the twin towers on CNN. There I knew that what I saw was real but I had to make the conscious effort to imagine the pain and horror that were experienced by the victims. The absolute proximity of that violence had to be imagined, that is: represented by images and feelings that were conjured up by words and pictures that in themselves did not show me what was happening beyond the flames of a burning and collapsing building. No matter how hard you try, you cannot really feel it. Without the communicative bridge of style and representation, other people's feelings remain something beyond our reach. That is where art plays a vital role. The realism in *The Passion* is shocking because it does not use distance to present a spectacle and does not leave it to the imagination to find images and feelings to fill in the blanks. It draws its viewers into an event without providing any means of looking at it dispassionately as a spectator. ("*The Passion* as Redemptive Non-Violence")

Immediately following the attacks on the World Trade Center, people frequently commented that footage of the planes crashing into the buildings looked just like a movie. For Veen, the video looked quite unlike a movie, and this made it less affecting.

While arguing that *The Passion* depicts the evil of which humanity is capable, Veen never reflects on his comparison of video that documents

75. Of course, genre conventions eventually become dated, and then conformity strikes the audience as silly or stilted.
76. For similar assessments, see Cunningham, "Were You There?," 169; Douglas, "Passions of the Reviewers," 130–31; Girard, "On Mel Gibson's *The Passion*"; Goodacre, "Power of *The Passion*," 35–36; Walls, "Christ's Atonement," 28; Willard, "Craftiness of Christ," 168–69; Wrathall, "Seeing the World," 16–18.

the deaths of thousands with a film that merely represents the death of a single person. Even if he is correct that newsreel footage distances the viewer, making it difficult, if not impossible, to access the feelings of the people within its images, this should give us pause and make us reflect, at a minimum, on the limits of our moral imagination in the face of aesthetic style. According to Veen, *The Passion* is laudable not because it accurately transcribes events, but because it presents them in a way that prevents the viewer from maintaining psychic distance and emotional neutrality. *The Passion* is praiseworthy, on Veen's account, because it compels engagement, in a particular manner, with the event depicted. Veen's description substantiates Prince's observation that style conveys meaning. Unlike Prince, however, Veen expresses no concern about the control *The Passion* exercises over the viewer's response. Prince and Veen, then, while assessing the film differently, similarly privilege representation over event in their analyses.

The flat style of home recording marks some World Trade Center footage as documentary, as transparent in relation to the event. Framed by sorrowful music and the American flag, the images of crashing planes have one meaning; framed by a crowd's cheers and Arabic script, they have quite another. Style conveys meaning and establishes truth, but only in parasitic relation to the video's evidentiary value. Insofar as stylization remains invisible, fact and interpretation appear seamless: plane crashing into building becomes "attack on America" or "justification for war." If numerous cultural discourses reinforce a given interpretation, the stylization is more likely to remain invisible. In an action film, the rapid editing, roving camera, pulsing soundtrack, and visual excess produce an endorphin rush, giving the audience a breathless thrill ride from peril to promise. The style is not so much parasitic on a seemingly factual event as it is wholly independent, generating a significant affective residue. Even though action film plots are incredible, their emotional charge is indelible, a source of abiding pleasure, a narcotic of masculine power and plenitude. While action films' stylization will never convince anyone that an explosion can be outrun or that blows from crowbars do not break human bones, it may create positive associations with fantasies of masculine strength, endurance, and triumph. In the overwhelmingly chaotic, but often pleasurable, flow of visual and auditory stimuli that is an action film, the heroic male body undergoes incredible pain, torment, and suffering, fends off assailants, outruns explosions, knocks down crosses on which it has been suspended, repairs its own wounds—and lives to fight another day. Through repeated exposure to a set of images, narratives, and pleasures, a mythic, yet plausible, masculinity takes hold of the viewer's imagination.

In one of her several essays about *The Passion of the Christ*, biblical scholar Paula Fredriksen wrote, "Let us be clear. . . . Anyone who has seen the final half-hour of *Braveheart* . . . has essentially seen *The Passion* already."[77] While the comparison is apt, the accusation, by Fredriksen and other critics, that Gibson's apparent reliance on action genre tropes distorted the Christian narrative fails to acknowledge that the suffering-hero narrative predates Christianity and had already provided a framing device for the gospel narratives. However blatant *The Passion*'s departures from the biblical and historical record, its use of a "good death" to configure an ostensibly defeated character as a hero, as victor rather than victim, is hardly a marked deviation from traditional Christian understandings of suffering. Passion narratives typically represent suffering as honorable and admirable, and other narratives that use this template—both those that precede and those that antedate the gospels—contribute to the story's meaning. Having influenced representational codes historically, the Christian imaginary cannot now extract itself from this stream of influence. The action genre's tropes and themes are not necessarily a deformation of Christian narratives; rather, they are a decoder ring for the gendered logic of crucifixion and resurrection.

★ ★ ★

A narrative of suffering and triumph fuels the action genre. Torments, trials, and resilient bodies craft a fantasy of ever-renewable power springing naturally and inevitably from the male body. Reviewing *Terminator 3: Rise of the Machines*, Philip Strick wrote that the T-101 is "a specialist in resurrection" (68). In the film's penultimate scene, Schwarzenegger's T-101 emerges from the burning wreckage of a crash-landed helicopter and announces, "I'm back." Earlier in the film, after blasting away at his opponent, a T-X Terminator, sending her plummeting down an air shaft, he stated matter-of-factly, "She'll be back." Delivered with a wink toward the frequently quoted "I'll be back" from the series' originating film, these lines highlight the importance of return and repetition in the *Terminator* franchise. As the first film informs its audience, a Terminator cannot be reasoned with, does not feel pity, and *will not stop*. And as films across the series demonstrate, it is remarkably difficult to kill a Terminator and keep it dead.

Having been tampered with, the T-101 must shut himself down to avoid harming John Connor, the future leader of a human rebellion against the machines. This self-induced death is not, however, the T-101's final appear-

77. Fredriksen, "Responsibility," 63.

ance in the film: he repairs himself, destroys the T-X, and sacrifices himself *again* for John's benefit. The film suggests, however, that the T-101's ability to return may not always have positive consequences. By serving as John's protector, the T-101 has become his surrogate father.[78] John admits the T-101's paternal significance when explaining that the T-101 from his adulthood (the third film) would have to be reeducated to resemble the T-101 from his adolescence (the second film). After John's moving self-disclosure, which reveals his longing for the father's return, the T-101 informs John matter-of-factly that he will die at the hands of a Terminator like himself in the future precisely because of this nostalgic attachment. (The plot of the most recent chapter in the series, *Terminator: Salvation* [2009], relies heavily on this feature of John's personality.) By repeating details from prior installments in a playful fashion, the third film rewards faithful viewers, but it also signals that this longing for the familiar—this desire to overcome the loss that is death—may have dangerous consequences.

The Passion also reveals resurrection's sinister edge. After Jesus has died, the crowd has fled, and the body has been taken down from the cross, Gibson stages a searing tableau. Jesus's corpse cuts a horizontal line across the lower half of the frame. Mary Magdalene kneels, clutching his feet and gazing mournfully on his face. Beside her, John also stares intently at Jesus's face, his hand resting tenderly inside Jesus's thigh. Cradling her son, her face stained with blood from kissing his pierced feet, Jesus's mother stares directly into the camera, breaking the frame: her eyes and hand reach out to the audience imploringly and accusingly. The characters are motionless as the camera tracks slowly backward and the screen fades to black.[79]

The screen stays black and the audio track remains silent for several uncomfortable seconds, but then a low rumble sounds and golden light shines. The camera pans a disorienting arc before coming to rest on a stone slab with a linen shroud. The shroud deflates as if the body it had swaddled were evaporating. The camera pulls back to reveal the profile of a restored Jesus. Against a swelling soundtrack featuring militaristic drums and horns, Jesus opens his eyes, lifts his head, and steps determinedly into off-screen space. Consistent with the biblical record, Jesus's body bears a large nail scar in its hand, but its remaining wounds—including the pierced side (contrary to scriptural warrant; John 20:27)—have all been healed, leaving smooth,

78. For discussion of *Terminator 2*'s conservative family politics, including its displacement of the maternal, see Jeffords, *Hard Bodies*, 160–63; Willis, *High Contrast*, 117–18.
79. For discussion of this *Pièta* tableau, see Baugh, "Palestinian Braveheart," 20; Blake, "Mel O'Drama," 24–25; McDannell, "Votive Offering," 331–32; Ortiz, "'Passion'-ate Women," 111.

naked skin for the audience's admiration.[80] The body's restoration effec-
tively cancels the grief of the *Pièta* image. It does a number of other things
as well.

Unlike all prior textual and visual representations, this resurrection
scene takes the viewer inside the tomb and depicts the moment of resur-
rection.[81] Jesus does not pause to acknowledge witnesses to this miraculous
event. Gibson's resurrected Jesus has no immediate connection to—or need
of—a community.[82] The moment of resurrection, this display of ultimate
power over death, contains the most explicitly erotic presentation of Jesus's
body in the film. As he strides off-screen, the camera captures the curve of
his naked buttocks and the bronze skin of his inner thigh. Finally, the res-
urrection is coded as something beyond a joyous celebration. The music's
martial quality and Jesus's determined gaze and movement mark his inten-
tions as ominous.[83] Echoing his comments about the combat that opens the
film, John Bartunek writes, "The Resurrection . . . adds a crucial element
to [Christ's] incomparable [sacrifice]: incomparable power" (*Inside the Pas-
sion*, 167–68).

In the action film, retributive violence always follows the hero's tri-
umph. Escape is only half the battle: the enemy must be eradicated. And
the hero's suffering is the measure of his revenge. In *Rambo: First Blood II*
(1985), our hero is released from prison to perform a reconnaissance mis-
sion, searching for POWs in Vietnam. He almost dies while parachuting

80. Given Gibson's demonstrated familiarity with the history of representations of
the crucifixion, one must wonder if his repair of Jesus's side wound relates to the fre-
quency with which that wound has been interpreted as vaginal, uterine, or feminine
in Christian mystical traditions. Or perhaps it is related to the wound's homoerotic
valence, as in Caravaggio's *Doubting Thomas*.
81. Goodacre, "Power of *The Passion*," 43; Miller, "Contexts," 49; Segal, "'How I
Stopped Worrying,'" 197.
82. Baugh, "*Imago Christi*," 167; Schaberg, "Gibson's Mary Magdalene," 76. This ex-
cision of a community of witnesses furthers the exclusion of women. Just as women
were not allowed to be confirming witnesses to the institution of the eucharist, they
are not required—contrary to scriptural sources—to confirm the experience of res-
urrection. For an argument that women are marginalized throughout the film, see
Walsh, *Male Trouble*, 43–45.
83. Bartchy, "Where Is the History," 90; Baugh, "*Imago Christi*," 168; Boyer, "Jesus
War," 59; Chilton, "Mel Gibson's Lethal *Passion*," 56; Edelstein, "Jesus H. Christ";
Hagelin, "*Passion of the Christ*," 162; Hollywood, "Kill Jesus," 166–67; Morgan,
"Manly Pain," 153; Thistlethwaite, "Mel Makes a War Movie," 134; Vander Stichele
and Penner, "Passion for (the) Real?" 28–29; Wallis, "*The Passion* and the Message,"
123. For contrary views, see Goodacre, "Power of *The Passion*," 38; Watts, "'Mirror,
Mirror,'" 211–12.

out of a plane, is nearly killed during a firefight on a river boat, is taken captive and tortured, and is abandoned in the field by the person in charge of the mission. After securing his freedom, he releases his fellow prisoners, kills his torturer, sets the prison camp on fire, steals a helicopter, incinerates his enemies and their hardware, and returns to his home base, where he demolishes equipment and threatens the life of the man who left him to die.

What, if anything, does Rambo's rampage teach us about Jesus's resurrection? Many commentators observed that, even if *The Passion* resembled an action film, it deviated from the generic formula by omitting the final act in which the hero annihilates his enemies; instead, Jesus loves and forgives. This claim founders, initially, on the film's details, namely, the scene of the devil screaming after Jesus's death and the cataclysmic destruction of the temple following the fall of a heavenly teardrop. Moreover, the flashbacks that contain Jesus's statements about love and forgiveness occur in contexts that do strange things to their meaning. During the scourging scene, a flashback depicts Jesus's promise of an advocate who will come and help the disciples. But help them do *what*? Is this advocate a source of consolation, protection, or retribution? Watching Jesus's brutalization, what kind of advocate are viewers likely to desire? As Jesus approaches Golgotha, another flashback shows him clarifying that he lays down his life willingly. Does this explain the meaning of his death? Or, like Wallace's cry, does it indicate Jesus's control over the situation, his strength in weakness? Finally, contrary to the gospels (Luke 23:34), Jesus twice asks God to forgive those who crucify him. The second request comes from off-screen, as Caiaphas walks away from the cross; Jesus's plea for forgiveness stops him in his tracks, and the good thief notes that the statement is aimed at the priest. Does this plea, marked in this way, foster compassion and mercy—or disgust and anger?

Having in several ways raised the specter of vengeance, *The Passion* need not depict it. Jesus's steadfastness in response to his brutalization indicates his heroic stature and generates sympathy for him over and against his tormenters. The stylistic, iconographic, and narrative frame of the action genre, then, triggers viewers' longing for, and expectation of, retribution: in most generic contexts, the brutalized hero's vengeance would not only be viewed as justified and legitimate, it would be watched with pleasure, as the inevitable and fitting conclusion to the tale. Although expectations are not uniform—not all audience members will read *The Passion* in terms of action-genre conventions—fan comments articulated in the language of victory and warfare provide some empirical verification of my theoretical

conjecture. As one fan put it, "Our God wins! Whose side do you want to be on?"[84]

According to William Fulco, a Jesuit professor who worked as a translator and advisor on *The Passion of the Christ*, Gibson was reluctant to include a resurrection scene.[85] This seems consistent with Gibson's public statements that Christian believers are healed by the wounds and blood of Jesus. While I imagine Gibson believes in the resurrection, his statements about his faith do not assign it central significance.[86] If the Christian story ended with the death of Jesus, would that be sufficient to rework the relationship between Christianity and hegemonic masculinity? Yes and no. Injury is not necessarily a sign of weakness, wounds are not necessarily signs of vulnerability, death is not necessarily a sign of defeat: each can be formally and narratively presented as proof that the hero is a stoic and valiant warrior.[87] What we can conclude with confidence is that images and narratives of resurrection are the primary mechanism for reframing the meaning of suffering and injury. Although a narrative without a recuperative moment will not necessarily signify limitation, vulnerability, and mortality, a narrative with a triumphant conclusion precludes such signification.[88]

One of the greatest reversals with respect to a defeated hero in the action genre is found in the *Rambo* films.[89] In the 1980s, Rambo became a symbol

84. For further discussion of *The Passion* as an action film, see Aitken et al., "Epilogue"; Humphries-Brooks, *Cinematic Savior*, 117–32; Márquez, "Lights! Camera! Action!"; Thislethwaite, "Mel Makes a War Movie"; Walsh, "Wrestling," 5–6.
85. Shepherd, "From Gospel to Gibson," 323, 329.
86. Boyer, "Jesus War"; Neff, "Passion of Mel Gibson"; Sawyer, *Mel Gibson's Passion*.
87. For an argument that emphasizes the role of suffering in establishing Jesus's masculinity in *The Passion*, see Walsh, *Male Trouble*, 48–57.
88. For a similar critique of *The Passion*, as well as a similar assessment of its homoeroticism, see Greven, *Manhood in Hollywood*, 209–17. Greven argues that masochism's critique of normative masculinity is too easily recuperable; as an alternative he proposes a narcissistic and homoerotic imaginary (19–21, 39–43). He concludes his study with a laudatory discussion of *Superman Returns* (2006). Commenting on a scene where a bullet hits and bounces off Superman's eye, Greven notes that the film "endows its beautiful young man with infinite strength at the very heart of the sign of physical vulnerability" (245). The film ends, he observes, with Superman "heroically rous[ing] himself to save Earth. Flying into the sunlight . . ., revivifying and restoring himself . . . [Superman] recalls the beautiful, youthful classical God Apollo" (245). Although Greven characterizes these images as "beyond the reactionary patterns of conventional Hollywood film," I consider them only more of the same.
89. Kendrick, *Hollywood Bloodshed*, 119–24; Savran, *Taking It Like a Man*, 199. For discussion of the *Rambo* films as a negotiation of America's Vietnam War legacy, see Auster and Quart, *How the War Was Remembered*; Hoberman, "Vietnam"; Jeffords, *Remasculinization*.

for violent, aggressive, militaristic forms of masculine power. References to Rambo-style violence became so ubiquitous that the name found its way into the *Oxford English Dictionary*. Ronald Reagan appealed to Rambo as a model for how to deal aggressively with hostage crises.[90] This image of Rambo as a no-nonsense icon of American power and prestige came primarily from the second and third films in the trilogy. In *First Blood* (1982), the film that initiated the series, Rambo is depicted as a skilled warrior but not a victorious one.

The film opens with an unkempt Rambo walking alone on a deserted highway. He arrives in a small Oregon town to reunite with a friend only to learn his comrade has succumbed to Agent Orange–induced cancer. Rambo is now his company's sole survivor. The sheriff assumes Rambo is a vagrant, orders him to leave town, and arrests him when he refuses to do so. Taken to jail, Rambo experiences flashbacks to his time as a prisoner of war in Vietnam and becomes violent.[91] After causing substantial damage to the town, he is cornered by his former commanding officer, Colonel Trautman. Crying hysterically, Rambo delivers a monologue about the traumas he experienced in Vietnam and upon his return to the States. He tells of a good friend's being eviscerated before his eyes and his own inability to reintegrate into American life psychically or economically. The film ends with Rambo being led to a police wagon by Trautman, handcuffed, eyes downcast, as a gentle rain falls.

First Blood depicts Rambo as a tragic figure who deserves compassion rather than a triumphant hero who merits adulation. While celebrating masculine virtues of endurance and ingenuity, its ending is not that of traditional action-genre fare.[92] The marked difference between the mournful conclusion of *First Blood* and the triumphant conclusions of the subsequent films points to audience discomfort with the hero's defeat, circumscription, or limitation. In many ways, the series serves as the resurrection to the first film's crucifixion.[93]

90. Weinraub, "Reagan Hails Move," A1, A10.

91. This is one of the most significant differences between the Rambo of the first film and the Rambo of the subsequent films. In *First Blood,* he so panics at the idea of being placed in a cell that he loses all sense of time and place, attacks the guards, and flees the police station. In *Rambo: First Blood II*, on the other hand, even when taken prisoner, returned to a prisoner-of-war camp, and brutally tortured, he remains calm and coherent.

92. David Morrell's novel has an even bleaker ending: Colonel Trautman kills Rambo. In this deviation, *First Blood* betrays the action genre's obsession with resurrection. For discussions of differences between novel and film, see Faludi, *Stiffed*, 359–406; Robinson, *No Less a Man*, 109–62.

93. The *Rocky* series, which also stars Stallone, could be described in similar terms. In the fight that concludes the first film, Rocky Balboa is defeated. In fact, he has no desire to win, he just wants to go the distance. Each of the next four films (*Rocky II*

Structural, narratological, iconographic, and thematic similarities be-
tween the action genre and the Christian imaginary justify the claim that
they share ideological commitments. It is not (merely) that the action genre
influences contemporary presentations and interpretations of the Passion
narrative, but that the action genre's celebration of the hero's capacity to
overcome injury, suffering, and death (or the threat thereof) provide insight
into how resurrection narratives sustain cultural understandings of a mas-
culine subject as totally without vulnerability or weakness. The triumph of
life over death in the previously brutalized, but eternally male, body of God
funds a particular fantasy of masculine plenitude. The action genre's rein-
scription of suffering as proof of strength and its celebration of triumph as
proof of superiority should at least make us suspicious about how remark-
ably similar moments in the Christian theological imaginary function with
respect to patriarchal notions of masculinity as the source of wholeness,
power, agency, and plenitude.[94] If we expand our vision to the suffering-
hero narrative more broadly, we see how action films, Westerns, war films,
disaster films, Christian theological discourses, and a number of other cul-
tural forms work together to present an image of the masculine subject as
capable of enduring astonishing injury and still surviving. Placing the action
genre's suffering-triumph narrative alongside Christianity's crucifixion-
resurrection narrative reorients us to how the Christian tradition supports
and sustains masculine domination. While feminist theologians have right-
fully pointed out how the maleness of Jesus has been used to establish the
male as God and how the suffering of Jesus has been relied on to admonish
oppressed people to suffer in silence, it may very well be that the doctrine
of the resurrection—with its quiet, subterranean, structural influence—has
played the largest role in maintaining the illusion of masculinity necessary
for the patriarchal denigration of women and womanish men.[95]

through *Rocky V*) ends with the hero's victory, although the sixth and most recent
chapter, *Rocky Balboa* (2006), restores the notion that going the distance is sufficient.
94. This argument does not require that *The Passion* be understood as a synecdoche
for Christianity. At the same time, *The Passion* draws on venerable theological tradi-
tions, and the structure of its narrative does not diverge markedly from other tellings
of the tale. In other words, even though *The Passion* and Christianity are not iden-
tical, to claim—as many commentators have—that *The Passion*'s vision is radically
foreign to traditional Christianity is simply not true. For further discussion of these
issues, see Walsh, "Wrestling," 10–14.
95. For the classic statement that Jesus's maleness deifies men, see Daly, *Beyond God
the Father*. For classic statements that atonement theologies work to quiet the op-
pressed, see Brown and Parker, "For God So Loved the World?," and Williams,
Sisters in the Wilderness. In *Consider Jesus*, however, Elizabeth Johnson observes, "If a

Trained by the action genre—not to mention Easter sunrise services—audiences wait patiently, if nervously, through the hero's trial in order to celebrate his triumph. The narrative arc both fosters anxiety and suspends it. Insofar as loss, vulnerability, and mortality challenge the illusion of masculine plenitude, the action genre covers them over to sustain the prevailing fantasy of masculine power. This strategy—always connecting suffering to triumph, victimization to victory, ordeal to overcoming—is a script borrowed from the Christian imaginary. Fantasies of resurrection—the desire for life that transcends death, for power without limit, for an eventual overcoming of the losses that define mortal existence—are kin to fantasies of masculine power and plenitude, told in more palatable, seemingly gender-neutral terms.

The fantasy of eradicating pain, suffering, and death is understandably seductive, but it nourishes problematic conceptions of what it means to be a subject, a human person, an agent in the world. It is difficult to face our limitations, to admit our vulnerability, and to acknowledge the certainty of our death. But our unwillingness to do so prevents us from genuinely encountering the other, and even inhibits our ability to experience the true quality and deep pleasures of own lives. Many might consider it irresponsible or inappropriate to demand a confrontation with pain, death, and loss with no palliative succor—especially from those who have experienced deep and abiding trauma. But this rejoinder assumes there is a class of person who has not felt death's hand. To claim that some need to acknowledge vulnerability, whereas others simply live it, is to replicate—from a different place—the very fantasy that keeps hegemonic masculinity, as well as other forms of oppressive power, in place. While equating too quickly different forms of "trauma" is certainly problematic, distinguishing too sharply between those who have been traumatized and those who have not also has a cost. There are obviously very real differences in the kinds of injury, suffering, and sorrow that different people—and groups of people—have endured, but this is *always* a matter of degree. When we suggest otherwise, we give safe harbor to an imaginary that distinguishes the relatively whole from the fractured, those in tip-top shape from those in need of repair. Such distinctions easily become value judgments, ontological

woman had preached and enacted compassion and given the gift of self even unto death, the world would have shrugged—is not this what women are supposed to do anyway? But for a man to live and die in this way in a world of male privilege is to challenge the patriarchal ideal of the dominating male at its root" (111). In the extensive feminist discussion of the cross, there has been virtually no development of this perspective.

pronouncements, dehumanizing categories. Those people over there—the traumatized ones—need "our" help, compassion, oversight, regulation. Recognizing shared vulnerabilities, mutual lacerations—and a common capacity for muddling through—challenges systems of differentiation, power, and control.

It is difficult to acknowledge one's fragility. But what if we did? What if we lingered in the rain with the battle-scarred Rambo? What if we genuinely bade farewell to the T-101? What if Rickenbacker died on his cross? What if Christianity cried out *"lama sabachtani"* more frequently than "He is risen"? Might we begin to see, hear, and engage one another differently?

[2] MASCULINITY MASOCHISM

The masochist ... loses all battles, except the last one.

THEODOR REIK

The love for the father is stored in the penis, safeguarded through an impervious denial, and the desire which now centers on that penis has that continual denial as its structure and its task.

JUDITH BUTLER

For a psycho-analysis is not an impartial scientific investigation, but a therapeutic measure. Its essence is not to prove anything, but merely to alter something.

SIGMUND FREUD

In the second volume of his monumental work *The Accursed Share*, Georges Bataille considers the relation between mysticism and eroticism. The mystic relies upon "not the discourse of theology but of human love." The language of love, however, is a language of expenditure, of laceration, of self-loss. While not reducing mysticism to eroticism, he notes that both the mystic and the lover "exhaust in their effusion all the energy that sustains them" (*ASII–III* 170).

In *Sensible Ecstasy*, her incisive study of twentieth-century French interest in the coalescence of "the feminine," mysticism, and politics, Amy Hollywood argues that Jacques Lacan has Bataille in mind when discussing male mystics who renounce phallic plenitude for other pleasures (*SEc* 65, 150).[1] In *Encore*, Lacan observes that

> one is not obliged, when one is male, to situate oneself on the side of [the phallic function]. One can also situate oneself on the side of the not-whole. There are men who are just as good as women. It happens. And who also feel just fine about it. Despite—I won't say their phallus—despite what encumbers them that goes by that name, they get the idea or sense that

1. Bataille and Lacan's relationship had both intellectual and personal dimensions. It included Bataille's encouraging Lacan to publish his work and Lacan's marrying Bataille's ex-wife. See *SEc* 321n11; Roudinesco, *Lacan and Co.*, 147, 294; Surya, *Georges Bataille*, 552n7, 554n14. According to Elisabeth Roudinesco, however, the intellectual influence went in one direction—from Bataille to Lacan. *Lacan*, 136–37.

there must be a jouissance that is beyond. Those are the ones we call mystics. (*SXX* 76)

Hollywood suggests that "Lacan's theories . . . explain, even if they do not fully resolve, the contradictions in Bataille's texts. In the process, Lacan makes explicit (and perhaps unnecessarily reifies) the gender dynamics of Bataille's mystical turn" (*SEc* 150).[2]

Psychoanalytic discourse—especially that of Freud and Lacan—seeks to establish a gendered order organized around wholeness and lack. Although such discourse frequently undoes itself in its articulation, usually containing the very materials that make critical intervention possible, the move toward an equation of maleness with plenitude and femaleness with incompletion is undeniable and has made psychoanalysis legitimately suspect in the eyes of many feminist critics. With an eye toward its gendered representations, and attention to the fissures and instabilities within these representations, this chapter examines psychoanalytic discourse about masculine subjectivity to understand how it secures, and subverts, prevailing fantasies of masculine power and privilege.

My consideration of these materials is deeply indebted to the work of Kaja Silverman. In *The Acoustic Mirror*, she examines the anxieties "lack" creates within film theory and psychoanalysis. She notes that both discourses enable masculine subjects to overcome lack's attendant displeasures by displacing it onto female subjects and bodies. She begins by discussing the anxiety the movie screen's border produces in the masculine subject (*AM* 2, 11–13). As apparatus theory contends, limitations on the spectator's field of vision signal that the film's site of production is under someone else's control; the viewer's desire will not control movement through diegetic time and space (*AM* 11).

Silverman compares these observations to Lacan's understanding of the relation between the subject and the system of signification (*AM* 29–31). Lacan emphasizes that systems of signification are both external to the subject and responsible for its shape, content, and meaning (*Éc* 207–8, 413, 578; *SIII* 273–74). This understanding of the relation between language and subjectivity grounds Lacan's notion that the subject vacillates between being and meaning: to become self-grounded, rooted in existence, the subject

2. I place more emphasis than Hollywood does on Lacan's reification of gender as a point of distinction between him and Bataille. While Lacan notes that the male is not obliged to situate himself on the side of the phallic function, he argues that the female is not capable of doing so. Unlike Lacan, Bataille recognizes the theoretical possibility that a "man may be just as much the object of a woman's desire as a woman is of a man's desire" (*Er* 130).

must retreat to a solipsistic, virtually autistic monism of being; if the subject seeks to engage the other, to communicate, to secure an identity with a significance, it necessarily relinquishes some or all of its ontic presence to the world of meaning generated by the other (*SXI* 211). This *aphanisis* that language works in the subject, this alienation to which signification condemns it, finds an echo in the displacement from the site of discursive production worked on the viewer through the cinematic apparatus (*AM* 30; *SXI* 207–10). The film-viewing experience—because it (re)activates a sense of loss, crisis, and alienation in the viewer—can reproduce affects similar to those associated with the subject's entry into language (*AM* 1–2, 11–13).

Lacan invokes the phallus as a partial remedy for the subject's alienation (*Éc* 575–84).[3] The phallus, however, works differently according to the subject's gender—or, stated more precisely, the phallus works to differentiate subjects along gendered lines (*Éc* 581–83). The masculine subject is defended against alienation because it is both symbolically and imaginatively constructed in closer alignment with the phallus; the phallus as privileged signifier ascribes both being and meaning to the male subject. Although Lacan insists no subject can ever perfectly identify with phallic plenitude, the male subject comes to understand his position in part through a recognition that the woman/mother lacks and desires the phallus that resides elsewhere (*Éc* 582–83). In other words, even if the male subject always aspires, without complete success, to possess the phallus, his striving is supported by an awareness that the female subject is always already—and permanently—deprived of it. Even if separation from the phallus is absolute for all subjects, the relative distance is not the same. Her lack is his gain.

Displacement from cinematic enunciation, according to Silverman, also has gendered implications (*AM* 27). The anxiety created by this displacement is assuaged by a narrative structure that assigns agency to male characters and passivity to female characters as well as a formal structure that generates greater possibilities of identification with male characters while circumscribing female characters to the role of spectacle (*AM* 12–13). According to Laura Mulvey's foundational text on the male gaze and classic Hollywood cinema, cited approvingly by Silverman, woman is defined by her "*to-be-looked-at-ness*"; her presence on the screen stops the narrative to allow for erotic contemplation.[4] Male characters possess the gaze; they are a site through which the spectator looks at the woman and, as importantly, exercises narrative agency.[5] As Silverman observes, introducing a character

3. "I say 'partial' both because no system of defense is impregnable, and because this one serves to protect only the male [subject]" (*AM* 1).

4. Mulvey, "Visual Pleasures," 19.

5. Ibid., 19–20.

with narrative agency compensates for loss of discursive power (*AM* 13). Given that this authoritative character is almost always male, only the masculine subject's loss is restored, only his anxiety assuaged; the female subject is displaced from the site of both wholeness and assurance. The formal devices of classic cinema and the theoretical explorations of psychoanalysis perform similar (gendered divisions of) labor: reassuring the masculine subject of its incontestable and autonomous power.

This chapter performs a close reading of psychoanalytic texts, primarily Freudian, to reveal the deep instability of their representations of masculine subjectivity. As Silverman argues, psychoanalytic theory discursively secures a position of plenitude, privilege, and power for masculine subjects by displacing onto female subjects the lack that haunts subjectivity. I consider Freud's essay on fetishism to examine the mechanics of this displacement—and its failures. I also consider Freud's texts on masochism to show, contrary to Silverman, that these texts just as readily aggrandize the value and valor of masculine subjectivity as expose the lack that pervades it. I conclude with an examination of materials on the Oedipal complex. On my reading, these texts expose the fault lines of masculinity in a fashion similar to Silverman's understanding of masochistic fantasy. My engagement with psychoanalytic texts, insofar as it is primarily an immanent critique, shows Silverman's influence, even though it locates critical leverage differently.

<p style="text-align:center">★ ★ ★</p>

In addition to noting how film theory has attended to the material conditions of cinematic production and exhibition that exclude the spectator from the site of enunciative agency, *The Acoustic Mirror* also treats film theory's anxious consideration of the relation between reality and representation. The film spectator, unlike her or his theatrical counterpart, has access only to flashes of light and shadow or to bits of electronically encoded data that are reassembled by the perceptual apparatus to resemble the substantial reality the material seeks to represent.[6] On Silverman's reading, "Film theory has been haunted since its inception by the specter of [this] loss or absence at the center of cinematic production" (*AM* 2).[7] Noting that Chri-

6. In this age of digital animation and manipulation, ideas about film's indexicality, the profilmic event's existence, and the camera's ability to record the real world must always be qualified. If the material circumstances of "classic" cinema conjured the specter of absence, then the material circumstances of computer-assisted image production effect an absence more than once removed.

7. If the cineplex is the audience's world and the soundstage is the actor's, then the film is a third world to which neither has access. This world depends on the film's formal features and narrative content, as well as the spectator's interpretive

sian Metz was the first to appropriate a psychoanalytic framework to ana-
lyze cinema, Silverman highlights his use of "the term *castration* to describe
cinema's structuring lack. . . . [He] not only refers to the loss of the object
as a castration, but . . . suggests that the viewer protects him- or herself
from the trauma of that castration through defensive mechanisms similar
to those adopted by Freud's male child—disavowal and fetishism" (*AM* 4).

Echoing the previously considered parallel between film and psychoana-
lytic theory regarding signifying practices and lack, Metz's language of cas-
tration, disavowal, and fetishism reveals a shared concern about the loss of
the object in film theory and psychoanalytic discourse. As noted, Lacan the-
orizes a loss at the heart of subjectivity that is caused by the subject's use of
language. Lacan further theorizes this sense of loss and alienation in his dis-
cussion of the mirror stage. In his formulation, the subject becomes a self by
finding an external, bodily *imago* mediated by the gaze of an other, usually
the mother (*Éc* 76–80). For Lacan, the awareness of self depends on an exter-
nally mediated, misrecognized image. At every turn, then, the subject, by
coming into being as a self—in fact, to come into being as a self—is always
already founded on a lack, a loss, an alienation. To defend against the ac-
companying anxiety, the symbolic order contains a gendered structuration
that repudiates the notion of lack for the male subject by displacing it onto
the female subject—or, in its Freudian incarnation, onto the female body.
The gender-neutral lack that haunts all subjectivity is transformed into a
gender-specific lack that differentiates men from women and, more signifi-
cantly, justifies the superiority of men over women. Freud's discussion of fe-
tishism serves as a prime example of how this displacement is accomplished.

According to Freud, the fetish, despite its form—a feather boa, red hair,
a shiny nose—always functions as a substitute for the penis.[8]

> It is not a substitute for any chance penis, but for a particular and quite
> special penis that had been extremely important in early childhood but
> had later been lost. That is to say, it should normally have been given up,
> but the fetish is precisely designed to preserve it from extinction. To put it
> more plainly: the fetish is a substitute for the woman's (the mother's) penis

agency. This world is inherently multiple, because of artistic intention and audience
reception. The plurality of signification means that even the diegetic world is never
fully present to any one person at any time.

8. Freud's essay on fetishism reports his findings from having studied "a number of
men whose object-choice was dominated by a fetish." Fetishism did not bring these
patients to analysis but "made its appearance . . . as a subsidiary finding." They did
not experience fetishism as a symptom but "praise[d] the way in which it ease[d]
their erotic life" (*SE* 21:152).

that the little boy once believed in and—for reasons familiar to us—does not want to give up. (*SE* 21:152)

Freud's account of the fetish depends on his assumption that all children, of both genders, originally assume that everyone is endowed with a penis (*SE* 7:195, 9:215–16, 19:142).[9] Prior to puberty, the child does not possess the categories "male" and "female," but rather thinks with the "antithesis . . . between having *a male genital* and being *castrated*" (*SE* 19:145). The existence of this "special penis," then, rests on a misunderstanding. In reality, it never existed and was, therefore, never lost, except from the child's fantastical image of the mother's body. The problem that the fetish solves is a problem that male fantasy—more specifically, male narcissism—creates.

In fact, fetishism diminishes, rather than exalts, the penis. If the fetish is a substitute for the penis, then the penis is not unique, irreplaceable, or instrinsically valuable; it has only symbolically worth, and other symbols will do.[10] Insofar as a fetish can function like a penis and "restore" the woman's body, it reveals not so much the female's genital wound as it does the fantastic status of all bodies, including the male's. In the essay's final sentence, Freud underscores this point when he writes, "We may say that the normal prototype of fetishes is a man's penis, just as the normal prototype of inferior organs is a woman's real small penis, the clitoris" (*SE* 21:157). This is a startling conclusion to an essay built around the supposed physiological distinction between women and men. Contrary to the fetishist's awareness, and consistent with the little boy's supposition, Freud concludes that both women and men are, in fact, endowed with penises. But what does the term "penis" mean if it can—or must—be further categorized as "man's" or "woman's"? What, after all, does it mean to describe the clitoris as a real— albeit small—penis? In a world where penises, clitorises, and fetishes are roughly interchangeable—each being the "prototype" for the other—empirical physiognomy retains little significance.[11]

9. This belief is so profound that, for the girl, the "clitoris behaves just like a penis," until she realizes her "inferiority" in "comparison with a playfellow of the other sex" (*SE* 21:178). What could "behaving like" possibly mean? Does the girl urinate from the clitoris or insert the clitoris into an orifice, or is Freud obliquely referring to the act of masturbation? Freud seems to have in mind that the clitoris has the significance to the little girl that the penis has to the little boy—until she compares it to the penis. What would it mean to (re)imagine—or insist that—a clitoris could behave *just like* a penis? And, if the clitoris and penis can behave just like each other, then why describe the clitoris as inferior?

10. See McCallum, *Object Lessons*, 15–31.

11. For an excellent discussion of Freud's equation between clitoris and penis, see Mc-Callum, *Object Lessons*, 5–15.

The problem the fetish solves is the crisis generated by the possibility of the boy's castration. If the woman could be castrated, "then his . . . penis [is] in danger" (*SE* 21:153).[12] Fetishistic restoration is motivated not out of concern for the woman's injury, but out of narcissistic concern for the penis and male corporeal integrity (*SE* 9:217, 21:143). The mother's castration is disavowed, then, not out of regard for her, but to calm the male child's self-involved anxiety and terror. Her lack is his pain.[13]

In her discussion of Freud's essay on the fetish, Susan Lurie argues that the woman is not feared because she is castrated, but because she is *not*:

> The sight of woman as castrated is not an early or a terrifying percep-
> tion, but rather a comforting and mature male wish-fulfillment fantasy,
> designed to counter the real terror the sight of woman inspires: *that she is
> not castrated* despite the fact that she has "no penis." . . . The sight of woman
> is a "crisis of meaning" for the male, a crisis that inspires an inscription of
> meaning onto her in the interests of preserving the signification of the pe-
> nis and what it means for him. Psychoanalytic discourse participates in a
> broad cultural project (to which . . . cinema contributes a complex effort)
> of constructing woman as castrated precisely because the sight of her does
> not signify her castration, because she appears to possess everything the pe-
> nis signifies without possessing a penis.[14]

Woman's castration is not based on empirical observation but on a signi-
fying act fueled by male anxiety surrounding her potency—namely, her capacity as a (sexual) agent without a penis. Various cultural forms impose powerlessness and passivity as the very meaning of female subjectivity in order to secure agency for male subjects and assuage male anxiety regard-
ing female power.[15]

Taking seriously Lacan's reworking of the Freudian notion of castration,

12. See also *SE* 23:277. Freud later affirms that the problem solved by the fetish is cas-
tration anxiety when arguing that the anxiety is related exclusively to possible loss of the penis, as opposed to loss of the mother or the trauma of birth (*SE* 21:155; see also *SE* 10:8n2, 19:144n2). By acknowledging these other traumas, Freud recognizes universal losses prior to castration. He denies their importance, though, preferring instead a loss that can be tracked onto gender difference.

13. Karen Horney, an early feminist psychoanalyst, explained fetishism as an anxi-
ety generated by the relation of the male child's penis to the adult woman's vagina. "Dread of Woman," 137–45.

14. Lurie, "Construction," 53. See also Creed, *Monstrous-Feminine*, 6.

15. Creed, *Monstrous-Feminine*; Williams, "When Woman Looks," 23. In her prac-
tice, Horney was overwhelmed by the presence and intensity of the "envy of preg-
nancy, childbirth, and motherhood" among her male patients. "Flight from Wom-
anhood," 60–61.

it would be inaccurate to claim that women are not castrated, because all subjects experience certain losses in order to become selves, but it is possible to characterize men and women as equivalently castrated. Given the relation between discourses of castration and justifications of social hierarchy, an equivalent castration must be read as the absence—or, at least, a profound refiguration—of castration. Recognition of a universal castration compels the recognition of a shared limitation; it allows for a transformation of the relation between gender and power—and the relation between subjects across difference more generally. Recognizing mutual lack undermines the autonomous individual as the site of ethical and political reflection. No longer can the political project be understood as raising everyone to the level, or including everyone in the category, of "the subject." If no one is an autonomous, self-sufficient individual, then the charge of being something less than that is greatly diminished.

The risk of such reconfiguration is managed within Freudian discourse by keeping the castrating wound at the level of anatomical detail. To interpret castration as a matter of anatomical difference between the genders "place[s] a maximum distance between the male subject and the notion of lack" and marks this distance as natural, empirical, obvious (AM 15). The anatomical distinction between men and women, however, is neutral: women lack a penis; men lack a vagina. Some system of representation is required to mark the woman's *difference* as a *lack* that signifies second-class citizenship.

Contrary to what Freud claims, the fetish does not impose a fictional penis on the woman's body, it inscribes a lack. The fetish does not quell the male's castration anxiety but secures the penis's value by signaling its absence in the woman's anatomy, marking this absence as a wound and anxiously anticipating the wounding gesture. As Linda Williams observes, "Freud . . . shares some of the fetishist's belief in the 'horror of castration' embodied in the female genitalia, unable to see beyond appearances to recognize how social relations of power have constructed him to so perceive women's genitals."[16] Given Williams's emphasis on Freud's inability to perceive the cultural forces that inform his explanation of fetishism, his rejection of the term "scotomization" as a descriptor for the fetishistic process can be viewed in a new light. Freud explains that scotomization is "unsuitable, for it suggests that the perception [of the woman's lack] is entirely wiped out, so that the result is the same as when a visual impression falls on the blind spot in the retina" (SE 21:153–54). Freud is content with the notions of repression and disavowal, which indicate the male subject's ability

16. Williams, *Hard Core*, 105.

to both deny and retain an awareness of the woman's lack. When characterizing the fetish as "a token of triumph over the threat of castration and a protection against it," he forgets the both/and of the disavowal (*SE* 21 :154). The fetish is a token of triumph over not only the man's fear of castration, but the woman's lack of castration. To state it more boldly, the fetish betokens man's victory over woman *precisely because it signifies her castrated status*. It does this by empowering the male child to mark the female body as the bearer of lack and to signify penis-possession as the most significant feature of bodily configuration. With all of this in mind, I conclude that even if the fetish disavows the woman's castration, "Fetishism" scotomizes the cultural work of castration discourse. The essay tries to render invisible the penis's fantastic superiority by asserting its natural superiority. It strives to blind both its writer and its reader to the penis's fantastic—and alterable—significance, to soothe the anxiety generated by a creeping suspicion that gender relations could be organized differently.

Freud's rejection of "scotomization," a term associated with visual power, signals an additional task of his essay. In Freudian psychoanalysis, "vision provides the agency whereby the female subject is established as being both different and inferior, the mechanism through which the male subject assures himself that it is not he but another who is castrated" (*AM* 17). In Freud's discussion of the fetish, as in his discussions elsewhere of the anxiety produced by the sight of the female genitals, the wound of castration is an observable fact; the male child does not *interpret* the vagina as a wound but *sees*—usually involuntarily and traumatically—the evidence of castration. This perception's self-evidence redounds on Freud's authority as a reporter of the attendant psychic processes and their significance. Men and women are separated into their previously noted categories of looker and to-be-looked-at. In the fetishistic operation, the male bears the gaze and the female is its object. As a fetishist (and an analyst), the masculine subject is positioned at the site of discursive authority. When looking at the woman's genitals, with Freud as his authorial representative, the masculine subject assigns meaning to female physiognomy. This visual agency should be kept in mind when thinking about the relation between masculinity and representation. Masculinity operates most powerfully and straightforwardly when the male body is origin rather than object of representation. Castration anxiety—of one form or another—arises whenever the male becomes the object of contemplation.[17]

Finally, there is a curious relationship between fetishism and homo-

17. On the relation between fetishism, masculinity, representation, and the displacement of lack, see also *MS* 45–47.

sexuality in Freudian discourse. On Freud's account, the fetish is adopted in response to the fright caused by the sight of the female genitals, a fear generated by narcissistic attachment to the penis (*SE* 21:153–54). Similarly, on Freud's account, male homosexuality is caused by the boy's fright at the sight of the woman's genitals and/or his overvaluation of the penis (*SE* 9:216–17, 10:109, 21:230). Why, then, do some men become fetishists and others homosexuals? Freud admits to having no definitive answer. What he does know is that the fetish "saves the fetishist from becoming a homosexual, by endowing women with the characteristic which makes them tolerable as sexual objects" (*SE* 21:154).[18] The characteristic with which the fetish endows women, thus rendering them tolerable, is, however, a (fantastic) penis. Conceding the difference between desire for a body with a fleshy penis and desire for a body with a fantastic one, I contend the distinction is blurry and unstable at best. And if phantasmically grafting a penis on the woman's body saves the fetishist from homosexual desire, his desire must, at the very least, be named as not pristinely heterosexual. Just as fetishistic restoration reveals an inscription of lack, the fetishist's desire for penis-possessing sexual objects exposes the homoerotic dimension of the male child's investment in his penis. Moreover, the fetish's soteriological operation is difficult to square with the example that closes Freud's essay. Discussing an "athletic support-belt" that "covered up the genitals entirely and concealed the distinction between them," Freud reports that "it signified that women were castrated and that they were not castrated; and it also allowed of the hypothesis that men were castrated, for all possibilities could equally well be concealed under the belt" (*SE* 21:156). If fetishes, on at least some occasions, are about the business of fantastically castrating men, then it is unclear how *these* fetishes save the fetishist from becoming homosexual (except insofar as they make the object of desire into a woman) or assuage castration anxiety.[19]

★ ★ ★

In *Male Subjectivity at the Margins*, Kaja Silverman argues that masochistic fantasy has the potential to unsettle the reigning fantasy of masculine subjectivity.[20] She argues that attention to fantasy is essential to ideological analysis because fantasy makes an ideological construct seem real to

18. Freud insists on the universality of homosexual object choice at some point in every child's sexual development (*SE* 7:145n1, 11:99). "Saving" the subject, then, must mean preventing action, not desire.

19. For further discussion, see *MS* 46.

20. For a similar argument that stresses the "tautological" relationship between masochism and sexuality, see Bersani, *Freudian Body* and "Is the Rectum a Grave?"

the subject: "Ideological belief . . . occurs at the moment when an image which the subject consciously knows to be culturally fabricated nevertheless succeeds in being recognized or acknowledged as 'a pure, naked perception of reality'" (*MS* 17, quoting Louis Althusser). Material and historical circumstances undoubtedly circumscribe the fantastic possibilities available to the subject, thus necessitating consideration of economic, social, and historical factors, but fantasies can only grasp the subject if they answer the desires of unconscious life (*MS* 41). Fantasy works through the dominant fiction—"'the privileged mode of representation by which the image of the social consensus is offered to the members of a social formation and within which they are asked to identify themselves'" (*MS* 30, quoting Jacques Rancière). This dominant fiction is secured through the "bank" of society's images, stories, and discourses: literary, journalistic, cinematic, theatrical, theological, medical, legal (*MS* 30–31). Taking all of this into account, Silverman emphasizes that ideological analysis must attend to historical, economic, cultural, and psychic orders even though— perhaps especially because—they cannot be reduced to each other (*MS* 32–34).[21]

With Lacan's distinction between subject and self in mind, Silverman begins her consideration of the dominant fiction's ideological power. She emphasizes that the subject is characterized by an alienation created by its entry into the system of images and stories that comprises the symbolic order: "Lack of being is the irreducible condition of subjectivity. In acceding to language, the subject forfeits all existential reality, and foregoes any future possibility of 'wholeness'" (*MS* 4). The self, on the other hand, is a fantastic construction that "fills the void at the center of subjectivity with an illusory plenitude" (*MS* 5). Cultural discourses of normative identity provide a sense of self in response to the subject's longing for wholeness. In other words, the dominant fiction responds to the psychic need for a substantial self (*MS* 20–22).[22]

21. For similar accounts, see Dean, *Beyond Sexuality*, 258–64, and Farmer, *Spectacular Passions*, 53–67.
22. Judith Butler's notion of the culturally intelligible subject provides a valuable supplement to this understanding of signification's role in securing a substantial self. While Butler emphasizes the problems that stem from the notion of an originary, foundational, prediscursive self in a way that Silverman does not (see *Bodies That Matter*, 1–56; *Gender Trouble*, 101–90; *Psychic Life of Power*, 1–30), Silverman's insights about how masochism exposes the fiction of the invulnerable masculine subject could be retained even if a prediscursive subject was abandoned, although the precise terms of the critique would need to be revised substantially. Butler and Silverman share, however, an understanding that cultural scripts of identity circumscribe the possibilities for self-construction free from social censure.

More specifically, Silverman argues that the positive Oedipal complex, as described by Freud and redescribed by Lacan, provides the "primary vehicle for insertion into" the dominant fiction (*MS* 2, 16). The Oedipal complex stages a fantastic scene and limits the possible positions, characters, and actions within that scene (*MS* 8, 18–19). The economic and cultural arrangement of the nuclear family in advanced capitalist societies imposes the Oedipal scene as a structure for ideological interpellation into a dominant fantasy in which male and female represent the only viable subject positions, heterosexuality represents the only legitimate form of desire, and exogamy represents the only normative form of kinship (*MS* 34–40). According to Silverman, this scene's chief constitutive element is an emphasis on "the adequacy of the male subject" (*MS* 15–16). The male subject's purported adequacy distinguishes him from the inadequate female subject; it marks him as the agent of desire and the answer to the female subject's desire for wholeness. This adequacy entails a denial of castration, a denial worked out by the fantastic equivocation between penis and phallus, the actual and symbolic father (*MS* 15–16, 42, 46). In language that should be read in light of the previous section, Silverman states that the dominant fiction's representation of masculinity is "a fetish for covering over the castration upon which male subjectivity is grounded" (*MS* 47). The masculine self, in other words, disavows—or perhaps even scotomizes—the (male) subject's vulnerability.

Given the strong role Silverman ascribes to the dominant fiction and the Oedipal complex, her account could be criticized as another fatalistic understanding of ideology that fails to acknowledge any outside, any point of leverage, any site of resistance—a criticism often leveled against Lacan and Althusser, Silverman's interlocutors. She attempts to avoid this problem by emphasizing that the Oedipal complex is experienced as fantasy. Relying on Jean Laplanche and J.-B. Pontalis's understanding of fantasy as the mise-en-scène of desire, Silverman points out that even if the dominant fiction circumscribes the subject's positions, roles, and functions, the subject can still occupy any position within the scene in order to become a self (*MS* 5, 18–19).[23] In other words, even though the Oedipal complex defines the masculine position as the site of plenitude and the feminine position as the site of lack, when a subject with a body bearing a penis takes up the feminine position within the fantasy, this expression/experience of self exposes the dominant fiction's attempt to construct the alignment of penis and plenitude as cultural and political, rather than natural and inevi-

23. See Laplanche and Pontalis, "Fantasy and the Origins of Sexuality."

table.[24] The Oedipal complex provides a structure through which the sub-
ject becomes a self, but that structure has multiple sites of identification,
desire, and action. When a subject fails to perform according to the domi-
nant fiction's logic, when it "perverts" the Oedipal order, Oedipality is not
destroyed or overthrown, but it is revealed as a fiction, a fantasy, an imagi-
native construction. The cultural order must provide some structure(s) to
organize the chaos of "personal" experience into intelligible form, but no
structure is ever totalizing, singular, or fully predictable in its cultural ef-
fect.[25] As Silverman notes, even if the lack related to entry into language
is an inevitable feature of subjectivity, it is important to attend to how it
is represented; representing it as a shared and universal characteristic opens
political and cultural options not possible in a system that represents lack as
borne only by some subjects (*MS* 38).

In order to challenge the dominant fiction, Silverman argues that at-
tention should be paid to representations of masculinity that "not only ac-
knowledge but embrace castration, alterity and specularity" (*MS* 3). Where
an image of the male body or a narrative of the masculine self represents
subjectivity as permeated with loss and lack, as deriving its value from an
external source, and as amenable to the eroticizing gaze of an other, the il-
lusion of masculine plenitude, self-sufficiency, and sexual agency is dis-
turbed. By attending to such representations, the meanings assigned by the
Oedipal complex and its distribution of plenitude and lack can be trans-
formed. This is a departure from the strategy of "seeking access for all sub-
jects to an illusory 'wholeness'" that is rendered impossible by the relation-
ship between the subject and signification:

> It . . . require[s] that we collectively acknowledge, at the deepest level of
> our psyches, that our desires and our identity come to us from the outside,
> and that they are founded on a void. . . . [It] hinge[s] first and foremost
> upon the confrontation of the male subject with the defining conditions
> of all subjectivity, conditions which the female subject is obliged compul-

24. I cannot help but think of theatrical experiments in which characters are cast ei-
ther without concern for or specifically against the racial and gender identities called
for in the script. Such productions illuminate the inscription of subjectivity, desire,
and norms within familiar cultural artifacts.

25. Although Silverman does not address the issue explicitly in *Male Subjectivity*, her
understanding of resistance is consistent with Butler's understanding of the political
potential of citation and repetition. For Butler's discussion of an agentless political
resistance, see *Gender Trouble*, 180–90. For an allusion to Butler's understanding of
politics, see Silverman, *Threshold*, 227.

sively to reenact, but upon the denial of which traditional masculinity is predicated: lack, specularity, and alterity. (*MS* 50–51)[26]

This vision challenges the status quo that ascribes plenitude only to men and lack only to women. As importantly, it challenges political discourses that seek to elevate denigrated subjects to cultural positions of power, plenitude, and privilege. It imagines a symbolic order in which the universal state of vulnerability and uncertainty is acknowledged. The language of lack and loss may ultimately be inadequate because it presupposes a pristine subject that is marred, injured, or less than.[27] Recognition of the shared experience of vulnerability allows for a different communal ethos, makes possible different political strategies, identities, coalitions, and discourses. Discourses that preserve the site of plenitude and invulnerability as a possibility for any subject will ultimately have either to repress large swaths of experience, to distribute vulnerability among subjects in a way that mirrors the symbolic logic of patriarchy, or both. Only by acknowledging an experience on the part of all subjects

26. Without repudiating the political value of revealing the lack at the heart of all subjectivity, Silverman, in *Threshold of the Visible World*, places more emphasis on idealization, identification, and love, arguing that the way to challenge the dominant fiction is to engage aesthetic work that fosters identification with the culturally despised, thereby disturbing the reigning ideals about subjectivities that deserve love and adoration (2–5). Recognizing that idealization always runs the risk of creating new hierarchies (205–6), she argues that part of this culturally transformative "active love" must always be understood as a "gift" or "conferral" of value on the despised and maligned, in terms markedly reminiscent of fetishism (76–79, 103). This strategy of acting "as if" the culturally despised have value and deserve love is problematic not only because it does not deny the falsity of fantasies that mark them as despised in the first place but, more importantly, because it implies that some subjects possess value and *can* confer it on others. In other words, the "active love" strategy reintroduces "wholeness" in a different form.

Threshold also discusses how aesthetic works can "help us see differently" by generating a "productive look" that reveals how the dominant fiction's ideals are only ever "partially approximated" by anyone (80–81, 225–27). This seems more closely related to *Male Subjectivity*. The "productive look" highlights the lack at the heart of subjectivity, by emphasizing the failure of all subjects to embody culturally normative ideals. Moreover, the "productive look," like the critique in *Male Subjectivity*, does nothing to implicitly reinscribe hierarchical difference between subjects.

27. Finding language to articulate this vision is challenging. Most of the commonly used terms—lack, loss, rupture, fracture—assume a pristine, complete, or whole subject that has come undone, rather than recognizing a subjectivity that is never coherent or complete. Challenges to the illusions of the dominant fiction must be carefully articulated so that they do not become implicitly evaluative or unwittingly evoke a never-existing, more-perfect past.

of continually striving and constantly failing to close the fissures, resolve the confusions, answer the uncertainties, and endure the traumas that life presents will it be possible to undo the kinds of exclusionary, hierarchical, and degrading social forms of which patriarchy is both emblematic and symptomatic.[28]

According to Silverman, masochistic fantasy confronts the masculine subject with these unsettling conditions. The male masochist

> acts out in an insistent and exaggerated way the basic conditions of cultural subjectivity, conditions that are normally disavowed; he loudly proclaims that his meaning comes from the Other, prostrates himself before the gaze even as he solicits it, exhibits his castration for all to see, and revels in the sacrificial basis of the social contract. The male masochist magnifies the losses and divisions upon which cultural identity is based, refusing to be sutured or recompensed. In short, he radiates a negativity inimical to the social order. (*MS* 186)

Within masochistic fantasy, the masculine subject performs a self that depends on the Oedipal configuration of plenitude and lack without conforming to its normative dictates. In so doing, unlike the fetishist, the male masochist identifies with castration and acknowledges the desire to be the object of another's erotic longing. In this way, masochistic fantasy and its representations in theory, literature, cinema, and religion expose the illusion sustained by the dominant fiction by rupturing the seemingly natural and purportedly obvious connection between penis and phallus. In short, they bring the lack, loss, vulnerability, and insufficiency that plague the masculine subject *as a subject* to the level of conscious reflection. Masochistic fantasy, then, becomes a site where the disavowals of masculinist fantasy are short-circuited; when these disavowals fail, the projection of lack onto bodies and subjects that fail to measure up to the masculine ideal is rendered more precarious.

While Silverman's central insight is potentially quite useful, a nuanced approach to representations of male masochism is required. As demonstrated by her comparative analysis of William Wyler's *The Best Years of Our Lives*, Frank Capra's *It's a Wonderful Life*, and Henry Levin's *The Guilt of Janet Ames* (all 1946), representations of masochism do not inevitably function to

28. Although Silverman focuses on representations of masculinity, she is concerned—as am I—with the cultural situation of nonmasculine subjects: "To effect a large-scale reconfiguration of male identification and desire would, at the very least, permit female subjectivity to be lived differently than it is at present" (*MS* 3). See also Butler, *Gender Trouble*, 56–57; Thomas, "Reenfleshing." For Silverman on racial subjectivities, see *MS* 298–338; on gay male subjectivities, *MS* 339–88.

expose male lack and criticize male superiority (*MS* 67–118).[29] Indeed, as Silverman's analysis of these films shows, masochistic narratives can meditate on the experience of male lack (*Best Years*), offer assurance that loss will be recompensed (*Wonderful Life*), or assign guilt to a woman for the fact of male suffering (*Janet Ames*). For a representation of masochistic desire, fantasy, or practice to operate in a critical fashion, it must expose the lack inherent to subjectivity rather than shore up the banks of the masculine self.

★　★　★

Freud's first detailed consideration of masochism appears in his discussion of sexual perversions in *Three Essays on the Theory of Sexuality*. He initially considers sadism and masochism as inverse forms of a single sexual perversion centering on pain as an avenue to pleasure (*SE* 7:157–59). At this point in his theoretical understanding, sadism is the active, externally directed form of the perversion, masochism the passive, internally focused form— the distinguishing feature being passivity, rather than desire for pain. Sadism and masochism are, Freud writes, "the most common and most significant of all the perversions" (*SE* 7:157). Although he gives no reason for choosing the second adjective, he most likely chose the first because he understands sadism as an exaggeration of the normal aggressive sexual instinct in men (*SE* 7:156, 158–59). While Freud opines that masochism is "further removed from the normal sexual aim than its counterpart," the logic of the transformation of a single sexual instinct into an active and passive form means that masochism shares in sadism's purported naturalness. This shared naturalness is further supported by Freud's contention that masochism is "nothing more than . . . sadism turned round upon the subject's own self, which . . . takes the place of the sexual object" (*SE* 7:159).

In "Instincts and Their Vicissitudes," written a decade after the first edition of *Three Essays*, Freud describes the mechanism of transformation from sadism to masochism as being fueled by narcissism (*SE* 14:132). Freud retains his understanding of sadism and masochism as inextricably bound and turning upon a single axis: he continues to describe sadism as cruelty directed externally for the purpose of sexual satisfaction and masochism as the desire for cruelty directed toward oneself. The presence of masochistic

29. Silverman understands these films from 1946 to be responses to the historical trauma of World War II. Abigail Solomon-Godeau takes issue with this specification of a historical moment of masculine crisis. Rather than attempting to identify the moment of supreme crisis, or even moments of extreme crisis, she suggests we should seek to understand how fantasies of masculinity can both represent and contain the notion of ruination, deploying it in a fashion that further instantiates power and privilege ("Male Trouble," 74–76).

desire in sadistic practice complicates the picture of how the instincts mu-
tate and transform:

> We have every reason to believe that sensations of pain, like other unplea-
> surable sensations, trench upon sexual excitation and produce a pleasurable
> condition, for the sake of which the subject will even willingly experience
> the unpleasure of pain. When once feeling pains has become a masochistic
> aim, the sadistic aim of *causing* pains can arise also, retrogressively; for while
> these pains are being inflicted on other people, they are enjoyed masochisti-
> cally by the subject through his identification of himself with the suffering
> object. . . . The enjoyment of pain would thus be an aim which was origi-
> nally masochistic, but which can only become an instinctual aim in some-
> one who was originally sadistic. (*SE* 14:128–29)

This account almost reverses the relationship between masochism and sa-
dism found in *Three Essays*. Although Freud will abandon some of these
ideas, his notion that sadism and masochism hide other forms of desire will
continue to develop.

In "'A Child is Being Beaten': A Contribution to the Study of the Ori-
gin of Sexual Perversions," Freud examines how masochistic fantasy and
practice differ by gender by considering what he characterizes as a very
common fantasy, both for those who are in analysis and those who are not
(*SE* 17:179). The short phrase "a child is being beaten" is the only descrip-
tion of the fantasy Freud provides; as he observes, those who indulge in the
fantasy are often uncertain as to the identity and number of victims or per-
petrators, their own relationship to them, their location in the fantasy, or
even whether the pleasure derived is best described as sadistic or masochistic
(*SE* 17:181). Freud reports that his male patients in both fantasy and perfor-
mance always cast a woman in the role of chastiser. In addition, in both per-
formance and fantasy, the male masochists "invariably transfer themselves
into the part of a woman; that is to say, their masochistic attitude coincides
with a *feminine* one" (*SE* 17:197).[30] While the figure of "woman" appears
to play an important role in male masochistic fantasy, it is the father who
is central. Freud contends that the fantasy of a woman chastiser is a trans-
lation of a prior, now unconscious, fantasy of being beaten by the father.
This unconscious, now repressed, fantasy disguises an even earlier longing
to be loved by the father:

> In the male phantasy . . . the being beaten also stands for being loved (in a
> genital sense), though this has been debased to a lower level owing to re-

30. The male masochist's passive/feminine character is troubled by the fact that he
conjures the fantasy or seeks the sexual encounter.

gression. So the original form of the unconscious male phantasy was not the provisional one that we have hitherto given: "I am being beaten by my father," but rather: "*I am loved by my father.*" The phantasy has been transformed by the processes with which we are now familiar into the conscious phantasy: "*I am being beaten by my mother.*" The boy's beating is therefore passive from the very beginning, and is derived from a feminine attitude toward his father. . . . *The beating-phantasy has its origin in an incestuous attachment to the father.* (*SE* 17:198)[31]

Initially, it appears the male child assigns value or surrenders power to the mother/woman, but analysis reveals that the father's significance and desirability fuels the fantasy. In other words, although the male masochistic adopts a feminine attitude and identity, his underlying desire reinforces the primacy of the paternal position. This desire for the father is the only feature common to boys' and girls' beating fantasies.

Echoing his understanding of the fetish, Freud notes that the conscious masochistic fantasy—the translation from love to violence, from father to mother—enables the male child to "evade" his homosexuality (*SE* 17:199). Like the fetish, masochistic fantasy and performance has an uncertain and unstable relationship to heterosexual identity. The supposed evasion is a retention. Moreover, this homoerotically cathected retention, despite its instantiation of the boy in a position of femininity and passivity, creates a bond between the boy and the father that makes men, the masculine ideal, the paternal signifier, and male-to-male relationships the primary figures of desire and desirability.[32]

Finally, in "The Economic Problem of Masochism," Freud seeks to square masochistic desire with the pleasure principle. In this essay, Freud distinguishes between three types of masochism: feminine, erotogenic, and moral. Feminine masochism, the most easily observable form, is found

31. In *Masochism in Modern Man*, Theodor Reik offers an analysis of beating fantasies that is contrary to Freud's on almost every point. First, Reik remains committed to the notion that masochism is a transformation of the sadistic instinct (177–79). Second, while acknowledging that the masochistic fantasy usually involves a female chastiser and is an attempt to negotiate the relationship with the father, Reik contends it is a mechanism for assuaging guilt over the desire to slay the father and secure the affections of the mother (22–23, 205–6). Finally, Reik contends that "the masochist who plays the female part in his phantasies and scenes seems at the same time to make fun of it by his distorted presentation. . . . The masochist indicates to the woman by his feminine behavior in what position he wants to see her" (197–99).
32. According to Butler, whenever Freud encounters what appears to be homoerotic desire, he reconfigures the desiring subject's gender to preserve heterosexuality. *Gender Trouble*, 77.

in male patients who, like those considered in "'A Child is Being Beaten,'" conjure fantasies or pursue situations in which they are "gagged, bound, painfully beaten, whipped, in some way maltreated, forced into unconditional obedience, dirtied and debased." These fantasies generally signify, according to Freud, "being castrated, or copulated with, or giving birth to a baby" (*SE* 19:162).[33] Erotogenic masochism, which underlies and supports the other forms, is characterized by a libidinal pleasure in pain (*SE* 17:161).[34] Moral masochism, the third form Freud considers, "is chiefly remarkable for having loosened its connection with what we recognize as sexuality":

> All other masochistic sufferings carry with them the condition that they shall emanate from the loved person and shall be endured at his command. This restriction has been dropped in moral masochism. The suffering itself is what matters; whether it is decreed by someone who is loved or by someone who is indifferent is of no importance. It may even be caused by impersonal powers or by circumstances; the true masochist always turns his cheek whenever he has a chance at receiving a blow. (*SE* 17:165)

This desexualization is only apparent. According to Freud, the superego, the agency that serves as the conscience, comes "into being through the introjection into the ego of the first objects of . . . libidinal impulses— namely, the two parents" (*SE* 17:167). The punishing force whose attention the masochistic ego seeks, therefore, has a personal identity. As Freud notes elsewhere, and as will become more apparent below, the father is the primary figure behind the superego. The connection between the masochistic ego and the paternal superego has a sexual charge:

> We now know that the wish, which so frequently appears in phantasies, to be beaten by the father stands very close to the other wish, to have a passive (feminine) sexual relation to him. . . . If we insert this explanation into the content of moral masochism, its hidden meaning becomes clear to us. Conscience and morality have arisen through the overcoming, the desexualization, of the Oedipus complex; but through moral masochism morality becomes sexualized once more. . . . Masochism creates a temptation to perform "sinful" action, which must then be expiated by the reproaches

33. Here, Freud's characterization of femininity relates to the fantasies' content rather than the fantasizers' (passive) attitude.

34. Abandoning the view of *Three Essays*, Freud now concedes there is a primary masochism. He admits that analysis can explain neither the interaction between the sexual and death instincts nor the precise reasons why the death instinct becomes externalized (sadistic) or internalized (masochistic). See *SE* 19:163–65.

of the sadistic conscience . . . or by chastisement from the great parental power of Destiny. (*SE* 17:169)

In a manner similar to the analysis of the beating fantasy of feminine masochism, this description of moral masochism aggrandizes paternal authority and marks the father as the focus of desire. Moral masochism, the form that seems most impersonal and nonerotic, turns out, upon analysis, to be (also) about sexual desire for the father. In addition, similar to the way in which discussions of fetishism and beating fantasies introduce homoerotic desire as a feature of heterosexual identity, this description of conscience's homoerotic substratum complicates the notion of the masochist's sexual identity. More interestingly, perhaps, insofar as moral masochism is only an exaggerated form of the normal course of development of the id, ego, and superego, homoerotic desire appears to have a role to play in moral (and identity) formation generally.

Silverman's account of the critical potential of masochistic fantasy depends on the ability of such fantasies to emphasize the conditions of lack that are part of male subjectivity, to challenge the dominant fiction that links the penis to the phallus, to pry open a gap between the actual and symbolic father. Although Freud's description of the male masochist's fantasy and practice emphasizes the feminine position adopted by the fantasizer (toward the father) and even draws attention to the male masochist's fascination with castration, it also creates a closed circuit of male-male desire that underscores the desirability of both the father and the paternal position and strongly cathects the male child who longs to acquire the phallus with the paternal figure who is understood to possess it. While undergoing a fantastic castration may be the price of admission to the masochistic scene, once in the arena the son becomes the object of the father's desire, the source of his sexual satisfaction, and the bearer of his children. Far from emphasizing universal conditions of lack and loss facing all subjects, the masochistic fantasy has as much potential to render female subjects irrelevant, reducing the world to fathers and sons by circumscribing desire to male homoerotic negotiations and aggrandizing male subjects by marking the father as the ultimate object of virtually all desire.

Masochism's aggrandizing potential can be brought into sharper focus by considering those case studies where Freud considers male masochistic fantasies. In "Psycho-analytic Notes on an Autobiographical Account of a Case of Paranoia," Freud examines Daniel Paul Schreber's *Memoirs of a Nervous Illness*.[35] Schreber, an appellate court judge from an important German

35. In her introduction to the English translation of Schreber's *Memoirs*, Rosemary Dinnage observes that it "must be the most written-about document in all psychiat-

family, suffered a mental breakdown and, while receiving treatment in a mental hospital, produced a memoir of his hallucinations. Freud emphasizes two points in Schreber's account: his hope/anxiety that he would be transformed into a woman and his understanding that he was destined to be the redeemer of the human race (*SE* 12:16–18). Schreber's fear of persecution and castration was "at first assigned to Professor Flechsig, the physician in whose charge he was; later . . ., [to] God Himself" (*SE* 12:18). Presaging his account of the translation of the male child's beating fantasies, Freud explains that Schreber's hatred for his doctor was a disavowal of his homosexual desire; his fear of Flechsig was a modification of sexual longing (*SE* 12:40–47). When his paranoic focus shifts from the human to the divine realm, Schreber vacillates between describing God's designs as those of a castrator and those of a lover; his position alternates between being God's victim and God's spouse (*SE* 12:18–25).[36]

For Freud, the castration fantasy, rather than the savior complex, is fundamental:

> The idea of being transformed into a woman (that is, of being emasculated) was the primary delusion. . . . [Schreber] began by regarding that act as constituting a serious injury and persecution, and . . . it only became related to his playing the part of Redeemer in a secondary way. There can be no doubt, moreover, that originally he believed that the transformation was to be effected for the purpose of sexual abuse and not so as to serve higher designs. The position may be formulated by saying that a sexual delusion of persecution was later on converted in the patient's mind into a religious delusion of grandeur. (*SE* 12:18)

Regardless of which comes first, temporally or analytically, I am interested in the coalescence of castration and redemption—emasculation and exaltation—in Freud's and Schreber's texts. Schreber's paranoic, homoerotic delusion undergirds his faith that if he is willing to undergo suffering, to experience the significant loss and bear the mark of lack that is castration, to become a woman, "he" will also become the world's redeemer, God's lover, and the progenitor of a new race (*SE* 12:27–30).[37] While it is true that associating himself with passivity, castration, and femininity are part of the

ric literature" (xi). For further discussion of Schreber's case, see Allison et al., *Psychosis*; Israels, *Schreber*; Lothane, *In Defense of Schreber*; Niederland, *Schreber Case*; Santner, *My Own Private Germany*.

36. See Schreber, *Memoirs*, 21–34, 45–46, 60–68.

37. Different, and potentially more radical, political possibilities are opened up if we take seriously that Schreber is not just a castrated man, but that he *becomes a woman* in order to become the world's redeemer.

process, the final stage seems markedly distinct from the renunciation of power and privilege. As Freud points out, Schreber's fantasy of redemption is not of the typical form, but includes rebellion against and resistance toward God (*SE* 12:28–29). On Schreber's own account, he is not merely castrated by God and then appointed redeemer, but struggles with God (despite his emasculation) and emerges as a victorious redeemer figure.[38] Returning to the issue of temporal and analytic order, the struggle between Schreber and God indicates that redeemer status is the reward for emasculation. In Schreber's delusion, castration does not identify the masculine subject with lack, but rather allows for the simultaneous acknowledgement and overcoming of it. While it may seem counterintuitive to characterize a fantasy so heavily figured around castration as trading in phallic power, it would be inaccurate to describe a representation of masochistic desire that culminates in the assumption of an identity as humanity's redeemer as one that draws attention to the lack that is the foundation of all subjectivity.

A christological masochistic fantasy also plays a prominent role in "From the History of an Infantile Neurosis." Often referred to as the "Wolf-Man" case study because of the role played by a dream of wolves, traced to the patient's witnessing the primal scene—that is, his parents' copulation—masochism, homoeroticism, and paranoia figure in this case as well.[39] When he was four and a half years old, the patient was "acquainted with the Bible story" of Christ's Passion by his female caregivers (*SE* 17:61–62). The patient had a threefold reaction. He exhibited intense curiosity as to whether Jesus had a "behind" like his own and "whether Christ used to shit too" (*SE* 17:63).[40] He also identified himself with Christ and his father with God (*SE* 17:115). Finally, he expressed

> critical dissatisfaction against God the Father. If he were almighty, then it
> was his fault that men were wicked and tormented others. . . . He ought to
> have made them good. . . . [The patient's] acuteness was on the alert, and
> was able to search out with remorseless severity the weak points of the sacred narrative. (*SE* 17:62–63)

Although Freud expresses disbelief over the patient's claim that his critique of the Passion story arose contemporaneously to his hearing it, he does not look behind the patient's mature "rationalistic criticism" to ask if something else was at stake in the expressed dissatisfaction with God (*SE* 17:63).

38. Schreber, *Memoirs*, 66–67, 125, 250.
39. For further discussion of homoeroticism, masculinity, and masochism in this case study, see Bersani, *Homos*, 108–12; Davis, *Drawing the Dream of Wolves*; Thomas, *Male Matters*, 74–92.
40. On the connections between God and shit in Scheber's fantasy life, see *SE* 12:26–27.

Freud acknowledges elsewhere in the case study that the patient identi-
fied with Christ because it gave him a mechanism to express and experience
his "extravagant love of his father":

> As Christ, he could love his father, who was now called God, with a fervour
> which had sought in vain to discharge itself so long as his father had been
> a mortal. The means by which he could bear witness to this love were laid
> down by religion, and they were haunted by that sense of guilt from which
> his individual feelings of love could not set themselves free. In this way it
> was still possible for him to drain off his deepest sexual current, which had
> already been precipitated in the form of unconscious homosexuality; and
> at the same time his more superficial masochistic impulsion found an in-
> comparable sublimation, without much renunciation, in the story of the
> Passion of Christ, who, at the behest of his divine Father and in his honor,
> had let himself be ill-treated and sacrificed. (*SE* 17:115)

Like Schreber, this patient's identification with Christ—specifically, the
position of suffering and abuse—indicates, on Freud's analysis, a longing
for the sexual affection and attention of the father and father-surrogates. In
other words, a masochistic fantasy—here, the story of Christ's Passion—
serves to keep alive homoerotic desire by translating it into a form that
strips off its transgressive veneer: the by-now familiar evasion/retention
of homosexuality.

The homoerotic edge of the fascination is confirmed by the patient's
interest in Jesus's behind and its functionality. As Freud contends, inter-
est in Christ's anus is not simply curiosity about whether it expelled fe-
cal matter, but is fundamentally a question about whether Christ was ca-
pable of being used sexually by his Father in the way the patient desired
to be sexually available to his own father (*SE* 17:64–65). If, as Freud ac-
knowledges, the patient used the Passion story to negotiate the terrain of
his erotic desire for his father; if, as Freud acknowledges, conscious de-
sire for pain is a way of expressing unconscious desire for sexual atten-
tion; and if, as Freud acknowledges, God and Christ are substitutes for
the patient's father and the patient respectively, then dissatisfaction with
God is not (only) a "rational," ethical critique of his rather shoddy treat-
ment of his son (and of humanity) but is also the patient's statement of
resentment and jealousy that God the Father is a better erotic partner to
Christ the Son than his father is to him. Just as the beating fantasy allows
the son to retain his repressed erotic longing for the father, identification
with the Passion narrative allows the Wolf-Man to experience the erotic
attention of the (f/F)ather. Freud's congratulatory words about his pa-
tient's critical insight regarding the shortcomings of the Christian narra-

tive prevents—or perhaps excuses—him from acknowledging the child's genuine complaint.

The patient's interest in Christ's habits of defecation are also related to the erotic dynamics of the father-son relationship. According to Freud, given the erotogenic pleasures associated with the anal cavity, holding feces is a substitute for the desire to be penetrated by the penis and releasing feces is a voluntary giving up of the penis, a gift of castrating loss from the child to the parent (*SE* 17:80–81, 84). When the patient saw his parents engaged in sexual intercourse, he responded by passing a stool; Freud contends that the stool represents the baby that would result from intercourse with the father, the castration required to assume the desired position in relation to the father, and the son's bestowal of a new penis to replace the one that the father "loses" during intercourse (*SE* 17:80–88). All of these meanings emphasize the penis's importance as an object of veneration and strengthen the bond between son and father by erotically cathecting the phallic identification between male child and male parent. Similar to the role of narcissism in the transformation of sadism to masochism, the boy's anxiety regarding both his and his father's castration was fueled, according to Freud, by a narcissistic investment in the penis (*SE* 17:87–88). As with the consideration of masochistic fantasies generally and Schreber's case specifically, the Wolf-Man's fantasies both figure loss at the site of the male body and at the same time overcome that loss; they celebrate the paternal position and strengthen the father-son dyad through homoerotic desire.[41]

The masochistic fantasies of Schreber and the Wolf-Man have two distinct phases: one characterized by suffering, pain, and castration, the other by aggrandizement, glorification, and power. These are mirrored by the key moments in the Christian imaginary: crucifixion and resurrection. These stories begin with pain and humiliation but end with restoration and exaltation. Silverman makes a similar observation in discussing how *It's a Wonderful Life* "succeeds in realigning penis and phallus" (*MS* 92). According to Silverman, the film "does not so much cancel as *defer* the phallic legacy . . . by invoking a sacred temporality within which the male subject's lack will finally be made good" (*MS* 92, 106). Christianity, Silverman notes, can represent pain and loss without threatening "the equation of the penis and the phallus, since that discourse acknowledges the distance separating the actual from the symbolic father [and] makes renunciation and suffering the

41. When discussing Christianity directly, Freud identifies a similar dynamic. Through a willingness to suffer, the Son becomes the Father, and through a ritual and narrative identification with the Son, sons become fathers (*SE* 13:154–55, 23:135–36).

necessary path leading from the former to the latter" (*MS* 102–3).[42] While Christian narratives of suffering and martyrdom have "radically emasculating implications," this impulse is quelled by the reward that attaches to the experience and attitude of submission (*MS* 197–98).[43] If one takes up one's cross, one will gain life, not lose it.[44]

★ ★ ★

On Freud's account, the Oedipal complex arises with the child's discovery of the penis and is resolved because of the value the child assigns to it.[45] Resolution of the complex, however, requires successful negotiation of its ambiguities:

> The Oedipus complex contains two possible schemes of desire and conflict. [The male child] could put himself in his father's place in a masculine fashion and have intercourse with his mother as his father did, in which case he would soon have felt the latter as a hindrance; or he might want to take

42. As this discussion shows, Silverman is aware of the ambiguous nature of masochistic fantasy. My disagreement is a matter of emphasis: she emphasizes masochism's critical potential; I emphasize its ambiguity.

43. For a similar discussion of the function of masochism generally and the cultural work of Christianity specifically, see Reik, *Masochism*, 274, 314–16, 347–48.

44. Deleuze's version of masochism, despite its stated intentions, does very little to supplant male power and privilege. At the beginning of "Coldness and Cruelty," he rejects psychoanalysis for a "*literary approach*, since it is from literature that stem the original definitions of sadism and masochism" (14). Deleuze argues that masochism is funded by a desire to reunite with the mother, expel the father, and punish the paternal remnant within the son. When concluding that masochism celebrates maternal power, he forgets his earlier observation that the masochist is "essentially an educator"—even a cajoler or tyrant—with respect to the female chastiser (21). As such, the son does not renounce phallic power but seizes it from the site of the masochistic object. Deleuze's claims also falter on the terms of the literary sources he takes as his guide. In Sacher-Masoch's *Venus in Furs*, for example, Severin meets his fantasy woman, Wanda, and convinces her to be his dominatrix. When she reluctantly assumes this role, Severin enters erotic encounters excited and aroused, but becomes angry and distressed when Wanda carries out acts of punishment and humiliation. When, on Severin's insistence, she takes another lover, who then brutalizes Severin, he unilaterally rescinds the masochistic contract. The novel concludes by reporting that Wanda is happily dominated by her male lover and Severin is the cruel master of several girls. Far from a tale about male renunciation of power, *Venus in Furs* depicts the seeming impossibility of men's occupying the space of suffering, vulnerability, and passivity.

45. Because my focus is on representations of masculinity, I consider only Freud's discussion of the male child's resolution of the Oedipal complex. For the different

the place of his mother and be loved by his father, in which case his mother
would become superfluous. (*SE* 19:176)

In the simplest terms, the male child seeks either to supplant the father be-
cause of a desire for the mother or to assume the role of the mother because
of a desire for the father (*SE* 17:35–36, 19:31–33, 21:249–50). Either desire
entails loss. If the child pursues the mother, he takes the father as a rival, a
rivalry that will culminate in the father's castrating blow. If the child pur-
sues the father, he must undergo castration to assume his mother's posi-
tion, a position that entails loss of the mother as a source of affection (*SE*
17:46–47, 19:32).[46]

Given this understanding of the conflicts, Freud concludes that it is the
threat of castration that "destroys" the Oedipal complex (*SE* 9:217, 19:177,
19:257). If both desires within the complex give rise to the threat of cas-
tration,

> the masculine one as a resulting punishment and the feminine one as a pre-
> condition . . ., a conflict is bound to arise between [the male child's] nar-
> cissistic interest in that part of his body and the libidinal cathexis of his pa-
> rental objects. In this conflict the first of these forces normally triumphs:
> the child's ego turns away from the Oedipus complex. (*SE* 19:176; see also
> *SE* 17:46–47)

In the situation Freud regards as normal, the boy renounces desire for the
mother in order to avoid castration.[47] This form of identifying with the fa-
ther, rather than seeking to supplant him, is described by Freud as a con-
solidation of masculinity (*SE* 11:95, 17:46–47, 19:32). Consistent with this
understanding of the boy's assumption of masculinity, Freud describes
the girl's desire to retain/obtain the penis as a "masculinity complex" (*SE*
19:251–53). Masculinity, then, regardless of who attempts to attain it, is

and complicated path that the female child must purportedly travel, see, in addition
to the materials discussed in this section, *SE* 21:225–43.

46. When discussing the rivalry with the father that is part of the positive Oedi-
pal complex, Freud never discusses the potential of losing him as a source of affec-
tion. He also rarely describes the mother as a rival in the Oedipal drama. This lack of
equivalence in describing the two Oedipal structures stems, no doubt, from Freud's
assumptions regarding normative gender and sexuality. My own language betrays
my internalization of these assumptions.

47. The fact that an alternate resolution of the complex is possible—and indeed, as
likely as the normative one—presents a challenge to the biological imperative that
sometimes appears on the surface of Freud's texts. Freud admits that resolution of the
Oedipal complex toward masculinity and heterosexuality depends on "authoritative
prohibition[s] by society" (*SE* 7:229).

focused on possession of the penis. With respect to the boy, Freud usually describes the desire to retain the penis in terms of the organ's associated physical pleasures; such a description marks the link between men and masculinity as biological. With respect to the girl, however, Freud is clear that it is the power and prestige associated with the penis that attracts her; such a description—while characterizing women's desire to access the privileges that accompany masculinity as aberrant—exposes the foundations of male privilege as cultural rather than biological. When Freud explains that the boy's observation of the girl's castrated status leads him to assume the girl's inferiority (e.g., *SE* 10:36), he gives further evidence of the social relevance of the penis and reveals his own attempt to inscribe that social fact on the body.

In addition to enabling a glimpse of the sleight of hand whereby biological facts are substituted for social conditions, Freud's discussion of how a narcissistic investment in the penis allows the male child to resolve the Oedipal complex in the direction of masculine identity performs another task in relation to the dominant fiction. The prevailing cultural script of masculinity separates normative male identity from homoerotic desire. While the masculine ideal is often represented using codes very similar to those that signify homoerotic desire, and while the performance of masculinity often betrays a fascination with the penis, the claim that masculine identity is motivated and secured by a sexualized desire circling around the male genital organ is, at the very least, distinct from what would usually be said regarding the contours of the masculine ideal. On the terms of Freud's analysis, however, masculinity is achieved by renouncing the first heterosexual object-choice (the mother) in favor of the marker of both male cultural power and masculine erotic desirability (the penis).

Reminiscent of the confusions inherent in the conclusion that the fetish preserves heterosexuality by transforming the woman into a penis-bearing sexual object, Freud's discussion of normative masculinity contains a similar confounding feature: masculinity and homosexuality are, ultimately, both founded on the penis's desirability. In other words, if we take Freud at his word, homoerotic desire is as much a component of masculine identity as it is its opposite. Even if, contrary to Freud, we interpret investment in the penis solely in political terms—as exclusively about cultural power and completely distinct from any erotic interests—we must acknowledge that masculine power is not a biological mandate but rather a cultural accomplishment and retaining the source of privilege is more important than obtaining the object of heterosexual desire. Although the representations that comprise the dominant fiction—including many claims by Freud regarding castration, women, and homosexuality—attempt to maintain a firm

and secure border between male and female, masculine and feminine, heterosexual and homosexual, biology and sociology, certain features of that fiction undermine its compulsive border patrolling.

The precise contours of normative masculine identity are further complicated by Freud's understanding of the superego's development. When the boy resolves the Oedipal complex by choosing his narcissistically invested penis rather than the libidinally charged parent,

> the object-cathexes are given up and replaced by identifications. The authority of the father or the parents is introjected into the ego and there it forms the nucleus of the super-ego, which takes over the severity of the father and perpetuates his prohibition against incest, and so secures the ego from the return of the libidinal object-cathexis. The libidinal trends belonging to the Oedipus complex are in part desexualized and sublimated (a thing which probably happens with every transformation into an identification) and in part inhibited in their aim and changed into impulses of affection. The whole process has, on the one hand, preserved the genital organ—has averted the danger of its loss—and, on the other, has paralysed it—has removed its function. (*SE* 19:176–77; see also *SE* 19:36, 257)

Although in this passage Freud writes that "the father or the parents" form the superego's nucleus, in other places he restricts this function to the father (*SE* 19:36–37).[48] In contrast to this passage, which speaks only of desexualization and sublimation, Freud acknowledges elsewhere that "large amounts of libido of an essentially homosexual kind are drawn into the formation of the narcissistic ego ideal and find outlet and satisfaction in maintaining it" (*SE* 14:96).[49] Moreover, as the previous section's discussion of moral masochism made clear, the relation between superego and ego should be understood as one that enables the preservation of sexual desire for the father. As with the uncertain dividing line between heterosexual and homosexual investment in the penis, Freud's statements about the development of the superego make it unclear where the precise line is between moral masochism and conventional morality or, more to the point,

48. Moreover, the logic of the passage requires a more powerful role for the father in the superego function. The superego secures the prohibition of incest, which is the role of the father in the Oedipal complex, and the relation between ego and superego is one of identification, which is not the relation between son and mother. Moreover, Freud's discussion of the woman's problematic development of a superego depends on the father-derivative character of the superego (*SE* 19:257–58).

49. Freud goes further: if it does not provide opportunities for the development of homoerotically charged relationships between men, society will fall ill (*SE* 14:101–2).

between masochistic and hegemonic masculinity. As with his description of the dissolution of the Oedipal complex, Freud once again introduces "foreign" elements—namely, homoeroticism and masochism—into his representation of masculinity.

A consideration of Lacan's interpretation of the Oedipal complex will provide further support for the contention that homoeroticism is both internal to and disruptive of masculine identity.[50] Lacan follows Freud in assigning a central role to the Oedipal complex and its relation to castration, but he articulates the phenomena in terms of the relation between the subject and signification (*Éc* 575–76; *SXI* 204). As noted above, on Lacan's account the subject finds its way to selfhood through the signifying system. The subject does not employ the culture's signifying elements to construct an identity but finds itself in signification, spoken *by* the signifier (*Éc* 578).[51] Given this relation to signification, the subject's self, meaning, and desire are articulated from the site of the Other (*Éc* 207–8, 579–82; *SXI* 207–8). The externalized reference point for identity creates a gap, a lack, a sense of alienation at the heart of subjectivity: "The phallus is [the] term for the signifier of [the subject's] alienation in signification."[52] Forever seeking to close this gap, the subject perpetually substitutes objects for the phallus, in an attempt to restore a fantastic wholeness that never existed.[53] Although Lacan insists that the phallus is a pure and transcendent signifier, that it is neither an object nor an organ but only a fantasy and an ideal, he often describes the phallus using terms that evoke the penis (*Éc* 579–82).[54] In addition, his description of how the subject realizes and overcomes the alienation that accompanies its entry into language establishes an equivocation, if not identification, between phallus and penis.

Although all subjects experience the alienation attending the entry into language and thus seek the phallus and its fantastic substitutes, the sub-

50. For more detailed considerations of Lacan's usefulness for critiquing heteronormativity, see Dean, *Beyond Sexuality*, 215–79; Restuccia, *Amorous Acts*, 119–53.

51. See also Lacan, "Desire and the Interpretation of Desire," 12. Lacan's account of the gaze as existing beyond both the subject and the Other provides a similar account of an externalized, alienating system of meaning that situates the subject in a position of selfhood (*SXI* 83–84). The notion that the subject's sense of self is visually and externally mediated as well as riven with an inevitable sense of alienation is the central conclusion of Lacan's work on the mirror stage (*Éc* 75–81).

52. Lacan, "Desire and the Interpretation of Desire," 28.

53. Ibid., 37–38.

54. For further discussion of the relation between phallus and penis, see Butler, *Bodies That Matter*, 78–80; Silverman, "Lacanian Phallus." For discussion of the relation between the phallus and the *objet a*, see Dean, *Beyond Sexuality*, 45–50, 264–68.

ject comes to realize something about where the phallus is and is not due to the Other's desire. Given the Other's desire for the subject, the subject comes to realize that the Other does not possess the phallus but is searching for it; the Other's desire creates a longing on the subject's part to become the phallus for the Other (*Éc* 582; *SXI* 214–15, 218–19). Although the structural terms of Lacan's description are subject and Other, implying that any desiring Other could come to be understood as lacking the phallus and requiring completion by and through the subject, Lacan frequently describes the lacking Other as the lowercase other or, more precisely, the mother (see especially *Éc* 582). Whereas neither the subject nor the Other have gendered identity when discussed in the most general terms, Lacan's description of the symbolic order requires that desiring others be positioned in specific gendered roles so that the subject can fantastically overcome its alienation. In order for the symbolic structure to operate, on Lacan's understanding, something must cover the gap in signification generated by the ever-circulating lack of signification's self-alienation. For Lacan, the only answer is the Name-of-the-Father; there is no maternal or feminine equivalent (*SIII* 96–97, 176–77). The actual father is, of course, always an impostor for the symbolic Father, a vague approximation of the figure that secures the Law and halts the flow of signification initiated by the desire and language of the Other—a relation akin to that of the penis to the phallus (*Éc* 688–89, 698). At the same time where the actual father does not sufficiently approximate the symbolic Father, the subject is likely to succumb to psychosis, unable to find its moorings in the ever-flowing tide of language, unable to structure a stable self (*Éc* 479–81; *SIII* 201–5).

Lacan identifies a number of ways in which the actual father can fail to resemble sufficiently or successfully the symbolic Father (*Éc* 482–83). If the actual father is undermined as an authority figure by the mother, repudiated as a figure who could instantiate and enforce the Law, then the relationship to the symbolic Father will be marred. If the actual father's life is riven with failures to attain the achievements and successes culturally assigned to male subjects, then he will also fall short in resembling the symbolic Father. Conversely, if the actual father is overwhelmingly successful and establishes himself as a close approximation of the symbolic Father, then his inevitable weaknesses and flaws will appear that much more glaring in relation to the symbolic Father that he *almost* exactly resembles. Given the multiple ways in which the actual father can fail to resemble the symbolic Father—given Lacan's admission that the actual father is always an impostor, that even the symbolic Father is only a fantastic substitute for the phallus, which is itself only an imaginary object—should we conclude that

virtually all subjects are psychotic to some degree?[55] Regardless of how we answer this question, Lacan's theoretical discourse reveals, at the very least, an attempt to secure a privileged function for paternal authority, a longing for the (f/F)ather to rescue the subject from the chaos and alienation generated by the (m)Other's desire. On my reading, Lacan's theory betrays a desire for the father that Freudian discourse willingly admits.

What is absent from Lacan's account is any explicit recognition that the subject could experience the father as the desiring other. The logic of the Lacanian structure demonstrates why this must be excluded as a possibility. If, on the one hand, the father could be the other who desires the subject, then the father would, like the mother, be recognized as lacking the phallus. In Lacan's system, desire signals lack; if the father is (also) a site of lack, then the symbolic order will collapse, because the Name-of-the-Father exists precisely as an answer to the ever-present, ever-circulating lack signified by the phallus. If, on the other hand, the father is either the source of homoerotic desire for the son or the object of the son's homoerotic desire, then, given the sexual order that Lacan assumes and the dominant fiction presupposes, the actual father is distanced from the symbolic Father because of the kind of sexual desire circling around him. Insofar as homoerotic desire flows between father and son, psychosis inevitably results—that is to say, homoeroticism nullifies the subject's attempt to become a self. At the same time, the subject's quest for an unalienated sense of self is fueled by a desire to rest secure in relation to the Father and the Father's Law. The longing for selfhood is discursively represented by Lacan as a captivation with the (f/F)ather that both is and cannot be homoerotic.

Freud can keep homoerotic desire discursively alive because he appeals to biology to make heterosexuality natural and inevitable. The boy will always choose the penis, which signifies maleness and implies heterosexual desire (except, of course, when it does not). Because Lacan's account does not take anatomy as its foundation, it cannot admit the possibility of homoerotic desire into the realm of masculine identity without revealing the arbitrary resolution of the alienating effects of signification in favor of the heterosexual and patriarchal status quo. If the boy finds himself in a universe comprised solely by others, lack, and desire, then there must be some mechanism for fixing the relationship between some others, some lacks, and some desires to maintain the gendered and sexualized division of power.

Taking Freud's ruminations on mourning and melancholia as her pri-

55. "The dilemma of the psychotic patient throws into relief our common malaise as linguistic subjects." Dean, *Beyond Sexuality*, 106.

mary texts, Judith Butler argues that the perpetually unacknowledged, eternally mourned object of homosexual desire is necessary to the consolidation of masculinity and that a strong sense of "oppositionally defined gender identity" serves to maintain the lost homosexual object through a constant gesture of disavowal.[56] In *Gender Trouble*, she contends that Freud and Lacan transform the social prohibition on homosexuality into a heterosexual disposition, thus providing heterosexual desire a natural rather than cultural foundation (73–82). She concludes her analysis of the connection between heterosexual desire and the lost homosexual object by considering the relation between disavowed homoerotic desire and the construction of the female subject: "The woman-as-object must be the sign that [the masculine subject] not only never felt homosexual desire, but never felt the grief over its loss. Indeed, the woman-as-sign must effectively displace and conceal that preheterosexual history in favor of one that consecrates a seamless heterosexuality" (91). According to Butler, the woman's cultural construction as a sexual object and the repression of masculinity's homoerotic substratum are mutually implicated. Thus, tracing the figuration of homoerotic desire in representations of normative masculinity has the potential to alter the construction of both women's and men's relationship to sexuality and subjectivity.

★ ★ ★

In her most recent book, *Flesh of My Flesh*, Kaja Silverman asserts that "finitude is the most capacious and enabling of the attributes we share with others" (4). Unlike the historical and biographical particularities that mark us as *individuals*, and unlike the differences of race, gender, class, and ability that can connect us to *some* people, the surety of death

> connects us to *every* other being. . . . Unfortunately, though, finitude is the most narcissistically injurious of all of the qualities we share with others, and therefore the one we are most likely to see in them, and deny in ourselves. Our refusal to acknowledge that we are limited beings has devastating and often fatal consequences for others. (4–5)

To trace how death has been denied in Western culture, and how confrontation with death has been revealed as devastatingly traumatic to the subject's stability and coherence, Silverman considers art, psychoanalysis, Christianity, Nietzsche, Rilke, and—most importantly—the myth of Orpheus and Eurydice. According to Silverman, this myth "is one of the ur-narratives

56. See Butler, *Gender Trouble*, 88–89; see also Butler, *Psychic Life of Power*, 132–50.

of Western subjectivity—equal in importance to, and perhaps even more important than, the one recounted by Sophocles in *Oedipus Rex*. . . . There is an Orpheus inside every Oedipus, and it is *he* who will determine our future" (58).

Silverman considers variations on the Orpheus and Eurydice story, focusing on how each treats the "second" loss of Eurydice. This moment forces Orpheus to acknowledge the possibility of his own death. He manages this revelation by feminizing death, displacing it onto the woman's body, thereby denying its ability to touch him. Different versions of the myth, on Silverman's reading, offer different judgments on Orpheus's repressive strategy. Linking Orpheus's loss of Eurydice to the child's loss of the maternal body, Silverman points out that the rage that attends the mother's supposed betrayal of the child has great costs for women in the cultural order, even though the lesson of loss and limitation the mother inevitably teaches is the lesson that death will eventually underscore: "Our culture should support [the mother] by providing enabling representations of maternal finitude, but instead it keeps alive . . . the tacit belief that she *could* satisfy our desire if she *really* wanted to" (94).

While reinforcing the child's disappointment with the mother, who becomes a target of anger and resentment for being death's unwitting tutor, the cultural order depicts the father as the source of power and satisfaction. Where the maternal has always already been lost, because it is associated with lack, finitude, and disappointment, the paternal represents an always-deferred promise of fulfillment, because it is associated with plenitude, power, and authority. Religious discourses magnify this perception: "Christianity . . . posits a father whose love and power know no limits. . . . [It] provides the actual father with a permanent safeguard against . . . disappointment and rage" (95). What is resurrection if not a promise that the losses of this life will someday be recompensed? And who, in the Christian imaginary, offers such a promise? The Father, through the Son.

Castration, alterity, specularity; loss, otherness, visibility. These are the characteristics the dominant fiction must exclude from its representations of masculine subjectivity. For only by excluding them can it deny the masculine subject's share in mortality; only thus can it hide the father's limitations. What makes this task nearly impossible—besides the universal fact of death—is masculinity's dependence on display for securing its privileged position, and spectacle's tendency to expose both the lack inherent in masculinity and masculinity's reliance on its other(s) to retain its ascendant position.

Masochistic fantasies help to secure the venerable and desirable status of

the paternal figure, but only at the cost of demonstrating the dependence of masculine subjectivity on the ever-receding, never-attainable love of a masculine other. Phallic displays, whether textual or visual, align the penis with the phallus but also expose the insufficient and paltry nature of the organ when placed aside the symbolic ground of its significance. Narratives of woman's nature as irredeemably and essentially castrated, as naturally and inevitably passive in relation to male (heterosexual) desire, constrict the cultural possibilities available to female subjects, but they also often reveal the desperate anxiety to disavow the narcissistic, homoerotic dimensions of masculine subjectivity.

The dominant fiction of masculine power, privilege, and plenitude is both more vulnerable and more resilient than it might at first appear. This can make a political project that depends on hermeneutic intervention as its primary strategy, like the one pursued here, seem astonishingly naive and refreshingly incisive in turn. As such a vision assumes, revelation of the dominant fiction's fictional and political character can be accomplished only by a close examination of its terms and structures. The prevailing imaginary must be taken as the starting point for any oppositional discourse, for the sake of intelligibility, legitimacy, credibility, and authority. To state it in different terms, perversion can be made intelligible and identifiable only in relation to the Oedipal drama. This is not an empirical claim about the universality of Oedipal desire but a methodological claim about how best to transform cultural discourses regarding gender, sexuality, and subjectivity.

Reconfiguring cultural fantasies about masculinity will depend, at least initially, on the ability to resignify the relevant hegemonic fantasies' key features. Neither seeking nor expecting a pristine enunciative location outside the reigning signifying practices, this perspective is funded by a faith in the possibility of speaking the mother tongue—or, more accurately, the father's discourse—with a fresh accent. Whether such hope is utopic, pragmatic, or delusional can be determined only in light of the fantasies and practices such interpretive interventions instigate.

As Silverman opines, "Until we learn to live in a way that takes cognizance of our mortality—to be oriented 'towards death'—all of our attempts to devise a more equitable society will end in failure" (180–81). The dominant fiction of masculine plenitude must be challenged not only because it justifies an unjust distribution of resources, privileges, and opportunities along lines of gender, sexuality, race, class, nation, and ability, but also because it is the archetypal fantasy for denying limitation, vulnerability, and fragility. The dominant fiction of masculine plenitude must not be challenged in ways that insist that nonmasculine subjects have as legitimate

a claim to autonomy, self-sufficiency, and agency as their masculine coun-
terparts, because this only reinforces the underlying logic of the prevailing
cultural order. We must learn the lessons of death as the fundamental facts
of existence, as the foundation of a new way of experiencing self and see-
ing the other.

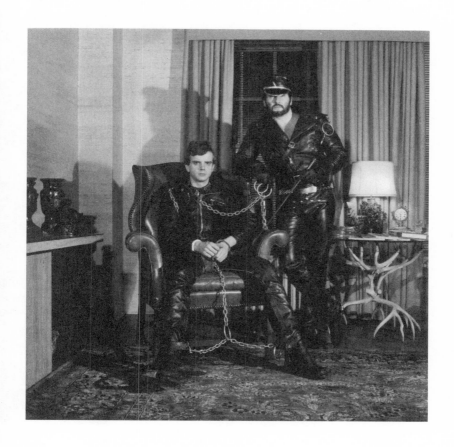

Robert Mapplethorpe, *Brian Ridley
and Lyle Heeter*, 1979. © The Robert
Mapplethorpe Foundation. Courtesy
Art+Commerce.

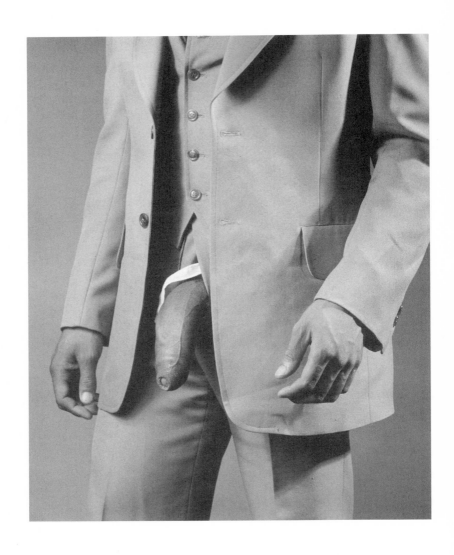

Robert Mapplethorpe, *Man in a Polyester
Suit*, 1980. © The Robert Mapplethorpe
Foundation. Courtesy Art+Commerce.

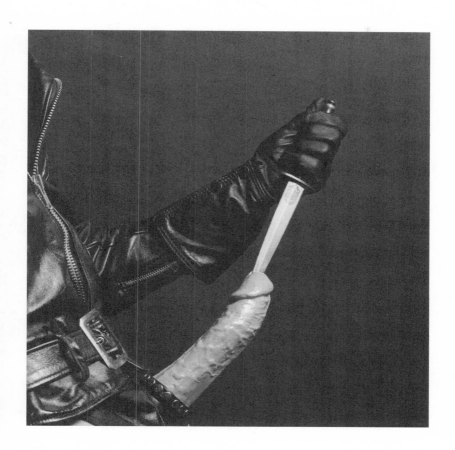

Robert Mapplethorpe, *Untitled (Bill King)*, 1980. © The Robert Mapplethorpe Foundation. Courtesy Art+Commerce.

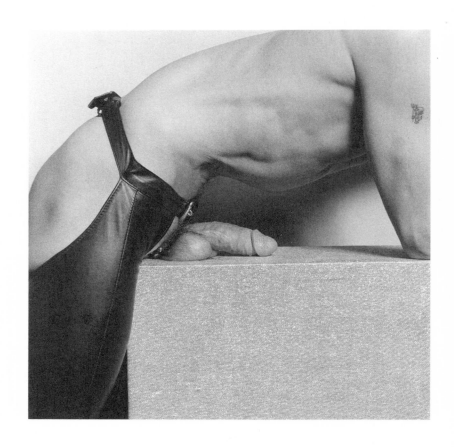

Robert Mapplethorpe, *Mark Stevens, Mr.
10½*, 1976. © The Robert Mapplethorpe
Foundation. Courtesy Art+Commerce.

Francis Bacon, *Crucifixion*, 1965. © 2011 The
Estate of Francis Bacon. All rights reserved.
Artists Rights Society (ARS), NY/Design and
Artists Copyright Society (DACS), London.
Photo: Bayerische Staatsgemäldesammlungen
—Sammlung Moderne Kunst in der Pinako-
thek der Moderne, München/Leihgeber: Stif-
tung Galerie-Verein, München.

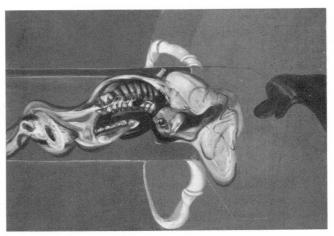

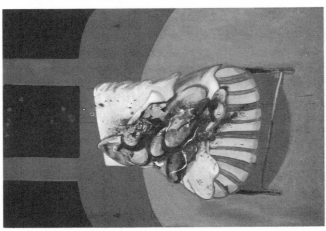

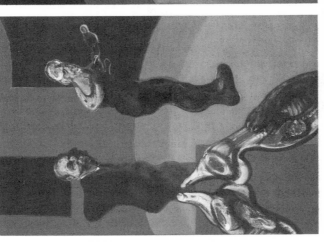

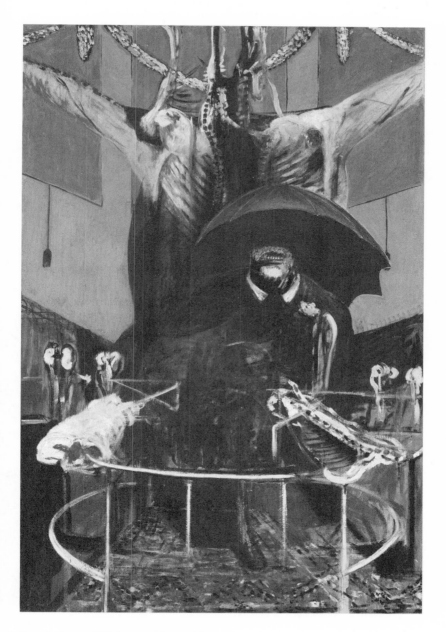

Francis Bacon, *Painting 1946*. © 2011 The
Estate of Francis Bacon. All rights reserved.
Artists Rights Society (ARS), NY/Design
and Artists Copyright Society (DACS),
London. Photo: The Museum of Modern
Art/Licensed by SCALA/Art Resource, NY.

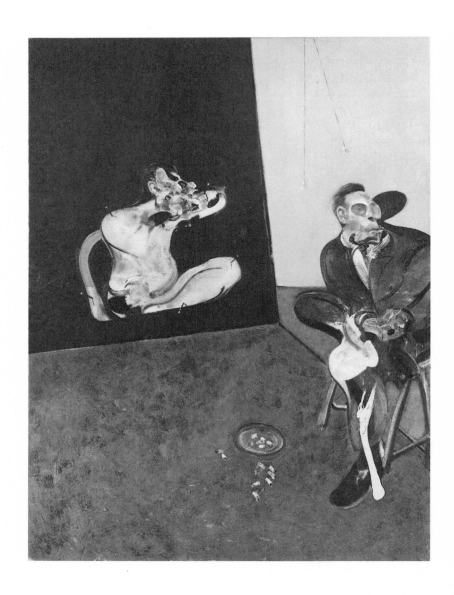

Francis Bacon, *Two Studies for a Portrait of George Dyer*, 1968. © 2011 The Estate of Francis Bacon. All rights reserved. Artists Rights Society (ARS), NY/Design and Artists Copyright Society (DACS), London. Photo: Jussi Koivun, Sara Hildén Foundation/Sara Hildén Art Museum, Tampere, Finland.

FORM CONTENT

The first time I went [to Times Square], I didn't know that
pornographic male magazines even existed.... I'd stare at
those pictures in the window and get a powerful feeling in my
stomach.... "God," I thought, "if you could only get that
feeling across in a piece of art."

When I've exhibited pictures ..., I've tried to juxtapose a
flower, then a picture of a cock, then a portrait, so that you could
see they were the same.... The [similarity] is that I'm seeing
them; it's my eyes that are photographing them.... I'm not see-
ing any differently.

When I have sex with someone I forget who I am....
It's the same thing when I'm behind the camera. I forget I exist.

ROBERT MAPPLETHORPE

Documents, Georges Bataille's dissident surrealist journal, was a brief experi-
ment in the productivity of unsettling juxtaposition. It "encompassed art,
ethnography, archaeology, film, photography and popular culture, with
discussions of jazz and music hall performances beside the work of ma-
jor modern artists, and illuminated manuscripts and sacred stone circles
alongside an analysis of the big toe."[1] Described by one of its cofounders
as "hardly justified except in the sense that it gives [its readers] Documents
about [Bataille's] state of mind" and by one of Bataille's friends as a "war
machine against received ideas," *Documents* was published in fifteen issues
between 1929 and 1931.[2] Following reaction to the inaugural issue, its finan-
cial backers reached a compromise with Bataille: his more outrageous mus-
ings could be published in the journal but would be segregated in a "critical
dictionary." "Soon, however, essays which would have been more at home
there began escaping into the main part of the review."[3]

In the seventh issue, Bataille published the following:

A dictionary begins when it no longer gives the meaning of words, but
their tasks. Thus *formless* is not only an adjective having a given meaning,
but a term that serves to bring things down in the world, generally requir-
ing that each thing have its form. What it designates has no rights in any

1. Ades and Bradley, "Introduction," 12.
2. Surya, *Georges Bataille,* 118; Ades and Bradley, "Introduction," 11.
3. Brotchie, "Introduction," 10.

sense and gets itself squashed everywhere, like a spider or an earthworm. In fact, for academic men to be happy, the universe would have to take shape. All of philosophy has no other goal: it is a matter of giving a frock coat to what is, a mathematical frock coat. On the other hand, affirming that the universe resembles nothing and is only *formless* amounts to saying that the universe is something like a spider or spit.[4]

Posing as a dictionary entry, this enigmatic definition proposes a new function for dictionaries, jamming the desire for order, classification, meaning, and understanding such works typically fulfill. (After all, of what use is an *enigmatic* dictionary?) Keeping with the function it assigns to (critical?) dictionaries, the entry describes the function of "formless" rather than detailing what it means. But what task does "formless" perform?

In their influential volume, *Formless: A User's Guide*, Yve-Alain Bois and Rosalind Krauss argue that the formless "crushes" "metaphor, figure, theme, morphology, meaning—everything that resembles something, everything that is gathered into the unity of a concept" (79), thus rendering the binary of form and content "null and void" (16). As the closing lines of Bataille's entry attest, however, to say that the universe is formless is not to reject all claims of resemblance, but rather to make the terms of resemblance incredibly unfamiliar. (In what way is the universe like a spider or spit? In what way are a spider and spit like each other?) As Bataille notes, formless's function seems dependent—or parasitic—on "each thing hav[ing a] form." Rather than obliterating form, then, the formless seems to engage it critically.[5] Recognizing that "stay[ing] outside the world of form . . . is arguably impossible," Patrick Crowley and Paul Hegarty argue in the introductory essays to their edited collection on the formless that it works with and against form, "rather than thinking itself outside form completely"; it "can be found in, under, around, behind, beneath form."[6] Whatever Bataille meant when writing this *Documents* entry, his literary and theoretical writings demonstrate a keen eye for form, a willing spirit for formal experimentation, and a sophisticated understanding of how manipulation of form can effect the reader's subjectivity and under-

4. Bataille, "Formless," 31.

5. Bois and Krauss acknowledge that their understanding of "formless" differs from Bataille's; they characterize their view as more advanced (79–80, 186). As James Elkins observes, "*Formless* oscillates between the art-historical study of Bataille's meanings and an art-critical interest in creating a more powerful theory" ("Very Theory," 11–12). Bataille's commitment to startling juxtaposition, rather than the eradication of form and content altogether, is evident in several of his early essays. His comparison of eroticism, sacrifice, and poetry throughout his corpus solidifies this notion.

6. Crowley and Hegarty, *Formless*, 188, 9.

score the author's perspective. As Bois and Krauss note, Bataille repudiated the value of discursive thought; he did not want to critique prevailing ideas by offering an alternative set but instead strove to communicate an experience through stylistic interruptions of explanatory speech—both within a single theoretical text and across his corpus.

This chapter considers the startling—and, I will argue, politically productive—juxtapositions in Robert Mapplethorpe's photographs.[7] My analysis focuses on how these images train their viewers not only to see the specific subject matter differently, but to see the practice of image-making—in art and life—differently. The beauty of Mapplethorpe's images reveals the desirability of the culturally unpalatable. Their composition highlights and magnifies the means by which selves are staged, stylized, constructed, performed, and perceived.

★ ★ ★

Mapplethorpe stages his photograph *Brian Ridley and Lyle Heeter* (1979) according to the conventions of the family portrait. Ridley and Heeter are positioned frontally in the center of the frame. The setting is domestic, presumably the couple's living space. The room's opulent furnishings signify a gay male self-stylization of a particular kind. Ridley and Heeter's costuming signifies a gay male self-stylization of a different, particular kind.

Ridley is seated. Heeter stands to his left, leaning against the chair in a relaxed but confident stance, nonchalantly holding two metal rings from which hangs a chain connected to the leather collar around Ridley's neck. In his left hand, Heeter holds a riding crop, resting inside the arm of the chair, in close proximity to Ridley's body. Heeter is adorned in full leather gear: cap, jacket, studded belt, pants, heavy boots. Ridley's uniform is virtually identical to Heeter's—heavy boots, leather chaps, zippered jacket. But instead of a cap, a collar; instead of the riding crop, chains. These details, along with the pair's physical positioning, signal the power differential the couple performs.

The photograph could be characterized as a family portrait of a sadomasochistic couple. But this characterization disturbs the classificatory terms it invokes. Can "family," "portrait," and "sadomasochism" mean the same thing together as they do separately? If this photograph is legible as a family portrait, is that evidence that notions of family and domesticity are

7. For biographical information, see Fritscher, *Mapplethorpe*; Marshall, "Mapplethorpe's Vision"; Morrisroe, *Mapplethorpe*; Smith, *Just Kids*; Squiers and Koch, "Mapplethorpe."

sufficiently elastic to incorporate sadomasochistic eroticism? Is it evidence that family and domesticity have always included sadomasochistic eroticism? Aside from complicating dominant narratives of familial relationships, what does the staging of Ridley and Heeter in leather regalia reveal about portraiture's ideological work? What does this photograph expose about the relationship between power, eroticism, theatricality, identity, and image-making? Given that both sets of questions relate to the tension between subject matter and representational code, it is the relation between content—sadomasochistic couple—and form—family portrait— that makes *Brian Ridley and Lyle Heeter* arresting. Stated another way, the photograph's combination of form and content, which helps the viewer see previously unrelated phenomena in a different way, makes this photograph worthy of reflection.

Most commentators identify the "curious disjunction . . . between the visual appeal of his photographs as pictures and the discomforting nature of his subject matter" as the quintessential element of Mapplethorpe's pictorial style.[8] Arthur Danto, one of Mapplethorpe's staunchest advocates, characterizes the artist's work as "Dionysian *and* Apollonian at once." The images' sexually charged content, he writes, stands in dialectic relation to their "chastely classic" style.[9] The pristine and mannered stylization of Mapplethorpe's images does not erase their forbidden and unsettling content, and even the most sexually explicit images both go beyond and fail as pornography, precisely because of their crisp, cool elegance.[10] "The content is preserved. But it is also negated, and it is transcended, and that means the work cannot *merely* be reduced to its content" (80). Ingrid Sischy, one of the most eloquent writers on Mapplethorpe's sexual imagery, identifies this tension as the source of shock in Mapplethorpe's photographs: "What shocks isn't just the material, but how it is so artfully presented. The content, lighting, composition, sense of order and aesthetics all combine to give the photographs an unforgettable impact."[11] This impact depends on the audacious choice to present the forbidden, the transgressive,

8. Grundberg, "Is Mapplethorpe Only Out to Shock?" H32; see also Celant, "Robert Mapplethorpe," 155; Hagen, "Robert Mapplethorpe," 140; Kardon, "Perfect Moment," 10; Morrisroe, *Mapplethorpe*, 147; Salatino, "Robert Mapplethorpe," 54; Stevens, "Direct Male," 27; Thornton, "Portraits."

9. Danto, *Playing with the Edge*, 23.

10. On the erotic failure of Mapplethorpe's style, see Fritscher, *Mapplethorpe*, 168; Kuspit, "Robert Mapplethorpe," 71; Lifson, "Philistine Photographer," 79; Mayes, "Good Sex Guide," 35; Morrisroe, *Mapplethorpe*, 193; Murray, "Calculated Opulence," 11.

11. Sischy, "That Feeling," n.p.

the subterranean, the violent, the repressed in a beautiful manner. As Sischy goes on to observe, the images' beauty enables them to challenge, among other things, prevailing notions about sadomasochism and homoeroticism. Germano Celant, writing in the catalog from an exhibit comparing Mapplethorpe's photographs with Mannerist paintings, argues that their style both defuses and legitimizes their content by linking them to venerated aesthetic codes.[12] Extending Danto's observation about the importance of the tension between form and content for understanding Mapplethorpe's work aesthetically, Sischy and Celant argue that it is key to evaluating his images politically.

Brian Ridley and Lyle Heeter illustrates how the relation between subject matter and stylization functions across Mapplethorpe's body of work. As already noted, it is the tension between the portrait's typical setting and style and the sitters' atypical costuming and character that arrests the viewer's attention. As Danto observes: "They look as if this were the most natural thing in the world for them to be doing in their middle-class living room. . . . [But] what is a sexual slave doing sitting that way in a comfortable armchair"?[13] The photograph also generates tension with respect to time. To what historical moment does it belong? As several commentators have noted, Mapplethorpe's sex photographs are important, if for no other reason, because they document a gay male subculture that largely failed to survive the ravages of AIDS.[14] This subject matter, closely tied to the sexual exploration of the 1970s, was captured, however, using a visual aesthetic associated with late nineteenth- and early twentieth-century photography, if not older notions of symmetry, order, and perfection.[15] As Joan Didion observes in her introductory essay to *Some Women*, Mapplethorpe's collection of female portraits:

> Robert Mapplethorpe's work has often been seen as an aesthetic sport, so entirely outside any historical or social context, and so "new," as to resist interpretation. This "newness" has in fact become so fixed an idea about Mapplethorpe that we tend to overlook the source of his strength, which derived, from the beginning, less from the shock of the new than from the

12. Celant, "Mapplethorpe as Neoclassicist," 38–39.
13. Danto, *Playing with the Edge*, 37–39.
14. Fritscher, *Mapplethorpe*, 90–91; Sischy, "That Feeling"; Weiley, "Prince of Darkness," 108; Wilkerson, "Jury Hears Passionate Arguments," 8.
15. For discussion of the influence of Mapplethorpe's Catholicism on his aesthetic vision, see Danto, *Playing with the Edge*, 91–92; Fritscher, *Mapplethorpe*, 13; Heartney, *Postmodern Heretics*, 82–86; Kardon, "Robert Mapplethorpe Interview," 24–25; Koch, "Guilt, Grace and Robert Mapplethorpe," 148–49; Morrisroe, *Mapplethorpe*, xiv, 17–18; Smith, *Just Kids*, 16, 59, 62, 67.

shock of the old. . . . There was, above all, the perilous imposition of order on chaos, of classical form on unthinkable images. (7)

Didion's comments clarify that Mapplethorpe's images are neither without historical context nor fixed within a single historical context. Instead, subject and style belong to different, seemingly disparate, moments and milieus. Mapplethorpe's style makes his subject matter "thinkable," palatable, legitimate. These juxtapositions, then, are anything but "aesthetic sport."

Brian Ridley and Lyle Heeter also plays with the distinction between public and private space. The picture captures domestic space, space hidden from the world's prying eyes and attendant judgments. By signifying culturally marginal practices, the subjects' costumes underscore the need for privacy. The portrait, however, as both a visual form and an artifact in a book or gallery, assumes public space. The subjects' staged presentation underscores that they have willingly opened their private space(s) to public scrutiny. This photograph is not a candid snapshot captured on the sly. It is a formal portrait that required planning. As Danto points out—when emphasizing the relationship of trust that Mapplethorpe must have developed with his photographic subjects, as indicated by the settings, the careful execution, and the use of full names in the titles—Brian Ridley and Lyle Heeter clearly have consented to having this image made. They have admitted Mapplethorpe (and, consequently, the viewer) into their lives, such that "the photographer [and, consequently, the viewer] shares a moral space with them" (39). Heeter and Ridley's opening of their home situates the spectator (nonconsensually?) in their space. The photograph forcibly inserts prohibited sexuality into the public square; by voluntarily relinquishing their "right to privacy," Ridley and Heeter challenge what the public can be asked to bear. The photograph's form as a posed portrait, then, sharpens the political challenge of its content.[16]

While the photograph suggests a relationship of dominance and submission, the power dynamics at play in the image are neither simple nor singular. On the most basic level, there is the power of the gaze, a power generated by the image that situates both spectator and pictorial subject. This gaze supposedly belongs to Mapplethorpe and the spectator and is exercised against Heeter and Ridley. Yet even if Heeter and Ridley have been costumed, posed, lit, and framed by Mapplethorpe, to claim that they have been objectified fails to account for the image's complexity. Both look at the camera with fixed stares; they are not giving over their bodies, their

16. For conservative critics' view that the photographs violated public space, see Jarzombek, "Mapplethorpe Trial," 59–67.

lives, or their subjectivities to the spectator.[17] Each adopts a physical pose that reinforces his look; Heeter's nonchalant stance and Ridley's sprawled legs situate them solidly in their corporeality. When looking at Heeter and Ridley, the spectator is just as likely to feel intimidated, challenged, and threatened as in control. At the same time, the leather traces their bodies' contours. The silver studs on Heeter's codpiece and the positioning of Ridley's legs and hands draw visual attention to their respective genital regions. In this way, the portrait relies on traditional mechanisms of eroticizing its subjects. Because they have been trapped in the image, and because this photograph will circulate freely, their resistance to the scopic regime is limited and partial. Although the photograph transforms Heeter and Ridley into objects for contemplation, their looks and poses, as well as the iconography of sadomasochism, challenge the spectator's sense of voyeuristic propriety. The gaze that structures this image is neither straightforward nor unidirectional.

The power dynamic between the portrait's subjects is also complex. Heeter's superior physical position, along with his grasp of a riding crop and Ridley's chains, evinces his dominance. At the same time, Ridley is foregrounded in the pictorial space and his face is both more clearly visible and more brightly lit, making him the focus of visual attention. Ridley's name also comes first in the portrait's title. While this priority is consistent with Mapplethorpe's left-to-right titling practice, it runs counter to the custom of those S/m practitioners who deny the submissive partner the use of a name, personal pronouns, or even capital letters. As Richard Meyer observes, "The contradictions of this portrait defeat any essentialist interpretation of Ridley and Heeter in (or as) their sadomasochistic roles."[18] Composition challenges iconography.

The incongruity of costume and setting also complicates interpretation of the image. In an essay largely critical of Mapplethorpe's images, C. S. Manegold writes that "the dream . . . promised" by this portrait "is one of pain, of submission, of servitude, a willing walk toward death."[19] She further claims that Mapplethorpe's S/m photographs are funded by a fascist aesthetic. While this image trades in the iconography of submission and servitude, and while Heeter and Ridley's costumes justify Manegold's concern about the recuperation of a fascist aesthetic, any interpretation of the image advancing only a single form of erotic or gendered self-presentation founders on its details. Looking only at Heeter's rid-

17. Meyer, "Robert Mapplethorpe," 371.
18. Ibid., 370.
19. Manegold, "Robert Mapplethorpe," 99.

ing crop and studded codpiece or only at Ridley's handcuffs and locked collar, Manegold's characterization seems accurate. What happens, however, when the spectator notices the antique brass clock, the carefully arranged books, the deer-antler table, or the delicate figurines that are also part of the picture? Are these details irrelevant? In what way do they signify death and embody fascism? Or do they expose the sadomasochistic self-presentation of Ridley and Heeter—as chilling, arousing, and disturbing as it might be—as, at root, a performance, a ritual, an enactment? Incongruity between mise-en-scène and wardrobe shows that each signifies a way to fashion (with various connotations of that word intended) a life. A less incongruous portrait could have been crafted by stripping the room of furniture, positioning Ridley on his knees and covering the walls with black paint. But a less incongruous picture could *also* have been crafted by stripping Ridley of his chains, seating Heeter on the arm of the chair, and dressing both in khakis and argyle sweaters. The placement of this master-slave duo in a well-appointed—almost fussy—living room evokes both systems of decoration, and their different relations to hegemonic masculinity. This tension shows that no subject—no person, no topic, no thematic—fits solely within any single ideological frame.

By riveting the viewer's attention, through sharp focus and bright lighting, on the stylization of their clothing and props, the portrait underscores that Heeter's and Ridley's gear is an outfit, an apparatus, a mode of self-presentation. By staging them in a setting where their self-presentation as devotees of sadomasochistic eroticism stands in exaggerated relief, it calls attention to the staginess of their identity. The inherent theatricality of the picture is emphasized by the iconography of sadomasochistic erotic play. Despite the genuineness of the pain and pleasure it entails, sadomasochism—with its emphasis on roles, costumes, props, and scenes —is a complex set of ritualized gestures. With these features in mind, it becomes easier to see how form and content are not merely in productive tension, but are virtually undone—almost reversed—by the portrait.

Given the portrait's emphasis on performance, artifice, and theatricality, "sadomasochistic couple"—its ostensible content—is as much a heuristic trope as a substantive, preinterpretive category. The viewer identifies Heeter and Ridley as S/m practitioners not because the photograph depicts sexual conduct, but because it uses particular uniforms and props. *Brian Ridley and Lyle Heeter* provides no evidence that its subjects participate in sadomasochistic acts, only that they participate in sadomasochistic *signification*. By the same token, the mannered stylization of a family portrait is not merely the formal code organizing the image; it is the photograph's very subject matter. On the one hand, Heeter and Ridley, as a sadomas-

ochistic couple, are irrelevant: they are little more than one possible signifier that enables a set of meanings and associations to attach to the image. Other visual and cultural incongruities could have been used to achieve the same effect. On the other hand, Ridley and Heeter's identity as a sadomasochistic couple is essential: not because it is at odds with the domestic setting, but because sadomasochism—as a highly theatrical, self-aware, ritualized mode of erotic behavior fraught with its own contradictions and tensions—provides the most useful set of signifying codes for exploring the formal concerns about (self-)stylization that the portrait engages. Sadomasochism's theatricality, captured in a highly stylized portrait, exposes the performance of masculinity that Heeter and Ridley—and countless others—attempt. In this way, the portrait's iconography both participates in and potentially disrupts certain fantastic constructions of the masculine self. Sadomasochism, then, provides a useful entry point into Mapplethorpe's larger body of work not only because it is the subject matter of a large number of his photographs or because it is the source of his notoriety but, most importantly, because it is formally similar to notions of theatrical self-presentation with which his images deal.[20]

<p style="text-align:center">★ ★ ★</p>

The photographs in Mapplethorpe's infamous X Portfolio are "perfect example[s]" of his desire not "merely [to document] the S&M subculture, but [to bring] his own aesthetic to bear on scenes that many people would normally find sordid or repugnant."[21] As such, these pictures testify to the

20. Mapplethorpe's photographs of female bodybuilder Lisa Lyon offer a complex examination of both masculine and feminine self-stylizations of the body. See Chatwin, "Eye and Some Body," 9–14; Kolbowski, "Covering Mapplethorpe's 'Lady,'" 10–11; Morrisroe, *Mapplethorpe*, 230–42; Simson, "Portraits of a Lady," 53–54. Similarly, his self-portraits are concerned with the staging of the self. See Danto, *Playing with the Edge*, 53–55; Morrisroe, *Mapplethorpe*, 302; Wolf, "Authentic Artlessness," 37–39. Because the interpretive issues raised by these images strike me as more straightforward, I do not consider them here.

21. Morrisroe, *Mapplethorpe*, 191. The X Portfolio, a collection of thirteen images containing sadomasochistic iconography, was first exhibited at the Robert Miller Gallery on March 21, 1979. The portfolio was most recently exhibited at the Robert Miller gallery in fall 2010. In the portfolio's introductory essay, Paul Schmidt wrote: "Here are the images of our modern martyrdom: our Scourgings, our Crownings with Thorns, our Crucifixions." Ibid., 218. When these images were incorporated into the retrospective "The Perfect Moment," they were displayed in a special case designed by Mapplethorpe and Janet Kardon, the curator of the exhibit. The slanted display case presented three rows of images: the X Portfolio's sex pictures, the Y Portfolio's flower pictures, and the Z Porfolio's African American portraits. The case

political possibilities of aesthetic form. The X Portfolio shows that gay sadomasochistic sex—with its violence, humiliation, degradation, cruelty, and pain—is alluring. Mapplethorpe's sex pictures do not simply record sadomasochistic activities, they render them beautifully—that is, they render them beautiful. Reviewing Mapplethorpe's retrospective at the Whitney Museum of American Art, Andy Grundburg comes close to recognizing this connection between aesthetics and politics:

> Because Mapplethorpe's photography fails to make distinctions—he seems willing to turn anything into an idealized icon—one could . . . argue that it has no center, no moral gravity that would lend the pictures weight. This, ultimately, is why the images . . . seem to be about style rather than substance. But for Mapplethorpe, style and substance are not opposites but components of each other.[22]

The images' formal composition *is* their moral claim; their subject matter defines the site of their political resistance. Mapplethorpe does not idealize *anything*; he mainly uses his stylistic gesture to idealize homoerotic desire and sadomasochistic practices. Failure to attend to the images' content undercuts their radical ethical demand.

One exemplary image from the X Portfolio, *Jim and Tom, Sausalito* (1977), depicts two men, dressed in leather, engaged in sexual activity in a beautifully lit military bunker. Jim is standing with his pelvis pushed slightly forward; he holds his penis in a gloved hand and urinates into the open, bearded mouth of Tom, who kneels before him. A stream of urine, in sharp focus, connects the bodies. Tom's relaxed posture demonstrates his willing participation in this act. The photograph's light can be described as heavenly, Tom's serene face as angelic; they convey a sense of bliss. The photograph's composition runs counter to any sense of disgust, degradation, or humiliation that viewers might associate with the act of one man pissing into another man's mouth. The content evokes one reaction, the form another, together critiquing the average viewer's initial response.

Mapplethorpe accomplishes a similar feat in *Jim, Sausalito* (1977). In this

drew attention to the similarities between disparate subjects; it also required spectators to make a physical effort to look at the images. See Artner, "Eye of the Storm," 5; Bettenhausen, "Artwork, Bodywork, Godwork," 147–48; Danto, *Playing with the Edge*, 5; Ischar, "Endangered Alibis"; Salatino, "Robert Mapplethorpe," 54; Sischy, "Photography," 138; Smith, *Just Kids*, 236. Following the controversy over the images, *Art Journal* decided to publish the X Portfolio. It had difficulty finding a publisher for the issue and angered many of its subscribers. See Cembalest, "'Who Does It Shock?'" 32–34; Storr, "Art, Censorship, and the First Amendment," 13.

22. Grundberg, "Allure of Mapplethorpe's Photography," H29.

picture, Jim appears alone, wearing the pants, gloves, and hood he sported in *Jim and Tom*. He crouches behind a ladder, in the same bunker, framed by a square of light, with his head turned to the side. Although his crouched position could suggest fear or dread, the quality of the light, as well as the gentle curl of his fingers and arms, suffuse the image with peace and tranquility.[23] Moreover, despite the hood that conceals his face, arguably depersonalizing him, the play of light on the eye slits and zippered mouth grants Jim a viable subjective presence. Again, subject matter and style must be considered in tandem.

The interaction between subject and style makes the images memorable. Without their unusual subject matter, they lose their power. *Jim and Tom* is not memorable because it is a beautiful photograph of something many would find beautiful but because it is a beautiful photograph of something most viewers would find grotesque. To photograph the conventionally attractive in an appealing fashion is fairly simple. To photograph the presumptively distasteful in a fashion that evokes desire is more daunting. Even for viewers who respond positively to the act depicted, recording it in a classically elegant manner and displaying it in a museum would be unexpected.[24]

Points of comparison can be found in Mapplethorpe's larger body of work. Although his flower pictures trade in a surprising erotic frankness, they begin with objects typically considered aesthetically appealing. Although Mapplethorpe's statue portraits imbue stone and metal with life, they start with objects that have been accorded cultural value. These images undoubtedly capture the viewer's attention through defamiliarization, but they are not organized around the same kind of aesthetic clash as the sex pictures, nor do they require the same kind of code-switching by the viewer. The flower and statue portraits are revelatory: they expose the erotic energy generated by nondesiring objects. But they do not require a rethinking of prior aesthetic norms or ethical principles. Mapplethorpe's sex pictures, on the other hand, not only expand the regnant conception of desire, exposing erotic activity that is often kept hidden, but show the elegance and grace of culturally disdained practices, thereby drawing atten-

23. Jim's position and hooded status in his solo portrait signify a submissive role. His position and activity in *Jim and Tom*, however, mark him as dominant. Together, the photos demonstrate that "dominant" and "submissive" do not define a person's essence, but rather describe a performance.

24. For a similar analysis, see Danto, *Playing with the Edge*, 92–93. According to Danto, to discuss *Jim and Tom* without referring to its content "would be like denying the wounds in Grünewald's depiction of Christ, and to focus merely on the way the crucified figure divides the space of the panel" (89).

tion to the normative principles that underlie judgments of beauty. The requirements imposed on the viewer by the sex pictures not only make these images more powerful and memorable, they make them more important politically and ethically.

The political import of Mapplethorpe's photographs can be understood, in part, by considering the controversy that surrounded the posthumous "Perfect Moment" retrospective.[25] Congressional leaders, spurred on by conservative religious cultural critics, denounced Mapplethorpe's images as an endorsement of homosexual and sadomasochistic acts. Although reasonable people can disagree about whether gay sadomasochistic sex should be celebrated, whether images of such practices should be displayed in the public arena, and whether the production of such images should be subsidized by the government, it is much harder to argue about whether Mapplethorpe's images are neutral with respect to the acts they depict. By decrying Mapplethorpe's images for endorsing certain practices, critics may have assumed without argument a denunciatory moral perspective on homoerotic and sadomasochistic desire, but they understood the import of the photographs under consideration. This understanding of the images' significance seems more astute than that of some of Mapplethorpe's defenders.

When the X Portfolio became the subject of an obscenity trial in Cincinnati, experts called by the defense to explain why the images had "redeeming social value" and thus fell outside the legal definition of obscenity, focused almost exclusively on their formal properties.[26] While tactically astute, this defense had significant drawbacks. First, the formalist focus required jurors to relinquish their own interpretive ability, their capacity to understand why art has social value.[27] When asked about *Helmut and Brooks* (1978), for example, Janet Kardon, curator of the exhibit, explained that it was a figure study, emphasizing the photograph's lighting and symmetrical composition as its most important features.[28] The photograph depicts two men: one kneels in a leather chair; the other has his hand and forearm inserted in the kneeling man's rectum. Kardon's formal description is unassailable: the play of light and shadow emphasizes Helmut's buttocks

25. For an overview of the controversy, see Dubin, *Arresting Images*, 159–96; Parachini, "Year of the Censor," 39–41; Perl, "Seeing Mapplethorpe," 646–53; Vance, "Misunderstanding Obscenity," 49–55; Vance, "War on Culture," 221–31.

26. For an overview of the Cincinnati trial, see Barrie, "Fighting an Indictment"; Cembalest, "Obscenity Trial"; Jarzombek, "Mapplethorpe Trial."

27. Danto, *Playing with the Edge*, 8.

28. Jarzombek, "Mapplethorpe Trial," 67–71; Merkel, "Art on Trial," 47; Wilkerson, "Clashes at Obscenity Trial," A22.

and back and Brooks's shoulder and elbow. The stretched flesh above and hair around Helmut's anus are near the center of the image. The echo of Brooks's and Helmut's elbows creates a visual rhythm in the image and draws attention to the leathery, almost human, skin of the chair on which Helmut kneels. The similar positioning of their arms blurs the line between human and object: Brooks fists Helmut, Helmut fists the chair.[29]

While accurate, Kardon's testimony failed to explain why a well-lit photograph of one man inserting his forearm into another man's anal cavity is socially valuable. Or why symmetrical composition should trump sexual perversion. Again, a helpful point of comparison can be found within Mapplethorpe's corpus. In addition to figure studies of fisting, Mapplethorpe produced studies of fruit and vegetables. His photograph of a cluster of grapes gives new meaning to the word "succulent," and his portrait of an eggplant gives new meaning to the word "phallic." An appreciation for the beauty of common, everyday objects radiates from these images. But if they were lost, it would be relatively easy to cull similar portraits from the work of other photographers. The fisting photographs are something rarer, in subject matter and, more importantly, in the aesthetic and moral codes with which they engage. There is not a community of people denied recognition as citizens because of their fondness for grapes, no subculture subjected to moral censure, economic discrimination, religious denunciation, cultural marginalization, and physical violence because its members delight in eggplant. Mapplethorpe's images of fisting are an act of communal self-representation that challenges a particular set of social norms. Their implicit moral demand—funded by the formal properties Kardon identifies, but related necessarily to the content she avoids—is what makes the photographs socially valuable.

By defending Mapplethorpe's sex pictures with a discourse related exclusively to artistic style, the expert witnesses engaged in a not-too-subtle form of intellectual and professional intimidation and squandered an opportunity to help the community think about the ability of art to address controversial subjects.[30] As their post-trial comments demonstrate, the jury did not come to understand or appreciate Mapplethorpe's sex pictures; they merely ceded authority to the experts, expressing disappointment that the prosecution did not present a stronger case by calling experts of its own.[31] More importantly, however, this retreat to the formal failed to join the debate about homosexuality of which conservative pundits had made Map-

29. Flannery, "'Queer' Photography," 268–70.
30. Barrie, "Fighting an Indictment," 63–64; Yenawine, "But What Has Changed?" 19.
31. "Mapplethorpe Photos May Be Lewd"; Wilkerson, "Obscenity Jurors," A12.

plethorpe's images a part. As art historian Douglas Crimp observes, the inscription of the photographs within a "museum discourse," while tactically successful, reduced them to "abstractions, lines and forms, light and shadow," and made "no case at all for the rights of sexual minorities to self-representation."[32] Paul Morrison states the point with more force:

> If we are to continue to exercise our right to consume in representation the perversions of others, logic, if nothing more, would dictate that someone, somewhere, must first have the right to engage in perverse sexual acts. The point is nothing if not obvious, yet it bears emphasizing, if only because the defense of Mapplethorpe has, to my knowledge, remained exclusively on the level of our right of access to representation.[33]

To turn away from the pictures' content and emphasize their formal properties is to mute their political cry.[34] As Sischy observed, the pictures' epic "revolt against the idea of the sexual secret" is why "they are masterpieces and [why] they really matter."[35] And as Mapplethorpe himself observed "when an interviewer drew the familiar contrast between pornography and 'redeeming social value,' . . . 'I think it could be pornography and still have redeeming social value. It can be both, which is my whole point in doing it.'"[36]

This defense of Mapplethorpe's images as an apology for gay male sexual practices—a defense grounded in the content of the photographs—is also

32. Crimp, *On the Museum's Ruins*, 10–11.
33. Morrison, "Coffee Table Sex," 20–21.
34. Other defenders of Mapplethorpe engaged in equally troubling strategies. For example, Robert Sobiezak, then senior curator at the International Museum of Photography at the George Eastman House in Rochester, New York, explained that the photographs had value because they represented Mapplethorpe's attempt to work out his troubled relationship to his sexuality. In addition to pathologizing homoeroticism and sadomasochism, Sobiezak provided no explanation as to why viewers who did not have similarly "troubled" sexualities should consider these pictures valuable. See Crimp, *On the Museum's Ruins*, 11; Jarzombek, "Mapplethorpe Trial," 70–71; Kinney, "Witness"; Masters, "Jurors View Photos," 47, 49. Even Danto, Sischy, and Dennis Barrie, director of the Cincinnati Arts Center—arguably Mapplethorpe's strongest defenders—never fail to mention that they find the photographs disturbing, difficult to look at, and, on occasion, nauseating. Both defenders and detractors distanced themselves from the content of Mapplethorpe's images. Two major posthumous exhibitions—"Robert Mapplethorpe and the Classical Tradition," at the Guggenheim in New York, and "Perfection in Form," at the Galleria dell'Accademia in Florence—have similarly tried to distance Mapplethorpe's art from controversy. See, e.g., Nelson, "Mapplethorpe's Search."
35. Sischy, "Society Artist," 84.
36. Danto, *Playing with the Edge*, 89.

a limited, even paltry, explanation of their political importance. These images are not only about gay male self-representation or an apologia for certain acts. Instead, they valorize the abject. Regardless of whether a viewer recognizes her- or himself in these particular practices and these specific desires, the images move the marginalized to the center and the invisible to the public square. The revelation and glorification of that which has been concealed, maligned, and degraded is significant for a range of demeaned subjectivities. More importantly, these images offer a critical apparatus for seeing cultural representations of masculine subjectivity and homoerotic desire differently. Mapplethorpe's photographs are not solely—perhaps not even primarily—noteworthy because they make a claim for the right to engage in particular forms of sexual conduct or because they display the practices of a hitherto invisible subculture, but rather because they reveal the strategic power of representation. Mapplethorpe's photographs are politically valuable not so much for *what* they depict as for *how* they depict. In a slightly different sense than the expert witnesses, then, I also identify the "redeeming social value" with their formal, aesthetic features. Ultimately, it is as works of art that they are political interventions.[37]

★ ★ ★

Mapplethorpe's photographs of African American men are funded by an aesthetic vision and strategy similar to that of his sex pictures. With his black male nude studies, Mapplethorpe "once again [performs] . . . a formalist tour de force . . . using loaded subject matter." He depicts black male bodies "as calm sources of beauty, more perfect than flesh. His formal approach sets them up as ideal, as almost sacred."[38] Given Mapplethorpe's adoration of the black male body, and the fact that he never photographs it bound, beaten, or tortured, these images may seem to have a tangential relation to an examination of the male-body-in-pain. I am mindful, however, of nonidiomatic meanings of "tangent," which entail a point of contact. Mapplethorpe's black nudes, like his sex pictures, critically deploy stylization. Like the sex pictures, the black nudes exploit tensions between form and content to train their viewers to see their subject matter with new

37. In her memoir of life with Mapplethorpe, Patti Smith writes that he was not trying "to make a political statement. . . . He was presenting something new, something not seen or explored as he saw and explored it. [He] sought to elevate aspects of male experience, to imbue homosexuality with mysticism" (*Just Kids*, 199). For reasons suggested above, I contend that this *is* a political intervention of the most significant kind.
38. Ellenzweig, "Robert Mapplethorpe at Robert Miller," 171; Celant, "Robert Mapplethorpe," 206.

eyes. Mapplethorpe's portraits of African American men, while not containing depictions of physically violated male bodies, provide another vantage point for seeing how representation of the male body works to sustain and subvert the cultural fantasies related to it. Moreover, given that most critics have typically treated either Mapplethorpe's sex pictures or his black nudes without analyzing their relation, bringing them together reveals the thematic, formal and political unity of Mapplethorpe's body of work.

Thomas (1986) features one of Mapplethorpe's last black model-muses and is typical of his portraits of African American men.[39] Bent at the waist, arms resting on a tall pedestal, head hidden in the crook of his arms, Thomas is made to look like a statue. Photographed in intense light, his skin has the sheen of marble. The contrast between light and shadow highlights his body's musculature; the sharp focus emphasizes the stillness of his pose. The pedestal indicates that Thomas is on display as a work of art. The *Ajitto* series (1981) is another illustration of the sculptural aesthetic that funds Mapplethorpe's photographs of black men. Ajitto sits nude on a pedestal, arms curled around his bent knees, head tucked away. The photographs show him from the right, front, back, and left. Unlike the sheen of Thomas's skin, the light in Ajitto's portraits captures the rough texture of his flesh; his body appears metallic, bronzed. Even more emphatically than *Thomas*, the *Ajitto* serial study displays the model as a work of art.

In an essay discussing his ambivalence toward Mapplethorpe's photographs of African American men, Kobena Mercer points out that Mapplethorpe's formalist approach highlights the relative absence of the black male body from Western art.[40] Seeing an African American body photographed in the pose of a Greco-Roman statue reminds the viewer that this kind of figure study has rarely taken the black body as its subject. By using the codes of the high-art canon to present the black male body, Mapplethorpe does more than acknowledge its prior absence; he demonstrates that such bodies are fully amenable to presentation under Western culture's dominant aesthetic codes.

Using settings and lighting that emphasize the color and texture of his models' skin, Mapplethorpe's photographs capture the black male body's specificity; using poses and forms that mimic familiar sculptural poses, they diminish its exoticism. This strategy of establishing the similarity of black and white bodies through an emphasis on their difference is exemplified in portraits featuring Ken Moody and Robert Sherman.[41] Moody and

39. Morrisroe, *Mapplethorpe*, 300–301.
40. Mercer, "Skin Head," 193–94.
41. Flannery, "'Queer' Photography," 266–67.

Sherman were both affected by severe alopecia, which in their cases rendered the entire body hairless. Their bald heads, smooth chests and legs, and browless, lashless eyes made them uncanny visual echoes. At the same time, Moody's skin was a rich, dark brown while Sherman's was a startlingly pale white. Mapplethorpe played off their striking physical similarities and dissimilarities. In joint portraits, Moody and Sherman are mirror and negative images of each other. This approach is, in some ways, the organizing principle of Mapplethorpe's sculptural portraits of African American men.[42] The blackness of these bodies marks their difference from the forms they are meant to copy—exposing the limitations of these historic forms; their formal presentation perfectly mimics the aesthetic sites from which they have been excluded—demonstrating the equivalent status of these heretofore excluded bodies.

Challenging racist representational practices by making the black male body into an art object has limitations. As Mercer notes, Mapplethorpe's "aesthetic equation . . . reduce[s] these black male bodies to abstract visual 'things,' silenced in their own right as subjects, serving only to enhance the name and reputation for the author in the rarefied world of art photography" (183).[43] Although photography as a practice renders human subjects into objects, this objectification can be more or less intense. In *Thomas*, the model is alone, his face buried in the crook of his arm; he cannot interact with the viewer and thus cannot establish a subjective presence. Moreover, the prop in this photograph—unlike the sex pictures' whips, nipple clamps, and knives—has no utilitarian value other than display. Thomas's relation to the pedestal is not one of subject to object, human to tool; instead, the prop makes his body an object, a passive spectacle to be examined and desired. Unlike *Brian Ridley and Lyle Heeter*, with its complication of private and public spaces, *Thomas* depicts the nonplace of the studio. Ridley and Heeter occupy a domestic space the viewer likely presumes is theirs (given the code of the family portrait); Thomas occupies a studio the viewer likely presumes is not his (given the code of the figure study).

Comparing Mapplethorpe's sex pictures and black male studies as series further clarifies the more pervasive objectification in the latter. With the sex pictures, the images' seriality conveys narrative and temporal progression: bodies move, models interact, action unfolds. The black nude series, on

42. Thomas Yingling argues that in the absence of sexual difference Mapplethorpe must rely on racial difference to figure desire ("How the Eye Is Caste," 9–10). To assume that desire requires difference is to reject the underlying homoeroticism that funds a great deal of Mapplethorpe's work.

43. See also Hamilton, "No Sympathy," 32; Koch, "Guilt, Grace and Robert Mapplethorpe," 149; Yingling, "How the Eye Is Caste," 11–23.

the other hand, have purely formal motivations. The *Ajitto* series places its model outside narrative and time: these pictures are characterized by stillness, lack of movement, absence of change.[44]

Neither Thomas nor Ajitto, moreover, unlike the subjects of the sex portraits, is photographed in a way that heightens awareness of the constructedness of his (racial) identity. In these statuesque portraits, the subjects are equated with the facticity of their bodies; nothing creates a conflict between image, code of representation, and spectatorial investment. While all of Mapplethorpe's photographs could arguably be criticized for objectifying—perhaps even exploiting—their subjects, the portraits that depict African American men as quasi-statues do so to a greater degree than do the photographs of white practitioners of sadomasochism. Mapplethorpe's formal presentation of the black male body, while undoubtedly capturing its beauty, also works to evacuate its humanity. This reduction of black men to "abstract visual 'things'" is certainly a high price to pay for demonstrating their equal stature as objects of contemplation. As Allen Ellenzweig observes, "This materialist, highly mannered approach isn't the one that the phrase 'black is beautiful' was intended to produce."[45]

Just as Mapplethorpe's aestheticization of African American men runs the risk of reducing them to objects, his emphasis on their physical beauty does little to challenge dominant racist fantasies. Fantasies of the black male body as bestial, sexually violent, and out of control are fueled by an iconography that highlights its desirability.[46] Unlike the sex pictures, where formal elegance resists the dominant fantasy concerning the ugliness of homoeroticism and sadomasochism, Mapplethorpe's photographs of African American men trade in an aesthetic vision similar, if not identical, to the dominant cultural perspective. The sex pictures show desires and practices that have been relatively invisible; the black nude studies depict bodies that have been hypervisibile. Although the black male body is absent from high-art canons, the dominant culture displays and inspects it in many other contexts. Mapplethorpe's black male studies, then, may ultimately represent only a (slight) difference of degree, not the difference of kind one discerns in the sex pictures.

While conceding that "in some instances Mapplethorpe's images disrupt and challenge conventional ways of seeing," bell hooks criticizes his images for perpetuating a white supremacist ideology that overidentifies blackness with carnality and physicality: "It is so obvious as to almost be unworthy

44. For further discussion of subjectivity in the sex pictures as compared to the black male studies, see Meyer, "Robert Mapplethorpe," 367.
45. Ellenzweig, "Robert Mapplethorpe at Robert Miller," 171.
46. hooks, "Representing the Black Male Body," 202–5.

of note, and certainly not prolonged debate, that racist/sexist iconogra-
phy of the black male body is reaffirmed and celebrated in much of Map-
plethorpe's work."[47] Although acknowledging the photographs' technical
and aesthetic sophistication, Essex Hemphill makes a similar charge, ac-
cusing Mapplethorpe of "*artistically* perpetuat[ing] racial stereotypes con-
structed around sexuality and desire" by photographically reducing black
men to their body parts.[48]

In her discussion, hooks does not single out any particular image as ei-
ther challenging or perpetuating dominant ways of seeing the black male
body. Hemphill, on the other hand, focuses on *Man in a Polyester Suit* (1980).
This portrait depicts an African American man wearing a cheaply made
suit. The photograph is cropped just below the model's shoulders and just
above his knees. The visual detail for which the picture is most famous is
the thick, uncircumcised, flaccid penis that dangles from the open zipper
of the model's pants. Hemphill contends that the picture's erasure of the
face and focus on the penis serve to reinforce racist fantasies regarding black
male sexuality:

> It can be assumed that many viewers who appreciate Mapplethorpe's work,
> and who construct sexual fantasies from it, probably wondered *first* how
> much larger would the penis become during erection, as opposed to won-
> dering *who* is the man in the photo or *why* is his head missing? What is insult-
> ing and endangering to black men is Mapplethorpe's *conscious* determination
> that the faces, heads, and by extension, the minds and experiences of some
> of his black subjects are not as important as close-up shots of their cocks.[49]

Man in a Polyester Suit undoubtedly evokes racist fantasies about black male
sexuality. Its focus on a large black penis trades in the racist reduction of a
black man to his sexual prowess. At the same time, it is unclear whether the

47. Ibid., 209–10.

48. Hemphill, "Does Your Mama Know?," 38. For a similar critique, see Yingling,
"How the Eye Is Caste." For more complicated interrogations, see Muñoz, *Disiden-
tifications*, 57–74; Stockton, *Beautiful Bottom*, 101–47.

49. Hemphill, "Does Your Mama Know?," 38–39. During his lifetime, Mapple-
thorpe published two collections of black male portraits: *Black Males*, in Amster-
dam, and *Black Book*, in the United States. Only a handful of these images focus
exclusively on the model's penis; almost two-thirds include the model's face. Only
the Amsterdam collection includes photographs with erect penises. With respect to
Man in a Polyester Suit, it was the model, Mapplethorpe's lover at the time, who re-
fused to show his face and his cock in the same photograph. Morrisroe, *Mapplethorpe*,
245. Any appeal to Mapplethorpe's life, however, provides evidence only for his rac-
ist fetishization, not his progressive intent. See Fritscher, *Mapplethorpe*, 207–12; Mor-
risroe, *Mapplethorpe*, 233–39, 252.

photograph "reaffirms and celebrates" this reduction or assists its viewer in constructing a sexual fantasy. While sharing hooks's and Hemphill's overall assessment, Thomas Yingling notes that this photograph, while "perhaps the most outrageous and potentially offensive image in *Black Book* . . ., is not coded as a pornographic text; its appeal is cerebral rather than libidinal."[50] The light and the white shirttail focus the viewer's attention on the penis, but it is presented factually, not erotically. It is flaccid; its skin appears dry, almost rough. The photograph does nothing to suggest the viewer should expect to touch or be touched by this penis. Even the model avoids the penis; his hands' awkward position generates an air of discomfort that undermines desire.[51] Other photographs show that Mapplethorpe knew how to depict the black penis erotically. For example, *Dennis Speight, N.Y.C.* (1980) shows the model cupping his hands just below his balls and pressing his erect cock toward his stomach. In this image, the light strikes the penis with a warm glow; its shaft glistens, and its tip meets the viewer's gaze. Even Ajitto's barely visible penis, from the four-picture series discussed above, generates more erotic energy than the one hanging from the polyester fly. While some viewers undoubtedly wonder, as Hemphill worries, how large the *Polyester Suit* cock would become when erect, the image does little to foster that fantastic engagement.

Man in a Polyester Suit so blatantly trades in the fantasy of the big-dicked black stud that it virtually explodes the racist imaginary it evokes. The image is so outrageous it cannot be taken seriously. Its bluntness demands a parodic reading, one that questions equivocation between the presentation of a racist fantasy and endorsement of it. As Stuart Morgan comments, "Racist stereotypes are not easily banished. Causing trouble with them is a way of testing how much they are founded on attraction or shame, as well as how much they still exist." Stephen Koch contends that Mapplethorpe asks the impossible: "He asks us, with a straight face, to look at some portrait of an anemone in the same way that we look at *The Man in the Polyester Suit* [*sic*]. That is, he asks us to look without shame."[52] Rather than asking us to look without shame, I contend *Polyester Suit* elicits a look borne out of the shameful legacy of racist objectification and degradation. By simul-

50. Yingling, "How the Eye Is Caste," 14.
51. By making the black penis appear so unusual, so out of place, so foreign, the photograph underscores its status as an anxiety-provoking object. Moreover, the image could be read as signifying the incompatibility of the black male body with professionalism, economic success, and fashion—either because the suit cannot contain the body or because a polyester suit signifies low economic status.
52. Morgan, "Something Magic," 122; Koch, "Guilt, Grace and Robert Mapplethorpe," 150.

taneously confronting the viewer with the racist fantasy's existence and the shame regarding its existence, the photograph uses the negative affect to disrupt the fantasy's allure. Through its frank, precise presentation of the black male body and its evocation of the unacknowledged fantasies encircling it, the photograph calls to attention the racist imaginary that constrains the black male body.[53]

Although hooks contends that any "oppositional aesthetic" regarding the black male body "may need to shift away from the black male nude,"[54] some of Mapplethorpe's images demonstrate how the nude black body can be presented in a manner that undercuts photography's objectifying tendencies. This can be seen most clearly by comparing Mapplethorpe's black nudes with his studies of nude white men.[55] In *Raymond Shelton, N.Y.C.* and *Scott Daley* (both 1979), the models strike virtually identical poses. Both are seated with their legs spread. Both extend their right leg and bend their left at the knee. Each relaxes his right arm at his side and bends his left arm at the elbow lifting his hand near his face. Both turn their heads and focus on something outside the frame. The main distinction between the models is their posture. Shelton, the African American model, slumps in his chair; Daley, the white model, sits rigid on his stool. Consistent with their postures, Shelton's extended leg is relaxed, while Daley's is taut with pointed toes. These differences make Daley appear much more posed; his body assists the camera in creating a spectacle: he willingly puts himself on display. Shelton's body is equally accessible to the spectator, but it refuses to cooperate with the eroticizing gaze. His resistance will not necessarily prevent spectators from fantasizing about his body, but his reluctance defuses the image's erotic charge. He collapses into his body and looks distracted; as a subject, he is somewhere other than in the picture. Shelton may have consented to being photographed, but he refuses to be on display.[56] The

53. This operation seems to imply, if not require, a white spectatorial presence. Political assessment of a particular representation needs to account for how discrepancy between the actual and implied spectator might alter the meaning of the image.
54. hooks, "Representing the Black Male Body," 211.
55. This comparison risks misrepresenting Mapplethorpe's corpus. When white men appear nude in his pictures, they are usually either paired with black men or engaged in a sadomasochistic ritual. The solitary, non-sadomasochistic black male nude, however, represents a substantial portion of his work.
56. Yingling notes the racist implications of characterizing a black model's confrontational gaze as signifying "suppressed violence" ("How the Eye Is Caste," 13). Shelton's face and body exhibit not rage but indifference. His refusal to engage the spectator may be infuriating, but the anger is the viewer's. This anger works like the shame generated by *Man in a Polyester Suit*. By recognizing the frustration generated by the black subject's dismissal of their presence, (white) viewers might become aware of

differences between *Tom* (1986) and *Bill Joulis* (1977) are more pronounced. In his portrait, Tom is standing, hands behind his back, one foot crossed over the other, with his head tilted and his mouth pressed into a firm line. In his portrait, Bill lies face down on a cloth-covered box. His prone body and relaxed face communicate resignation and accessibility. Like Shelton's, Tom's black body is available for the viewer's inspection, but his stance and his eyes, like Ridley's and Heeter's, meet the spectator's gaze.[57] Like *Man in a Polyester Suit*, *Raymond Shelton* and *Tom* activate a desire for the black male body while at the same time circumscribing that desire's operation. The formal devices within *Raymond Shelton* and *Tom* short-circuit the gaze; they both participate in and subtly subvert the codes of the nude portrait.

In her assessment of Mapplethorpe's photographs, hooks writes that "subversive elements within any image or series of images . . . do not necessarily counter the myriad ways those same images may reinscribe and perpetuate existing structures of racial or sexual domination."[58] Yingling goes even further. He argues that apologetic appeal to Mapplethorpe's style "implies, wrongly, that objects are free of ideological associations—that they have not performed other, 'pre-photographic' cultural work."[59] If Yingling is correct, then there is no way artistic inscription can ever resignify culturally, and if this is so—if works of art cannot, at least partially, disrupt existing ideological frames of meaning—then art has no political significance whatsoever, or at least none outside prevailing norms. If certain "objects" always signify in one ideological fashion, regardless of the formal codes used to represent them, then how are we to critique, challenge, and change cultural understandings of gender, race, sexuality, and power? Although artistic representation may not be sufficient for political change, resignification—at some level and in some fashion—is certainly necessary.

the underlying racist presumption that requires black bodies to respect them through acknowledgement.

57. This gesture of refusal is more emphatic in *Ken Moody* (1983). The nude, muscular model walks away from the camera, hand upraised in a gesture of dismissal. (Moody refused to pose for photographs involving frontal nudity. Morrisroe, *Mapplethorpe*, 290.)

58. hooks, "Representing the Black Male Body," 209. hooks also worries that focusing on whether Mapplethorpe's images are racist averts attention from other representations of the black male body. As explained earlier, I attend to Mapplethorpe's images to provide an account of how they train their audiences to see the black male body and to show their formal and thematic relation to Mapplethorpe's larger body of work.

59. Yingling, "How the Eye Is Caste," 22. Given Yingling's attention to the language used by Mapplethorpe's defenders, it is striking that he uses the term "object" to refer to human models.

Without resuscitating the notion of authorial intent or the romantic ideal of the artist as freedom's champion, we can retain an idea that art signifies in ways contrary to prevailing cultural codes, and therefore opens up alternative imaginaries, providing—at the least—ideological tension and static. Agreeing with Jane Gaines, I hold open the possibility that the "artist . . . can use racially-charged signs—whether linguistic or photographic—without . . . passing on their pejorative history."[60] Subversive details do not excuse the racist or sexist work performed by a particular representation, but attention to detail is critical to determining whether an image or text reinscribes or disturbs, perpetuates or resists, supports or critiques, endorses or challenges "existing structures of racial or sexual domination."

Attending to the features of Mapplethorpe's photographs that work against racist apprehensions provides a set of tools for negotiating not only his images but other representations as well. Because they use such a wide array of strategies, to varying degrees of success, Mapplethorpe's black portraits help us think about the political operation of spectacle. By employing an iconography so close to the dominant racial fantasy, thus exposing its existence and mode of operation, Mapplethorpe's images both evoke and critique problematic codes of representation. These photographs can teach us how to look at the black male body specifically, and to think about representation generally, in more complicated ways.

★ ★ ★

What the black male portraits teach about productive tension between explicit imagery and encircling fantasy can be applied also to Mapplethorpe's sex pictures. With their frequent and loving display of the male body and, more specifically, the penis, Mapplethorpe's sex pictures can be experienced as an iconographic celebration of the phallus and of phallic power. These images, however, usually show the penis constricted, endangered, bound, tortured, or bloodied.[61] Much as his black nudes skate a razor's edge between endorsing and critiquing racist fantasies, the spectacular display of phallic supremacy and masculine domination in Mapplethorpe's sex pictures swerves between glorification and interrogation.

Richard (1978) is a diptych constructed from photographs documenting the binding, torture, and mutilation of the model's penis. On the left, Richard's penis is shown in its "original" state: bound in a wooden stock, it glistens as it strains against its trusses. On the right, it is shown mutilated: the

60. Gaines, "Competing Glances," 25.
61. This is also true for his self-portraits. As noted above, however, the black penis is never shown as the target of physical violence.

skin no longer glows but appears mottled, covered by ink-dark blood, having been sliced with razor blades and punctured with nails. The left-hand photograph is surrounded by a bright red mat; the right-hand photograph is framed in black. Given that red signifies blood and that the blood in these pictures appears black, each image implies the penis is always already bleeding. At the same time, the left half of the diptych—given the brightness of the mat, the quality of light in the photograph, and the relatively intact state of the depicted penis—seems infused with life, health, and energy. This vital penis, however, is tethered in a wooden frame. When even the image of wholeness depicts the penis trapped and bound, it is only with difficulty that it can support the fantastic alignment of the penis with phallic power; the penis must struggle mightily to be the phallus when its visual and erotic interest circles around its torture and mutilation.[62]

The *Richard* diptych was culled from a larger series that tells a slightly different story about the threatened penis. One image from the series shows the act of mutilation itself: as Richard's blood-stained hand holds the wooden frame, another hand holds a nail against the tip of Richard's penis and positions a hammer to strike. The photograph that appears as the diptych's right-hand image memorializes the effect of this abuse, presenting the bloody penis as a still-life study. The series also includes a picture of Richard's relatively free penis. Although his testicles remain bound and his urethral opening oozes a dark liquid, with the blood wiped away and the wooden frame removed, the penis appears almost completely—and magically—restored. While both diptych and series depict the male body subjected to violence and suffering pain, the latter emphasizes the male body's perseverance and thus supports the identification of the penis with the phallus. In other words, the iconography of pain and suffering alone may be insufficient to challenge the fantasy of phallic supremacy; it can function critically only when embedded within (circumscribed by?) a particular kind of narrative.

Mapplethorpe's 1980 photograph *Untitled (Bill King)* collapses the distinctions between the *Richard* diptych and the *Richard* series into a single image. The photo is a cropped shot of a leather-clad male figure, his gloved left hand holding a knife. The knife thrusts downward from the upper right corner; the man's erect, thickly veined penis cuts upward from the lower left. They meet in the center of the frame, where the tip of the

62. Donald Kuspit argues that in these photographs "the penis is monumentalized in all its glory. . . . [It] becomess the grandiose phallus" ("Robert Mapplethorpe," 68). His claim, however, turns on the erroneous assumption that the penis is erect (66, 68). While Kuspit's interpretation of the diptych founders on its details, his conclusion applies to the *Richard* series as a whole.

knife has been inserted into the figure's urethra and turned slightly to open it.

Knife and penis—given their placement, their contact, and the play of light on them—are visual echoes. From which direction is the viewer to interpret their relationship? Read from bottom left to upper right, the knife could be interpreted as an extension of the penis, its status as dangerous weapon absorbed through the cock's piss slit. Read from upper right to bottom left, the knife could be read as penetrating and injuring the penis, the latter's status as emblem of sexual vitality rent by the blade's gleaming edge. Given the strong diagonal across the frame, the knife's partial disappearance inside the penile opening, and the contact between the two phallic symbols, the photo stages a reading of conflict and struggle rather than consolidation and alignment. At the same time, the penis's engorged status, the hypermasculine coding of the body, and the glint of the exposed blade suffuse the image with an aura of power, potency, and potential violence.[63]

Would interpretation of *Bill King* be simpler if the knife were removed? Without the knife to threaten the model's penis, everything in the photograph would signify masculine power; it would depict, simply, a leather-clad male body displaying a formidable erection. But would the difference between leather-clad body and exposed penis be more blatant in this imagined picture? If the leather uniform is understood both to protect the body like armor and to signify its virility, then how does the unsheathed penis participate in this leather-based masculinity? Why, after all, are there no visible penises in the portrait of Brian Ridley and Lyle Heeter? The conflict between knife and penis potentially plays up the tension between phallus and penis. The relation can also, however, be understood as one of survival and perseverance. Seen in this light, the tension helps secure the identity of the penis as phallus. A starkly visible penis, on the other hand, would seem exposed and vulnerable. This imagined version of *Bill King* demonstrates spectacle's critical role in dismantling the symbolic equivalence between penis and phallus.

Mark Stevens, Mr. 10 ½ (1976) also illustrates this point about the penis as spectacle. Wearing only chaps, Stevens bends at the waist and rests his cock and balls on the surface of a grey cube.[64] Several details focus the viewer's attention on his genitals. They are well lit. The white line of the box's edge

63. *Bill King* captures a single moment. But the threat of injury generates a sense of temporality and narrativity. What makes the image compelling and fascinating is the question of what will happen next: will the knife be turned more? will the penis be cut? will it bleed?

64. The display is not unlike that of Thomas and Ajitto. Just as they were reduced to their bodies, Stevens is reduced to his cock.

visually underscores the surface on which they lie. The chaps' dark leather and the shadow cast by Stevens's body stand in marked contrast to the pale flesh of his prodigious member. The triangle created by the bend of his elbow and the line of his chest and the triangle created by the line of his pelvis and the inhalation of his stomach both point to his cock.

Although the picture focuses attention on Stevens's penis, it does little to visually glorify it. The penis lies flat. It appears exhausted, devoid of energy, dead.[65] Stevens's thighs smash his testicles onto the cube's surface. He sucks in his gut so that other portions of his anatomy can be seen more easily. His posture also renders the display's meaning uncertain. Has he bent over in submission and surrender? If so, what is the relation between his submissive body posture and his phallic display? Most importantly, is the cube to be understood as a pedestal—with his penis as a trophy—or a butcher's block?[66] Given this uncertainty, the picture's sharp lines assume a menacing air. In the final analysis, does the image glorify or endanger his cock by exposing it to the gaze?[67]

Oddly, this image, which contains neither blood nor instruments of pain, may do more to demonstrate the penis's vulnerability—its unsuitability to stand in for the phallus—than Mapplethorpe's more explicitly violent photographs. According to art critic Lisa Jardine, *Mark Stevens, Mr. 10 ½* "persistently recalls" the *Richard* images and "exists as the controlled, manageable version of the dangerous others."[68] Assessing the relative threat in Mapplethorpe's various penis photographs is difficult. If, as noted above, the *Richard* series demonstrates the penis's invulnerability, then those images pose no threat to a symbolic order that supports male supremacy by equating the penis with the phallus. By the same token, images that demonstrate the penis's vulnerability through display alone—like *Mark Stevens* and, possibly, *Bill King*—may be more disruptive to the phallic order. In other words, the iconography of pain and suffering may be neither sufficient nor necessary for demonstrating how the male body falls

65. Or, perhaps, it awaits arousal to display its tumescent glory. The penis's "to-be-arousedness," however, marks it as a bodily site beyond the masculine subject's conscious control.

66. Bourdon, "Robert Mapplethorpe," 7.

67. In an image from the X Portfolio, Patrice wears a leather jacket and a jockstrap. The jacket, his clenched fist, and the jockstrap's rough texture exude an aura of masculine power. In another image, cropped to show the same portion of Patrice's body, the jacket is gone, his hand is relaxed, and the jockstrap has been pulled to one side to reveal his flaccid penis. Although other signifiers of masculine power have been removed, the flaccid penis's visibility in itself does a great deal to diffuse the former image's power.

68. Jardine, "Robert Mapplethorpe," 70.

short of the masculine ideal. The body's mere incorporation into the scopic regime may be enough.

Dominick and Elliot (1979) is one of a number of photographs that capture this pair during sadomasochistic play. In this photograph, Dominick's feet are bound with leather cuffs and hung from a metal hook. His head, at the bottom of the frame, rests on a vinyl mat and bears most of his body's weight. His hands are bound, his arms stretched in a broad V shape. A heavy chain running from his groin to his neck emphasizes the vertical line of his naked body. Elliot stands nonchalantly at his partner's side, one forearm inserted between Dominick's thighs, his hand gently cupping Dominick's testicles in a proprietary gesture. His other hand rests on his own thigh, holding a cigarette. Everything in the image—chains, leather, Levis, hirsute bodies, bearded faces, furrowed brows—signifies a male power consistent with hegemonic masculinity. At the same time, Dominick and Elliot are obviously, explicitly, emphatically *posing*; this photograph does not capture them in the throes of erotic abandon, but presents them at rest for the audience's examination.[69] They engage the audience; their hard and fixed stares acknowledge the spectator's presence, even if the menace in their eyes suggests they do not welcome it.[70] The photograph's marking of Dominick and Elliot's adoption of a pose, a role, a gesture that signifies masculinity, undercuts the idea that masculine power (and any subsequent privileges) inheres within their bodies.

Like *Man in a Polyester Suit*, it is difficult to take *Dominick and Elliot* seriously. Its concern with staging, lighting, and self-presentation draws attention to detail in a way that runs counter to the rough masculine ideal presented on the bodies' surface. Unlike *Brian Ridley and Lyle Heeter*, the incongruous fussiness of *Dominick and Elliot* is not part of the photograph's content but is signaled solely by its formal construction. Like *Mark Stevens*, and possibly *Bill King*, *Dominick and Elliot* demonstrates that rendering the masculine ideal visible can expose its artifice.[71]

69. Meyer, "Robert Mapplethorpe," 367–69.
70. Weiley, "Prince of Darkness," 110.
71. This observation is, of course, informed by Judith Butler's ideas about the political operation of drag. Butler's analysis, however, turns on the tension between the cultural meaning of the performer's body and the cultural meaning of the performer's self-stylization. My analysis of Mapplethorpe's images shows that even when cultural significations relating to body and gender are in alignment, exaggerated self-presentation can expose the ritualized gesture of gender performance. Both analyses, however, give pride of place to the visual. One learns about the "reality" of gender by *seeing* its performance. This is, in part, why the male body's display is ambiguous in relation to masculine power.

The *Richard* diptych and *Bill King* show that images of the male-body-in-pain are one device for dismantling the association of penis with phallus. *Brian Ridley and Lyle Heeter, Bill King, Mark Stevens*, and *Dominick and Elliot* reveal that the depiction of pain may not be a necessary element of this critical project. Certain displays of the masculine ideal may be sufficient, in themselves, to demonstrate its radical tenuousness. The iconography of sadomasochism is closely tied to the illusion's exposure, not (only or primarily) because it reveals the desirability of submission, humiliation, and pain, but because it is a detailed and ritualized mode of self-presentation. Sadomasochism parallels not only Mapplethorpe's aesthetic stylization but also the underlying political critique available through his images.

<p style="text-align:center">★ ★ ★</p>

In an essay entitled "Is Art above the Laws of Decency?" art critic Hilton Kramer answered his title question in the negative and argued that Mapplethorpe's images, while undeniably art—although of the lowest and most pernicious kind—clearly violated those laws. Kramer's chief complaint was that Mapplethorpe's images "are designed to aggrandize and abet erotic rituals involving coercion, degradation, bloodshed and the infliction of pain." In addition, the photographs' "absolute and extreme concentration on male sexual endowments" was morally problematic because it made "every other attribute of the human subject" insignificant. Kramer complained that "in these photographs, men are rendered as nothing but sexual—which is to say, homosexual—objects" (7). This suggests, consistent with prior considerations, that when the male body becomes the object of an eroticizing gaze it ceases to be a normative male body.

Engaging Kramer's statement about the precise character of objectification in Mapplethorpe's photographs, Douglas Crimp contends that they force a shift in focus from artifact to audience. In other words, Mapplethorpe's photographs do not render male models homosexual objects, rather they transform male viewers into homosexual subjects.

Mapplethorpe's images, on Crimp's analysis, transform the relation between image and viewer. "Kramer decried Mapplethorpe's 'reduction' of the human subject to a sexual object . . . not, as he might think or might wish us to think, because the photographs . . . dehumanize their sitters [but] because Kramer, solicited as a viewing subject of the photographs, found himself in the position of a man gazing at another man's genitals."[72] Mapplethorpe's images are a challenge to previous understandings of art, following the terms of these two critics, because of how they require the

72. Crimp, *On the Museum's Ruins*, 27.

spectator to see. For Kramer, it is the manner in which they "aggrandize and abet" a particular set of erotic rituals that makes Mapplethorpe's images indecent. Does Kramer intend to denounce as indecent all images that "involv[e] coercion, degradation, bloodshed and the infliction of pain"? If so, then a vast number of paintings, photographs, and statues that take as their subject the cruelties of war, sexual violence, and religious martyrdom would have to be removed from museums and galleries—or at least vociferously denounced as a violation of common decency by critics and curators. Perhaps this is an unfair reading of Kramer's principle: after all, it is not the violence in Mapplethorpe's pictures that troubles him, but the representation of "erotic rituals" that involve inflicting pain. Does this mean that images of violence can be displayed, as long as the violence has no erotic frisson? Or is Kramer only concerned about representations that *glorify* violent eroticism?

Even if Kramer's rule is formulated narrowly to prohibit only eroticized violence depicted in an appealing and desirable fashion, it would make little difference. After all, what is more appealingly erotic than Caravaggio's depiction of Thomas touching Christ's wound, or Rembrandt's depiction of Jesus on the cross, or Michelangelo's *Pièta*? Examples of "coercion, degradation, bloodshed and the infliction of pain" represented within an appealing and eroticizing frame, especially within Christian art, are simply too numerous to catalog. Mapplethorpe's photographs offend not because they bring homoerotic and sadomasochistic content into the museum; they scandalize because they compel the viewer to acknowledge that this content was always present.[73] They compel the viewer to confront the allure of such unsettling, disturbing, and troubling images. Mapplethorpe, unlike many an artist depicting homoerotic or sadomasochistic desires before him, simply refuses to play the game of representational misdirection. The refusal to keep the secret secret is the true violation of public decency.

73. One of the best examples of the revelatory power of Mapplethorpe's work is an early piece, *The Slave* (1974), consisting of an art book, held open by a knife, resting on a piece of bare plywood. The book is opened to two pictures of Michelangelo's *The Dying Slave*, a statue of a young, muscular male in a languorous pose. With respect to its materials and its form, the work is virtually identical to other "found art" pieces from Mapplethorpe's early work. These other pieces, however, used images from gay male pornography. By giving Michelangelo's statue a new context, Mapplethorpe shows that homoeroticism is the disavowed content of the high art canon. As Paul Morrison observes, "Any attempt to deny Mapplethorpe the space of the museum would need, then, to deny Michelangelo as well." Morrison, "Coffee Table Sex," 22. For further discussion of *The Slave*, see Wolf, "Authentic Artlessness," 47–50.

Photographs incorporating crucifixes, from the earliest phase of Mapplethorpe's career, explore the erotic desire circling the crucified body in a fairly stark manner. In a handful of Polaroids from the early 1970s, Mapplethorpe incorporates a barrel with a silver crucifix on its head. In one photograph, the barrel is shot from above; the crucifix is visible in the upper right corner; a man's erect penis occupies the frame's lower half. From the framing and the position of the penis, the viewer could easily conclude that the model intends to urinate on the cross. At the same time, the (inverted) crucifix and cock echo each other. They are roughly the same size in the image, both oriented vertically, and both shot out of focus relative to the picture's other details. In another photograph, a nude male is seated on the barrel. His butt cheeks rest above the crossbeam and on either side of the caput. Because he is bent over touching the floor, his asshole is clearly visible. Again, the relation between body and crucifix is ambiguous: is the model preparing to defecate on the cross or to use it as a metal dildo? Both of these images shift between desecration and eroticization of the crucifix; either way, the central Christian symbol does not retain its standard meaning.

During the last year of his life, along with other statue studies, Mapplethorpe photographed a statue of the crucified body of Jesus. In *Christ* (1988), Jesus's head has the familiar sag, his arms, chest, abdomen, and thighs the familiar, well-developed musculature. Wear on the statue gives the impression of blood (or lesions from Kaposi's sarcoma) on Jesus's side and legs; fingers broken off the hands make the figure seem more tragic. This body, however, while in a cruciform pose, is not affixed to a cross but rests on a background of dark pebbles. The absence of the cross, with its obvious implication, the agony of the body, with its emphatic beauty, the title's focus on the person, with the image's evocation of an event, expose the erotic violence not simply of art or photography generally but of the crucifixion specifically.

This is, in the final analysis, the power and radicality of Mapplethorpe's sex pictures. They unavoidably, undeniably, and unmistakably confront their spectators with the idea that the violated, degraded, humiliated male body is a desirable object. By so doing, they challenge not only strictures on contemplating the male body as an object of beauty but strictures on imagining that the infliction of pain can be pleasurable. Mapplethorpe's images reveal that the motivations stirring devotion to the body of Christ and veneration of the saints may be vastly more complicated than certain theological discourses would allow. Jardine opined that Mark Stevens's glorified penis recalled Richard's brutalized penis; *Christ* does something similar. In the images recording the brutalization of Richard's penis, the ground

is dark wood, and the figure is a brutalized, vertically oriented male organ. In *Christ*, the ground is dark stones and the figure is a brutalized, vertically oriented male body. If Mapplethorpe's sex pictures mark the absence/presence of homoerotic desire in the classical art tradition, then the formal similarities between his cock and Christ photographs perform a similar feat with respect to the Christian tradition. *Richard* and *Christ* reveal something about what Christianity venerates and how the venerated object supports and resists hegemonic fantasies of masculinity.

The act of making the invisible visible could be understood as the organizing principle of Mapplethorpe's body of work. In the sex pictures, Mapplethorpe renders masculine stylization visible, revealing self-representation as a ritualized, codified gesture distinguishable from bodies. Through their stark depiction of masculinist fantasies, they not only render visible the fantasy of masculine power and plenitude, they render it visible *as a fantasy*. Similarly, in his portraits of African American men, Mapplethorpe makes visible racist iconographies, compelling the viewer to deny, renounce, or embrace the fantasies in which they trade. Again, the stark display of a culturally unacknowledged imaginary is the critical mechanism of Mapplethorpe's photography.

Mapplethorpe's images make the invisible visible not merely by documenting previously undocumented content, but by depicting this content in a manner that makes it desirable and appealing. Any discussion that focuses only on the images' depiction of previously taboo content, without attending to how they train their audiences to see anew the power of image-making and representation, fails to recognize Mapplethorpe's contribution as a photographer—and as a social critic. But to attend only to their formal brilliance, without thinking about what the form does to the content, is to miss something as well.

With the exposure of a repressed homoerotic dynamic in crucifixion images in mind, then, theological discourses relating to the cross may need modification. The content of the crucifixion is the brutalization, humiliation, and degradation of a male body. Just as critical apologies for Mapplethorpe that focus on lighting, composition, and tonal value fail to grapple with the important claim inherent in his subject matter, theological discourses about the cross that focus exclusively on love, forgiveness, or reconciliation fail to grapple with the messy details of the event. In what way do theological interpretations of the *cross* occlude the facts of *crucifixion*? When discussing the relation between shame and beauty in Mapplethorpe's sex pictures, Koch suggestively asserts they evoke a state of grace.[74]

74. Koch, "Guilt, Grace, and Robert Mapplethorpe," 150.

Grace: a transcendent, conciliatory state that neither cancels nor denies the seemingly contradictory elements it brings into relation. This is the crucifixion's scandal, mystery, challenge. How can the violent destruction of a human body bring comfort, peace, or joy? The failure to grapple with this tension dampens the ethical complexity and political possibilities of the crucifixion.

Certain theological discourses glibly pass over the pain and degradation memorialized by the crucifixion; others fail to make productive use of its grisly detail. While historically the maleness of Jesus has been used to legitimate various systems of male domination, the crucifixion troubles any notion that he exemplifies masculine power and privilege. The crucifixion reveals a male body that is wounded, suffering, bleeding, dying, and defeated. Theological critiques that focus exclusively on the *interpretive history* of the cross without returning to the crucifixion itself miss an opportunity to deploy this image as a repudiation of hegemonic masculinity. Just as Richard's bound, trussed, and impaled penis undercuts the male body's phallicization, Jesus's nail- and spear-pierced body runs counter to prevailing fantasies of male power within the Christian imaginary. Although fantasies of resurrection, like representations of the penis's durability, complicate the relation between Jesus's body and the privileges ascribed to other male bodies, the crucifixion remains a useful site for fixing attention on a particular revelation of the divine in relation to dominant understandings of masculinity.

The rendering visible of certain fantastic constructions of race and gender, especially the rendering visible of the male body, can sometimes work to undermine those very fantasies. In many ways, the Passion narrative can be interpreted as a progressive rendering visible of Jesus's body and its distance from hegemonic understandings of masculine supremacy. On the cross, his body not only suffers and dies; it is *clearly visible*. From the triumphal entry on Palm Sunday, to the public discourses in the temple, to the betrayal in the Garden, to the trials before various political and religious leaders, to the presentation to the crowd, to the parading through the streets of Jerusalem on the way to Golgotha, Jesus is made progressively more visible. At each moment, he is a spectacle, looked at, caught in a controlling gaze. The Eucharist, the central Christian ritual, participates in this work as well. To remember Jesus, believers are instructed to use tangible elements that make him—and his suffering and death—perpetually visible. Jesus's entire life makes the unseen seen. In becoming human flesh, Jesus makes the invisible God visible. Jesus's incarnation, like his crucifixion, has often been characterized as an act of degradation, humiliation, submission. Mapplethorpe's images help us identify the impor-

tance of visibility in the saving work of Jesus the Christ; more precisely, Mapplethorpe's work connects visibility to vulnerability, revealing a similar relation between incarnation and crucifixion. Jesus's obedient and submissive surrender to suffering and death is connected to his being rendered visible. This willingness to be degraded and humiliated—while in the form of a man—renders visible the vulnerability of masculinity. *Ecce homo* indeed.

REPRESENTATION

CRUCIFIXION

It isn't so much the image which matters, but what you do with it, and what effect some images have on other images. . . . I think that every image, everything we see, changes our way of seeing everything else. . . . There's a sort of influence of image upon image.

I don't think of my work as being in the least bit macabre. I think of it as being slightly truthful sometimes.

Everybody has his own interpretation of a painting he sees. I don't mind if people have different interpretations of what I have painted.

FRANCIS BACON

Meat is revelatory. Or so thought Francis Bacon. And Georges Bataille.

In the essay "Slaughterhouse," written for *Documents*, Bataille observed that "the slaughterhouse is linked to religion in so far as the temples of bygone eras . . . served two purposes: they were used both for prayer and for killing" (72–73). "In our time," he continues, "the slaughterhouse is cursed and quarantined like a plague-ridden ship" (73). This causes "good folk . . . to exile themselves, out of propriety, to a flabby world in which nothing fearful remains and in which, subject to the ineradicable obsession of shame, they are reduced to eating cheese" (73).

In keeping with *Documents'* spirit of experimental juxtaposition, Bataille commissioned Eli Lotar to photograph scenes from an abattoir to accompany his essay. Given that Bacon was familiar with the journal, perhaps it is these photographs he had in mind when he opined:

> I've always been very moved by pictures about slaughterhouses and meat. . . . There've been extraordinary photographs which have been done of animals just being taken up before they were slaughtered and they smell of death. We don't know, of course, but it appears by these photographs that they're so aware of what is going to happen to them, they do everything to attempt to escape. I think [my crucifixion paintings] were very much based on that kind of thing, which to me is very, very near this whole thing of the Crucifixion.[1]

1. Sylvester, *Interviews*, 23. On Bacon's familiarity with *Documents*, see Ades, "Web of Images," 12; Peppiatt, *Francis Bacon: Anatomy*, 39. On the relation between Bataille

To Bacon, the butcher shop displays "the whole horror of life—of one thing living off another."[2] This horror has a specific character: "We live off one another. The shadow of dead meat is cast as soon as we are born. I can never look at a chop without thinking of death."[3] And a personal dimension: "Well, of course, we are meat, we are potential carcasses. If I go into a butcher's shop I always think it's surprising that I wasn't there instead of the animal."[4]

Meat, then, has something to teach us. But, as Bataille's comments highlight, society works very hard to sequester the slaughterhouse and suppress its lessons. Bacon's painterly corpus can be understood as an attempt to make meat speak again—even if its voice is a choked, strained, guttural scream.

This chapter examines the theme of crucifixion—the reduction of flesh to meat—in Bacon's work.[5] It reflects on Bacon's depiction of the male body and the alluring beauty of its vulnerability and collapse. It traces the relation between the violence of crucifixion and the violation of representation in his paintings to explore the inherent vulnerability of the male body on display.

★ ★ ★

The first painting for which Bacon received any official notice was a fairly traditional depiction of cruciform imagery.[6] *Crucifixion* (1933) depicts a skeletal figure, hands affixed to a cross, on a dark ground.[7] This figure is em-

and Bacon, see Ades, "Web of Images," 12–13, 18–19; Arya, "A-theology"; Hammer, *Bacon and Sutherland*, 223–24; Jones, "Bacon and Bataille."

2. Sylvester, *Interviews*, 48.

3. Peppiatt, "Three Interviews," 41.

4. Sylvester, *Interviews*, 46. Like Bataille, Bacon linked meat's violence to eroticism: "When you fuck, it's a piece of meat penetrating another piece of meat." Cappock, "Motif of Meat and Flesh," 315.

5. The key treatments of the crucifixion theme in Bacon's work are Cappock, "Motif of Meat and Flesh"; Gale, "Crucifixion"; Gamper, "Motif of the Crucifixion"; Laessoe, "Francis Bacon's Crucifixions"; Moorhouse, "Crucifixion in Bacon's Art"; Yates, "Francis Bacon"; and Zimmerman, *Francis Bacon*.

6. This painting was reproduced by Herbert Read in his book *Art Now*, exhibited by Freddy Mayor, and purchased by Michael Sadler. This "represented about as much as could be achieved in so short a time in the England of the 1930s." Russell, *Francis Bacon*, 17. See also Baldassari, *Bacon—Picasso*, 87; Harrison, *In Camera*, 21; Peppiatt, *Francis Bacon: Anatomy*, 64–65; Sinclair, *Francis Bacon*, 65–66.

7. Unfortunately, for clarity's sake, there are three crucifixion paintings from 1933, all entitled *Crucifixion*. The second is sometimes referred to as *Golgotha* due to the presence of a skull. Alley, "Works of Francis Bacon," 30; Davies, *Francis Bacon*, 21–22.

braced by a second, spectral figure, whose head rests on its chest and whose body curves into the left-hand side of the painting.[8] Possibly inspired by this painting's evocation of the skeletal, art collector Michael Sadler sent Bacon an x-ray of his skull and commissioned a self-portrait; Bacon incorporated Sadler's skull into a second crucifixion painting.[9] Its lower background retains the first's dark tone, but the upper two-thirds are in the bright orange of many subsequent paintings. The figure is not on a cross, but is in a cruciform pose.[10] The second painting repeats the first's rib-cage motif, but its figure is fleshier, with a left half rendered in a swath of red-orange. In Bacon's third crucifixion painting from 1933, there are three figures, all behind bars, each in a cruciform pose; two stand, one sits.[11] Their forms fall between the spectral bodies of the first crucifixion and the fleshier form of the second.

These paintings presaged the formal concerns that would occupy Bacon for the remainder of his career. The first and second illustrate the sharp distinction he draws between figure and ground.[12] The third, with its incorporation of prison bars, prefigures his use of cages, boxes, and other frames to focus attention on the figure. Insofar as the embrace of figures in the first crucifixion is meant to have amorous overtones, it shows that multiple figures almost always signify eroticism in his paintings—an eroticism generally linked to violence and death. These paintings show Bacon

8. Matthew Gale identifies this figure as Thomas inserting his hand into Jesus's wounds. "Crucifixion," 137.

9. Davies, *Francis Bacon*, 21–22; Peppiatt, *Francis Bacon: Anatomy*, 65; Russell, *Francis Bacon*, 18. Following his patron's wishes, the painting incorporates the image of a skull in profile, looking off to the left. The skull is depicted with large fleshy lips, has a pink field for its brain, and white tendrils that could be nerves or blood vessels.

10. Hugh Davies notes that "there is really very little about this painting, other than the title, to suggest that the subject is a crucifixion." *Francis Bacon*, 22. While he is right, with the exception of the first 1933 crucifixion painting and *Fragment of a Crucifixion*, none of Bacon's crucifixion paintings would likely be so identified save for their titles.

11. In his study of Bacon's early paintings, Davies opines that the seated figure with a line extending from its body into the chest of the pale standing figure could be understood either as the Roman soldier Longinus inserting a lance into Jesus's side or as the disciple Thomas inserting a hand into Jesus's wounds. *Francis Bacon*, 20–21. Davies does not comment on the significant difference between these two figures vis-à-vis the image's meaning.

12. Davies and Yard, *Francis Bacon*, 12. "The distinguishing feature of Bacon's painting style is the disjunction . . . of figure and ground." Schmied, *Francis Bacon*, 95; see also Deleuze, *Francis Bacon*, 8, 13.

grappling with forms from master painters, especially Picasso, and developing the idiosyncratic biomorphic forms of his mature style.[13] In the second crucifixion, Bacon reveals "his gift for the macabre made more disturbing by his gift for portraying carnal voluptuousness."[14] Beautifully rendered, anguishing human flesh is the central preoccupation of Bacon's oeuvre.

Similar to these early paintings, but unlike later renditions, *Fragment of a Crucifixion* (1950) stays fairly close to traditional iconography.[15] The painting is dominated by a dark, T-shaped cross. A canine figure—suggested by the shape of its rear haunches and front "paws"—with a bloodied, dripping wound where its head should be, hangs over the cross-bar. A white blur of paint with an open (screaming?) mouth hangs on the shaft of the cross.[16] Streaks of paint surrounding the mouth could be arms and legs, strokes under it could be the outlines of female genitals.[17] Regardless of its corporeal referent, the blurry paint signifies motion, tremulousness, vibrating energy. In Bacon's paintings, movement is always eruptive: a spasm, a thrash, an ejaculation.[18] Most recent commentators identify two figures in

13. See esp. Baldassari, *Bacon—Picasso*; see also Ades, "Web of Images," 18; Davies and Yard, *Francis Bacon,* 12; Peppiatt, *Francis Bacon: Anatomy,* 63–64; Sylvester, "Bacon's Course," 19. Bacon's first crucifixion painting from 1933 demonstrated his ability to engage the pictorial vocabulary of the most significant painter of his time while developing his own personal style. Davies, *Francis Bacon,* 20; Peppiatt, *Francis Bacon: Anatomy,* 63; Sylvester, *Looking Back,* 13. By placing this painting opposite Picasso's *Baigneuse* (1929) in *Art Now,* Read made explicit the similarity between the artists' work. Brighton, *Francis Bacon,* 27; Harrison, *In Camera,* 21; Peppiatt, *Francis Bacon: Anatomy,* 64.

14. Peppiatt, *Francis Bacon: Anatomy,* 65.

15. Some commentators have noted that this painting seems more like a traditional deposition of Christ than a crucifixion. Davies and Yard, *Francis Bacon,* 22; Melville, "Iconoclasm," 64. Bacon later repudiated this painting as being too close to traditional understandings of narrative and illustration, in both its iconography and its gruesomeness. Davies, *Francis Bacon,* 89; Domino, *Francis Bacon,* 57; Russell, *Francis Bacon,* 76, 82, 84.

16. Confessing his fascination with the mouth's beauty, Bacon rejected his treatment of it as a failure. *Sylvester, Interviews,* 34–35, 48–50. He insisted his mouths were solely aesthetic objects: to interpret them as screams or infer sexual meaning was to trammel his images' ambiguity. Davies, "Screaming Pope," 50; Peppiatt, *Francis Bacon: Anatomy,* 141–42; Sylvester, *Looking Back,* 29.

17. Reading the crucified creature as possessing female genitals, biographer Andrew Brighton sees this creature as descended from the Furies of *Three Studies for Figures at the Base of a Crucifixion* (1944). Brighton, *Francis Bacon,* 55.

18. Deleuze, *Francis Bacon,* 36; Geldzahler, "Introduction," 7; Harrison, *In Camera,* 98; Russell, *Francis Bacon,* 123.

the image.[19] Contemporary critic Robert Melville, on the other hand, contemplates a single figure:

> The crucified flesh itself, attempting to draw away from its own misery, slips the nails, looms up over the top of the cross and begins to crawl down the other side like a dog, dripping magenta mucus. It is so far gone that the agony leads a life of its own, and becomes a detached lump of flayed flesh, with a scream at its centre, hovering like a fat bird and beating the air with stiff quills of blood. It will, one supposes, evaporate when the body hanging above it is finally dead.[20]

Melville's description suggests that the body rends itself in the trial of crucifixion, participating and completing the act of destruction begun by an external mechanism.

The tiny human figures and cars in the distance enhance the horror in the foreground. Here, Bacon depicts the crucifixion not as an event that transforms the world, but as a moment of astonishing agony ignored by workaday folk going about their business; this painting represents not only cruelty, but indifference.[21] Like the 1933 crucifixions, *Fragment* exemplifies Bacon's formal concerns. Like the man-in-blue/caged-executive portraits of the 1950s, this painting operates within a very restricted chromatic range. Motion and temporality, signified by the blurriness of the paint and distortion of the image, are common features in his work. Finally, as with so many of his later images—equally unsettling, if not comparably gruesome—Bacon uses an economy of means to provide a richness of expression.

The final single-frame crucifixion to be considered, *Wound for a Crucifixion* (1933), was exhibited in February 1934 in Bacon's first single-artist show:[22]

> This [painting] was set in a hospital ward, or corridor, with the wall painted dark green to waist-high and cream above, with a long, narrow, horizontal black line in between. On a sculptor's armature was a large section of hu-

19. Davies and Yard, *Francis Bacon,* 21–22; Schmied, *Francis Bacon,* 79; Sinclair, *Francis Bacon,* 145–46; Sylvester, *Looking Back,* 40; Yates, "Francis Bacon," 179.

20. Melville, "Iconoclasm," 64. Given the headless state of the doglike creature and the prominent mouth of the entity on the shaft, as well as Bacon's marked preference for portraying single figures, I find Melville's interpretation of the image as depicting a solitary, but violently rent, creature more convincing than that of recent commentators who suppose multiple figures.

21. Davies, *Francis Bacon,* 89; Yates, "Francis Bacon," 179, 181.

22. Peppiatt, *Francis Bacon: Anatomy,* 67; Russell, *Francis Bacon,* 17.

man flesh: a specimen wound, and a "very beautiful wound" according to Bacon's recollection.[23]

Because the show received negative reviews, Bacon destroyed this painting, a decision he later regretted.[24] Like Bacon's other crucifixion paintings, *Wound* was important to his overall development as a painter. "This elevated, gashed lump of human flesh . . . should be viewed as an early version of what became the upraised, openmouthed snarling biomorphs which populate the three panels of the Tate triptych of 1944."[25] Before turning to the 1944 triptych, *Three Studies for Figures at the Base of a Crucifixion*, I consider Bacon's crucifixion triptychs from the 1960s.[26]

Painted quickly in the two weeks leading up to his first retrospective at London's prestigious Tate Gallery—between bouts of serious drinking and consequent hangovers—*Three Studies for a Crucifixion* (1962) marks important shifts in Bacon's format, technique, and iconography.[27] This crucifixion, the first triptych Bacon had painted since 1944, marked his return to a format that would become central to his output.[28] The 1962 triptych's panels were "four times the area of those of the 1944 *Crucifixion* triptych."[29] Even if the earlier work prepared visitors to Bacon's retrospective for the new painting's form, its size—the panels were over six feet tall and, combined, almost eighteen feet across—likely overwhelmed them.[30] The panels were also scaled to their spectators' world. "Bacon's scale was probably less varied than that of almost any painter one can think of . . . and was most often three-quarters life size."[31] The central panel's mangled figure is roughly the size of an adult viewer. Relation through scale is enhanced by Bacon's insistence that his paintings be exhibited under glass: one inevitable consequence is that viewers see their reflections in Bacon's paint-

23. Russell, *Francis Bacon*, 17; see also Farson, *Gilded Gutter Life*, 33.

24. For the review, see "Mr. Francis Bacon," 9. On the painting's destruction and Bacon's regret, see Boxer, "Early Works," 11; Farson, *Gilded Gutter Life*, 33; Russell, *Francis Bacon*, 17.

25. Davies, *Francis Bacon*, 25–26. In his crucifixion triptychs of the 1960s, Bacon will use a similar device to stage the crucified figure.

26. Peppiatt reports that Bacon also painted a "dead body of Christ bandaged and laid out on a table" during the 1930s. *Francis Bacon: Studies*, 102.

27. Kennedy, "Francis Bacon," 29; Peppiatt, *Francis Bacon: Anatomy*, 189; Sinclair, *Francis Bacon*, 166; Sylvester, *Interviews*, 13.

28. Brighton, *Francis Bacon*, 55; Davies and Yard, *Francis Bacon*, 16; Sylvester, *Looking Back*, 107.

29. Sylvester, *Looking Back*, 100.

30. Rothenstein, *Time's Thievish Progress*, 86.

31. Sylvester, *Looking Back*, 78; see also Davies and Yard, *Francis Bacon,* 114; Hammer, *Bacon and Sutherland*, 27; Nixon, "Francis Bacon," 132–37.

ings.[32] In this triptych, a spectator of average height would see her or his face superimposed on the mangled, blown-apart head of the central panel's crumpled figure or floating in the dark cavity of the right-hand panel's inverted carcass.

In addition to the painting's size and scale, its colors would have shocked viewers. Although the 1944 triptych had a bright orange background and although Bacon had experimented with brightly colored pigments in his van Gogh series, the majority of his work through the 1940s and 1950s had been rendered in dark colors, and individual paintings were composed using a narrow range of hues. With the 1962 painting, the colors alone—deep red, bright orange, vibrant green, dazzling white—would have startled gallerygoers.

Like Bacon's return to the triptych form, the use of distorted human figures was a return to prior stylistic elements. A few paintings from the early 1930s and 1940s contain distorted human figures crafted with a similarly free handling of paint. But his use of color, application of paint, and figural composition in the 1962 triptych represented a radical extension of the earlier paintings' gestures, as well as a marked break from his most recent work.[33] These shifts were most noticeable in Bacon's treatment of the body: "In the 1962 triptych, his handling of flesh becomes more visceral, more direct and even more sensuous."[34] The choice of colors for the depiction of bodies, the buildup of paint in the central figure's smashed head (and the splattering of paint behind it, indicating a shattered skull), the repeated carcass motif in the left and right panels, the combination of human and animal features in the right panel's figure (including a snarling mouth with fanglike teeth), and the opening up and hollowing out of creatures in the central and right panels make this painting one of Bacon's most gruesome, alluring, and visually arresting images. "As the last painting in his first retrospective in the Tate Gallery, there could hardly [have been] a more offensive image."[35]

32. Ficacci, *Francis Bacon*, 17; Melville, "Iconoclasm," 64; Rothenstein, "Introduction," 19; Sinclair, *Francis Bacon*, 178–79. For Bacon's motivations, see Borel, "Francis Bacon," 193; Domino, *Francis Bacon*, 81–82; Ficacci, *Francis Bacon*, 27; Melville, "Iconoclasm," 64; Rothenstein, "Introduction," 19; Sinclair, *Francis Bacon*, 178–79; Sylvester, *Looking Back*, 24.

33. Shone, "Paris and Munich," 843–44; Sylvester, "Bacon's Course," 52. For discussion of Bacon's work in the 1950s, see Peppiatt, *Francis Bacon: Studies*, 46–95.

34. Cappock, "Motif of Meat and Flesh," 311.

35. Brighton, *Francis Bacon*, 61. In 1962 the painting was denounced as an exercise in "wanton self-indulgence, an enjoyment of horror for horror's sake." Roberts, "Mr. Francis Bacon," 20. Brighton argued more recently that the painting's sensational content, as well as its possible autobiographical inspiration, overwhelmed Bacon's

The triptych's panels are linked by Bacon's use of color: the bright red walls of the background, the orange floors of the foreground. As with his later triptychs, color and spatial signifiers unify the panels.[36] But unlike most of these triptychs, the curve of the floor across the panels fails to demarcate the three panels as a single space. Like many Bacon paintings, the images are not bound by internal markers but open onto the space occupied by the spectator. With an ever-expanding floor and curved walls, the triptych seeps into the exhibition hall, closing in on the viewer, rendering unstable the border between painting and gallery.[37]

In the left-hand panel, there are two human figures. The paint comprising the rightmost figure's head evokes a split skull and exposed brain, not unlike the second crucifixion painting from 1933. In the foreground, a split animal carcass rests on a red platform.

The creature in the central panel is composed of thick, rough paint. The buildup of paint distinguishes this figure from those in the left and right panels, with their comparatively flat surfaces, and gives the triptych a notably tactile dimension. Although distorted, the figure is unavoidably recognizable as human. The shape of buttocks and feet, the bend of knees, the exposed teeth—all attest to a once-solid human frame. At the same time, the crumpled body no longer has eyes, its face and brain cavity are nothing more than a splatter of red paint, its (remaining?) arm is impossibly twisted, and its legs are arranged in a way that does not conform to normal human physiology. The figure languishes in a pool of blood in a room with blood-stained windows. The two white splatters behind its head are probably its missing eyes. This creature is a study for the writhing, bedridden forms that appear with remarkable frequency in Bacon's portraits of the next two decades.[38]

In the right-hand panel, a red and green plinth holds an inverted, eviscerated carcass that appears to have a cow's legs and a human head. This creature's snarling mouth gives it a living intensity; the circle of bones behind it, however, signifies death and decay. The carcass's staging on a sculptural platform adds to the panel's horror: is this a grotesque museum piece? is it intended as a thing of beauty? is it offered as an object for aesthetic contemplation? The shadow in the panel's foreground resembles the color and shape of the figures in the left-hand panel, just as the carcass in the fore-

ability to execute a balanced image. *Francis Bacon,* 59, 62; see also Gayford, "Brutality of Fact," 45. Even Russell, Bacon's stalwart champion, claims the triptych lacks the cohesion and unity of Bacon's later work. Russell, *Francis Bacon,* 114.

36. Domino, *Francis Bacon,* 68.

37. Leiris, *Francis Bacon,* 19; Sinclair, *Francis Bacon,* 227.

38. Michael Peppiatt notes that Bacon had a large collection of photos of male hysterics from Salpêtrière Hospital. *Francis Bacon: Studies,* 39.

ground of the left-hand panel resembles the colors and details of the right panel's suspended carcass. These iconographic echoes mark a visual X across the triptych that contributes to its unity.

Except for the triptych's title, there is little that would identify it as a crucifixion.[39] Although the central figure is recognizable as a human being who has undergone an excruciating physical ordeal, its pose does not suggest traditional crucifixion iconography. The only detail linking this figure to traditional iconographies is the white dot on its foot, which could be read as a nail scar.[40] The distribution of visual attention across the three panels, rather than a focus on the central panel, further distances the work from traditional crucifixion triptychs.[41] If the triptych represents a crucifixion, which figure has been or is being crucified? Without explicitly defending the interpretive prominence they assign to any particular figure, commentators describe the painting as if the crucified figure is in the central panel, the right-hand panel, or both. One of the few to take seriously the title's suggestion and interpret each panel as a crucifixion scene is Michael Peppiatt, who in a biographical interpretation of the triptych, gives each panel equal weight as depicting a crucifixion event in which Bacon himself is the victim.[42] Other commentators underplay Bacon's personal suffering, interpreting the triptych as commenting on the suffering endemic to the human condition.[43]

After the 1962 triptych, viewers were probably less shocked by Bacon's 1965 *Crucifixion*. This triptych repeats the 1962 painting's use of reds and oranges, echoes its treatment of bloodied flesh, and continues to blur the

39. Bacon acknowledged that the carcass in the right-hand panel was indebted to a thirteenth-century crucifixion by Cimabue; by inverting the figure, he hoped to capture the wormlike undulation of Christ's body down the cross that he saw in Cimabue's painting. Gowing, "Positioning," 22; Russell, *Francis Bacon*, 113; Sylvester, *Interviews*, 14; Trucchi, "Delirium of the Body," 118. Given the figure's inversion and the body's translation into a beef carcass, the allusion would most likely not be apparent to the uninformed spectator.

40. Brighton, "Why Bacon Is a Great Artist," 6.

41. Gamper, "Motif of the Crucifixion," 329–30.

42. Peppiatt, *Francis Bacon: Anatomy*, 189–91. For Peppiatt's insistence that all of Bacon's paintings can be understood autobiographically, see ibid., 82–83. For a thorough biographical interpretation of Bacon's crucifixion paintings, see Laessoe, "Francis Bacon's Crucifixions."

43. For contemporaneous views, see Carritt, "Bacon," 18; "In the New Grand Manner," 82; Richardson, "Grunts from the Underground," 46. For more recent views, see Yates, "Francis Bacon," 186. Consistent with his discussion of his other works and of painting generally, Bacon denied that the triptych had any rational explanation. Brighton, *Francis Bacon*, 58–59; Russell, *Francis Bacon*, 114.

boundary between human and animal. The 1965 triptych, however, reorganizes the scenes from the earlier painting: the suspended carcass is now in the central panel and the bedridden bag of flesh is to the left.[44] In the right panel's foreground, a muscular, broad-shouldered figure holds another (formerly?) human figure down. "Given the position of the dominated figure and the dash of red there is a suggestion of bloody fellatio."[45] Whether or not their interaction has a sexual element, the figure on top has brutalized— or decimated—the dominated figure. The dominating figure wears a swastika armband and the dominated figure a roseate similar to the one worn by the mangled figure in the left-hand panel.[46] Bacon's use of the swastika and a roseate resembling that of the British Royal Air Force have "encouraged a historical reading of the work."[47] Peppiatt argues that Bacon attempted to "empty [the swastika] of its usual significance"; such an exercise is exactly

44. For the range of opinion, see Hobhouse, "Francis Bacon," 38; Peppiatt, *Francis Bacon: Anatomy*, 224–27; Russell, *Francis Bacon*, 128–29; Schmied, *Francis Bacon*, 80; Sylvester, *Looking Back*, 14. Commentators agree that visual attention is distributed across the 1962 crucifixion; they also agree the 1965 crucifixion is superior aesthetically because it fixes the viewer's attention to the central panel. Russell, *Francis Bacon*, 128; Schmied, *Francis Bacon*, 80; Sinclair, *Francis Bacon*, 200–201; Sylvester, *Looking Back*, 114; Yates, "Francis Bacon," 189. While my eyes sometimes gravitate to the grotesque figure in the center, they quickly glide down its curvature and land on the bleeding figure in the left-hand panel. On other occasions, given the beauty with which Bacon has rendered the muscular flesh of its foreground figure, my attention fixes on the right-hand panel. In either case, the painting fails to fix my attention on the central panel. Here, again, Bacon incorporates movement and energy; the eye literally has difficulty staying fixed in any one spot.

45. Brighton, *Francis Bacon,* 62; see also Boxer, "Early Works," 181; Leiris, *Francis Bacon*, 41. In *Figures in a Landscape* (1956–57), similarly depicted figures appear to be engaged in oral sex. Comparing these images supports the inference that for Bacon violence and eroticism are intimately bound.

46. Davies and Yard liken these roseate-wearing figures to "the two thieves who shared Christ's fate on Golgotha." *Francis Bacon*, 45.

47. Domino, *Francis Bacon*, 61. Noting that the roseates are in the colors of the French revolution, Gale suggests a slightly different historical read of the swastika-bearing brutalizer. "Crucifixion," 143. Consistent with his biographical interpretations of Bacon's images, Peppiatt suggests that the right-hand panel may recall Bacon's turbulent homosexual youth in 1920s Berlin. Peppiatt, *Francis Bacon: Studies*, 110. Bacon rejected any historical reference for the swastika: "I wanted to put an armband to break the continuity of the arm and to add the colour of this red round the arm. . . . It was done entirely as part of trying to make the figure work. . . . I was looking at that time at some coloured photographs of Hitler standing with his entourage and all of them had these bands round their arms with a swastika." Domino, *Francis Bacon*, 61. "Bacon later regretted the literal reading suggested by this confrontation of World War II symbols." Davies and Yard, *Francis Bacon*, 45.

parallel to the triptych's strategy to empty the crucifixion "of all its tradi-
tional connotations."[48] Contrary to Peppiatt's understanding, however, the
history of the swastika—or the crucifixion—may overwhelm Bacon's for-
mal strategy. In other words, Bacon has not emptied the cross and the swas-
tika of their historical meaning, but has exposed their full horror by situat-
ing them in a new formal arrangement and symbolic order.[49]

Behind the swastika-bearing brutalizer, two men in dark business suits
stand at a railing. In his early and influential study of Bacon, John Russell
identifies it as a "secular altar-rail" and the onlookers as the donor figures of
traditional crucifixion paintings; he claims they look like "Australian out-
of-towners who have dropped by to see a not very good cricket match."[50]
Such bystanders appear frequently in Bacon's subsequent paintings. In this
triptych, they find their echo in the woman next to the bed in the left-hand
panel.[51] While "attendant" seems like an appropriate word for these figures,
"witness" is far too strong. Although situated near an act of brutalization,
these figures seem remarkably unconcerned. At most, they gaze casually,
and disinterestedly, at the mangled body in the left-hand panel, at the flayed
carcass in the center panel, or off into space. "Their lack of outward con-
cern is far more telling, in its context, than any sensational posturing."[52]
This representation of unconcerned witnesses at a scene of astonishing vi-
olence links *Fragment of a Crucifixion*, the 1965 triptych, and numerous sub-
sequent attendant-witness paintings.

Crucifixion's left-hand panel depicts a bloody figure on a bed and a nude
female attendant figure. The bedridden creature retains more of its skull
than its counterpart in the 1962 triptych, but its lower body is more with-
ered than the 1962 figure's fleshy legs. The 1965 figure is composed of simi-
larly rough paint and leaks a pool of blood from its body to the floor, while
resting its head on a blood-soaked pillow. Despite this horrific sight, the
awkwardly posed female stands by silent and unmoved.[53]

48. Peppiatt, *Francis Bacon: Anatomy*, 227.
49. Ficacci, *Francis Bacon*, 67; Yates, "Francis Bacon," 189.
50. Russell, *Francis Bacon*, 128.
51. Davies and Yard understand these figures as the replacements for the two figures
in the left-hand panel of the 1962 crucifixion triptych. *Francis Bacon*, 45. Because
they seem so much more detached from the goings-on of the triptych than the two
dark figures in the 1962 painting, I find such a reading unconvincing. Martin Har-
rison suggests that the figure on the bed is based on a book of photos from the Al-
gerian revolution Bacon owned, yet another possible historical reference. Harrison,
"Bacon's Paintings," 45.
52. Russell, *Francis Bacon*, 128.
53. Brighton wonders whether this triptych may not also have autobiographical
overtones. *Francis Bacon*, 61.

The central panel of the 1965 triptych, like the right-hand panel of the 1962 painting, is dominated by a hanging form with both human and animal features. As in the earlier painting, this figure rests on a red plinth with a green stripe, again suggesting a museum piece. Unlike the former painting, however, the animal and human features are not blended into a single creature, but most likely represent two. The animal creature hangs upside down; the human figure sits with its back against the green-striped board of the display platform. Although Bacon's distortions make identification of his figures a challenge, the rounded curves to the right of the bandaged limbs appear to be buttocks, which would make the splinted appendages legs and the exposed nubs feet. If this is an accurate interpretation, then the animal in this panel is devouring a wounded, defenseless human. The central panel, then, unlike the central and right-hand panels of *Three Studies for a Crucifixion*—or even *Fragment of a Crucifixion*—does not depict a ruptured, bleeding, screaming body, but rather the moment and activity of torture itself. Unlike all the prior crucifixion paintings considered here, the 1965 triptych is not the memorialization of crucifixion's effects in paint; here, the event itself is the artist's subject matter.[54]

Just as the 1965 triptych depicts the crucifixion event, *Three Studies for Figures at the Base of a Crucifixion* (1944) renders its audience. The triptych represents Bacon's first treatment of witnesses, here the painting's exclusive subject, a thematic feature he will return to in *Fragment of a Crucifixion*, the 1965 triptych, and many subsequent paintings. Each panel consists of a bright orange background with a few sparse lines that define a room; each contains a pale monster, comprising recognizably human and animal features, confronts the viewer. These bulbous creatures bear no resemblance to the sorrowful witnesses traditionally situated at the foot of the cross.[55]

54. Wilson Yates observes that these images unflinchingly record the moment of God's death ("Francis Bacon," 187). He goes on to write that "the human spirit remains capable, if given the means by which the truth can be known, of experiencing expiation and release from its bleak situation." While this may in fact be true, one would be hard pressed to find evidence for the claim in Bacon's paintings.

55. In his study of Bacon's early paintings, David Wayne Boxer interprets the creatures on the left and right as Mary and John, respectively. He notes that the bandage on the central figure's eyes is an allusion to Grünewald's *The Mocking of Christ* and that this creature's elevation on a platform operates to further identify it with Christ. He interprets the creatures in the side panels as witnesses and thieves, mourners, and cosufferers. On Boxer's account, the figures' ambiguity gives the triptych its power ("Early Works," 21–25); see also Hammer, *Bacon and Sutherland*, 113. This interpretation of the painting, like Davies's reading of the third crucifixion painting from 1933, demonstrates that critics long to link Bacon's paintings to traditional iconographies. Focusing on the indefinite article in the painting's title, several commentators

The facial expression of the figure in the left-hand panel cannot be seen clearly, but the grimaces of the other two could identify them as either the agents behind the execution or infuriated protestors, asserting the crucified victim's innocence. Either way, these witnesses are not paralyzed with sorrow or wracked with guilt as are the onlookers in traditional crucifixion paintings. "They become the ones over against the figures being crucified—the ones who crucify or who embody the emotions that feed vengeance and the cruelty of the act of crucifixion."[56] These figures reveal the thin lines between mourning, bearing witness, demanding suffering, and enacting violence. While the mouth of the central, blind-folded figure signifies only rage, the right-hand figure's cry could just as easily be sorrowful, and the collapsed, expressionless creature in the left-hand panel exudes an air of quiet despair.[57]

For the contemporaneous audience, the shock of the images came from their assumed connection to the events of World War II.[58] *Three Studies* was

reject these attempts. Davies, *Francis Bacon*, 46; Farson, *Gilded Gutter Life*, 45; Russell, *Francis Bacon*, 11.

56. Yates, "Francis Bacon," 174.

57. Bacon's later statement that these figures were based on the vengeful Furies from the Oresteia cycle and composed as studies for figures at the base of a large crucifixion generates more questions than it resolves. Boxer, "Early Works," 29–30; Clair, "Pathos and Death," 139; Laessoe, "Francis Bacon's Crucifixions," 7–13; Sylvester, *Interviews*, 112. Are the Furies agents of crucifixion? Or are they avenging angels? How are we to understand the relation between Greek and Christian mythologies? Given that the cross is traditionally interpreted as a triumph of mercy over law, and the Oresteia cycle as a triumph of law over vengeance, how does the painting want us to understand the relation among death, violence, mercy, sacrifice, revenge, justice, and grief? If these figures are the Furies—the female embodiment of the principle of revenge—why are the creatures in the center and left-hand panels so emphatically and exaggeratedly phallic? Given that the witnesses to the crucifixion in canonical texts and traditional iconography are overwhelmingly female, interpreting the figures according to Christian mythology does not provide an answer to this question. For discussion of phallicism and castration in the triptych, see Boxer, "Early Works," 63–65.

58. According to Martin Hammer, *Figure in a Landscape* (1945), a painting exhibited with the 1944 triptych and based on a snapshot of Bacon's lover and patron, Eric Hall, is "as important in establishing the distinctive characteristics and concerns of [Bacon's] work" as *Three Figures*. Hammer, *Bacon and Sutherland*, 24; see also Alley, "Francis Bacon's Place," 20; Brighton, *Francis Bacon*, 46; Davies, *Francis Bacon*, 66; Rothenstein, "Introduction," 11. The bright blue sky, the color of the grass and flowers, the presence of thick shrubs, the outline of a park bench, and the detail of a man's suit jacket all suggest the real world setting of the source photograph. The painting's surface was scrubbed by Bacon to give it the look of a newsprint photo. This evocation of newspaper photographs, combined with a fairly realistic representation of a machine gun firing at the viewer, transformed the fragments of Hall's body into the

originally exhibited in April 1945, shortly before the Nazi surrender, and "became one of the most discussed paintings of its era."[59] Bacon's painting, exhibited alongside more optimistic works by Henry Moore, Matthew Smith, and Graham Sutherland, would not allow its viewers to forget the horrific violence pervading modern society.[60] Russell recalls initial reaction to the painting:

> Visitors went into the Lefevre Gallery in a spirit of thanksgiving for perils honourably surmounted. Some of them came out pretty fast. For immediately to the right of the door were images so unrelievedly awful that the mind snapped shut at the sight of them. . . . They caused a total consternation. We had no name for them, and no name for what we felt about them. They were regarded as freaks, monsters irrelevant to the concerns of the day, and the product of an imagination so eccentric as not to count in any possible permanent way. They were spectres at what we all hoped was going to be a feast, and most people hoped that they would just quietly be put away.[61]

By linking contemporary violence with the spectacle of crucifixion, the painting connected the recent conflagration's horrors to the foundational structure of European society and even to cosmic history.[62] By painting the "ghouls . . . who gather . . . round any scene of human degradation," Bacon held up a mirror to the gallery audience, revealing the worst tendencies of human nature.[63]

figure of a dictator or warlord. Alley, "Francis Bacon's Place," 20; Davies and Yard, *Francis Bacon*, 16; Laessoe, "Francis Bacon's Crucifixions," 13. While in conversation with the World War II context in which it was created and exhibited, this painting evokes a terror and dread far beyond any specific historical reference. The black void where the figure's body and head should be heightens the image's ambiguous horror. The combination of cheerful colors with menacing action also unsettles the viewer—what is the appropriate affective response? John Rothenstein, director of the Tate Gallery at the time of Bacon's first retrospective, wrote that this painting "suggest[ed] the impending calamity that was to characterize many of Bacon's paintings during the next decades." "Francis Bacon," 163.

59. Gale, "Crucifixion," 139. For a detailed account of the composition, critical reception, and interpretation of this painting, see Hammer, *Bacon and Sutherland*.

60. Davies, *Francis Bacon*, 44; Russell, *Francis Bacon*, 9–10; Sinclair, *Francis Bacon*, 95.

61. Russell, *Francis Bacon*, 10–11. While critical reaction was mixed, most critics concluded that the 1944 triptych demonstrated that Bacon was a serious painter who deserved the attention of London's art world. Brighton, *Francis Bacon*, 10; Mortimer, "At the Lefevre," 239; Peppiatt, *Francis Bacon: Anatomy*, 109; Rothenstein, "Francis Bacon," 162–63.

62. Domino, *Francis Bacon*, 26; Ficacci, *Francis Bacon*, 13–18; Hammer, *Bacon and Sutherland*, 85–88.

63. Russell, *Francis Bacon*, 11.

In addition to the creatures' distorted physiognomies, other formal aspects of the triptych ratchet up viewers' anxiety and fear. The pictorial space appears cramped; the individual panels close down claustrophobically on the creatures.[64] The left-hand figure crouches without room to extend its neck. The central figure's head, consisting almost entirely of teeth, seems ready to tear through the canvas. Unable to raise its head (like the creature on the left), the creature on the right appears too large for its panel (like the creature in the center). Not only do they occupy spaces too small for their bodies, the triptych form isolates them "so that none can alleviate the other's torment."[65] The background color and its rough application work together as assaultive visual stimuli.

The creatures' distorted forms and indeterminate corporealities are largely responsible for viewers' affective response. Through the 1930s and 1940s, Bacon had been struggling with the biomorphic form. In *Abstraction* and *Abstraction from the Human Form* (both 1936, and both subsequently destroyed by Bacon), he experimented with distorted forms similar to the creature in the 1944 triptych's central panel.[66] The original version of *Landscape with Car*, painted in 1939 or 1940, featured a creature with the same penile neck and menacing teeth as the one in the 1944 triptych's central panel.[67] The snarling mouth had appeared in *Man in a Cap* (1941); *Study for a Figure* (1944) depicts a creature virtually identical to the figure in the left-hand panel of the 1944 triptych; and an untitled painting dated 1943 or 1944 depicts a creature virtually identical to the figure in the triptych's right-hand panel, except that this earlier creature is devouring a bouquet of roses.

Given its relation to these various paintings, *Three Studies for Figures at the Base of a Crucifixion* could be interpreted as the culmination of a series of formal experiments. Peppiatt opines that "*Three Studies* exactly fulfilled the requirements of the traditional 'masterpiece' in which the apprentice absorbs the style of the master (in this case, primarily Picasso) while estab-

64. Boxer, "Early Works," 57–58, 62. On Bacon's use of claustrophic spaces, see Griffin, "Francis Bacon," 169; Rothenstein, "Introduction," 14; Russell, *Francis Bacon*, 75. Bacon's use of space in the 1944 triptych is much more obvious when this painting is compared to its reimagining in *Second Version of Triptych 1944* (1988). In the second version, the panels are much larger and the creatures do not occupy as much of the frame: the emptiness is as menacing as the figures.

65. Sinclair, *Francis Bacon*, 95.

66. Baldassari, *Bacon—Picasso*, 151; Boxer, "Early Works," 15–16; Davies, *Francis Bacon*, 34–36; Peppiatt, *Francis Bacon: Anatomy*, 75–76.

67. Davies, *Francis Bacon*, 42; Peppiatt, *Francis Bacon: Anatomy*, 84–85; Sinclair, *Francis Bacon*, 73–74. When Bacon reworked *Landscape with Car* in 1946, he obscured the creature by adding dense foliage. This use of foliage is consistent with *Figure in a Landscape* and *Figure Study I* and *II* painted in 1945 and 1946.

lishing a style unmistakably his own."[68] Bacon insisted that this painting marked his beginning as a painter; to enforce this understanding, he refused to allow any works painted prior to the 1944 triptych to be shown in exhibits organized during his lifetime.[69] Regardless of how we analyze the triptych—as beginning or endpoint, in thematic or formal terms—it represents another important moment in Bacon's career that was marked by a crucifixion painting.[70]

Bacon's recurring motif of a putatively human figure in a scene plagued by violence is given a profound and unforgettable treatment in *Painting 1946*.[71] This painting again uses a bright background color to set off the central figure, but the 1944 triptych's assaultive orange has been replaced by shocking pink. Like most of Bacon's crucifixion paintings, with the exception of *Fragment of a Crucifixion*, the space of *Painting 1946* is marked as an interior, in this case by window shades, oriental carpet, and a tubular circle in the foreground. The nature of this space, however, is unclear: is it a sumptuously appointed butcher shop, a gruesome chapel, or a meat-adorned throne room?[72] This disorientation comes from the painting's fantastic arrangement of realistic details: no individual pictorial element lacks a referent in the real world; it is their combination in a single image that unnerves. From its chin, mouth, teeth, shirt collar, and boutonniere, the seated figure, though partially decapitated, is legibly human. Over its head is a realistically rendered umbrella; whether it obscures the figure's face, has obliter-

68. Peppiatt, *Francis Bacon: Anatomy*, 109; see also Davies, *Francis Bacon*, 70.

69. Brighton, *Francis Bacon*, 20; Domino, *Francis Bacon*, 26; Peppiatt, *Francis Bacon: Anatomy*, 237.

70. In the years immediately following the first exhibition of *Three Studies*, Bacon painted two figure studies that bore a striking resemblance to it. *Figure Study I* and *Figure Study II* (1945–46) were similar in their coloring, construction of space, and invocation of a monstrous but humanoid presence. Erroneous titles affixed to these works indicate that some exhibitor, collector, critic, or gallery owner had recognized this connection. According to Alley, *Figure Study I* has "sometimes been incorrectly and misleadingly known as 'Study for the Human Figure at the Cross II,'" and *Figure Study II* has been "sometimes been incorrectly known as 'The Magdalene.'" Bacon repudiated these titles and made it clear that he "never associated [these paintings] in any way with the Crucifixion." Alley, "Works of Francis Bacon," 38–39.

71. Like the first 1933 crucifixion and *Three Studies for Figures at the Base of a Crucifixion*, this painting was a milestone in the development of Bacon's professional reputation. Shortly after it was first exhibited, Alfred Barr purchased it for the Museum of Modern Art in New York. It was the first Bacon painting acquired by a museum. Farson, *Gilded Gutter Life*, 234–35; Laessoe, "Francis Bacon's Crucifixions," 21; Peppiatt, *Francis Bacon: Anatomy*, 117–18.

72. Readings advanced by, respectively, Gowing, "Francis Bacon," 14; Sylvester, *Looking Back*, 30; and Davies and Yard, *Francis Bacon*, 16–17.

ated it, or protects it from the bloody carcass looming above is unclear. The carcass dominates the frame; its white legs starkly distinguishing it from the pink background and the black of the umbrella and the figure's coat. Halved, its sundered spinal column forms a central vertical, its splayed legs a cruciform; the exposed rib cage underscores the violence of execution. In *Painting 1946*, Bacon initiates the connection between the crucified body and dead meat that will inform many subsequent paintings. This equation, as well as the beautiful stylization of meat, has a long pedigree in the European high-art tradition, but unlike his predecessors, Bacon's rendering

> suggests that the carcass is not simply hanging . . . but rather is literally being torn asunder. This feeling of rendering is amplified by the apparent cleavage in the center and the splitting apart of the vertebral column of the carcass. The idea of Crucifixion may be intimated in Rembrandt and perhaps in Soutine but it is certainly made more explicit in Bacon's treatment.[73]

To balance the carcass, smaller sides of meat have been placed on a circular frame in front of the figure; the shape, angle, and detail of these slabs of meat are similar to those in the left-hand panel of *Three Studies for a Crucifixion* (1962).

Like the howling creatures of the 1944 triptych, but in a manner "infinitely more powerful and successful," the figure in *Painting 1946* is ambiguously related to the violence and horror conjured by its setting.[74] Is the figure screaming, gasping, yawning, laughing, and in response to what? Is it threatened or threatening? Howling in fright at the charnel house scene or itself responsible for the torn carcasses? Is it the officiant at this massacre or its next victim—or both? Again, it is the enigmatic arrangement of realistic items rather than any specific detail that most unsettles the viewer.[75] *Painting 1946* extends the ambiguity of the 1944 triptych, where the divisions human/animal, witness/spectacle, and rage/despair were initially confused. Similarly, in the later crucifixion triptychs, the copresence of victims, witnesses, and aggressors creates a problem of identification for the viewer. Bacon's crucifixion paintings permanently unsettle the line between butcher and carcass, executioner and victim, crucified and crucifier.

73. Boxer, "Early Works," 84–85; see also Ades, "Web of Images," 18; Davies, *Francis Bacon*, 73–74; Stephens, "Animal," 92–94.
74. Peppiatt, *Francis Bacon: Studies*, 53.
75. Hammer, *Bacon and Sutherland*, 139–42. Given the painting's size, its display under glass, and the black void in place of the figure's head, the viewer standing in front of the painting sees her or his face where the seated, screaming form's face should be. The image's ambiguity thus redounds on the viewer: is the viewer an agent of terror or an endangered victim?

★ ★ ★

Born October 28, 1909, to English parents in Dublin, Ireland, in the neigh-
borhood where Oscar Wilde had been born some fifty years earlier, Ba-
con was baptized, attended church with his family during his childhood,
and received several months of his sporadic education from a local Protes-
tant clergyman.[76] As an adult, Bacon was a staunch atheist, materialist, and
nihilist who insisted "that Christianity was a ridiculous harness to put on
people."[77] Nonetheless, "for over half his career, Bacon's work revolved
around two of the most potent images of the Christian faith, the body
on the cross and the pope on his throne."[78] While I do not discuss Bacon's
interest in the pope, this section considers Bacon's proffered reasons for
his interest in the crucifixion. His words are offered not as authoritative
guides for understanding his images, but rather to emphasize that even on
his account of why he painted—and stopped painting—crucifixions, it is

76. For biographical information, see Brighton, *Francis Bacon*; Domino, *Francis Ba-
con*; Farson, *Gilded Gutter Life*; Peppiatt, *Francis Bacon: Anatomy*; Russell, *Francis Ba-
con*; and Sinclair, *Francis Bacon*.
77. Sinclair, *Francis Bacon*, 26; see also Harrison, "Francis Bacon," 52–55.
78. Peppiatt, *Francis Bacon: Anatomy*, 63, 69. Beginning in 1949 with *Head VI* and
concluding in 1971 with the second version of *Study of Red Pope*, Bacon painted
scores of images that took the pope as their subject matter. Alley, "Works of Fran-
cis Bacon," 45; Davies and Yard, *Francis Bacon,* 19–20; Sylvester, "Bacon's Course,"
32. Velásquez's portrait of Innocent X and a photograph of Pope Pius XII were
Bacon's sources for these paintings. Davies and Yard, *Francis Bacon*, 24; Peppiatt,
Francis Bacon: Anatomy, 129; Steffen, "Papal Portraits," 119. Bacon denied that his
papal portraits had any significance as either images of adoration or caricature, in-
sisting they were formal experiments following the genius of Velásquez and, ulti-
mately, failures. Archimbaud, *Francis Bacon in Conversation*, 158; Clair, "Pathos and
Death," 134; Sylvester, *Interviews*, 24–26, 37–38. Commentators have observed that
by painting distorted images based on Velásquez's papal portrait, Bacon was in one
fell swoop able to challenge the authority both of the church and of the Western
high-art tradition. Davies, "Bacon's Popes," 11–13; Newton, "Art," 708; Peppiatt,
Francis Bacon: Anatomy, 140; "Reviews and Previews," 43; Rothenstein, "Introduc-
tion," 14; Schmied, *Francis Bacon*, 21; Sinclair, *Francis Bacon*, 128; van Alphen, *Fran-
cis Bacon*, 110. Like the figures in his crucifixion paintings, Bacon's screaming popes
retain something of their grandeur and stature despite the extreme conditions in
which they find themselves. Moreover, like his crucifixion paintings, Bacon used
the papal portraits to work out formal problems. Alley, "Works of Francis Ba-
con," 45; Davies and Yard, *Francis Bacon*, 19–20. Finally, the presence of carcasses
looming up and over the papal figure in *Figure with Meat* (1954) and the slab of
meat on the side table in *Pope No. 2* (1960) link the crucifixion and pope paintings
iconographically. See Gamper, "Motif of the Crucifixion," 331; Sylvester, *Looking
Back*, 100.

permissible, perhaps necessary, to identify "crucifixion" motifs across his corpus.[79]

As with so many other aspects of painting generally or his painting specifically, Bacon claimed that his interest in painting crucifixions derived from formal concerns:

> One of the things about the Crucifixion is the very fact that the central figure of Christ is raised into a very pronounced and isolated position, which gives it, from a formal point of view, greater possibilities than having all the different figures placed on the same level. The alteration of level is, from my point of view, very important.[80]

Here Bacon was explaining why he abandoned the crucifixion as a subject. In *Fragment of a Crucifixion*, he had used a cross to isolate and elevate a figure. In Bacon's only other crucifixion painting to use a cross—the first *Crucifixion* from 1933—the two figures are on the same level because the second figure is clinging to the crucified body. Despite its title, then, this painting does not fit Bacon's formal definition of a "crucifixion." In the crucifixion triptychs from the 1960s, he elevates figures using gallery plinths and beds, while in the 1944 triptych, the central figure is on a stool. Surveying his larger body of work, one finds Bacon relying on couches, boxes, rails, pedestals, and trapeze wires to elevate, isolate, and focus attention on figures. Given the frequency with which Bacon elevates figures within his paintings, and the infrequency with which he uses a cross to do so, this formal feature can hardly be relied on to distinguish his crucifixion paintings from the rest of his images.

Bacon's other chief explanation for why he painted crucifixions relates to the motif's affective quality. According to Bacon, the crucifixion is "a magnificent armature on which you can hang all types of feeling and sensation. . . . I haven't found another subject so far that has been as helpful for covering certain areas of human feeling and behavior." Relying on the crucifixion, Bacon intended to capture life's intrinsic violence and cruelty. "I know for religious people, for Christians, the Crucifixion has a totally different significance. But as a non-believer, it was just an act of man's behaviour, a way of behaviour to another."[81] When asked by Jean Clair near the

79. On Bacon's caginess as an interview subject, see Gale and Stephens, "On the Margin," 22. On his motivations, see Peppiatt, *Francis Bacon: Studies*, 103.
80. Sylvester, *Interviews*, 46.
81. Sylvester, *Interviews*, 44, 23; see also Peppiatt, *Francis Bacon: Anatomy*, 63, 69. The feelings and sensations related to the crucifixion have something to do with the facts of crucifixion, which Bacon embraced, and with an emotional connection to the crucified Jesus, which Bacon denied. The affective power of Bacon's paintings depends,

end of his life whether the right-hand panel of *Three Studies for a Crucifixion* (1962) was "something more than a Crucifixion [because] it's almost a scene of slaughter, butchery, mutilated meat and flesh," Bacon responded, "Well, that's all the Crucifixion was, wasn't it?"[82] To explore this area of feeling, Bacon painted wounded, mutilated, bleeding, screaming figures. The sensations for which the crucifixion was such a magnificent armature were accessible not only through the body on the cross, which Bacon rarely painted, but through the distorted human figure, which he painted obsessively. Like the elevated figure, the distorted figure is present or suggested in the vast majority of Bacon's paintings.[83]

As noted at the start of this chapter, Bacon also related his interest in the crucifixion to a fascination with, and emotional response to, meat and slaughterhouses. Apart from meat's evocation of mortality, Bacon claimed that he was drawn to it for formal reasons, namely, "the great beauty of the colour of meat."[84] His comments about the beauty of meat, about the relation between meat and mortality, and about his personal identification with meat help explain why animal carcasses appear so frequently in his crucifixion paintings. They also illuminate why Bacon so vividly renders his figures' mutilated flesh. What remains an open question, however, is how to understand the meatlike flesh that comprises the overwhelming majority of Bacon's figures: what does it mean that almost all of Bacon's bodies look as if they have just run the abattoir's gauntlet?[85] If brightly colored, freshly slaughtered meat is closely connected to the crucifixion in Bacon's imagination, then it seems wherever flesh is rendered in the colors, smells, and cuts available in a butcher shop, the aroma of the crucifixion lingers. Given that Melville identified Bacon as "the greatest painter of flesh since Renoir," able to render it with an "intense beauty" that "is at the same time

in part, on liturgical and theological tradition, demonstrating that Bacon's putatively secular images are somewhat dependent on a particular religious sensibility.

82. Clair, "Pathos and Death," 135.

83. Hammer suggests that the crucifixion—a "naked male figure who is the innocent victim of extreme violence and persecution"—might have appealed to Bacon because of his homosexuality. *Bacon and Sutherland*, 126. As Bacon told Sylvester, painting a crucifixion is "almost [like painting] . . . a self-portrait. You are working on all sorts of very private feelings about behavior and about the way life is." *Interviews*, 46.

84. Gross, "Bringing Home Bacon," 29. "It's nothing to do with mortality, as people often think," Bacon claimed in the same interview. Since one of the reasons people might have thought that is because he had told them that was what he was thinking, this comment, like so many others from Bacon, seems slightly disingenuous. See also Giacobetti, "Francis Bacon," 29.

85. Bryson, "Bacon's Dialogues," 51–52; Cappock, "Motif of Meat and Flesh," 315–16; Deleuze, *Francis Bacon*, 21–22; Schwartz, "Paris Newsletter," 57.

horrifying," it remains unclear which of his paintings are not concerned with the splendor of meat, with the allure of mortality, with the spectacle of the crucifixion.[86]

Commentators on Bacon's treatment of the crucifixion have offered little assistance in unraveling his fascination. Like the artist, they focus on the emotional valence of his crucifixion images. Several note that Bacon uses the cross "as a traditional, emotionally powerful, figurative subject which dramatically symbolizes man's inhumanity to man."[87] Others note that the crucifixion paintings thematize the specter of mortality facing all human beings.[88] Because Bacon's meditations on cruelty and death are almost always worked out on the site of the body, these observations fail to distinguish his crucifixion paintings from the rest of his corpus. As Russell observes, for Bacon "crucifixion" is "a generic name for an environment in which bodily harm is done to one or more persons and one or more other persons gather to watch."[89] If that is true, if a Bacon crucifixion is (merely) a scene where bodily damage is done to a figure in front of an audience, they abound in his catalog.[90] Milan Kundera links Bacon's fascination with the crucifixion to his interest in the fate of the human body:

> Even the great subject of the Crucifixion, which used to concentrate within itself the whole ethics, the whole religion, indeed the whole history of the West, becomes in Bacon's hands a simple physiological scandal. . . . To link Jesus nailed to the Cross with slaughterhouses and animals' fear might seem sacrilegious. . . . No, not sacrilege; rather a clear-sighted, sorrowing, thoughtful gaze that tries to penetrate into the essential. And what essential thing is revealed when all the social dreams have evaporated and man sees "religious possibilities . . . completely cancelled out for him": The body. The mere *Ecce homo*, visible, moving, concrete.[91]

For Bacon, the crucifixion is a platform that displays the body's contingency, a formal mechanism that pierces death's denial, a framework that reveals life's violence. Viewer response is not primarily intellectual: when looking at Bacon's paintings, we not only gain a new awareness of death's

86. Melville, "Iconoclasm," 64.
87. Davies, *Francis Bacon*, 18; see also Moorhouse, "Crucifixion in Bacon's Art," 24–27; Rothenstein, "Introduction," 20.
88. Trucchi, *Francis Bacon*, 118.
89. Russell, *Francis Bacon*, 113.
90. Cappock, "Motif of Meat and Flesh," 311; Domino, *Francis Bacon*, 93; Ficacci, *Francis Bacon*, 65–66.
91. Kundera, "Painter's Brutal Gesture," 16–17.

inevitability, but, through his depiction of the mutilated body, feel mortality's cold fingers stroking our flesh.

Bacon's comments regarding crucifixion's formal, affective, and thematic potential explain why it might appeal to an atheistic painter. They fail, however, to distinguish Bacon's paintings that treat the theme from those that do not. Insofar as paintings across Bacon's oeuvre treat the same concerns that motivate the production of his self-proclaimed crucifixion images, it may not be the case, as Bacon insisted, that he abandoned the crucifixion theme after his 1965 triptych.[92] "Crucifixion paintings" may indeed not be a category distinct from Bacon's body of work as a whole.[93] Crucifixion is a perspective on bodies and their position in the world that informs Bacon's entire corpus. Bacon's crucifixion paintings must be placed alongside his other images when discerning what his work reveals about the condition and character of the human body in relation to violence and representation.[94]

92. Davies, *Francis Bacon*, 22–23. In comments to Sylvester, Bacon acknowledged that the motivations behind the crucifixion paintings continued to inform his later work: "I hope never to do the Crucifixion again, and I hope to be able to do figures arising out of their own flesh with their bowler hats and their umbrellas and make them as poignant as the Crucifixion." *Looking Back*, 237.

93. In claiming that crucifixion themes are present across Bacon's oeuvre, I am not suggesting they are present in every painting. I would be hard pressed to explain, for example, how his occasional landscapes, dog portraits, van Gogh studies, or jet-of-water paintings are about the violence and anxiety endemic to embodied existence (although the dog portraits exude a similar mood of unease). I am also not suggesting that crucifixion themes are present in all of Bacon's paintings in the same way. For example, the caged-executive/man-in-blue series from the 1950s reveal something about the isolating, claustrophobic anguish of modern life, but they use different techniques; the suffering does not occur on the body's surface. Similar observations could be made about Bacon's self-portraits or his portraits of Isabel Rawsthorne, Lucian Freud, Peter Beard, and John Edwards. Bacon's female nudes, especially his paintings using Henrietta Moraes as a model, would add another dimension to the discussion, but given my interest in representations of the male body, I do not discuss them here. For a discussion of Bacon's female nudes, see van Alphen, *Francis Bacon*, 169–74.

94. One possible source of Bacon's interest in the crucifixion, noted by commentators but unacknowledged by Bacon, is his friendship with the Australian painter Roy de Maistre. De Maistre was Bacon's senior by a few decades, but their family and class backgrounds were similar and both were homosexual. Bacon admitted learning a great deal about the technical aspects of painting from de Maistre, who, during the 1930s, was painting crucifixions along with other religious subjects. For a discussion of DeMaistre and Bacon, see Brighton, *Francis Bacon*, 22–26; Farson, *Gilded Gutter Life*, 30–31, 45; Harrison, *In Camera*, 35; Sinclair, *Francis Bacon*, 61–65. For a discussion of the influence of British painter Graham Sutherland on Bacon's crucifixions, see Hammer, *Bacon and Sutherland*, 109–32.

* ★ ★

Two sets of paintings illustrate the influence of crucifixion thematics in Bacon's larger body of work: portraits of George Dyer and depictions of male couples. In these paintings, Bacon subjects the male body to distortion, injury, violence, and trauma. In these images, the male body—especially its flesh—is in a state of crisis. Bacon gives his male-bodies-in-pain no reprieve, while still reveling in their majesty and allure.

Bacon met George Dyer in 1964. At least two stories of their meeting circulate. In the more prosaic, they met over drinks in a Soho pub.[95] In the more colorful, told by both Bacon and John Maybury's biopic *Love Is the Devil* (1999), they met when Dyer broke into Bacon's studio and the latter told the former he could take anything he wanted if he first spent the night.[96] Although Dyer represented Bacon's ideal of masculine beauty and allowed Bacon to assume the mentor role that Bacon's previous partners had assumed toward him, Dyer's lack of education, excessive drinking, emotional problems, and comparative youth made for a tumultuous relationship.[97] Regardless, Bacon had deep affection for Dyer, who "became his chief model . . . [and whose] lusty, fleshy, evasive nature would dominate his work."[98] Bacon worked Dyer's image into nearly fifty paintings, almost half of them after Dyer's suicide.[99] "As a final tribute, Dyer's face was featured on the poster and the cover of the catalogue for the second Tate retrospective in May 1985."[100]

Portrait of George Dyer Crouching (1966) features a nude Dyer crouching on the end of a board that extends over a circular sofa. His back, thighs, buttocks, and shoulders are sumptuously rendered in thick paint. This corporeal swirl folds in upon itself; without Dyer's right arm positioned between

95. Peppiatt, *Francis Bacon: Anatomy*, 211.
96. Sinclair, *Francis Bacon*, 197.
97. Brighton, *Francis Bacon*, 68; Domino, *Francis Bacon*, 46; Gale, "Memorial," 201; Peppiatt, *Francis Bacon: Anatomy*, 211; Russell, *Francis Bacon,* 160–61; Sinclair, *Francis Bacon*, 197–98.
98. Sinclair, *Francis Bacon*, 180–82, 198; see also Stephens, "Portrait," 182.
99. Nixon, "Francis Bacon," 324–35. Dyer died from a drug overdose on the eve of Bacon's retrospective in Paris. Farson, *Gilded Gutter Life*, 190–92; Peppiatt, *Francis Bacon: Anatomy*, 235–36; Sinclair, *Francis Bacons*, 217. For a discussion of works painted in response to Dyer's death, see Davies, "Bacon's 'Black' Triptychs," 62–68. Dyer was, after the pope, the personage to whom Bacon gave the most sustained attention.
100. Farson, *Gilded Gutter Life*, 192. Another testament to Dyer's importance in Bacon's life and work is that only with respect to the triptychs painted in the years immediately following Dyer's suicide did Bacon ever acknowledge a specific connection between his biography and his painting. Glueck, "Briton Speaks," 46; Peppiatt, *Francis Bacon: Anatomy,* 252; Sinclair, *Francis Bacon*, 222.

his legs, he would appear boneless, a human form not so much crouched as collapsed. This pose echoes several other crouching figures Bacon painted in the 1950s, but unlike those paintings, where the figure crouches on a rail in a virtually empty space, Dyer occupies a room dominated by a piece of realistically rendered furniture.[101] Although the earlier crouching figures appear desolate in their isolation, Dyer seems even more forlorn because his presence in this space is so clearly absurd and inappropriate. Whether he is cowering in fear, collapsing in pain, or readying himself for a leap into the sofa, his pose and environment mark him as a figure that does not fit. Not only is his body disintegrating for some inexplicable reason, his very corporeal presence in the world is plagued by discomfort.

Dyer's face is rendered in cubist fashion. His right eye gazes out of the painting at the viewer; his left stares into it. The twist of his face has split his nose so that he now has two; his mouth has been similarly divided. His face's leftmost incarnation slips off his skull. The crouching body, the disintegrating face, and the splash of white paint on the top of his head suggest that Dyer has been caught in the middle of or in the preparatory moments immediately prior to a leap.

Like the crouching nudes that occupied Bacon in the 1950s, Dyer's isolation, displacement, and dislocation are significant features of the painting. Like the human, bedridden figures in the crucifixion triptychs of the 1960s, Dyer is both sumptuously rendered and grotesquely collapsing. Like Bacon's crucified figures, the crouching Dyer has been elevated above the ground of the painting to focus the viewer's attention. Finally, as in so many of Bacon's paintings, movement and time are suggested by the application of paint and linked thematically to the corruption of the body.

In *Portrait of George Dyer Riding a Bicycle* (1966), the figure's elevation, its cubist stylization, and its corporeal disintegration are all magnified. The titular bicycle, moving across a dark, roughly textured ground, floats or falls in space. Two curved green lines could be ropes supporting the bicycle's wheels; even so, Dyer's suspension in the space of the painting remains tenuous. As with *Painting 1946*, realistic forms—a human body, a bicycle—in a fantastic setting create a vaguely unsettling image. Dyer's body appears slightly more comfortable in this painting than in the crouching portrait. He is wearing clothes; he is in a conventional pose; his left leg is fully realized with a solidity that suggests power and permanence. At the same time, his arms are black shadows, and he has no hands with which to grasp the bicycle's handlebars; his right leg is either absent or a black, shad-

101. For a discussion of Bacon's crouching figure paintings, see Boxer, "Early Works," 141–43; Davies, *Francis Bacon*, 131–32.

owy stump like his arms. His face is again split. And splashes of white paint suggest that image-making overwhelms bodily existence. A large shadow, in the shape of Dyer's characteristic profile, envelops a partially rendered, flesh-colored visage. Dyer's heads do not face the same direction, and neither has a complete set of features: the profile is nothing but shadow, the fleshy face lacks an eye. The bicycle's front wheel has split into three, adding to the air of instability. The very fact of movement distorts material objects, animate or not.

But neither does remaining motionless conserve the body, as *Portrait of George Dyer Staring at Blind Cord* (1966) and *Portrait of George Dyer Talking* (1966) illustrate. In these paintings, Dyer is seated on a stool, in a room with a curved floor, once again elevated in pictorial space. Sweeping curves that form powerful shoulders, arms, thighs, and buttocks simultaneously highlight the bodily features that are indistinct, mutilated, or absent. Moreover, the paint used to render his body is applied in a fashion markedly distinct from the smooth color that makes up the ground; this formal difference further isolates the figure and introduces a dynamic element in its flesh. In *Blind Cord*, the outlines of Dyer's body are no longer distinct and his head is not fully rendered. The collapse of Dyer's face to a single eye, half a nose, and a gaping mouth produces an image quite similar to the figure in the central panel of *Three Studies for a Crucifixion* (1962), albeit without the blood splatters. This resemblance between a head presumably shattered by a violent blow and a head rendered partially in a portrait blurs the line between the mutilation and the representation of the human form. In *George Dyer Talking*, Dyer's head is fully rendered in profile, but his body is distorted: his clasped hands disappear in a smear of white and pink; his legs cross in a way that is not humanly possible; his feet are useless blurs of pigment. These figures are not monstrous; they remain evidently human. They are, however, tenuous. Because they so closely approximate human form, because they are rendered in beautiful colors with such masterful technique, their incompletion and distortion are all the more disturbing.

George Dyer Talking has always struck me as one of the most somber and unsettling of the Dyer portraits. Dyer is alone. The painting is empty, debris litters the floor. Only a black line in a large white smear suggests a mouth. He looks off to the side, not at the viewer. His "talking" reaches no one. Just as his body has collapsed, his personhood, his ability to communicate, to enter into relation, is foreclosed by his formal presentation.[102]

102. Dyer suffered from a speech impediment that was often the subject of ridicule by Bacon and his verbally adept social set. Farson, *Gilded Gutter Life*, 181; Peppiatt, *Francis Bacon: Anatomy*, 211.

Several of the Dyer paintings contain multiple images of Dyer in a single frame.[103] In *Two Studies for a Portrait of George Dyer* (1968), he appears in the foreground dressed in a suit, seated on a chair, with only the slightest physical distortion. In the background, his naked form, bent in a cross-legged seated position, with missing limbs and smashed face, has been pinned to a canvas. By depicting Dyer's mangled body nailed to a canvas, *Two Studies* gestures to the violence of representation and image-making. By *nailing* it to a canvas, the painting evokes crucifixion. *Portrait of George Dyer Staring into a Mirror* (1967) and *Study of George Dyer in a Mirror* (1968) also treat this theme. In both paintings, the portion of Dyer's head not present in the foregound figure appears in a mirror within the painting. Only by combining the image from the mirror and the image from the main pictorial plane can one assemble the complete figure. In the right-hand panel of *Triptych (In Memory of George Dyer)* (1971), the first triptych Bacon painted in the wake of Dyer's suicide, is an upright canvas on which Dyer's head appears in profile. On this canvas, the head appears solid, stable, undistorted. A wash of paint spills from this bust, floods the canvas, and pours over the edge. This evocation of death and disintegration over the plane of a canvas is a stunning self-indictment of Bacon's use of Dyer as a model.[104] Dyer's "posthumous presence—unique in Bacon's art—is indicative of guilt as well as loss, as the occasionally absurdist portrayal during his lifetime (seen in *Portrait of George Dyer Riding a Bicycle*) gave way to memorialisation."[105]

These paintings that trade in broken, distorted, fragmented corporeal forms move the theme of physical corruption into new terrain. It is not only flesh's fragility or time's march that undoes these bodies; the gaze of the other and the codes of representation through which we are forced to present and understand ourselves also undo corporeal integrity.

I conclude my discussion of the Dyer portraits with a consideration of *Seated Figure* (1978). Here, Dyer's image is not the painting's central focus. He is represented in profile, with a slightly blurred face, as a statuesque figure in the painting's foreground. Given that the bust is in front of the circular platform on which the painting's other figure is crouching—elevated on a round, brightly colored platform, framed by a box that could be a canvas—Dyer could be understood as outside the space of the painting altogether. A number of features recall *Painting 1946*: the background color and overall composition, and the central figure's

103. See Schmied, *Francis Bacon*, 27–29; van Alphen, *Francis Bacon*.

104. For a fictional, first-person account of what it felt like to be Bacon's model, see Martin, "Dyer."

105. Gale, "Memorial," 201.

placement under an umbrella with a partially occluded head. Pursuing
the comparison further, one finds Dyer substituted for the earlier paint-
ings' carcasses. With *Seated Figure*, then, Bacon marks Dyer as the cru-
cified one.

The central panel of another triptych painted in the wake of Dyer's
death treats this section's second motif. *Triptych, August* (1972) features
one of Bacon's variations on Eadweard Muybridge's stop-motion pho-
tographs of male wrestlers, an image Bacon consistently translates into a
representation of male homosexual intercourse.[106] As with his other de-
pictions of wrestling copulators, the individual male bodies in this trip-
tych are indistinct: both figures are headless, buttocks and thighs exude
strength and violent motion, and there is the slightest suggestion of a
penis below the shadow covering the top figure's abdomen. Smears and
blurs in the paint, as well as a stray white mark near the top figure's calf,
indicate motion. The body is once again distorted, once again mobile,
once again beautifully rendered, once again in distress, once again on the
brink of disintegration. The wrestling couple signifies the sexual act as a
bodily crisis.

Bacon had first treated the wrestling lovers in *Two Figures* (1953).[107] Sev-
eral features of the painting are consistent with Bacon's other work from
this period: its restricted palette; its blurry figures, which here look as if
bars were passing through them. The ground is exceedingly dark, with

106. Some commentators write about the wrestlers in Bacon's paintings as coded,
disguised references to homosexual couplings. Snookes, "Roomful of Bacon," 351.
Others observe that Bacon merely made explicit the homoerotic subtext of the Muy-
bridge photos. Boxer, "Early Works," 152; Roskill, "Francis Bacon as a Manner-
ist," 44; Sinclair, *Francis Bacon*, 123–24. Others claim Bacon added the homoeroti-
cism. Davies, *Francis Bacon*, 150. Simon Ofield, on the other hand, has provided a
detailed account of the relation between these paintings and the iconography of
British physical-culture magazines from the 1950s. Ofield, "Comparative Strang-
ers"; Ofield, "Wrestling with Francis Bacon." With characteristic wit, Bacon report-
edly observed, "Of course we don't know what the wrestlers were *thinking*." Farson,
Gilded Gutter Life, 8.

107. Given that homosexuality was still a criminally punishable offense when *Two
Figures* and *Two Figures in the Grass* were first exhibited, their display was not free from
controversy. *Two Figures* "was kept in an upstairs room in case the gallery was raided
by the police." Farson, *Gilded Gutter Life*, 223; see also Peppiatt, *Francis Bacon: Anat-
omy*, 161; Sinclair, *Francis Bacon*, 124–25. "A member of the public complained to po-
lice that it was indecent; although officers investigated, no charges were brought."
Harrison, "Francis Bacon," 41. The painting was not shown again until almost a de-
cade later, at Bacon's first retrospective. Sylvester, *Looking Back*, 72. For a discussion
of Bacon's professional marginalization because of his work's homoeroticism, see
Tinterow, "Bacon and His Critics."

sparse lines suggesting a box that both focuses attention on and traps the figures. Although the scene has obvious sexual overtones, the bottom figure's grimace runs counter to straightforward notions of erotic pleasure. The scene is overrun by pain, fear, and—insofar as the bottom figure's face is reminiscent of a skull—death.[108] If this image links sex and death by placing two distorted, blurred figures on a bed, then how are we to understand the bloody, mutilated, eviscerated corpses lying alone on beds in the crucifixion triptychs? Do Bacon's paintings suggest that crucifixion is a sexual act and sex an act of crucifixion?

Two Figures in the Grass (1954) is slightly less obvious in its depiction of the sexual act. Without the title, in fact, it is difficult to discern that the painting contains two figures.[109] The sex act's ability to blur lines between independent bodies is a recurring theme in Bacon's work; corporeal integrity, the self's physical boundary, is a casualty of erotic pleasure.[110] The one clearly discernible figure is in motion, his powerful legs and well-rounded buttocks in plain view. If the grey-pink blur of paint on the far left edge is the second figure's head, unlike the grimacing entity of the 1953 painting, it appears to be turning and giving its partner a kiss. At the same time, the blurriness that indicates motion, combined with the figures' placement on the painting's edge, suggests that one figure has pursued, captured, and forced the other into this amorous embrace. Despite the kiss, violence is not absent from the painting.

In *Two Figures Lying on a Bed with Attendants* (1968) and *Studies from the Human Body* (1970), attendant figures are introduced into paintings with sexual overtones. The floor's curve in the 1968 triptych defines the panels as a single space. Two naked figures lying together in the center panel are watched by two figures sitting separately in the left and right panels. The attendants in these paintings look like Dyer figures. As with the attendants in the right-hand panel of *Crucifixion* (1965), their emotional engagement with the scene they observe, if any, is difficult to discern. Their presence introduces motion and time; as potential witnesses, they demand action, a next moment. Because they are being watched while sleeping naked, the central figures exude vulnerability. Because they rest in a bed like those

108. The painting may have a biographical source. See Cappock, "Motif of Meat and Flesh," Sylvester, "Bacon's Course," 46. On the influence of Bacon's relationship with Peter Lacy on his work, see Domino, *Francis Bacon*, 46; Farson, *Gilded Gutter Life*, 143, 159–60; Peppiatt, *Francis Bacon: Anatomy*, 134, 145, 152, 169, 171, 175, 192; Sinclair, *Francis Bacon*, 136, 141, 166–67.

109. "Until 1963 this work was known in the singular as 'Study from the Human Figure.'" Davies, *Francis Bacon*, 153.

110. Van Alphen, *Francis Bacon*, 123.

found in the crucifixion triptychs, they seem endangered. Identifying with the attendants, the viewer worries with them about the safety of the lying figures; identifying with the lying figures, the viewer experiences anxiety at being gazed upon in such an intimate context.

The wrestling figures in the central panel of *Studies from the Human Body* are muscular, but they have no heads; through intercourse, their bodies have coalesced into a single lump of flesh. Thematizing vision, an attendant figure in the right-hand panel sits in a doorway behind an old-fashioned movie camera.[111] The maroon and flesh-colored figure in the left-hand panel and the collapsed human figure in the right-panel find echoes in Bacon's later studies of figures in motion. Motion's disfiguring power is thus represented in each of the three panels. These paintings suggest that any motion—copulating, walking, dancing, dying—undoes the body. Insofar as violence is a gesture which marks, reshapes, and distorts the body, *Studies from the Human Body* suggests, as do the crucifixion paintings and the Dyer portraits, that life is a violent experience. On the one hand, this equivalence empties violence of content and robs it of moral force. On the other, it highlights the anxiety that is deflected and contained by narratives of subjective stability, bodily integrity, and phallic superiority. By gesturing toward forces of dissolution in the most mundane aspects of lived experience—perception, representation, movement, and time—Bacon's paintings undermine ideologies and rhetorics of wholeness, solidity, and stability that undergird the gendered distribution of power in contemporary culture.

The Wrestlers (1980), one of Bacon's last treatments of this motif, brings together virtually all of the themes from this section. It depicts the sexual act as combat: the bottom figure's eyeless, faceless head breaks open into a teeth-baring, gape-mouthed scream. The figures' deformed and misshapen bodies are crafted with colors and lines that exude beauty and grace. The eroticized struggle between two figures undergoing corporeal disintegration takes place in front of a panel that could easily be a blank canvas. They resist—or, perhaps, succumb to—representation's powerful force. Their blurred forms imply motion, indicating that the painting captures only a single moment in a continuing drama. The vast open space in front of the figures, their placement against a canvaslike backdrop, and the evocation of time, motion, and narrative make us aware of our role as witnesses. We do not simply look at them; we are made self-conscious of our looking.

Bacon's crucifixion paintings depict isolated, elevated figures enduring

111. For a discussion of voyeurism in this painting, see Davies, "Bacon's 'Black' Triptychs," 63; Russell, *Francis Bacon*, 65–66; van Alphen, *Francis Bacon*, 47–48.

bodily crisis in the presence of disengaged witnesses in a manner suggesting motion and the passage of time. Bacon's Dyer portraits depict an isolated, elevated figure undergoing bodily deformation in settings that call attention to the mechanics of perception and representation and suggest movement and temporal duration. Bacon's paintings of copulating wrestlers . . . well, hopefully, the point is clear. Bacon's paintings depict bodies undergoing violent changes because of their movement through time and space, because of the presence of witnesses, because systems of representation work to undo them.

★ ★ ★

The anxiety generated by Bacon's paintings centers on the body.[112] These bodies are disturbing because they are recognizably human despite their distortion. They contain *just enough* reality.[113] Bacon's paintings display the human body's decline; they are tragic because the figure cannot flee its demise. We are repulsed, nauseated, terrified, undone precisely because we identify with the bodies Bacon paints; we cannot *not* see our mortality, fragility, and instability in his distorted figures.[114] The recognizability of Bacon's bodies—despite, or perhaps because of, their torsion and fragmentation—enables them to signal the viewer's corporeal vulnerability. The mutilated, bedridden figures of the crucifixion triptychs are horrifying not because of their bloody, eviscerated state; they are horrifying because hands, feet, teeth, and eyes testify to human residue. These paintings' carcasses do not evoke pity, anxiety, and fear because of their bestial qualities, but due to their recognizably human features.

112. Kunth, "Representations of Nudes," 263; van Alphen, *Francis Bacon*, 32. In his analysis of Bacon's work, Gilles Deleuze draws a sharp distinction between the figurative and the figural, arguing that Bacon's art was focused solely on the latter. See also Domino, *Francis Bacon*, 84–85; van Alphen, *Francis Bacon*, 28. Although Deleuze's discussion helpfully draws attention to how Bacon's work foregrounds perception, the distinction Deleuze draws between the referential dimension of figurative painting and the supposed nonreferential depiction of the figural founders on the details of Bacon's paintings. As noted in the discussion of *Painting 1946*, several crucifixion paintings, and the Dyer portraits, Bacon's paintings are a jumbled combination of mimeticism and distortion. They are unnerving precisely because of their incorporation of realistic and recognizable details, in the midst of corporeal distortion and the violent application of paint.
113. "Traces of human presence are echoed, in Bacon's later paintings, by the—ostensibly incidental—incorporation of incidental items such as ashtrays, sculptures or discarded papers, forensic evidence of human activity." Harrison, *In Camera*, 121; see also Davies and Yard, *Francis Bacon*, 78; Domino, *Francis Bacon*, 90; van Alphen, *Francis Bacon*, 96.
114. Faerna, *Bacon*, 6.

As Kundera observes, Bacon's portraits do not arouse a familiar horror, "one in response to the insanities of history, to torture, persecution, war, massacres, suffering. No. This is a different horror: it comes from the *accidental nature*, suddenly unveiled by the painter, of the human body."[115] In addition to the similarity between the painted bodies and our own, the formal aspects of Bacon's paintings—scale, construction of space, method of exhibition—which envelop and incorporate the viewer, increase the potential for identification between spectator and image. The reflection of the spectator's face in the black void that is the head of the seated figure in *Painting 1946*; the enclosing structure of the rooms in *Three Studies for a Crucifixion*; the human-size torso of the writhing figure in *Fragment of a Crucifixion*—all serve to trap the viewer, virtually, in the scene of violence, torture, pain, and death. Just as certain Christian discourses command the believer to identify with the crucified body on the cross, the formal devices of Bacon's paintings compel the viewer to identify with the mutilated body on the canvas. In both instances, the body eliciting identification bears within itself the possibility of undoing the stability of the viewing subject.

Bacon's body-in-crisis is not, however, a generic body; the body that garners his attention is, almost exclusively, a *male*-body-in-pain. Bacon's male nudes, and his male couples, appeared in "a cultural scene where even female nudes were a rarity."[116] By giving male flesh—in his second 1933 crucifixion, in the violated bodies of his crucifixion triptychs, in the Dyer portraits, in the bodies of wrestling sodomites—a voluptuousness reminiscent of Michelangelo, Rembrandt, and Caravaggio, Bacon appeals to venerated representational codes.[117] At the same time, his explicit eroticization of the male form marks a significant departure from—or, perhaps, a noteworthy disclosure of—the dominant thematics controlling its depiction and reception.[118] More radical still than his conformation of the male form to his own personal erotic desires, Bacon's work exposes the illusory foundation of the social construct of masculinity.[119]

Insofar as the masculine subject is culturally understood as the epitome of wholeness, completeness, stability, power, and agency, it is never the subject of Bacon's painting. The crouching Dyer is poised to leap, but his body betrays him; the bicycle-riding Dyer moves through space, but the

115. Kundera, "Painter's Brutal Gesture," 18.

116. Domino, *Francis Bacon*, 39.

117. Kunth, "Representations of Nudes," 267; Sylvester, "Images of the Human Body," 35.

118. Tinterow, "Bacon and His Critics," 35.

119. Van Alphen, *Francis Bacon*, 190; see also Kunth, "Representations of Nudes," 267–68.

effort destroys his physical form; the sexual predator forces his partner to submit to penetration, but his own corporeal integrity is undone in the process; the crucified body is rent and affixed to a cross or flayed and discarded on a bed. The male body, with all its erotic desirability, majestic beauty, and grand fleshiness, is always torn, twisted, and coming undone in Bacon's paintings. Far from being an ideal worthy of envy and emulation, Bacon's masculine subject hovers on the brink of annihilation, barely able to complete the simplest tasks or maintain its existence from one moment to the next. Insofar as it draws attention to the male body and marks this body as a norm for humanity, the cross, like the bodies on Bacon's canvases, undermines the power ascribed to masculine subjectivity. The male body on the cross is lacerated, bleeding, pierced, thirsty, immobile, and dying; this male body at this particular moment cannot emblematize plenitude, impenetrability, or capacity. The male body on Bacon's canvases and Christianity's cross is not capable of securing a stable self. It is, rather, "the domain where the self is contested and ultimately lost."[120]

According to Ernst van Alphen, the violence of Bacon's paintings stems not so much from their representations of the violated body as from their thematization of how representation works to deform the human body. Van Alphen's nuanced and detailed reading of Bacon's images reveals how they depict the crisis of the subject vis-a-vis perception and representation. The affective character of Bacon's images, on van Alphen's account, relates primarily to their "hyper-reflexivity," to the way they foreground and assault the viewer's perceptual vulnerabilities, rather than their ability to secure an identification between the viewer and the bodies on the canvas.[121] The ubiquity of attendant figures, the iconography of image-making practices, and the foregrounding of voyeuristic desire in Bacon's paintings thematizes perception and representation in his work. The Dyer portraits, among other paintings, mark perception and representation as menacing, threatening, violent phenomena. This theme is rendered most emphatically in *Three Studies for Figures at the Base of a Crucifixion* (1944): violence and witnessing, this triptych tells us, are inseparable. Representation's violence, especially as signified in the Dyer portraits, stems precisely from the precarious situation it creates for the subject. While representation constrains, fragments, and destabilizes according to codes, rules, and narratives that precede the subject both temporally and logically, it also enables, grounds, and forms the subject by providing a frame that strives to establish a sense of internal coherence and secure a position of cultural legitimacy.

120. Van Alphen, *Francis Bacon*, 186.
121. Ibid., 13–15, 3032, 80–81.

The subject is not only unable to discover an outside to the codes of representation that define it, but can only locate itself as a possible object within the codes of representation that always already constrain it. The injury of representation, of the perceptive gaze of the other, is, therefore, a tragic violence: the subject cannot exist outside the constraints of representation, and representation cannot avoid marring the subject. The mutilated, disintegrating, fragmented, screaming, isolated, and surveilled human forms on Bacon's canvases attest to this fact.

Van Alphen links Bacon's critique of representation to his use of the crucifixion. For Bacon, he writes,

> the crucifixion betokens the inevitable consequence of representation, the tearing apart of the subject, the destructive effect of reproductive mimesis. And this is even more obvious in those works [e.g., *Two Portraits of George Dyer*] where the crucifixion is not represented by the cross or by slaughter, but subtly and microscopically by nails. As indexes of the immense suffering and total mortification of the body, the nails suggest that any attempt to represent mimetically may be regarded literally as an attempt to *nail the subject down*. Bacon accuses mimetic representation, by foregrounding its mortifying effects on the subject.[122]

Mimetic representation is the attempt to copy details of the world as they appear; it is the effort to make an image resemble a fact, to construct an artifact that captures reality. Where mimetic representation is understood as a legitimate goal for and viable possibility of artistic depiction, the faithful rendering of a person's face is given greater evidentiary value than its grotesque distortion so common in Bacon's paintings, even though both are highly stylized and conventionalized forms of representation. By making his distortions evident and extreme, Bacon calls attention to the representational violence of all image-making.

Theological discourses often understand themselves as attempts to reveal and describe the deep structure and meaning of reality. Christian theological discourses typically relate this deep structure to the incarnation, death, and resurrection of Jesus of Nazareth. In many ways, Christian discourses about the cross do precisely what van Alphen argues Bacon's crucifixion paintings criticize. By positioning a single person (Jesus), a single gender (male), or a single act (suffering) as redemptive, theologies of the cross mark details surrounding the crucifixion as ultimate facts. By offering a single understanding of the cross as *the* narrative of redemption, certain theologies hide the representational violence endemic to their construction of

122. Ibid., 247; see also 91–94.

meaning. As Bacon's paintings demonstrate, representation and meaning-making are inherently tragic: to assign meaning in a formal system of representation that suppresses its own meaning-making process—to present a meaning, that is, according to codes that presume transparency between representation and reality—is to preclude other meanings as legitimate interpretations. Any theological discourse that fails to acknowledge this tragic dimension of representation, that fails to acknowledge its partiality, specificity, and limitation, that fails to acknowledge that it is in fact a representation, that attempts to assign meaning and significance to the "facts" it relates, enacts violence on its adherents, actual or potential. The crucifixion is inexplicable: life from death, violence as an expression of love, the destruction of an omnipotent God, an innocent sacrificed for the guilty, existence arising from the abyss. Christian theologians should be wary of assigning a meaning to the cross; the crucifixion, by its form and content, shatters the possibility of meaning. The violence of the cross, like the violence of Bacon's paintings, potentially challenges not only our understanding of the stable self and the practices of masculine domination, but also radically challenges any notion of the unity and singularity of (theological) meaning.

★ ★ ★

In the now near-canonical interviews David Sylvester conducted with Francis Bacon, the late artist stated that he longed "to paint the one picture that will annihilate all the other ones, to concentrate everything into one painting."[123] Bacon's comment offers some insight into why his paintings share such marked formal, thematic, affective, and iconographic similarities. While different surveyors of his catalog would likely make different suggestions as to the image that most closely meets Bacon's purported goal, and while some would give the master's pronouncement of failure final authority, I offer his 1971 painting *Lying Figure in a Mirror* as a candidate for this ideal, conflagrational, consummate painting.[124]

In this painting, a room with lilac walls, a mustard-colored floor, and three black window shades is dominated by a large, flat panel. The panel—presumably the mirror of the title, but just as easily a canvas—displays a naked, muscular, rose-colored male body. Its undulating curves heighten its allure; its realistically rendered aureole and nipple rivet the viewer's attention.

123. Sylvester, *Interviews*, 22.
124. In making this suggestion, I am not implying that the paintings Bacon executed after 1971 do not merit attention. *Blood on the Floor* (1986) and *Blood on Pavement* (1988), for example, with their evocation of isolation and violence in the absence of a human figure, are particularly haunting.

This body is distorted in Bacon's typical fashion. The flesh of its legs, arms, and abdomen seems to be slipping off the bone. The body is liquefying—introducing motion and temporality into the image. The figure appears headless, with just the merest suggestion of a chin.

The space in which this body is displayed threatens to engulf spectators. With no external edge, the painting's floor slides into the audience's space. The mirror surface on which the body appears makes it the spectator's reflection.

The painting's affective dynamics are complicated. Any disgust or anxiety generated by the figure's headlessness, the awkward bends in its arms, and the twist of its legs is undercut, if not overcome, by the beauty of its flesh. Moreover, this body's distortion is not the result of an external violent gesture. It has not been wounded, flayed, or mutilated. Whatever force has been working its distorting power comes from within the corporeal form: this body simply collapses in on itself—the painting shows that bodies are their own worst enemies.

The mirror displaying this body must be understood as essential to its distortion: representation undoes the body. Mirrored reflection, however, is not the only relevant representational code. Posed similarly to a traditional female nude, this male body lies prone, fully exposed to an eroticizing gaze. Although disintegrating, this body is neither monstrous nor pitiable; its flesh remains warm and inviting. The painting depicts the risk run by those bodies offered up as objects of worship. It reveals that, just as female bodies can be rendered objects by the spectator's erotic gaze, the male body can be undone when caught in an objectifying code of representation. Far from being the source of power and meaning, the male body on display becomes the male body in crisis, a crisis brought on by the very attempt to aggrandize itself to the status of ultimate signifier.

Lying Figure in a Mirror exposes the razor edge of representation. To enable veneration and adoration, the figure must be isolated and aestheticized. These processes, however, transform the body into a signifier, with plural and unpredictable meanings. Bacon's figural distortion is a formal device for displaying the effects of this process. Instead of rendering his figures according to representational codes of mimetic realism, Bacon relies on formal devices and compositional techniques that make the figure ambiguous. Is the lying figure of this painting beautiful or grotesque, undulating with life or writhing in pain, solidly muscular or sickeningly mucosal? Because this transformation relies on the figure's aestheticization, it risks being infected with an erotic energy. No longer an object with a singular and stable empirical referent, the figure becomes the bearer of pluriform desire. Contrary to representational codes that depict the male body as the source

of sexual agency, Bacon's figures expose the desirability of the male body. These figures are erotic without becoming feminine. Bacon's bodies exude the voluptuousness of *male* flesh. Placement in the stream of signification and sexual contemplation, however, resituates them in relation to dominant codes of masculinity. Although Bacon's figures bear the marks of male corporeality and stylization, they do not embody the completion, stability, or control typically associated with masculinity.

Lying Figure in a Mirror displays a beautiful male body coming undone. This dissolution is depicted in visual terms that invite, implicate, and indict the loving adoration of the spectator. The collapse of the male body across Bacon's oeuvre challenges notions of masculine superiority and stability. The corporeal crisis of the male figure destroyed by the very representational codes that seek to elevate it to a position of dominance and superiority is the drama that pervades and shapes Bacon's work. His oeuvre continually restages the drama of crucifixion.

The crucifixion is a scene overrun by violence, pain, suffering, grief, and loss. Insofar as the Crucified One of the Christian tradition has been identified with God and insofar as faithful Christian spectators are supposed to identify with the Crucified One, the pain and death of the body on the cross is a source of anxiety and terror with both cosmic and personal dimensions. As an artistic subject, the crucifixion has for centuries allowed artists to explore techniques for representing the human form, and more particularly, the male body. Bacon obsessively returned to the crucified body, unrelentingly depicting its suffering and pain, unremittingly capturing its beauty and allure. Glorification of violated male flesh sometimes can recuperate and revalue the male-body-in-pain as something to be admired, celebrated, and worshipped—and Bacon most definitely celebrates male flesh's majestic splendor. But Bacon's images do not dwell lovingly on the body per se—his images rarely depict figures recognizable as stable human bodies. Rather, Bacon compels us to adore, to gaze upon lovingly, to appreciate aesthetically the male-body-in-pain as a body coming undone. Bacon glories in the ecstatic terror, the sublime horror, the blissful trauma of the male-body-in-pain. Fully resisting any recuperative consolation, Bacon's images visualize the haunting refrain, *"lama sabachtani."*

POSTLUDE

The mainspring of human activity is generally the desire to reach the point farthest from the funereal domain, which is rotten, dirty and impure. We make every effort to efface the traces, signs and symbols of death. Then, if we can, we efface the traces and signs of these efforts.

To ask oneself before another: by what means does he calm within himself the desire to be everything?

GEORGES BATAILLE

In the opening paragraph of a short pornographic novel written in the fall of 1941, which Bataille characterizes as key to understanding his theoretical text *Inner Experience*, the narrator stumbles drunk through the Paris streets, alone and half naked, until he enters the Mirror, a brothel "packed with men and women" (*ME* 149).[1] There, he selects the "ravishing" Madame Edwarda from a "swarm of girls"; they share a "sickly kiss"—and an orgasm—which causes the nameless john to shatter "like a pane of glass" and the shameless prostitute to "break in two at the same instant" (*ME* 149). In his postcoital stupor, the narrator falls into a "dazed confusion," only to be pulled back into focus by Edwarda's "thin . . . [and] obscene" voice:

> "I guess what you want is to see the old rag and ruin," she said. Hanging on to the tabletop with both hands, I twisted around toward her. She was seated, she held one leg stuck up in the air, to open her crack yet wider she used fingers to draw the folds of skin apart. And so Madame Edwarda's "old rag and ruin" loured at me, hairy and pink, just as full of life as some loathsome squid. "Why," I stammered in a subdued tone, "why are you doing that?" "You can see for yourself," she said, "I'm GOD." "I'm going crazy—" "Oh, no you don't, you've got to see, look . . ." (*ME* 150; ellipsis in original)

1. For Bataille's understanding of the relation between *Madame Edwarda* and *Inner Experience*, see *SEc* 116; Lukacher, *Maternal Fictions*, 164–65.

In *Sensible Ecstasy*, Amy Hollywood relies on this scene, which to her eyes "looks like a classic moment of fetishization," to bolster her contention that "for Bataille, the female sex is a wound, a terrifying and beautiful mark of castration, of the emergence of life out of laceration" (*SEc* 116–17). This moment from *Madame Edwarda* is crucial to assessing Bataille's representation of women, not because, as Hollywood suggests, it looks like the fetishistic drama, but precisely because it looks quite *unlike* it, assigning new roles and reactions to the actors, culminating in an alternate climax.

Madame Edwarda repeatedly draws attention to female genitals, describing them using metaphors of castration, but it does not sharply distinguish male from female according to a logic of castration. *Madame Edwarda* does not tell the story of Edwarda's woundedness or the narrator's self-loss; rather it relates a shared experience of coming undone. Bataille relies on metaphors of female lack and conceptions of heterosexual desire to undo the categories upon which they depend. Hollywood fails to recognize possibilities within Bataille's theoretical writings and pornographic fiction because she inscribes *Madame Edwarda* within a psychoanalytic logic of castration and fetishism. But Bataille's writings, especially his fiction, do not *repeat* the phallic logic of male plenitude and female lack; they *restage* the drama of loss and rupture. Although they use the terms, categories, and metaphors of plenitude and lack, they demonstrate their instability and mobility across male and female bodies. Perhaps such a restaging is merely another internal critique of phallic masculinity that Hollywood (and others) would reject as insufficient, but before dismissing it—and its potential political usefulness—we must have a clear understanding of how this critique differs from the representations it seeks to disrupt. By adhering closely to the metaphors of fetishism, *Madame Edwarda* both reveals its mechanism and presents an alternative imaginary.

To liken *Madame Edwarda*'s "rag and ruin" revelation scene to Freud's notion of fetishism is to forget that for Bataille the woman's "wound" is terrifying *and* beautiful. According to Freud, "no male human being is spared the fright of castration at the sight of a female genital"—a fright so powerful as to cause some men to become homosexual (*SE* 21:154). The fetish covers the mark of castration and endows "women with the characteristic which makes them tolerable as sexual objects" (*SE* 21:154). Bataille's unnamed protagonist, on the other hand, experiences a powerful desire *for* Madame Edwarda that exceeds the tolerance of Freud's fetishist. After Edwarda pulls apart her crack to show it to her client, and commands him to come to her, he reports:

> I was shaking. . . . I sank down on my knees and feverishly pressed my lips to that running, teeming wound. Her bare thigh caressingly nudged my

ear. . . . I was breathing (it seemed to me that I was choking, I was flushed, I was sweating). I hung strangely suspended, quite as though at that same point we, Edwarda and I, were losing ourselves in a wind-freighted night, on the edge of the ocean. (*ME* 150)[2]

The sight of Edwarda's divinized genitals creates unsettling physical and psychic reactions in the narrator, but these are mixed with—and even heighten—his desire for her. Immediately after this initial disclosure, Edwarda leads him upstairs where they "mak[e] . . . love [that] liberated us at last" (*ME* 151). After they finish, she quickly dresses and leads the narrator on a nightscape chase through the city streets. The novel culminates with Edwarda once again eagerly showing her crack and fucking a cab driver while the narrator watches (*ME* 157).[3] Although the narrator experiences anxiety, madness, anguish, and nausea, his desire for Edwarda, his longing to find her, his sense that she is a source of inexplicable pleasure—even divine revelation—never wavers. His reaction to Madame Edwarda's "castration" is vastly different than the reaction of Freud's fetishist.

More important than the quality of the narrator's desire, however, is the narrative's refusal to disavow castration. Freud understands disavowal as a psychic process that allows the fetishist to retain belief in the woman's penis and her castration simultaneously (*SE* 21:154). By fantastically concealing the mark of castration, the fetish supports disavowal. Bataille provides no such cover. From the "rag and ruin" scene near its beginning to the taxicab scene near its end, *Madame Edwarda* returns relentlessly to Edwarda's corporeal difference. Nothing in the novel supports belief in a female penis. But

2. Hollywood compares this scene to "Angela of Foligno pressing her lips to the wound on Christ's side" (*SEc* 116). (Andrew Hussey draws a similar comparison, but identifies the kisser as Thomas—confusing scriptural and mystical accounts. *Inner Scar*, 151.) Earlier in her text, Hollywood compares the wound in the Chinese torture victim's chest to the wound in Christ's side, claiming that both look "distinctly vaginal, suggesting a conflation of the wound with the female sex" (*SEc* 115). Although there are several paintings of Christ on the cross as well as numerous mystical texts that support an interpretation of his wound as vaginal, the Chinese man's wound seems much too expansive to be read this way. As with her conflation of Lacan with Bataille on the question of lack, Hollywood overemphasizes a similarity here. This prevents her from thinking about the significance of the torture photo's—and the crucifixion's—representation of a wounded *male* body as a site of ecstatic abandon.

3. On the ritualized repetitions of *Madame Edwarda*'s narrative, see Stoekl, "Recognition." Edwarda's insistence on displaying her crack marks another distinction between the novel and Freud's understanding of fetishism. In Freud's writing, the little boy sees the woman's genitals because he actively looks for or inadvertently glimpses them. In Bataille's novel, the woman shows off her body and compels male characters to look against their will.

the fetish's work is not simply a matter of concealment. As Hollywood explains, it also transforms the woman's body—"or, more commonly, parts of that body and/or clothing and other adornments associated with it"—so that it "becomes a substitute phallus with which [the fetishist] can replace his own penis if it is lost or threatened" (*SEc* 117). This description fits *Madame Edwarda* more closely, if still inadequately.

When preparing to leave the brothel, Edwarda "put[s] on a white bolero . . . [that] disguise[s] her nakedness" (*ME* 151). Her clothing conceals her body—and its "wound"—and functions as her metonymic replacement, allowing the narrator to spy her as she runs ahead of him through the streets. At the same time, when he catches up to Edwarda, "her thrashings had left her naked, her breasts spilled through her bolero . . . I saw her flat, pallid belly, and above her stockings, her hairy crack yawned" (*ME* 154; ellipsis in original). If Edwarda's clothing initially functions fetishistically, it fails to maintain the illusion it sought to foster. At the novel's conclusion, Edwarda is described in terms that liken her to the phallus. She sits "bolt upright" on the cab driver's "long heavy member," her

> head angled sharply back, her hair straying loose. Supporting her nape, I looked into her eyes: they gleamed white. She pressed against the hand that was holding her up, the tension thickened the wail in her throat. Her eyes swung to rights and then she seemed to grow easy. . . . I knew she was drifting home from the "impossible" and in her nether depths I could discern a dizzying fixity. The milky outpouring traveling through her, the jet spitting from the root, flooding her with joy, came spurting out again in her very tears: burning tears streamed from her wide-open eyes. (*ME* 157–58)

Paralleling the driver's stiff cock and Edwarda's upright body, his ejaculation and her orgasm, his cum and her tears, the novel transforms her body into something like a penis. At the same time, unlike the phallus, Edwarda requires the narrator's support, her pleasure is linked to the appearance of death, and she is penetrated. As with fetishistic disavowal, there is a doubleness here, but it cuts the other way: Edwarda *appears* to be the phallus, but the narrative goes to great lengths to undermine that interpretation (or to change the meaning of "phallic" altogether). Shortly after the passage quoted above, the narrator reports that "everything . . . drowned in [Edwarda's] dreaming stare: a long member, stubby fingers prying open fragile flesh, my anguish, and the recollection of scum-flecked lips" (*ME* 158). However much Edwarda becomes phallic, the narrative never loses sight of her body, its vulnerability, its specificity.

In the most significant departure from fetishism, *Madame Edwarda* pro-

vides no protection from the threat of castration—instead, at almost every turn, the narrative heightens the sense of dissolution that comes with erotic desire. During their initial encounter, the narrator shatters. This shattering leaves him dazed and confused. He partially recovers only to be compelled by Edwarda to look at her hairy, pink genitals, leaving him feeling crazy. He is next led upstairs, where he ruts like a pig and is left exhausted, surrounded by the "pungent odor" of Edwarda's flesh and his own (*ME* 151). After Edwarda rushes out, she eludes him, slipping away through the darkened streets, making him feel empty, terrified, desperate, and alone. When the narrator finally catches up to Edwarda, she is in some kind of respiratory distress. He carries her to a taxi stand, where she again takes charge, first telling the cab driver where to go, then insisting the driver fuck her. Although the narrator mentions his erect penis in the second paragraph and selects Edwarda as his nocturnal companion in the fourth, the remainder of the story is driven by Edwarda's narrative agency.[4]

At the formal level, the novel reveals the narrator's limitations. In the opening sentences, he refers to his "foul dizzying anguish" and nausea. Soon thereafter he reveals his inadequacy *as a narrator*: "The beginning is tough. My way of telling about these things is raw. I could have avoided that and still made it sound plausible. . . . But this is how it has to be, there is no beginning by scuttling in sidewise. I continue . . . and it gets tougher" (*ME* 148). At the novel's conclusion, having drifted into sleep with Edwarda, he makes a similar confession—"Continue? I meant to. But I don't care now. I've lost interest. I put down what oppresses me at the moment of writing"—and then provides a brief disquisition on meaninglessness and nonsense (*ME* 158–59). In the middle of the story, when he has caught up

4. In her essay on Bataille's conception of virility, Susan Rubin Suleiman relies on the narrator's erection and selection of Edwarda to conclude that "despite [Bataille's] persistent anguish and obsession with 'undoing' . . ., the narrator of *Madame Edwarda* is a potent male." "Bataille in the Street," 28. While recognizing that this is not a full description of the novel, she fails to acknowledge that the narrator *begins* with relative potency and then rapidly and progressively comes undone, due in large part to interactions with the very prostitute he selected. After reading the novel in its entirety, it is difficult to accept Suleiman's characterization of its narrator. On the narrator's limitations, see Mayné, *Eroticism*, 134–35.

Suleiman argues that Bataille transvalues virility into actively chosen self-sundering. She concludes that this is an inadequate political intervention because even though virility, for Bataille, comes to signify almost the exact opposite of what it means traditionally, he cannot strip the word of its cultural history. Ultimately, Suleiman seems dissatisfied not with Bataille's retention of virility, but rather with the politically quiescent *content* he gives it (41–43). This is a different claim and requires a different argument.

to Edwarda and is struggling with "a certain power" welling up inside, an invading "ugliness," a feverish desire that could signify his longing to sexually assault her, he does not relate his conquest but once again parenthetically refers to his inability to use language, to convey secrets, to perform the work of narration (*ME* 156).[5] And, between his encounter with Edwarda's "loathsome squid" and their "animal coupling," two and a half lines of text are completely struck, utterly without words. In the final sentence, he does not awake and resume mastery after a night of debauchery, but reports that "the rest is irony, long, weary waiting for death . . ." (*ME* 159). His tale concludes with an open-ended ellipsis, not a definitive period. As both a character and a function, the narrator comes undone in the text.[6]

Unlike psychoanalytic discourses that signify the woman as lacking something the man has, the narrator and Edwarda are rendered as similar. During their sickly kiss, they "break in two at the same instant" (*ME* 149). When the narrator kisses her teeming wound, he feels them experiencing a similar sense of self-loss. After intercourse, the smell of their flesh "commingled," flinging them "into the same heart's utter exhaustion" (*ME* 151). Finding her "writhing on the pavement," the narrator "enter[s] a similar state of absorption" (*ME* 155–56). And in the cab, watching her climax, the narrator shares Edwarda's anguished pleasure until "the same sleepiness" bears down upon them (*ME* 158). Unlike castration discourses that differentiate male and female bodies, *Madame Edwarda* strives to show how Edwarda and the narrator are the same.

5. The language that most strongly suggests rape is his description of "a power that would be mine upon the condition I agree to hate myself. . . . The vertiginous sliding which was tipping me into ruin had opened up a prospect of indifference, of concerns, of desires there was no longer any question: at this point, the fever's desiccating ecstasy was issuing out of my utter inability to check myself. (. . . Should no one unclothe what I have said, I shall have written in vain. . . . Led on by [Edwarda], I came to want to do the leading in my turn. This book has its secret, I may not disclose it. Now more words.) Finally, the crisis subsided" (*ME* 156). While this passage prevents characterizing the narrator's self-loss as total, it does not fully recuperate him. More importantly, even if this passage describes a sexual assault—or the desire for one—it does not celebrate or glorify that desire. Strangely, none of the critical feminist readings of *Madame Edwarda* mention this passage.

6. Judith Surkis argues that Bataille's notion of self-loss and Michel Foucault's appropriation of it are inadequate because they retain a narrational/authorial presence, usually coded male, that witnesses/theorizes the loss and therefore does not experience it directly and fully. While technically accurate, Surkis fails to do justice to the lengths to which Bataille goes, especially in his fiction, to undermine the traditional authority of the narrational voice. See Surkis, "No Fun and Games."

Hollywood claims that Madame Edwarda's "body [is] fully [inscribed] within a phallic logic in which the female sex is experienced and represented only as an absence" (*SEc* 117). This claim simply cannot be squared with the novel's details: Edwarda is "experienced and represented" as a narrative agent who exercises initiative and expresses desire; insofar as her body is described as wounded, it signifies not absence, but a desirable, if confounding, presence.[7] Hollywood rejects as inadequate Bataille's attempt to "undermine phallic masculinity" because it is performed "within its terms" (*SEc* 116).[8] But Bataille's novel is not simply—or even primarily—a critique of Freudian logic; rather, it offers a different representation of desire, embodiment, (inter)subjectivity, and meaning (or lack thereof). Because it echoes the structural logic of fetishistic desire, it has affective power. The novel bumps right up against representations of women (and men) that sustain fantasies of masculine power, only to use these representations against themselves to undo the illusions of both (masculine) plenitude and (feminine) lack with a narrative of intersubjective intimacy and erotic desire grounded in anguished laceration.[9] The doubleness of Bataille's representations of women—the way they both inhabit and transform culturally dominant metaphors—is the source of their critical purchase.

7. When the text does draw attention to Edwarda's "nothingness" and "absence," it is describing her flight from the narrator—i.e., her literal physical absence. It may be problematic to link her narrative agency with nothingness, but this is not the same operation as the one Hollywood faults.

8. I focus my attention on Hollywood's work throughout this chapter not because her treatment of Bataille is especially problematic, but rather because she offers one of the most supple and sophisticated readings of Bataille in the secondary literature. In *Sensible Ecstasy*, Hollywood offers a remarkably lucid and persuasive account of the value of Bataille's concern about historical and political narratives that seek to justify or explain human suffering, as well as the ways he challenges fantasies of phallic mastery. When discussing each, however, she expresses marked reservations about his approach. Her strongest critical statements concern Bataille's treatment of women as representing lack, but she modifies and qualifies these statements in her footnotes. On my reading, Bataille provides helpful answers to the questions with which Hollywood concludes (*SEc* 277) and, but for his conception of lack—which Hollywood herself nuances—I do not understand why she assesses him differently. Given the complexity of her characterization and evaluation of Bataille, my disagreement with Hollywood may be narrower than my text suggests. But given the overall nuance of her consideration, the places she stops short are exceptionally jarring.

9. I am mindful of Jean Hyppolite's comment about *Inner Experience*. Recognizing that Bataille could have avoided certain criticism by not invoking Christianity, Hyppolite concluded that this would have made the book "infinitely less interesting." Bataille, "Discussion on Sin," 73.

* * *

Despite his refusal of "the fantasy of male phallicism," Bataille does not escape fetishistic thinking, on Hollywood's reading, because "women continue to represent lack *for* men" (*SEc* 118). While she appears to base this claim on her discussion of Bataille's use of "the prostitute [as] the 'erotic object' . . . through which both mortality and the sacred can be apprehended by men" (*SEc* 117), she recognizes that both women and men can be prostitutes and that Bataille's understanding of the prostitute's loss of autonomy "begins with the assumption of women's freedom and full subjectivity" (*SEc* 311n14). Hollywood assumes, without argument—and seemingly against some of her own observations—that Bataille's "erotic object" necessarily entails and represents female lack.[10]

For Bataille, "the object of desire . . . is not eroticism in its completeness." Rather, "eroticism work[s] through [the object] . . . [and is] expressed by an object" (*Er* 130; see also *ASII–III* 139–40). "The object of desire" exists not "for itself but for the other's desire" (*ASII–III* 143). The prostitute is the object of desire par excellence, because "prostitution makes an offered woman into a dead object" (*ASII–III* 140, 143). Although every woman is "not a potential prostitute . . ., prostitution is the logical consequence of the feminine attitude" of passivity (*Er* 131).

While I do not deny the problematic character of these comments, Bataille's writing about the erotic object has a complexity that his feminist critics fail to note. The doubleness in his conception of the erotic object must be brought to light before its relation to the notion of lack can be assessed. Initially, it should be noted that Bataille recognizes that imagining a human being as an object, even an erotic object, "is a little disconcerting" (*ASII–III* 137). He points out that a human being is always a *subject*, never a thing (*ASII–III* 137–38). Writing in France at the same time Simone de Beauvoir published *The Second Sex*, he likens men's attitudes toward and perceptions of women to the objectifying degradations of slavery (*ASII–III* 139).[11] He characterizes slavery as an attempt to reduce humans to things—stating that it "was necessarily a fiction" (*ASII–III* 138).[12] Al-

10. For similar critiques, see Guerlac, *Literary Polemics*, 23–35; Suleiman, *Subversive Intent*, 82–83.

11. Bataille suggests that "low prostitution," or prostitution that is necessitated by poverty, does not have the same transgressive power as the "ideal" prostitution of passive femininity (*Er* 134–35). While hardly canceling the problematic implications of his discussion of prostitution and feminine passivity, this evinces his awareness of the difference between representation and material reality.

12. When human beings are made into things, the "communion" between them is broken (*IE* 132).

though Bataille's worries about objectification do not fully respond to Hollywood's concerns, given his assumption that such representations are necessary to erotic interaction, they show that he distinguishes between how women are perceived and who they are in reality, and recognizes that representations have material consequences.

Not only does Bataille explicitly note that construing human beings as objects is a problematic cultural representation, he also states that objectification need not follow gender lines. "Theoretically a man may be just as much the object of a woman's desire as a woman is of a man's desire" (*Er* 130). While this reversal does not expel objectification from erotic desire, it suggests that women and men can occupy either position, which means that neither is necessarily associated with plenitude or lack, even if we assume with Hollywood that object status entails lack.[13] But Bataille also divides men and women along an active/passive axis that seems to be more fixed.

"The first step towards sexual intercourse . . . is usually the pursuit of a woman by a man. Men have the initiative, and women have the power of exciting desire in men. . . . [Women] are no more desirable, but they lay themselves open to be desired" (*Er* 130–31). Although women and men are both erotically desirable, men actively pursue the objects of their desire, whereas women remain "passive" and "try by exciting desire to bring about the conjunction that men achieve by pursuing them" (*Er* 131). While Bataille's description of women's powers of seduction resembles stereotypical pronouncements—"By the care she lavishes on her toilet . . ., a woman regards herself as an object always trying to attract men's attention" (*Er* 131)—his account renders unstable the distinction between activity and passivity. Why is the man's pursuit active and woman's coquettishness passive? After all, "the concern she has for her beauty" requires a tremendous amount of attention, energy, thought, and planning.[14] While I am not suggesting that the feminine masquerade alone is a sufficient political strategy (even if, as Judith Butler and Mary Ann Doane suggest, it might be valuable as one of a range of political tools), it is certainly an *activity*. What Bataille most likely means is that the woman cannot be *perceived* as an active participant in the

13. Moreover, even with his caveat that sexual difference makes erotic desire more powerful, Bataille's explicit acknowledgment that eroticism works in fundamentally the same way for homosexuals suggests that the categories of active and passive do not adhere essentially to male and female bodies. See *ASII–III* 437n2; *Er* 99.

14. When conforming to cultural norms of physical attractiveness, women can—and often do—treat themselves as objects whose value resides only in the desiring gaze of a man. Much feminist ink has been spilled trying to bring this to conscious attention and thus break its hold.

dance of desire; her performance must convince both herself and her erotic partner that she is a passive object.[15]

For Bataille,

> the whole business of eroticism is to strike to the inmost core of the living being. . . . Transition from the normal state to that of erotic desire presupposes a partial dissolution of the person as he exists in the realm of discontinuity. . . . The male partner has generally an active role, while the female partner is passive. The passive, female side is essentially the one that is dissolved as a separate entity. But for the male partner the dissolution of the passive partner means one thing only: it is paving the way for a fusion where both are mingled, attaining at length the same degree of dissolution. The whole business of eroticism is to destroy the self-contained character of the participators as they are in their normal lives. (*Er* 17)

Bataille's eroticism seems to require the spectacle of a passive woman undergoing dissolution so that the actively desiring man can experience self-loss. On one reading, emphasizing the gender exclusivity of the pronoun describing the person who experiences "partial dissolution," the woman is a thing the man uses to attain this experience; she has no access to the experience herself. Another reading, however, would emphasize that both parties "[attain] at length the *same degree* of dissolution," even if the woman experiences it (first?) passively and the man experiences it (subsequently?) actively. Without question—and without questioning—Bataille relies on (and reinforces) cultural assumptions about male activity and female passivity, but this distinction, on Bataille's account, neither precludes the woman's experience of erotic ecstasy nor differentiates the character of the man's experience of self-dissolution. Finally, and perhaps most importantly, insofar as eroticism requires the woman's dissolution, she must be experienced, in "the normal state" of things, as *not* dissolved, as a "self-contained" "separate entity." In other words, for eroticism to work in the way that Bataille understands, women—whether they are considered passive objects or not—must have some kind of subjective stability, unity, and solidity in the cultural imaginary.[16] For a woman to dissolve during erotic abandon, she must, at some point, represent something other than lack and loss.

15. This finds further support in Bataille's claim that the erotic object's beauty is enhanced when it seems distant from the capacity for work. See *ASII–III* 145–46; *Er* 143.

16. For this reason, the collapse of Lacan's conception of woman as "not whole" into Bataille's conception of woman as erotic object must be reconsidered. For the view that Bataille and Lacan are similar on the question of lack, see Dean, *Self and Its Pleasures*, 244–45; *SEc* 148–51, 181. For the view that they are not, see Sweedler, *Dismembered Community*, 123–24.

While Bataille's characterization of an active-passive relation suggests a distinction in how men and women experience eroticism, this distinction cannot be maintained in light of his broader discussion of the erotic object. For Bataille, the erotic object is paradoxical: it is "an object which implies the abolition of the limits of all objects" (*Er* 130). In *Inner Experience*, he distinguishes ecstasy from love by how they relate to the subject-object distinction.

> Ecstasy is not love: love is possession for which the object is necessary, and at the same time possession of the subject, possessed by it. There is no longer subject-object, but a "yawning gap" between the one and the other and, in the gap, the subject, the object are dissolved; there is passage, communication, but not from one to the other: *the one* and *the other* have lost their separate existence.
> . . . The subject is no longer there; its interrogation no longer has either meaning or a principle. . . . No answer remains possible. The answer should be "such is the object," when there is no longer a distinct object. (59–60)

Here, subject and object are not gendered, nor linked to activity and passivity; moreover, they both come undone—become indistinguishable—in the ecstatic encounter. Even if eroticism initially requires a passive object, as *Erotism* suggests, it does not sustain an imaginary of objectification, as both *Erotism* and *Inner Experience* explicitly state. Instead, erotic ecstasy, through dissolution of both partners' sense of isolated existence, undoes the order that "subject" and "object" seek to impose on profane reality.

In *Erotism*, Bataille notes that, in orgasm,

> each being contributes to the self-negation of the other, yet the negation is not by any means a recognition of the other as a partner. . . . The violence of one goes out to meet the violence of the other; on each side there is an inner compulsion to get out of the limits of individual continuity. . . . Both creatures are simultaneously open to continuity.[17]

Once again, Bataille insists on a shared experience. Insofar as the failure to recognize the other as a partner—or subject—reintroduces objectification as a condition for erotic experience, Bataille suggests that each participant perceives, and is perceived as an object to be violated. This emphasis on an equivalent experience for both entities suggests that the subject-object re-

17. Bataille claims that orgasm occurs "slowly for the female, but often for the male with fulminating force" (*Er* 103). Consistent with his privileging of the subjective dimension of eroticism over the objective, he concludes by stating that orgasm is "simultaneously [its] most intense and . . . least significant" feature (*Er* 103).

lation, and perhaps the active-passive distinction, are not objective facts but subjective experiences. In other words, in the frenzy of erotic passion I experience myself as a subject undone by an object, but my beloved has the same experience, with "me" playing the role of violated, dissolving object.

In "History of Eroticism," the second volume of *The Accursed Share*, Bataille provides his fullest account of erotic desire. He clarifies that it "always seeks two objects." One "is mobile and alive," the other "fixed and dead" (*ASII–III* 143). The mobile, living object equals my desire's intensity; it consumes me. Known first as "*other*, as different from" me, it eventually responds to my desire, "in the transparence of an intimate comprehension" (*ASII–III* 113). The fixed, dead object "corresponds [not] to the desire to lose or to risk" but rather to a longing for "acquisition and conservation." It is in this latter sense that "men generally . . . see women as things . . ., [as] objects to be possessed . . ., [as] the *objects* of erotic desire" (*ASII–III* 139).

Although the "fixed and dead" object is "an essential element of eroticism . . ., we usually prefer . . . the movements of beings more real, existing for themselves and wanting to respond first to their own desire" (*ASII–III* 143). Eroticism, then, is the movement, the struggle, between the "mobile-living" and the "fixed-dead." This dialectic "make[s] up the totality of eroticism," and within this totality, we strive to "lead the mobile-living" to "the *dead point*," because the former disrupts our fantasy of autonomous, self-contained existence (*ASII–III* 139, 143). When confronted by active beings who exist for themselves, "we cannot prevent ourselves from struggling toward a destruction": therefore, "we . . . bring this object equal to ourselves . . . inside the purview of the dead object, of the infinitely available object . . ., the prostitute" (*ASII–III* 143).

While recognizing a doubleness in erotic desire, Bataille concludes by asserting that "a fulgurating character is not *directly* alluring" (*ASII–III* 144). Because an object with its own desire creates an impediment to the subject's desire *for* the object, it is necessarily less attractive, because less capable of being fully owned and controlled.[18] In other words, eroticism in its totality might have two strands, but the acquisitive, possessive strand—the one that construes women as utterly passive—most powerfully stirs desire. When Bataille revisits eroticism a few years later, the mobile-living object is given no textual expression. In *Erotism*, he insists on the woman's passivity and characterizes "prostitution"—that is, the dead object—as "the logical consequence of the feminine attitude" (*Er* 131). He does not discuss eroticism's

18. For this reason, Bataille considers Sade's novels the ultimate and most consistent articulation of erotic desire, while recognizing that the desires they narrate can only be practiced in literary form. See *ASII–III*, 177–78.

dual nature in this later text but instead explains the subjective experience of eroticism by comparing it to religious sacrifice (*Er* 21–22). Likening the sexual encounter to ritual killing may seem as reprehensible as comparing women to dead objects, but the generativity of this metaphoric alignment can be found in Bataille's description of the sacrificial victim's peculiar status.

Although Bataille does not spell out his full understanding of the unique character of the sacrificial victim in *Erotism*, the book contains valuable hints. First, Bataille surmises that human sacrifice is a recent phenomenon and that animals were "often slain as substitutes for" humans, especially when animals were considered "no different," even "regarded as more sacred, more god-like" (*Er* 81). Whether Bataille's history is correct, these observations reveal his understanding that the sacrificial victim has a human dimension: the victim is selected for sacrifice not because it is a thing, but because it is not. When comparing sacrifice and eroticism, Bataille focuses on their shared capacity for "revelation of continuity" (*Er* 22). Continuity—intimate connection with the other—is not susceptible to rational description, "but it can be experienced in such fashions, always somewhat dubious, as hazard allows" (*Er* 23). Sacrifice reveals continuous existence—"to those who watch it as a solemn rite" (*Er* 22). Under what conditions does "the death of a discontinuous being" have "the power to reveal what normally escapes notice" (*Er* 22)? And what does an understanding of the sacrificial victim's revelatory power reveal about the nature of the erotic object?

These questions find their answer in Bataille's *Theory of Religion*, written almost a decade before *Erotism* and around the same time as "History of Eroticism." Beginning with his oft-stated principle that sacrifice must destroy that which is useful, Bataille distinguishes the violence of sacrifice from the violence of war. Specifically, Bataille discusses the sacrifice of slaves—degraded human beings considered as objects (*TR* 59–60). Killing a slave is distinct from killing an enemy because the slave is one's property: the slave is useful, has significance to the community, is not fully expendable (*TR* 60). At the same time, killing the slave is not a "pure" sacrifice, because the slave is still considered a thing, an object, not completely part of the group. Sacrifice "requires victims . . . who are not only the useful wealth of a people, but this people itself . . . such as the sovereign or the children" (*TR* 61). In other words, sacrificial violence requires a victim that bears a close identity to the sacrificer—if the victim is an object or a thing, its distance from the sacrificing subject diminishes the sacrifice's effect.[19]

19. Elsewhere Bataille goes further and argues that the purest form of sacrifice is one that does violence to the self alone. See his "Psychological Structure of Fascism" and "Sacrificial Mutilation."

The victim must be numerically distinct so that its spectacular destruction can be perceived and continuity experienced, but it cannot be qualitatively distinct, or its destruction has no revelatory power. Taking seriously Bataille's repeated statements that sacrifice and eroticism have similar structural relations to violence and continuity, eroticism cannot be built on an absolute subject-object dynamic, even representationally. The rupture and shattering of one's erotic partner creates an anguished shock only because the other is perceived, at least in part, as a subject—just as the sacrificial victim is perceived, at least in part, as a nonthing: this is the reason spectacular destruction is unnerving to the spectating subject.[20] Although Bataille eventually forecloses one strand of eroticism's totality, he has to forget his discussion of the sacrificial mechanism and the connection between sacrifice and eroticism to do so. Even if he intended to do this, we do not have to follow him. The best account of the connection between sacrificial violence and erotic ecstasy—and "best" here should be understood not (only) as politically and ethically palatable, but rather as explanatorily sound—requires an erotic "object" with a subjective dimension.

Earlier in *Theory of Religion*, Bataille mixes descriptions of sacrifice's destruction of the thing, restoration of intimate connection, and erotic desire:

> When the offered animal enters the circle in which the priest will immolate it, it passes from the world of things . . . to the world that is immanent to it, *intimate*, known as the wife is known in sexual consumption. . . . The sacrificer declares: "*Intimately*, I belong . . . to the world of violent and uncalculated generosity, just as my wife belongs to my desires. I withdraw you, victim, from the world in which you were and could only be reduced to the condition of a thing. . . . I call you back to the *intimacy* of the divine world, of the profound immanence of all that is. (*TR* 43–44)

Again, Bataille's language is hardly designed to quell feminist anxieties, but thinking with his categories of thing, utility, intimacy, work, and violence, the object appears much more complicated than critics allow. The intended victim is (perceived as) a thing prior to its entry into ritual space. In sacrifice—as in the erotic encounter—intimate connection, a relation beyond subject-object, is the norm. The victim is called back, through sacrificial violence, to a world of intimacy, a world that stands in contrast to the profane reality of subject-object relations: this intimate, sacred world is identified with the erotic world. Although the sacrificial victim and the sacrifi-

20. Bataille discusses the different perceptions of a horse by a stable owner, who recognizes its beauty and grace, and a butcher, who sees only its meat. Only the stable owner can *sacrifice* the horse, the butcher just slaughters it. See "From the Stone Age," 150.

cer's wife are described as possessions, they are also represented as distinct from things, as sacred, as part of an intimate order.

In *Guilty*, Bataille links discussion of the Chinese torture victim, sacrifice, crucifixion, and eroticism to the object's status. The intimate communication experienced by gazing upon the torture victim's photograph can be best understood, he writes, by thinking about the "wave versus particle" distinction in physics: this "[problem] of physics clarif[ies] the way two images of life are opposed: one erotic and religious, the other profane and matter-of-fact. One is open, the other closed" (G 46). What Bataille does not add is that these are two perspectives on, two representations of, a single world: the world that physics describes is not one of waves *or* particles, but waves *and* particles simultaneously. Thinking with this model of simultaneity, Bataille connects sex and death, crucifixion and erotic abandon. Through laceration, the other opens itself to communication: "The divinity becomes available like a beloved or like a woman giving you her nakedness in the throes of love. A god torn by wounds and a woman at the edge of pleasure transcribe ecstasy's outcry. . . . But in attaining the object in my outcry, I know I've destroyed what deserves to be called 'object'" (G 46–47).

In almost every instance that Bataille discusses the sacrificial victim or the erotic object, he insists on a doubleness—a paradoxical, counterintuitive undoing and exceeding of thingness and objectification, as well as selfhood and subjectivity. The erotic object is an object that stops being an object. The erotic object is the struggle to make a human being into an object that always fails. The erotic object is the object that is sufficiently similar to the desiring subject to make it aware of the untenability of the subject-object distinction. The erotic object is that which is not experienced as an object in the excesses of passionate desire. The erotic object undoes the category "object" by generating a mobile, living, and fluid desire. The erotic object is double: both a profane thing and a citizen of the sacred realm. The erotic object effects a self-dissolution that reveals the violence of objectifying desire. The erotic object disturbs precisely because it evinces a subjective presence.

★ ★ ★

Discussing Bataille's writing, Amy Hollywood mentions Jean-Luc Nancy's observation that it is "'a sacrifice of writing, by writing, which redeems writing.'" She notes that, "given Bataille's persistent rejection of salvific narratives, the language of redemption is particularly problematic" (SEc 108). A similar charge could be made against my investigation, ostensibly inspired by Bataille, of the male-body-in-pain as redemptive figure.

The salvation Bataille rejects is one that propels the redeemed into the future, eternally isolating them. This problematic redemption secures the self, promising subject-object relations . . . forever. The redemptive figure I have invoked—representations of suffering male bodies, metaphors of self-dissolution, Jesus on the cross—works against these desires and aspirations. This redemption is only ever a risk, a chance at glimpsing oneself in the other across the wound's abyss, a headlong fall of dizzying ecstasy . . . with no end. Following Bataille, I have lingered on figures that open up the subject, that violently rend the viewer's and reader's sense of a unified, stable, masterful self. The salvific narrative Bataille rejects is one that attempts to make sense of suffering. The redemption he imagines is one in which suffering is encountered in its facticity, its brute reality engaged through witness, with quiet awe and gentle respect. The redemptive loss of self figured by the male-body-in-pain does not make suffering meritorious or provide an account of its origins; rather, it recognizes pain, violence, and trauma as the givens of human existence and reimagines intersubjective relation and human community in light of them. This redemptive figure does not offer itself as an instrument of healing and transformation but reveals that self-shattering, while traumatic, is always something more. Bataille rejected "salvation" because it perpetuates the alienating conditions that constitute profane reality, but he sought to foster, through aesthetic (and) theoretical texts, a transformative encounter with sacred violence: an anxiety-provoking, nausea-inducing, terror-generating, bliss-producing rattle of the subject's cage. The redemption offered does not comfort, nor guarantee, nor linger. It is not assurance but accident—a temporary, unexpected breach of day-to-day reality that can only be anxiously anticipated.

Found(er)ing redemption on self-shattering and fragmentation raises a number of important ethical and political questions. I have gestured toward some of them, but have only cleared the ground and provided a framework for future examination, perhaps by other voices. To treat these questions quickly—and, hence, superficially—in this closing moment would be an act of violence: it would fail to treat them with the seriousness they deserve, not giving these important questions the same weight I have assigned the images and texts that raise them.

To articulate the questions and try to give answers in terms of rational concepts and abstract principles would perform an additional violence: it would rely on the discursive speech of intellectual labor. I am unconvinced that we commit ourselves to ethical and political positions because of reasoned belief; a worldview's plausibility seems to depend much more heavily on its aesthetic appeal. (Recognizing, of course, that what we find aesthetically appealing is hardly a matter of individual, conscious choice.) This does not mean that persuasion is impossible, that it is futile to try and change someone's mind—only that the means for doing so need to be carefully considered.

What account of who we are, how we might live together, and what we can become is most compelling? What image of self, other, and world is most alluring? As claims for decency and dignity veer toward a picture of human life that celebrates the individual's

capacities and abilities—culturally acknowledged or not—I feel chill sterility. When I see images or engage narratives of fractured persons striving, stumbling, flailing about in the hopes of genuinely knowing one another, but often inflicting astonishing damage despite their best intentions, I experience recognition.

(While I was working on this book, several stories occupied the headlines—stories about health care, immigration, bailouts, natural disasters, marriage, environmental devastation—and, in the very final stages of writing, a fever-pitch chorus of voices rose around efforts to build a mosque in Manhattan, clamoring to establish the purest lineage of victimhood. As I observed, and participated in, these debates, I wondered how differently they might sound if our abiding image of who we are was based less on autonomy and self-sufficiency, less even on the responsibility of the "privileged" for the "less fortunate," but rather on a fundamental conviction of shared vulnerability, mutual laceration, ubiquitous fragmentation that cannot be overcome—only denied.)

In my life, the richest moments have been the most difficult, the most painful, the most complex—they resist neat classification according to single affects. When I have watched others bear loss, faced my own limitations, seen people acting indecently, rec-ognized my capacity for cruelty, I have borne witness to our common endeavor to find bearings in a world characterized primarily by a chaotic violence that not merely undoes selves but eradicates them. The people who are dearest to me are not merely compan-ions, not merely people who are near me, who occupy a common space. They are, in-stead, those who have shown me their soft underside, to whom I have bared my throat, the ones who have been willing to turn with a sharp upbraiding, the ones who have challenged my insistence on my own way, my assurance of my own rightness, my pur-suit of my own desires: it is those who have revealed their woundedness and pierced my ever-thickening epidermis who constitute my community. The most profound human experiences—sharing long-held secrets, comforting the mourning, falling in love, witnessing moments of exceptional happiness or sorrow, confessing mistakes, coun-seling a friend, teaching, learning, listening, seeking political change, sitting with a loved one in her or his final moments—are fraught with uncertainty, require the risk of self, conjure the specter of failure and heartbreak. This is why they are meaningful. The deep, abiding "pleasures" of human existence are neither joy nor pain, but some inexpressible—and inexplicable—admixture of the two.

Related both to the ethical concerns lingering in the air, and my sense that their resolution is an aesthetic endeavor, my abiding anxiety is that I have failed to capture the beauty, the intensity, the wonder of the images and texts upon which I have re-lied. In the final analysis, they are the argument. My words are only so much static— feeble commentary in a childish babble. As I draw this book to a close, my question is not, "Have you been convinced?" but rather, "Have you been taken in?" Have you seen anything beautiful? Have you been seduced? Did you experience awe? Did you, however briefly, lose yourself? Were you ever forced to pause just because? Attend to those moments.

Ecce homo. *Behold the man. Behold the suffering man. Behold the male-body-in-pain. Behold the figure of a masculine subject incapable of sustaining the fiction of its coherence, uniqueness, and claim to power and privilege. Behold the woman's body that desires despite the cultural assignation of lack. Behold the sacrificial victim that heralds the inevitability of death. Behold the erotic object that challenges the circumscription of self. Behold the subject willingly come undone. Behold the object that undoes objectification. Behold.*

★ ★ ★

In her discussion of Bataille's first (surviving) pornographic novel, Hollywood recognizes a doubleness in his treatment of the erotic object. While the prostitute enacts a "'fiction of death' . . . for the male reader and writer," Bataille's "insistence . . . that the other be recognized . . . contests this fetishizing movement" of objectification, "even as his texts continually make it" (*SEc* 293n53). In *Story of the Eye*, the "voyeuristic-sadistic mastery" that longs for the dead object, and the "fetishistic-masochistic . . ., self-subverting ironization" that challenges this desire, "stand side by side; one cannot, finally, decide between them" (*SEc* 55). Hollywood's insightful and nuanced reading of the novel's "inescapable" undecidability turns primarily on the relation between "The Tale" and the much shorter section, "Coincidences," that purports to be the story's interpretive key.[21] As she notes, nothing in the text signals that the second section should be read as a nonfiction supplement to a fictional narrative, even though the text has often been interpreted in this manner (*SEc* 44). In "Coincidences," Bataille uses the voice of memoir to exercise mastery over the story's meaning, while simultaneously undermining that voice's authority and reliability (*SEc* 46). In "The Tale," he narrates from the perspective of a frequently sadistic male character who is often overwhelmed by and incapable of controlling events he witnesses (*SEc* 53).[22] Although it revels in the shattering of the masculine subject in its paralleled tales of a blind, abject, impotent father ("Coincidences") and blinded male characters perceived by an often inadequate male narrator ("The Tale"), *Story of the Eye*, on Hollywood's reading, views the feminized body through a punishing "sadistic-voyeuristic look" that establishes its lack (*SEc* 51). This, along with the novel's masochistic

21. Hollywood is alone in striking this balance. In their analyses of *Story of the Eye*, Dean and Suleiman focus most of their attention on the "Coincidences" section. Dean, *Self and Its Pleasures*, 235–45; Suleiman, *Subversive Intent*, 72–87. See also Barthes, "Metaphor of the Eye"; Dragon, "Work of Alterity," 38–42; MacGregor, "Eye of the Storm," Philips, "'Law of the Mother.'"

22. And as one of my anonymous readers observed, the novel's pseudonymous publication also undermines Bataille's authorial presence.

"usurp[ation] and appropriat[ion] of the feminine position," makes it pro-
foundly difficult, she suggests, to interpret the novel as compatible with a
feminist vision.[23]

Although Hollywood's account recognizes the novel's complex dance
between sadism and masochism, mastery and self-loss, it schematizes its
material too sharply. While *Story of the Eye* does invoke the categories Hol-
lywood uses, it distributes them across the masculine-feminine divide in
a manner that makes the novel a more complex text than her readings al-
lows. Most significantly, she sequesters to a footnote a significant feature of
the novel's complexity that challenges her characterizations—namely, the
character Simone's desire. Simone, a teenage girl, and the narrator, her dis-
tant relative, engage in a wide array of erotic activities—from mutual mas-
turbation to cunnilingus to anal sex to vaginal intercourse to sexual play in-
volving eggs, milk, and urine. They develop a sexual obsession with one of
their friends, Marcelle, that eventually drives her to suicide. On the run in
the wake of Marcelle's death, Simone and the narrator travel to Seville with
a wealthy Englishman, Sir Edmond, who takes them to a bullfight, where
they witness a matador's death—and to a church, where they sexually as-
sault and murder a priest.

The novel's depiction of Marcelle most fully exemplifies the voyeuristic-
sadistic perspective Hollywood identifies. Introduced as "the purest and
most poignant of [their] friends," she enters the story by stumbling upon
the narrator and Simone *in flagrante delicto*. Ignoring her at first because
"too strongly contracted in [their] dreadful position to move even a hair's
breadth," the perverse protagonists "hurl" themselves on her when she
"collapse[s] and huddle[s] in the grass amid sobs" (*StE* 7). What follows
should most likely be read as a scene of sexual assault—"'Marcelle,' I ex-
claimed, 'please, please don't cry. I want you to kiss me on the mouth'"—
but the text hints at Marcelle's awakening sexual "frenzy" (*StE* 8). Running
into her on the street a week later, Simone apologizes for the pair's conduct

23. Hollywood notes, after discussing the narrator's self-shattering masochism in the
body of the text, that "it would be precipitous to read this masculine masochism as
feminist or even as compatible with feminism. Rather, one could argue with Iriga-
ray that Bataille usurps and appropriates the feminine position, thereby reestablishing
the ubiquity of men." Hollywood's final assessment is muddied here. Is it difficult
or impossible to make Bataille compatible with feminism? Does the Irigarian argu-
ment one *could* make—an argument Hollywood *does* make—settle the matter? Hol-
lywood's insistence that Irigaray's critique of Lacan applies equally to Bataille is the
basis of her conclusion that neither thinker can be particularly useful to feminism.
"At the same time," she notes, "it is important to see that a certain crisis of masculin-
ity is being enacted by Bataille" (*SEc* 291n38).

and convinces a reluctant Marcelle to join them for tea. When their friends gather, champagne is drunk instead and debauchery follows. Marcelle— embarrassed, afraid, and angry—expresses a desire to leave. "But then," the narrator reports, "she said to me, without even seeing me, that she wanted to take off her dress. . . . After I fingered her cunt a bit and kissed her on the mouth, she glided across the room to a large antique bridal wardrobe, where she shut herself in after whispering a few words to Simone." Left alone in the armoire to masturbate and micturate, Marcelle emerges in "a sickly but violent terror" that results in her institutionalization (*StE* 14, 15). On their second attempt, the narrator and Simone successfully rescue their friend, but she "grasped absolutely nothing of what was going on," living now in a world of horrifying delusions generated by her sexual trauma. Upon seeing the armoire, Marcelle recognizes her tormentors and kills herself. As the culmination of their obsessive desire, Simone and the narrator "fucked . . . for the first time, next to the corpse. It was very painful for both of us, but we were glad precisely because it *was* painful" (*StE* 50). Like the passive, dead object, Marcelle has virtually no desire of her own—and whatever desire she possesses offers no effective resistance to the desires of Simone and the narrator. As "The Tale" relates, the protagonists' desire for Marcelle—and for each other *through* Marcelle—reaches its zenith when she is a dead object.[24]

Given the protagonists' manipulative, obsessive, and finally lethal desire, "The Tale" undoubtedly characterizes their longing for Marcelle as sadistic.[25] Hollywood suggests that associations between Marcelle and the priest Don Aminado also mark him, sadistically, with "feminized . . . lack" (*StE* 50–51). In the story's penultimate scene, the narrator, Simone, and Sir Edmond visit a church reputed to house Don Juan's burial plot. Simone en-

24. Hollywood suggests that "Coincidences" associates "Marcelle with the mother" (*SEc* 50). In "Coincidences," Bataille suggests that such an association "if not false," is "exaggerated. . . . Marcelle is also a fourteen-year-old girl who once sat opposite me for a quarter of an hour at the Café des deux Magots in Paris" (*StE* 95). Dean, Hollywood, and Suleiman all point to the moment in "Coincidences" when the narrator's blind father accuses the doctor of having sex with his wife as "sexualizing" the mother's body. See Dean, *Self and Its Pleasures*, 239–40; *SEc* 49–50; Suleiman, *Subversive Intent*, 85–87; see also *StE* 94–95. Why read this (only) as a sexualization of the mother's body? Could it not also register the hypocrisy of marital monogamy? Or be a provocation toward general perversion? If this moment from "Coincidences" is read more broadly, then "The Tale" becomes more a narrative of excessive desire and less a story about erotic obsession with the mother.

25. The singularity of their sadism is troubled both by the death scene that follows their first attempt to rescue Marcelle, discussed below, and by the pain they gladly experience when fucking near her corpse.

ters the confessional, where she regales the priest with tales of her sexual exploits while masturbating. As a dramatic, concluding flourish, she flings open the door to the priest's chamber only to find him "mopping a sweat-bathed brow" and concealing a "hard . . . cock under [his] cassock" (*StE* 74). The trio proceeds to rape and murder the priest, pausing only long enough to force him to urinate in the communion chalice and ejaculate on the host. After choking him to death, which forces him to come one final time, Sim-one demands that Sir Edmond cut out his eye so that she may "play with it" (*StE* 82). The eye becomes Simone's sex toy, eventually inserted—like eggs and bull testicles before it—into her vagina. Once "in *Simone's* hairy vagina," the narrator sees in the priest's excavated orb "the wan blue eye of *Marcelle*" (*StE* 84). Through his eye and his victimization, the priest ostensibly becomes Marcelle.

But "The Tale" will not allow a simple equation between them. In contrast to the text's fairly consistent refrain about Marcelle's purity and na-ïveté (despite brief intimations of her sexual curiosity and agency), the priest is presented as perverse independent of the central characters' machinations. While his sexual violation and death parallel him to Marcelle, this preexisting perversity distinguishes him from her. Morever, the text also links the priest to Simone. When she groped the priest in his booth, "she pulled up the filthy black skirt [of his cassock] so that the long cock stuck out, pink and hard" (*StE* 74).[26] In the story's first paragraph, Simone is de-scribed as "wearing a black pinafore" that, when lifted, would reveal her cunt's "'pink and dark' flesh," As the church scene begins, her cunt is again described as "pink and dark" (*StE* 3–4, 65). And when the narrator sees Marcelle in the priest's eye, the eye is in "*Simone's* hairy vagina." Because the novel characterizes Marcelle and Simone quite differently, this dual associa-tion is significant for assessing the priest's function in the overall character system.

More importantly, as Hollywood acknowledges, although he wears a "skirt" and may be feminized simply by being a priest, Don Aminado is "still a man and a figure of authority" (*SEc* 291n35). "The Tale" focuses a great deal of attention on both his erection and his symbolic stature, which is mocked by Simone's confession and Sir Edmond's mass. Hollywood con-tends, following Laura Mulvey, that "the sadistic-voyeuristic look . . . punishe[s women] for their lack of a penis"; she then suggests that this look punishes "Marcelle and the feminized priest . . . in order to establish

26. Yanked from the confessional, "his fly . . . open, his cock dangling," the priest "sniveled, 'You must think I'm a hypocrite.' 'No,' replied Sir Edmond with a catego-rial intonation" (*StE* 74).

their lack" (*StE* 51). What she does not grapple with fully is that the text represents the motivation for the sexual violation of Marcelle and of the priest quite differently: Marcelle is desired because she is *genuinely* innocent and powerless, the priest because he is *posing* as innocent and embodies authority. The priest and Marcelle are both undone by the voracious sexual aggression of the narrator and Simone, but *what* is undone in them is remarkably different: it cannot be characterized with an unqualified "and."

Attributing a feminizing sadism to the narrative becomes even more problematic when the matador's enucleation is considered. Prior to their desecration of the sacristy, the fearsome threesome attend a bullfight. The afternoon's star is an "extremely popular . . ., handsome, tall," twenty-year-old matador named Granero. Like Marcelle, he exhibits a "childlike simplicity" (*StE* 58–59). Like Don Aminado, he has a phallic presence: "He looked . . . like a very manly prince charming with a perfectly elegant figure. . . . The matador's costume . . . safeguards the straight line shooting up so rigid and erect every time the lunging bull grazes the body and . . . the pants so tightly sheathe the ass." His masculine beauty, the narrator tells us, "stood out from the rest of the matadors because there was nothing of the butcher about him" (*StE* 59). The narrator's allusions to anal eroticism and death impose limitations on Granero's phallic presence. With Granero, then, the story introduces another character that moves between masculine and feminine.

The narrator explains that watching a bullfight inflames erotic desire. On the afternoon in question, this desire is intensified because Sir Edmond has arranged both for Granero to dine with them and for Simone to receive the testicles of the first bull Granero slaughters. After the first kill, filled "with an exhilaration at least equal to" the narrator's, Simone leads the narrator "to an outer courtyard of the filthy arena," where they fuck in "a stinking shithouse, where sordid flies whirled about in a sunbeam" (*StE* 61). The narrator had earlier likened the dangerous thrusts of the bull's horns to the "lunging typical of the game of coitus"; here he notes that "a bull's orgasm is not more powerful than the one that wrenched through our loins to tear us to shreds" (*StE* 56, 61). When they return to the stadium, the promised orbs rest on a silver tray on Simone's seat. She grows increasingly agitated and expresses her desire to sit on the plate—to treat the testicles as she has treated eggs and will later treat an eye. Violently interrupting the narrator's frustration with Simone's increasing petulance, "Granero was thrown back by the bull and wedged against a balustrade. . . . One horn plunged into the right eye and through the head. . . . Men instantly rushed over to haul away Granero's body, the right eye dangling." At the same time, and in an order the narrator cannot reproduce,

not because [the events] weren't actually related, but because my attention was so absent as to remain absolutely dissociated. . . . Simone bit into one of the raw balls . . . [and] with a blood-red face and a suffocating lewdness, uncovered her long white thighs up to her moist vulva, into which she slowly and surely fitted the second pale globule.

When Granero is struck by the bull's horn, "a shriek of unmeasured horror coincided with a brief orgasm for Simone" (*StE* 64).

The most obvious association produced by this scene is a connection between Granero and Don Aminado—both are phallicized men who excite Simone's sadistic desire. Although she plays a more active role in the priest's brutalization than in the matador's, in both scenes she takes erotic delight in another character's pain and torment. If Granero is associated with Don Aminado as a victim of (sexualized) violence who loses an eye, then he must also be associated with Marcelle, whose violation and blue eye connect her to the priest. Unlike the priest and like Marcelle, Granero is an innocent; unlike Marcelle and like the priest, Granero is phallic. Why, then, must he be punished, and how, if at all, does his "punishment" signify lack?[27]

Where does the narrator fit? On the one hand, through his animalistic rutting with Simone, he is associated with the bull, the bringer of violence and death. On the other, Granero's death and Simone's debauchery undoes him as an effective witness, coherent subject, and reliable narrator. Something remarkably similar happens during the scene with Don Aminado. As throughout the story, the narrator is Simone's accomplice and shares her delight in the priest's rape and murder. At the same time, from the moment he follows Simone into the church, the narrator has no idea what she is thinking or doing and little control over what she does—even though he keeps trying to (re)insert himself into the action.

Simone's sexual agency is the moving force of "The Tale"—the narrator rarely, if ever, controls the timing, place, or content of their sexual encounters and usually conveys confusion or uncertainty about (the meaning of) events unfolding around him.[28] Simone initiates their first carnal encounter, immediately sets limitations on their erotic conduct, and thereafter stages their sexual play: from the orgy outside Marcelle's armoire, to their fetish-

27. There is obvious castration imagery, given Freudian associations of blindness with castration, as well as the characterization, in "Coincidences,"' of a blind, incontinent, impotent, insane father. But both the blind father and the blinded Granero are described as erotically desirable objects (*StE* 58–59, 93). And Granero is depicted much more as a victim of tragic circumstance than of sexualized violence.

28. Through his lack of control and comprehension, he is associated with the father of "Coincidences."

istic experimentation with eggs, to their adventures with Sir Edmond, to their fucking at the bullfight, to the climax in the church. Like the matador, the priest, Marcelle, and Sir Edmond, the narrator is controlled by Simone's active desire. But he is never overcome: he is not a passive, dead object that offers no answer to her desire. In other words, despite his frequent masochistic shattering, the narrator is never fully associated with lack—and never stops desiring the sadistic Simone.

Hollywood acknowledges, in a footnote, that her reading of "The Tale" as relying on a sadistic-voyeuristic look that establishes the lack of feminized bodies "is problematized by Simone, who seems to triumph in her sexualization and violence" (*SEc* 290n31). On my reading, Simone completely undoes Hollywood's schema. Simone not only triumphs, she is the novel's primary source of sadistic-voyeuristic desire. Hollywood's understanding of feminized lack might stand if Simone were associated with the "phallic mother," whose lack is refused, who remains "forever . . . sexualized, and threatening," thus rendering "the child potentially psychotic" (*SEc* 290n29).[29] If "The Tale" phallicized Simone, then Marcelle would, arguably, be left as a feminized body representing lack. Simone's "lack," however, is not refused. "The Tale" constantly, almost tiresomely, draws the reader's attention to her "cunt"—which the narrator considers "by far the loveliest of the names for the vagina"—and her anus—thus insisting on her penetrability (*StE* 4). At the bullfight, for example, where Simone actively pursues sex with the narrator and takes delight both in eating, and fucking herself with, bull testicles during Granero's death throes, the narrator tells how he "exposed Simone's cunt, and into her blood-red, slobbery flesh I stuck my fingers, then my penis, which entered that cavern of blood while I jerked off her ass, thrusting my bony middle finger deep inside" (*StE* 61). The narrator's mention of the shared bull-like orgasm that tore them both to shreds magnifies this account's violence, especially given the bull's murder of Granero. Despite this explicit description of Simone's gory, penetrated vaginal cavity, her agency, desirability, and sadism do not disappear from the narrative. They do not even disappear from the scene. Simone is identified both with voyeuristic-sadism and woundedness—over and over again—in ways that neither refuse her lack nor identify her with it, in ways that signify both her dangerousness and her desirability, and in ways that render the narrative unstable without making the narrator (or narrative) completely incoherent.

29. Hollywood does not make this claim explicitly but does link Simone to the "castrating" mother of "Coincidences" (*SEc* 50).

To complicate the picture further, Simone is, like Marcelle, associated with death. After their initial, failed attempt to rescue Marcelle from the sanitorium, the narrator and Simone flee into the night on their bicycles, naked. Watching Simone in front of him, the narrator has a clear sight of both her "bare cunt, which was inevitably jerked by the legs pumping up and down on the spinning pedals," and "the crevice of [her] naked ass" (*StE* 32). This sight gives him an erection, "and it [strikes him] that death was [its] sole outcome" (*StE* 33). He meditates on his own death—connected directly to his erection/phallus and only indirectly to Simone's cunt/castration—and then watches as Simone, distracted by the masturbatory force of her bicycle seat, is "hurled upon an embankment with an awful scraping of steel on the pebbles and a piercing shriek" (*StE* 33–34). When the narrator finds Simone, she is "inert, her head hanging down, a thin trickle of blood running from the corner of her mouth." Seeing her like this, the narrator is "overcome with bloody spasms" that call to mind his blood-engorged erection.[30] Simone's sexually "besmirched . . . corpse" slowly awakes: "No injury, no bruise marked the body" (*StE* 34). Simone, like Marcelle (and the priest and Granero), excites desire as a dead object; unlike Marcelle (or the priest or Granero), she rises from the dead to, once again, exercise control over the narrator's sexual exploits. At the same time, Simone needs, on this occasion, to be rescued by the narrator and cared for by him as she recuperates.[31]

More than challenging the notion of the novel's sadistic imposition of lack on feminized bodies, this consideration of Simone shows the flaw in Hollywood's observation "that Bataille usurps and appropriates the feminine position, thereby reestablishing the ubiquity of men," through his invocation of a "masculine masochism" (*StE* 291n38). Simone shows, more clearly than any other character, that feminine and masculine, sadism and masochism, mastery and lack, *simply do not operate as fixed binaries*

30. This scene echoes an earlier one where Simone and the narrator crash their car into a girl on a bicycle, "almost totally ripp[ing] her head off." At the sight of her corpse, they experience nausea, "horror and despair," while still noting the dead girl's beauty and experiencing sexual desire (*StE* 5–6). Both scenes are recalled when Marcelle hangs herself and the narrator and Simone have intercourse for the first time. Given the multiple ways characters relate and various scenes echo, the novel is almost devoid of identifiable characters or discreet events, but is rather a rush of associative links, an operation of desire's flood. For discussion of the novel along these lines, see Barthes, "Metaphor of the Eye"; Winnubst, "Bataille's Queer Pleasures."

31. Even convalescing, Simone directs a significant amount of sexual play, most of it involving eggs and urination.

in this novel.[32] Neither Bataille nor "The Tale"'s anonymous male narrator nor "Coincidences"' blind father can appropriate the feminine position because feminine and masculine—as stable positions that *could be* usurped, appropriated or held by anyone—are radically undone in *Story of the Eye*'s pornographic excess.

Does Marcelle occupy the feminine position? She lacks power relative to Simone and the narrator and is a relatively passive object to their desire, but they, both a male and a female character, exhibit their own forms of lack, powerlessness, and passivity. Does she occupy the masculine position? She actively participates in some sexual encounters, expresses and pursues desire, and takes charge of her own destiny by killing herself rather than succumbing to further torment, but she is valued primarily as a dead object.[33] Does the priest occupy the feminine position? He is overcome, sexually violated, murdered, and metaphorically castrated, but he symbolically represents authority, he has sexual desire, and he is male. Does he occupy the masculine position? He is a "father" of the church, possesses sexual desire, and bears an erect cock like the one the narrator displays throughout the story, but he is violently overcome by sadistic (female) desire. Does Granero occupy the feminine position? He has Marcelle's innocence, is on visual display, and experiences a metaphoric castration like the priest's. Does he occupy the masculine position? He epitomizes male beauty and strength, and engages in courageous, violent acts.[34] Does the narrator occupy the feminine position? He is penetrated sexually, loses control of the narrative, and is usually at the mercy of Simone's more aggressive desire. Does he occupy the masculine position? He *is*, after all, the narrator, he helps destroy both Marcelle and the priest, and he is constantly fucking Simone. Does Simone occupy the masculine position? She is powerful, in control, and moves

32. For other interpretations along these lines, see Direk, "Erotic Experience"; McWhorter, "Is There Sexual Difference?"; Mayné, *Eroticism*, 114–15, 130; Winnubst, "Bataille's Queer Pleasures."

33. Any reading suggesting Marcelle is the *most* feminized ignores the way the priest is the object of an active sadistic streak that occupies much greater textual space.

34. Insofar as castrating violence "feminizes" these male characters, it arguably does the same thing to Marcelle, but if it does the same thing to her, then she does not represent lack *as a woman* (i.e., she was not feminized before being an object of violence). If sadistic violence does not do the same thing to all of these characters, then it cannot easily be described as always establishing a feminizing lack. Arguing, as Hollywood does, that violence always imposes feminizing lack implies that there is no possibility of a feminist representation of violence. Whether enacted by a man or a woman, whether inflicted on a female or male body, Hollywood suggests, all representations of violence speak with the same voice. If this is true, there is no reason to engage in a close reading of any text that depicts violence: we already know what it says.

the narrative forward; her violent, sadistic desire finds multiple expressions over the course of the novel. Does she occupy the feminine position? Her cunt is represented as a bloody wound and is the focus of the narrator's desire; she (temporarily) becomes a corpse and excites desire as a dead object.[35]

Mastery and lack, sadism and masochism, femininity and masculinity undoubtedly activate *Story of the Eye*. But the novel reorganizes and distributes them in a variety of ways, across male and female bodies, in an operation of proliferating desire. *Story of the Eye*, like *Madame Edwarda*, imagines a violent, shattering erotic desire that undoes the stability, coherence, and separation of masculinity-mastery-sadism and femininity-lack-masochism. *Story of the Eye*, like Bataille's theoretical writings, relies on disturbing metaphoric deployments of femininity and masculinity to move beyond any simple conception of subject and object.

Bringing together transgressive sexual desire, representations of violence, and an insistence on sacrificial rupture, Bataille imagines a space of anguished ecstasy that propels the desiring subject and desired object beyond subjectivity, beyond objectivity, beyond gender, beyond identity. Propelled, through rupture, into fragmentation, we find ourselves—by losing ourselves—anew.

35. Sir Edmond is depicted relatively consistently, even though his action moves from the role of facilitating voyeur to that of active sadistic participant. At the same time, he is clearly in thrall to Simone and acts largely on her bidding. Moreover, he is a minor character and does not appear until the second half of "The Tale." Even if he was fully phallic and sadistic, he does not have sufficient textual presence to undo the chaos of the overall character system.

Works Cited

Ades, Dawn. "Web of Images." In *Francis Bacon*, ed. Dawn Ades and Andrew Forge, 8–23. New York: Harry N. Abrams, 1985.

Ades, Dawn, and Fiona Bradley. "Introduction." In *Undercover Surrealism: Georges Bataille and* Documents, ed. Dawn Ades and Simon Baker, 11–16. Cambridge, MA: MIT Press, 2006.

Aitken, Tom, Eric S. Christianson, Peter Francis, Jeffrey F. Keuss, Robert Pope, William R. Telford, and Melanie Wright. "Epilogue: Table Talk—Reflections on *The Passion of the Christ*." In *Cinéma Divinité: Religion, Theology and the Bible in Film*, ed. Eric S. Christianson, 311–30. London: SCM Press, 2005.

Alley, Ronald. "Francis Bacon's Place in Twentieth-Century Art." In *Francis Bacon*, ed. Rudy Chiappini, 15–30. Milan: Electa, 1993.

———. "Works of Francis Bacon." In *Francis Bacon*, ed. Ronald Alley, 23–155. New York: Viking Press, 1964.

Allison, David B., Prado de Oliviera, Mark S. Roberts, and Allen S. Weiss, eds. *Psychosis and Sexual Identity: Toward a Post-Analytic View of the Schreber Case*. Albany: SUNY Press, 1998.

Altman, Rick. *Film/Genre*. London: BFI Publishing, 1999.

———. "A Semantic/Syntactic Approach to Film Genre." In *Film Genre Reader III*, ed. Barry Keith Grant, 27–42. Austin: University of Texas Press, 2003.

Apostolos-Cappadona, Diane. "On Seeing *The Passion*: Is There a Painting in This Film? Or Is This Film a Painting?" In *Re-Viewing* The Passion: *Mel Gibson's Film and Its Critics*, ed. S. Brent Plate, 97–108. New York: Palgrave, 2004.

Archimbaud, Michel. *Francis Bacon in Conversation with Michel Archimbaud*. London: Phaidon, 1993 [1992].

Artner, Alan G. "The Eye of the Storm." *Chicago Tribune*, December 31, 1989, 4–5, 23.

Arya, Rina. "A-theology and the Recovery of the Sacred in Georges Bataille and Francis Bacon." *Revue Silence* (2008): 59–73.

Auster, Albert, and Leonard Quart. *How the War Was Remembered: Hollywood and Vietnam*. New York: Praeger, 1988.

Bailey, John, and Stephen Pizzello. "A Savior's Pain." *American Cinematographer* 85, no. 3 (March 2004): 48–61.

Baldassari, Anne, ed. *Bacon—Picasso: The Life of Images*. New York: Rizzoli, 2005.

Barrie, Dennis. "Fighting an Indictment: My Life with Robert Mapplethorpe." *Museum News* 69 (July–August 1990): 63–64.

Bartchy, S. Scott. "Where Is the History in Mel Gibson's *The Passion of the Christ?*"

In *Mel Gibson's* Passion: *The Film, the Controversy, and Its Implications*, ed. Zev Garber, 76–92. West Lafayette, IN: Purdue University Press, 2006.

Barthes, Roland. "From Work to Text." In *Image/Music/Text*, ed. and trans. Stephen Heath, 155–64. New York: Hill & Wang, 1977 [1971].

———. "The Metaphor of the Eye." In *Critical Essays*, 239–48. Trans. Richard Howard. Evanston, IL: Northwestern University Press, 1972 [1963].

Bartunek, John. *Inside the Passion: An Insider's Look at* The Passion of the Christ. West Chester, PA: Ascension Press, 2005.

Bataille, Georges. "The Cradle of Humanity." In *The Cradle of Humanity: Prehistoric Art and Culture*, ed. Stuart Kendall, 143–73. Trans. Michelle Kendall and Stuart Kendall. New York: Zone Books, 2005 [1959].

———. "Discussion on Sin." In *The Unfinished System of Nonknowledge*, ed. Stuart Kendall, 26–74. Trans. Michelle Kendall and Stuart Kendall. Minneapolis: University of Minnesota Press, 2001 [1944].

———. "Formless." In *Visions of Excess: Selected Writings, 1927–1939*, ed. and trans. Allan Stoekl, 31. Minneapolis: University of Minnesota Press, 1985 [1929].

———. "From the Stone Age to Jacques Prévert." In *The Absence of Myth: Writings on Surrealism*, ed. and trans. Michael Richardson, 137–54. New York: Verso, 1994 [1946].

———. "Happiness, Eroticism and Literature." In *The Absence of Myth: Writings on Surrealism*, ed. and trans. Michael Richardson, 186–208. New York: Verso, 1994 [1949].

———. "Hegel, Death and Sacrifice." In *The Bataille Reader*, ed. Fred Botting and Scott Wilson, 279–95. Trans. Jonathan Strauss. Malden, MA: Blackwell Publishing, 1997 [1955].

———. "The Jesuve." In *Visions of Excess: Selected Writings, 1927–1939*, ed. and trans. Allan Stoekl, 73–78. Minneapolis: University of Minnesota Press, 1985 [1930].

———. "Lecture, January 18, 1955." In *The Cradle of Humanity: Prehistoric Art and Culture*, ed. Stuart Kendall, 87–104. Trans. Michelle Kendall and Stuart Kendall. New York: Zone Books, 2005 [1955].

———. "Letter to René Char on the Incompatibilities of the Writer." Trans. Christopher Carsten. *Yale French Studies* 78 (1990): 31–43.

———. "The Notion of Expenditure." In *Visions of Excess: Selected Writings, 1927–1939*, ed. and trans. Allan Stoekl, 116–29. Minneapolis: University of Minnesota Press, 1985 [1933].

———. "The Passage from Animal to Man and the Birth of Art." In *The Cradle of Humanity: Prehistoric Art and Culture*, ed. Stuart Kendall, 57–80. Trans. Michelle Kendall and Stuart Kendall. New York: Zone Books, 2005 [1953].

———. "The Practice of Joy before Death." In *Visions of Excess: Selected Writings, 1927–1939*, ed. and trans. Allan Stoekl, 235–39. Minneapolis: University of Minnesota Press, 1985 [1939].

———. "The Psychological Structure of Fascism." In *Visions of Excess: Selected Writings, 1927–1939*, ed. and trans. Allan Stoekl, 137–60. Minneapolis: University of Minnesota Press, 1985 [1934].

———. "Sacrifice." Trans. Annette Michelsen. *October* 36 (Spring 1986 [1939–40]): 61–74.

————. "Sacrifices." In *Visions of Excess: Selected Writings, 1927–1939*, ed. and trans. Allan Stoekl, 130–36. Minneapolis: University of Minnesota Press, 1985 [1933].

————. "Sacrificial Mutilation and the Severed Ear of Vincent Van Gogh." In *Visions of Excess: Selected Writings, 1927–1939*, ed. and trans. Allan Stoekl, 61–72. Minneapolis: University of Minnesota Press, 1985 [1930].

————. "Slaughterhouse." In *Encyclopedia Acephalica*, ed. Alastair Brotchie, 72–73. Trans. Iain White. London: Atlas Press, 1995 [1929].

————. "Teaching of Death." In *The Unfinished System of Nonknowledge*, ed. Stuart Kendall, 119–28. Trans. Michelle Kendall and Stuart Kendall. Minnesota: University of Minnesota Press, 2001 [1952].

Baugh, Lloyd. "*Imago Christi*: Aesthetic and Theological Issues in Jesus Films by Pasolini, Scorsese, and Gibson." In *After* The Passion *Is Gone: American Religious Consequences*, ed. J. Shawn Landres and Michael Berenbaum, 159–71. New York: AltaMira Press, 2004.

————. "Palestinian Braveheart." *America* 190, no. 6 (February 23, 2004): 17–21.

Bersani, Leo. *The Freudian Body: Psychoanalysis and Art*. New York: Columbia University Press, 1986.

————. *Homos*. Cambridge, MA: Harvard University Press, 1995.

————. "Is the Rectum a Grave?" In *Is the Rectum a Grave? and Other Essays*, 3–30. Chicago: University of Chicago Press, 2010 [1987].

Bettenhausen, Elizabeth. "Artwork, Bodywork, Godwork." *Christianity and Crisis* 51, no. 7 (May 13, 1991): 147–49.

Biles, Jeremy. *Ecce Monstrum: Georges Bataille and the Sacrifice of Form*. New York: Fordham University Press, 2007.

Blake, Richard A. "Mel O'Drama." *America* 190, no. 9 (March 15, 2004): 22–25.

Boer, Roland. "Christological Slippage and Ideological Structures in Schwarzenegger's *Terminator*." *Semeia* 69–70 (1995): 165–93.

Bois, Yve-Alain, and Rosalind E. Krauss. *Formless: A User's Guide*. New York: Zone Books, 1997.

Borel, France. "Francis Bacon: The Face Flayed." In *Bacon: Portraits and Self-Portraits*, ed. France Borel, 187–203. Trans. Ruth Taylor. London: Thames & Hudson, 1996.

Bourdon, David. "Robert Mapplethorpe." *Arts Magazine* 51, no. 8 (April 1977): 7.

Boxer, David Wayne. "The Early Works of Francis Bacon." PhD diss. Johns Hopkins University, 1975.

Boyer, Peter J. "The Jesus War: Mel Gibson's Obsession." *New Yorker* (September 15, 2003): 58–71.

Brighton, Andrew. *Francis Bacon*. Princeton, NJ: Princeton University Press, 2001.

————. "Why Bacon Is a Great Artist." *Art Monthly* 88 (July–August 1985): 3–6.

Brintnall, Kent L. "Pursuing *The Passion*'s Passions." In *Shopping for Jesus: Faith in Marketing in the USA*, ed. Dominic Janes, 217–51. Washington, DC: New Academia Publishing, 2008.

Brook, Timothy, Jérôme Bourgon, and Gregory Blue. *Death by a Thousand Cuts*. Cambridge, MA: Harvard University Press, 2008.

Brotchie, Alastair. Introduction. In *Encyclopedia Acephalica*, 9–28. Trans. Iain White. London: Atlas Press, 1995.

Brown, Jeffrey A. "Gender, Sexuality and Toughness: The Bad Girls of Action Films and Comic Books." In *Action Chicks: New Images of Tough Women in Popular Culture*, ed. Sherrie A. Inness, 47–74. New York: Palgrave, 2004.

———. "The Tortures of Mel Gibson: Masochism and the Sexy Male Body." *Men and Masculinities* 5, no. 2 (October 2002): 123–43.

Brown, Joanne Carlson, and Rebecca Parker. "For God So Loved the World?" In *Christianity, Patriarchy and Abuse: A Feminist Critique,* ed. Joanne Carlson Brown and Carole R. Bohn, 1–30. Clevelend, OH: Pilgrim Press, 1989.

Brown, William J., John D. Keeler, and Terrence R. Lindvall. "Audience Responses to *The Passion of the Christ.*" *Journal of Media and Religion* 6, no. 2 (2007): 87–107.

Bryson, Norman. "Bacon's Dialogues with the Past." In *Francis Bacon and the Tradition of Art*, ed. Wilfred Seipel, Barbara Steffen, and Christoph Vitali, 43–55. Trans. Christopher Roth, Joshua Stein, and John Winbigler. Milan: Skira, 2003.

Burnett, Fred. "The Characterization of Martin Riggs in *Lethal Weapon* 1: An Archetypal Hero." In *Screening Scripture: Intertextual Connections between Scripture and Film*, ed. George Aichele and Richard Walsh, 251–78. Harrisburg, PA: Trinity Press International, 2002.

Butler, Judith. *Bodies That Matter: On the Discursive Limits of "Sex."* New York: Routledge, 1993.

———. *Gender Trouble: Feminism and the Subversion of Identity*. Rev. ed. New York: Routledge, 1999 [1990].

———. *The Psychic Life of Power: Theories in Subjection*. Stanford, CA: Stanford University Press, 1997.

Caldwell, Brian. "Muscling In on the Movies: Excess and the Representation of the Male Body in Films of the 1980s and 1990s." In *American Bodies: Cultural Histories of the Physique*, ed. Tim Armstrong, 133–40. New York: Sheffield Academic Press, 1996.

Caldwell, Deborah. "Selling *Passion*." In *On* The Passion of the Christ: *Exploring the Issues Raised by the Controversial Movie*, ed. Paula Fredriksen, 211–24. Berkeley: University of California Press, 2006.

Cappock, Margarita. "The Motif of Meat and Flesh." In *Francis Bacon and the Tradition of Art*, ed. Wilfred Seipel, Barbara Steffen, and Christoph Vitali, 311–16. Trans. Christopher Roth, Joshua Stein, and John Winbigler. Milan: Skira, 2003.

Carritt, David. "Bacon: The Painter Who Evokes Horror." *Evening Standard*, May 25, 1962, 18.

Celant, Germano. "Mapplethorpe as Neoclassicist." In *Robert Mapplethorpe and the Classicist Tradition: Photographs and Mannerist Prints*, ed. Germano Celant, 36–51. Trans. Stephen Sartarelli. New York: Guggenheim Museum Publications, 2004.

———. "Robert Mapplethorpe: Man in a Polyester Suit." Trans. Marguerite Shore. *Artforum International* 32 (September 1993): 154–55, 204, 206.

Cembalest, Robin. "The Obscenity Trial: How They Voted to Acquit." *Artnews* 89 (December 1990): 136–41.

———. "'Who Does It Shock? Why Does It Shock?'" *Artnews* 91, no. 3 (March 1992): 32–34.

Chatwin, Bruce. "An Eye and Some Body." In *Lady: Lisa Lyon*, 9–14. New York: St. Martin's Press, 1983.

Chilton, Bruce. "Mel Gibson's Lethal *Passion*." In *Mel Gibson's Bible: Religion, Popular Culture, and* The Passion of the Christ, ed. Timothy K. Beal and Tod Linafelt, 51–58. Chicago: University of Chicago Press, 2006.

Clair, Jean. "Pathos and Death: Interview with Francis Bacon by Jean Clair." In *The Body on the Cross*, ed. Gilles Fage, 130–41. Trans. Neil Kroetsch. Montreal: Montreal Museum of Fine Arts, 1992.

Connor, Peter Tracey. *Georges Bataille and the Mysticism of Sin*. Baltimore: Johns Hopkins University Press, 2000.

Corley, Kathleen E., and Robert L. Webb, eds. *Jesus and Mel Gibson's* The Passion of the Christ: *The Film, the Gospels and the Claims of History*. New York: Continuum, 2004.

Creed, Barbara. *The Monstrous-Feminine: Film, Feminism, Psychoanalysis*. New York: Routledge, 1993.

Crimp, Douglas. *On the Museum's Ruins*. Cambridge, MA: MIT Press, 1993.

Crossan, John Dominic. "Hymn to a Savage God." In *Jesus and Mel Gibson's* The Passion of the Christ: *The Film, the Gospels and the Claims of History*, ed. Kathleen E. Corley and Robert L. Webb, 8–27. New York: Continuum, 2004.

Crowley, Patrick, and Paul Hegarty, eds. *Formless: Ways In and Out of Form*. New York: Peter Lang, 2005.

Cunningham, Maddy. "Were You There When They Crucified My Lord? The Psychological Risks of 'Witnessing' the Passion." In *Pondering the Passion: What's at Stake for Christians and Jews*, ed. Philip A. Cunningham, 169–79. New York: Sheed & Ward, 2004.

Daly, Mary. *Beyond God the Father: Toward a Philosophy of Women's Liberation*. Boston: Beacon Press, 1985 [1973].

Danto, Arthur C. *Playing with the Edge: The Photographic Achievement of Robert Mapplethorpe*. Berkeley: University of California Press, 1996.

Davies, Hugh M. "Bacon's 'Black' Triptychs." *Art in America* 63, no. 2 (March–April 1975): 62–68.

———. "Bacon's Popes: *Ex Cathedra* to *In Camera*." In *Francis Bacon: The Papal Portraits of 1953*, 11–19. New York: Distributed Art Publishers, 2001.

———. *Francis Bacon: The Early and Middle Years, 1928–1958*. New York: Garland Publishing, 1978.

———. "The Screaming Pope: Past Art and Present Reality." In *Francis Bacon*, ed. Rudy Chiappini, 33–62. Milan: Electra, 1993.

Davies, Hugh M., and Sally Yard. *Francis Bacon*. New York: Abbeville Press, 1986.

Davis, Whitney. *Drawing the Dream of Wolves: Homosexuality, Interpretation and Freud's "Wolf Man."* Indianapolis: Indiana University Press, 1995.

Deacy, Christopher. *Faith in Film: Religious Themes in Contemporary Cinema*. Burlington, VT: Ashgate, 2005.

Dean, Carolyn J. *The Self and Its Pleasures: Bataille, Lacan, and the History of the Decentered Subject*. Ithaca, NY: Cornell University Press, 1992.

Dean, Tim. *Beyond Sexuality*. Chicago: University of Chicago Press, 2000.

DeAngelis, Michael. *Gay Fandom and Crossover Stardom: James Dean, Mel Gibson, and Keanu Reeves*. Durham: Duke University Press, 2001.

Deleuze, Gilles. "Coldness and Cruelty." In *Masochism*, 9–138. Trans. Jean McNeil. New York: Zone Books, 1989 [1967].

————. *Francis Bacon: The Logic of Sensation*. Trans. Daniel W. Smith. Minneapolis: University of Minnesota Press, 2004 [1981].

Denton-Borhaug, Kelly. "A Bloodthirsty Salvation: Behind the Popular Polarized Reaction to Gibson's *The Passion*." *Journal of Religion and Film* 9, no. 2 (April 2005). http://www.unomaha.edu/jrf.

Didion, Joan. "Some Women: An Annotation." In *Some Women*, 4–7. Boston: Little, Brown, 1989.

Dinnage, Rosemary. Introduction. In Daniel Paul Schreber, *Memoirs of My Nervous Illness*, ed. and trans. Ida MacAlpine and Richard Hunter, xi–xxiv. New York: New York Review Books, 2000 [1955 (1911)].

Direk, Zeynep. "Erotic Experience and Sexual Difference in Bataille." In *Reading Bataille Now*, ed. Shannon Winnubst, 94–115. Bloomington: Indiana University Press, 2007.

Domino, Christophe. *Francis Bacon: Painter of Dark Vision*. Trans. Ruth Sharman. New York: Harry N. Abrams, 1997.

Douglas, Mark. "The Passions of the Reviewers; or, Why Liberals are Right for the Wrong Reasons and Conservatives are Wrong for the Right Ones." In *Mel Gibson's Bible: Religion, Popular Culture, and* The Passion of the Christ, ed. Timothy K. Beal and Tod Linafelt, 129–37. Chicago: University of Chicago Press, 2006.

Dragon, Jean. "The Work of Alterity: Bataille and Lacan." *Diacritics* 26, no. 2 (Summer 1996): 31–48.

Dubin, Steven C. *Arresting Images: Impolitic Art and Uncivil Actions*. New York: Routledge, 1992.

Duncan, Jody. "Passion Play." *Cinefex* 97 (April 2004): 27–37.

Dyer, Richard. "Don't Look Now: The Male Pin-Up." In *The Sexual Subject: A Screen Reader in Sexuality*, 265–76. New York: Routledge, 1992 [1982].

Edelstein, David. "Jesus H. Christ: *The Passion*, Mel Gibson's Bloody Mess." http://www.slate.com/id//2096025.

Elkins, James. "The Very Thought of Transgression: Bataille, *Lingchi*, and Surrealism." *Australian and New Zealand Journal of Art* 5, no. 2 (2004): 5–19.

Ellenzweig, Allen. "Robert Mapplethorpe at Robert Miller." *Art in America* 69, no. 9 (November 1981): 171–72.

Faerna, José Maria. *Bacon*. Trans. Wayne Finke. New York: Harry N. Abrams, 1995 [1994].

Faludi, Susan. *Stiffed: The Betrayal of the American Man*. New York: William Morrow, 1999.

Farmer, Brett. *Spectacular Passions: Cinema, Fantasy, Gay Male Spectatorships*. Durham: Duke University Press, 2000.

Farson, Daniel. *The Gilded Gutter Life of Francis Bacon*. New York: Pantheon, 1993.

Ficacci, Luigi. *Francis Bacon*. Trans. Bradley Dick. London: Taschen, 2003.

Flannery, Denis. "'Queer' Photography and the 'Culture Wars': Robert Map-

plethorpe's Aesthetic of the Pair." In *American Visual Cultures*, ed. David Hollo-
way and John Beck, 265–73. New York: Continuum, 2005.

Fradley, Martin. "Maximus Melodramaticus: Masculinity, Masochism and White
Male Paranoia in Contemporary Hollywood Cinema." In *Action and Adventure
Cinema*, ed. Yvonne Tasker, 235–41. New York: Routledge, 2004.

Fredriksen, Paula. "Gospel Truths: Hollywood, History, and Christianity." In *On
The Passion of the Christ: Exploring the Issues Raised by the Controversial Movie*, ed.
Paula Fredriksen, 31–47. Berkeley: University of California Press, 2006.

———. "Responsibility for Gibson's *Passion of the Christ*." In *Passionate Controversy:
A Viewer's Guide to* The Passion of the Christ, ed. Carolyn Hack, 60–66. N.p.:
Lulu.com, 2004.

Freeland, Cynthia. "The Women Who Loved Jesus: Suffering and the Traditional
Female Role." In *Mel Gibson's* Passion *and Philosophy: The Cross, the Questions, the
Controversy*, ed. Jorge J. E. Gracia, 151–63. Chicago: Open Court, 2004.

Fritscher, Jack. *Mapplethorpe: Assault with a Deadly Camera*. Mamaroneck, NY: Hast-
ings House, 1994.

Gaines, Jane. "Competing Glances: Who Is Reading Robert Mapplethorpe's *Black
Book?*" *New Formations* 16 (Spring 1992): 24–39.

Gale, Matthew. "Crucifixion." In *Francis Bacon*, ed. Matthew Gale and Chris Ste-
phens, 137–43. London: Tate Publishing, 2008.

———. "Memorial." In *Francis Bacon*, ed. Matthew Gale and Chris Stephens,
201–5. London: Tate Publishing, 2008.

Gale, Matthew, and Chris Stephens. "On the Margin of the Impossible." In *Francis
Bacon*, ed. Matthew Gale and Chris Stephens, 14–27. London: Tate Publishing,
2008.

Gallagher, Mark. *Action Figures: Men, Action Films, and Contemporary Adventure Nar-
ratives*. New York: Palgrave, 2006.

———. "I Married Rambo." In *Mythologies of Violence in Postmodern Media*, ed.
Christopher Sharrett, 199–25. Detroit: Wayne State University Press, 1999.

Gamper, Verena. "The Motif of the Crucifixion in Triptych Format." In *Francis
Bacon and the Tradition of Art*, ed. Wilfred Seipel, Barbara Steffen, and Christoph
Vitali, 329–32. Trans. Christopher Roth, Joshua Stein, and John Winbigler. Mi-
lan: Skira, 2003.

Gayford, Martin. "The Brutality of Fact." *Modern Painters* 9 (Autumn 1996): 43–49.

Geldzahler, Henry. "Introduction." In *Francis Bacon: Recent Paintings, 1968–1974*,
5–13. Geneva, Switzerland: Roto-Sadag, 1975.

Giacobetti, Francis. "Francis Bacon: I Painted to Be Loved." *The Art Newspaper* 137
(June 2003): 28–29.

Girard, René. "On Mel Gibson's *The Passion of the Christ*." Trans. Robert Doran.
Anthropoetics 10, no. 1 (Spring-Summer 2004). http://www.anthropoetics.ucla
.edu/ap1001/RGGibson.htm.

Gledhill, Christine. "Rethinking Genre." In *Reinventing Film Studies*, ed. Chris-
tine Gledhill and Linda Williams, 221–43. New York: Oxford University Press,
2000.

Glueck, Grace. "Briton Speaks about Pain and Painting." *New York Times*, March
20, 1975, 46.

Goa, David J. "*The Passion,* Classical Art and Re-presentation." In *Jesus and Mel Gibson's* The Passion of the Christ: *The Film, the Gospels and the Claims of History,* ed. Kathleen E. Corley and Robert L. Webb, 151–59. New York: Continuum, 2004.

Goodacre, Mark. "The Power of *The Passion*: Reacting and Over-Reacting to Gibson's Artistic Vision." In *Jesus and Mel Gibson's* The Passion of the Christ: *The Film, the Gospels and the Claims of History,* ed. Kathleen E. Corley and Robert L. Webb, 28–44. New York: Continuum, 2004.

Gowing, Lawrence. "Francis Bacon: The Human Presence." In *Francis Bacon,* ed. Lawrence Gowing and Sam Hunter, 11–26. London: Thames & Hudson, 1989.

———. "Positioning in Representation." *Studio* 183, no. 940 (January 1972): 14–22.

Greven, David. *Manhood in Hollywood from Bush to Bush.* Austin: University of Texas Press, 2009.

Griffin, Howard. "Francis Bacon: Case-History Painting." *Studio* 161 (May 1961): 164–69.

Gross, Miriam. "Bringing Home Bacon." *Observer,* November 30, 1980, 29, 31.

Grundberg, Andy. "The Allure of Mapplethorpe's Photographs." *New York Times,* July 31, 1988, H29.

———. "Is Mapplethorpe Only Out to Shock?" *New York Times,* March 13, 1983, H32, H35.

Guerlac, Suzanne. *Literary Polemics: Bataille, Sartre, Valéry, Breton.* Stanford, CA: Stanford University Press, 1997.

Hagelin, Sarah. "*The Passion of the Christ* and the Lust for Certitude." In *Passionate Dialogues: Critical Perspectives on Mel Gibson's* The Passion of the Christ, ed. Daniel Burston and Rebecca Denova, 149–67. Pittsburgh, PA: Mise Publications, 2005.

Hagen, Charles. "Robert Mapplethorpe: Whitney Museum of American Art." *Artforum International* 27 (November 1988): 140.

Hamilton, Peter. "No Sympathy for the Devil." *British Journal of Photography,* no. 7094 (September 18, 1996): 28–29, 32–33.

Hammer, Martin. *Bacon and Sutherland.* New Haven: Yale University Press, 2005.

Harrison, Martin. "Bacon's Paintings." In *Francis Bacon,* ed. Matthew Gale and Chris Stephens, 40–49. London: Tate Publishing, 2008.

———. "Francis Bacon: Caged—Uncaged." In *Francis Bacon: Caged—Uncaged,* ed. Maria Ramos, 34–71. Trans. Sofia Gomes and Maria Ramos. Porto, Portugal: Fundacão de Serralves, 2003.

———. *In Camera: Francis Bacon—Photography, Film and the Practice of Painting.* New York: Thames & Hudson, 2005.

Heartney, Eleanor. *Postmodern Heretics: The Catholic Imagination in Contemporary Art.* New York: Midmarch Arts Press, 2004.

Hemphill, Essex. "Does Your Mama Know about Me?" In *Ceremonies: Prose and Poetry,* 37–42. New York: Penguin Books, 1992.

Hoberman, J. "The Fascist Guns in the West." *American Films* 11, no. 5 (March 1986): 42–48.

———. "Vietnam: The Remake." In *Remaking History,* ed. Barbara Kruger and Phil Mariani, 175–96. Seattle: Bay Press, 1989.

Hobhouse, Janet. "Francis Bacon." *Arts Magazine* 46, no. 4 (February 1972): 36–38.

Holland, Isabel. *The Man without a Face*. New York: Harper Collins, 1972.

Hollier, Denis. "A Tale of Unsatisfied Desire." In *Guilty*, vii–xiii. Trans. Bruce Boone. San Francisco: Lapis Press, 1988.

Hollywood, Amy. "Kill Jesus." In *Mel Gibson's Bible: Religion, Popular Culture, and* The Passion of the Christ, ed. Timothy K. Beal and Tod Linafelt, 159–67. Chicago: University of Chicago Press, 2006.

Holmlund, Chris. "Masculinity as Multiple Masquerade: The 'Mature' Stallone and the Stallone Clone." In *Screening the Male: Exploring Masculinities in Hollywood Cinema*, ed. Steven Cohan and Ina Rae Clark, 213–29. New York: Routledge, 1993.

hooks, bell. "Representing the Black Male Body." In *Art on My Mind: Visual Politics*, 202–12. New York: New Press, 1995.

Horney, Karen. "The Dread of Woman: Observations on a Specific Difference in the Dread Felt by Men and by Women Respectively for the Opposite Sex." In *Feminine Psychology*, ed. Harold Kelman, 133–46. New York: Norton, 1967 [1932].

———. "The Flight from Womanhood: The Masculinity-Complex in Women as Viewed by Men and Women." In *Feminine Psychology*, ed. Harold Kelman, 54–70. New York: Norton, 1967 [1926].

Humphries-Brooks, Stephenson. *Cinematic Savior: Hollywood's Making of the American Christ*. Westport, CT: Praeger, 2006.

Hussey, Andrew. *The Inner Scar: The Mysticism of Georges Bataille*. Atlanta, GA: Rodopi, 2000.

"In the New Grand Manner." *Time* 82 (November 1, 1963): 82–83.

Inness, Sherrie A. *Tough Girls: Women Warriors and Wonder Women in Popular Culture*. Philadelphia: University of Pennsylvania Press, 1999.

Irwin, Alexander. *Saints of the Impossible: Bataille, Weil, and the Politics of the Sacred*. Minneapolis: University of Minnesota Press, 2002.

Ischar, Doug. "Endangered Alibis." *Afterimage* 17, no. 10 (May 1990): 8–11.

Israels, Hans. *Schreber: Father and Son*. Madison, WI: International Universities Press, 1989.

Jardine, Lisa. "Robert Mapplethorpe: Squandering Beauty." *Modern Painters* 9 (Winter 1996): 68–71.

Jarzombek, Mark. "The Mapplethorpe Trial and the Paradox of Its Formalist and Liberal Defense: Sights of Contention." *Appendix* 2 (Spring 1994): 58–81.

Jeffords, Susan. *Hard Bodies: Hollywood Masculinity in the Reagan Era*. New Brunswick, NJ: Rutgers University Press, 1994.

———. *The Remasculinization of America: Gender and the Vietnam War*. Indianapolis: Indiana University Press, 1989.

Johnson, Elizabeth A. *Consider Jesus: Waves of Renewal in Christology*. New York: Crossroad, 1990.

Jones, Peter. "Bacon and Bataille." *Art Criticism* 11, no. 1 (1996): 27–54.

Jordan, Mark D., and Kent L. Brintnall. "Mel Gibson, Bride of Christ." In *Mel Gibson's Bible: Religion, Popular Culture, and* The Passion of the Christ, ed. Timo-

thy K. Beal and Tod Linafelt, 81–87. Chicago: University of Chicago Press, 2006.

Kardon, Janet. "The Perfect Moment." In *Robert Mapplethorpe: The Perfect Moment*, 9–13. Philadelphia: Institute for Contemporary Art, 1988.

———. "Robert Mapplethorpe Interview." In *Robert Mapplethorpe: The Perfect Moment*, 23–29. Philadelphia: Institute for Contemporary Art, 1988.

Keller, James. "Masculinity and Marginality in *Rob Roy* and *Braveheart*." *Journal of Popular Film and Television* 24, no. 4 (Winter 1997): 147–51.

Kendrick, James. *Hollywood Bloodshed: Violence in the 1980s American Cinema*. Carbondale: Southern Illinois University Press, 2009.

Kennedy, R. C. "Francis Bacon." *Art International* 10, no. 10 (December 12, 1960): 24–29.

Kinney, Terry. "Witness: Mapplethorpe Took Photos to Come to Grips with Life." Associated Press, October 2, 1990, n.p.

Klinger, Barbara. "'Cinema/Ideology/Criticism' Revisited: The Progressive Genre." In *Film Genre Reader III*, ed. Barry Keith Grant, 75–91. Austin: University of Texas Press, 2003.

Koch, Stephen. "Guilt, Grace and Robert Mapplethorpe." *Art in America* 74, no. 11 (November 1986): 144–50.

Kolbowski, Silvia. "Covering Mapplethorpe's 'Lady'." *Art in America* 71, no. 6 (Summer 1983): 10–11.

Kramer, Hilton. "Is Art above the Laws of Decency?" *New York Times*, July 2, 1989, 1, 7.

Kundera, Milan. "The Painter's Brutal Gesture." In *Bacon: Portraits and Self-Portraits*, ed. France Borel, 8–18. Trans. Linda Asher. London: Thames & Hudson, 1996.

Kunth, Felicitas. "Representations of Nudes according to Traditional Models." In *Francis Bacon and the Tradition of Art*, ed. Wilfred Seipel, Barbara Steffen, and Christoph Vitali, 263–69. Trans. Christopher Roth, Joshua Stein, and John Winbigler. Milan: Skira, 2003.

Kuspit, Donald. "Robert Mapplethorpe: Aestheticizing the Perverse." *Artscribe International* 72 (November–December 1988): 65–71.

Lacan, Jacques. "Desire and the Interpretation of Desire in *Hamlet*." Ed. Jacques-Alain Miller. Trans. James Hulbert. *Yale French Studies* 55/56 (1977 [1959]): 11–52.

Laessoe, Rolf. "Francis Bacon's Crucifixions and Related Themes." *Hafnia* 11 (1987): 7–38.

Laplanche, Jean, and Jean-Bertrand Pontalis. "Fantasy and the Origins of Sexuality." In *Formations of Fantasy*, ed. Victor Borgin, James Donald and Pat Caplan, 5–34. London: Methuen, 1986 [1964].

Leiris, Michel. *Francis Bacon: Full Face and in Profile*. Trans. John Weightman. New York: Arthur A. Bartley, 1987.

Levine, Amy-Jill. "Mel Gibson, the Scribes, and the Pharisees." In *Re-Viewing The Passion: Mel Gibson's Film and Its Critics*, ed. S. Brent Plate, 137–49. New York: Palgrave, 2004.

Lichtenfeld, Eric. *Action Speaks Louder: Violence, Spectacle, and the American Action Movie*. Westport, CT: Praeger, 2004.

Lifson, Ben. "The Philistine Photographer: Reassessing Mapplethorpe." *Village Voice* 24, no. 15 (April 9, 1979): 79.

Lothane, Zvi. *In Defense of Schreber: Soul Murder and Psychiatry*. Hillsdale, NJ: Analytic Press, 1992.

Luhr, William. "Mutilating Mel: Martyrdom and Masculinity in *Braveheart*." In *Mythologies of Violence in Postmodern Media*, ed. Christopher Sharrett, 227–46. Detroit: Wayne State University Press, 1999.

Lukacher, Maryline. *Maternal Fictions: Stendahl, Sand, Rachilde, and Bataille*. Durham, NC: Duke University Press, 1994.

Lurie, Susan. "The Construction of the 'Castrated Woman' in Psychoanalysis and Cinema." *Discourse* 4 (1981–82): 52–74.

MacGregor, Cathy. "The Eye of the Storm: Female Representation in Bataille's *Madame Edwarda* and *Histoire de l'oeil*." In *The Beast at Heaven's Gate: Georges Bataille and the Art of Transgression*, ed. Andrew Hussey, 101–10. New York: Rodolpi, 2006.

Manegold, C. S. "Robert Mapplethorpe, 1970–1983; On the 1983–84 Retrospective." *Arts Magazine* 58, no. 6 (February 1984): 96–99.

"Mapplethorpe Photos May Be Lewd, but They're Art." Associated Press, October 7, 1990, n.p.

Marchetti, Gina. "Action-Adventure as Ideology." In *Cultural Politics in Contemporary America*, ed. Ian Angus and Sut Jhally, 182–97. New York: Routledge, 1989.

Márquez, José. "Lights! Camera! Action!" In *Mel Gibson's Bible: Religion, Popular Culture, and* The Passion of the Christ, ed. Timothy K. Beal and Tod Linafelt, 177–86. Chicago: University of Chicago Press, 2006.

Marshall, Richard. "Mapplethorpe's Vision." In *Robert Mapplethorpe*, ed. Richard Marshall, 8–15. New York: Whitney Museum of American Art, 1988.

Martin, Douglas A. "Dyer." In *Your Body Figured*, 91–146. New York: Nightboat Books, 2008.

Masters, Kim. "Jurors View Photos of Children." *Washington Post*, October 3, 1990, C1.

Mayes, Stephen. "Good Sex Guide." *Creative Review*, April 1, 1999, 35–36.

Mayné, Gilles. *Eroticism in Georges Bataille and Henry Miller*. Birmingham, AL: Summa Publications, 1993.

McArthur, Colin. Brigadoon, Braveheart *and the Scots: Distortions of Scotland in Hollywood Cinema*. New York: I. B. Tauris, 2003.

McCallum, E. L. *Object Lessons: How to Do Things with Fetishism*. Albany: State University of New York Press, 1999.

McDannell, Colleen. "Votive Offering." In *Catholics in the Movies*, 317–45. New York: Oxford University Press, 2008.

McWhorter, Ladelle. "Is There Sexual Difference in the Work of Georges Bataille?" *International Studies in Philosophy* 27, no. 1 (1995): 33–41.

Melville, Robert. "The Iconoclasm of Francis Bacon." *World Review* 23 (January 1951): 63–65.

Mercer, Kobena. "Skin Head Sex Thing: Racial Difference and the Homoerotic Imaginary." In *Art Matters: How the Culture Wars Changed America*, ed. Brian

Wallis, Marianne Weems, and Philip Yenawine, 193–209. New York: New York University Press, 1999.

Merkel, Jayne. "Art on Trial." *Art in America* 78, no. 12 (December 1990): 41–51.

Meyer, Richard. "Robert Mapplethorpe and the Discipline of Photography." In *The Lesbian and Gay Studies Reader*, ed. Henry Abelove, Michèle Aina Barale, and David Halperin, 360–80. New York: Routledge, 1993 [1990].

Miles, Jack. "The Art of *The Passion*." In *Mel Gibson's Bible: Religion, Popular Culture, and* The Passion of the Christ, ed. Timothy K. Beal and Tod Linafelt, 11–20. Chicago: University of Chicago Press, 2006.

Miller, Monica Migliorino. *The Theology of* The Passion of the Christ. Staten Island, NY: Alba House, 2005.

Miller, Vincent. "Contexts: Theology, Devotion, and Culture." In *Mel Gibson's Bible: Religion, Popular Culture, and* The Passion of the Christ, ed. Timothy K. Beal and Tod Linafelt, 39–49. Chicago: University of Chicago Press, 2006.

Millett, Kate. *The Politics of Cruelty: An Essay on the Literature of Political Imprisonment.* New York: Norton, 1994.

"Mr. Francis Bacon." *Times* (London), February 9, 1934, 9.

Mitchell, Lee Clark. "Violence in the Film Western." In *Violence and American Cinema*, ed. J. David Slocum, 176–91. New York: Routledge, 2001.

Moorhouse, Paul. "The Crucifixion in Bacon's Art: 'A Magnificent Armature'." *Art International* 8 (Autumn 1989): 23–27.

Morgan, David. "Catholic Visual Piety and *The Passion of the Christ*." In *Re-Viewing* The Passion: *Mel Gibson's Film and Its Critics*, ed. S. Brent Plate, 85–96. New York: Palgrave, 2004.

———. "Manly Pain and Motherly Love: Mel Gibson's Big Picture." In *After* The Passion *Is Gone: American Religious Consequences*, ed. J. Shawn Landres and Michael Berenbaum, 149–57. New York: AltaMira Press, 2004.

Morgan, Stuart. "Something Magic." *Artforum International* 25 (May 1987): 118–23.

Morrell, David. *First Blood*. New York: Warner Books, 2000 [1972].

Morrison, Paul. "Coffee Table Sex: Robert Mapplethorpe and the Sadomasochism of Everyday Life." *Genders* 11 (Fall 1991): 17–36.

Morrisroe, Patricia. *Mapplethorpe: A Biography*. New York: Random House, 1995.

Mortimer, Raymond. "At the Lefevre." *New Statesman and Nation* 29, no. 738 (April 14, 1945): 239.

Mulvey, Laura. "Visual Pleasures and Narrative Cinema." In *Visual and Other Pleasures*, 14–26. Indianapolis: Indiana University Press, 1989 [1975].

Muñoz, José Esteban. *Disidentifications: Queers of Color and the Performance of Politics*. Minneapolis: University of Minnesota Press, 1999.

Murray, Joan. "Calculated Opulence." *Artweek* 12 (November 21, 1981): 11–12.

Neale, Steve. *Genre and Hollywood*. New York: Routledge, 2000.

———. "Masculinity as Spectacle." In *The Sexual Subject: A* Screen *Reader on Sexuality*, 277–87. New York: Routledge, 1992 [1983].

———. "Questions of Genre." In *Film Genre Reader III*, ed. Barry Keith Grant, 160–84. Austin: University of Texas Press, 2003.

Neff, David. "The Passion of Mel Gibson." *Christianity Today* 48, no. 3 (March 2004): 30–34.

Nelson, Jonathan. "Mapplethorpe's Search for Intense, Ordered Beauty." In *Robert Mapplethorpe: Perfection in Form*, ed. Franca Falletti and Jonathan Nelson, 16–63. New York: teNeues Publishing, 2009.

Newton, Eric. "Art—Imagination and Fantasy." *Time and Tide* 20 (June 1959): 708.

Niederland, William G. *The Schreber Case: Psychoanalytic Profile of a Paranoid Personality*. Hillsdale, NJ: Analytic Press, 1984.

Nikolopoulou, Kalliopi. "Elements of Experience: Bataille's Drama." In *The Obsessions of Georges Bataille: Community and Communication*, ed. Andrew J. Mitchell and Jason Kemp Winfree, 99–118. Albany: SUNY Press, 2009.

Nixon, John Williams. "Francis Bacon: Paintings 1959–1979—Opposites and Structural Rationalism." PhD diss. University of Ulster, 1986.

O'Day, Marc. "Beauty in Motion: Gender, Spectacle and Action Babe Cinema." In *Action and Adventure Cinema*, ed. Yvonne Tasker, 201–18. New York: Routledge, 2004.

Ofield, Simon. "Comparative Strangers." In *Francis Bacon*, ed. Matthew Gale and Chris Stephens, 64–73. London: Tate Publishing, 2008.

———. "Wrestling with Francis Bacon." *Oxford Art Journal* 24, no. 1 (2001): 113–30.

Oliver, Paul. "Francis Bacon." *Arts Review*, March 18, 1967, 80–81.

Ortiz, Gaye W. "'Passion'-ate Women: The Female Presence in *The Passion of the Christ*." In *Re-Viewing* The Passion: *Mel Gibson's Film and Its Critics*, ed. S. Brent Plate, 109–20. New York: Palgrave, 2004.

Parachini, Allan. "Year of the Censor." *American Photo* 1 (November–December 1990): 39–41, 111.

Peppiatt, Michael. *Francis Bacon: Anatomy of an Enigma*. Boulder, CO: Westview Press, 1998.

———. *Francis Bacon: Studies for a Portrait*. New Haven: Yale University Press, 2008.

———. "Three Interviews with Francis Bacon." In *Francis Bacon: A Retrospective*, ed. Dennis Farr, 38–50. New York: Harry N. Abrams, 1999.

Perl, Jed. "Seeing Mapplethorpe." *Partisan Review* 56, no. 4 (1989): 646–53.

Philips, John. "'The Law of the Mother': Masochism, Fetishism and Subjectivity in Georges Bataille's *Histoire de l'oiel*." In *The Beast at Heaven's Gate: Georges Bataille and the Art of Transgression*, ed. Andrew Hussey, 111–25. New York: Rodolpi, 2006.

Powell, Mark Allan. "Satan and the Demons." In *Jesus and Mel Gibson's* The Passion of the Christ: *The Film, the Gospels and the Claims of History*, ed. Kathleen E. Corley and Robert L. Webb, 71–78. New York: Continuum, 2004.

Prince, Stephen. "Beholding Blood Sacrifice in *The Passion of the Christ*: How Real Is Movie Violence?" *Film Quarterly* 59, no. 4 (2006): 11–22.

———. *A New Pot of Gold: Hollywood under the Electronic Rainbow, 1980–89*. (Berkeley: University of California Press, 2000)

Ray, Robert B. *A Certain Tendency of the Hollywood Cinema, 1930–1980*. Princeton, NJ: Princeton University Press, 1985.

Reik, Theodor. *Masochism in Modern Man*. Trans. Margaret H. Beigel and Gertrud M. Kurth. New York: Farrar, Strauss, 1941.

Restuccia, Frances L. *Amorous Acts: Lacanian Ethics in Modernism, Film, and Queer Theory*. Stanford, CA: Stanford University Press, 2006.

"Reviews and Previews: Francis Bacon." *Artnews* 52 (November 1953): 42–43.

Richardson, John. "Grunts from the Underground." *Show: The Magazine of the Arts* (October 1963): 46, 123.

Roberts, Keith. "Mr. Francis Bacon in the Woodshed." *Time and Tide* 43 (May 31, 1962): 19–20.

Robinson, Doug. *No Less a Man: Masculist Art in a Feminist Age*. Bowling Green, OH: Bowling Green State University Popular Press, 1994.

Roskill, Mark. "Francis Bacon as a Mannerist." *Art International* 7, no. 7 (September 25, 1963): 44–48.

Rothenstein, John. "Francis Bacon." In *Modern English Painters: Wood to Hockney*, 157–75, 242–43. New York: St. Martin's Press, 1974.

———. "Introduction." In *Francis Bacon*, ed. Ronald Alley, 7–21. New York: Viking Press, 1964.

———. *Time's Thievish Progress: Autobiography III*. London: Cassell, 1970.

Roudinesco, Elisabeth. *Jacques Lacan*. Trans. Barbara Bray. New York: Columbia University Press, 1997.

———. *Jacques Lacan and Co.: A History of Psychoanalysis in France, 1925–1985*. Trans. Jeffrey Mehlman. Chicago: University of Chicago Press, 1990 [1986].

Russell, John. *Francis Bacon*. Rev. ed. New York: Thames & Hudson, 1993.

Salatino, Kevin. "Robert Mapplethorpe." *New Art Examiner* 16 (May 1989): 53–54.

Santner, Eric. *My Own Private Germany: Daniel Paul Schreber's Secret History of Modernity*. Princeton, NJ: Princeton University Press, 1996.

Savran, David. *Taking It Like a Man: White Masculinity, Masochism, and Contemporary Culture*. Princeton, NJ: Princeton University Press, 1998.

Sawyer, Diane. *Mel Gibson's Passion*. ABC Primetime Special, 2004.

Schaberg, Jane. "Gibson's Mary Magdalene." In *Mel Gibson's Bible: Religion, Popular Culture, and* The Passion of the Christ, ed. Timothy K. Beal and Tod Linafelt, 69–79. Chicago: University of Chicago Press, 2006.

Schatz, Thomas. *Hollywood Genres: Formulas, Filmmaking, and the Studio System*. New York: McGraw Hill, 1981.

Schmied, Wieland. *Francis Bacon: Commitment and Conflict*. Trans. John Ormrod. New York: Prestel, 1996 [1985].

Schneider, Karen. "With Violence If Necessary: Rearticulating the Family in the Contemporary Action-Thriller." *Journal of Popular Film and Television* 27, no. 1 (Spring 1999): 2–11.

Schreber, Daniel Paul. *Memoirs of My Nervous Illness*. Ed. and trans. Ida MacAlpine and Richard A. Hunter. New York: New York Review Books, 1955 [1911].

Schubart, Rikke. "Passion and Acceleration: Generic Change in the Action Film." In *Violence and the American Cinema*, ed. J. David Slocum, 192–207. New York: Routledge, 1999.

Schwartz, Ellen. "Paris Newsletter: November." *Art International* 16, no. 1 (January 20, 1972): 54–58.

Segal, Alan. "'How I Stopped Worrying about Mel Gibson and Learned to Love

the Quest for the Historical Jesus': A Review of Mel Gibson's *The Passion of the Christ*." *Journal for the Study of the Historical Jesus* 2, no. 2 (2004): 190–208.

Shepherd, David. "From Gospel to Gibson: An Interview with the Writers behind Mel Gibson's *The Passion of the Christ*." *Religion and the Arts* 9, nos. 3–4 (2005): 321–31

Shone, Richard. "Paris and Munich: Francis Bacon." *Burlington Magazine* 138, no. 1125 (December 1996): 842–44.

Silk, Mark. "Almost a Culture War: The Making of *The Passion* Controversy." In *After* The Passion *Is Gone: American Religious Consequences*, ed. J. Shawn Landres and Michael Berenbaum, 23–34. New York: AltaMira Press, 2004.

Silverman, Kaja. *Flesh of My Flesh*. Stanford, CA: Stanford University Press, 2009.

———. "The Lacanian Phallus." *differences: A Journal of Feminist Cultural Studies* 4, no. 1 (1992): 84–115.

———. *Threshold of the Visible World*. New York: Routledge, 1996.

Simson, Emily. "Portraits of a Lady." *Artnews* 82, no. 9 (November 1983): 53–54.

Sinclair, Andrew. *Francis Bacon: His Life and Violent Times*. New York: Crown Publishers, 1993.

Sischy, Ingrid. "Photography: White and Black." *New Yorker* 65, no. 39 (November 13, 1989): 124–46.

———. "A Society Artist." In *Robert Mapplethorpe*, ed. Richard Marshall, 76–88. New York: Whitney Museum of American Art, 1988.

———. "That Feeling in the Stomach." In *Robert Mapplethorpe: Pictures*, ed. Dimitri Levas. New York: Arena Publications, 1999.

Smith, Leslie E. "Living *in* the World, but Not *of* the World: Understanding Evangelical Support for *The Passion of the Christ*." In *After* The Passion *Is Gone: American Religious Consequences*, ed. J. Shawn Landres and Michael Berenbaum, 47–58. New York: AltaMira Press, 2004.

Smith, Patti. *Just Kids*. New York: HarperCollins, 2010.

Snookes, Rory. "A Roomful of Bacon at the Tate." *Apollo* 134, no. 357 (November 1991): 350–51.

Sobchack, Thomas. "Genre Film: A Classical Experience." In *Film Genre Reader III*, ed. Barry Keith Grant, 103–14. Austin: University of Texas Press, 2003.

Solomon-Godeau, Abigail. "Male Trouble." In *Constructing Masculinity*, ed. Maurice Berger, Brian Wallis, and Simon Watson, 69–76. New York: Routledge, 1995.

Squiers, Carol, and Steven Koch. "Mapplethorpe." Ed. Allan Ripp. *American Photographer* 20 (January 1988): 44–55.

Steffen, Barbara. "The Papal Portraits." In *Francis Bacon and the Tradition of Art*, ed. Wilfred Seipel, Barbara Steffen, and Christoph Vitali, 115–20. Trans. Christopher Roth, Joshua Stein, and John Winbigler. Milan: Skira, 2003.

Stephens, Chris. "Animal." In *Francis Bacon*, ed. Matthew Gale and Chris Stephens, 91–95. London: Tate Publishing, 2008.

———. "Portrait." In *Francis Bacon*, ed. Matthew Gale and Chris Stephens, 181–85. London: Tate Publishing, 2008.

Stevens, Mark. "Direct Male." *New Republic* (September 26, 1988): 27–30.

Stockton, Kathryn Bond. *Beautiful Bottom, Beautiful Shame: Where "Black" Meets "Queer."* Durham: Duke University Press, 2006.

Stoekl, Allan. *Bataille's Peak: Energy, Religion, and Postsustainability.* Minneapolis: University of Minnesota Press, 2007.

———. "Recognition in *Madame Edwarda.*" In *Bataille: Writing the Sacred*, ed. Carolyn Bailey Gill, 77–90. New York: Routledge, 1995.

Storr, Robert. "Art, Censorship, and the First Amendment." *Art Journal* 50, no. 3 (Fall 1991): 12–26.

Strick, Philip. "*Terminator 3: Rise of the Machines.*" *Sight & Sound* 13, no. 10 (October 2003): 67–68.

Suleiman, Susan Rubin. "Bataille in the Street: The Search for Virility in the 1930s." In *Bataille: Writing the Sacred*, ed. Carolyn Bailey Gill, 26–45. New York: Routledge, 1995.

———. *Subversive Intent: Gender, Politics, and the Avant-Garde.* Cambridge, MA: Harvard University Press, 1990.

Surkis, Judith. "No Fun and Games until Someone Loses an Eye: Transgression and Masculinity in Bataille and Foucault." *Diacritics* 26, no. 2 (Summer 1996): 18–30.

Surya, Michel. *Georges Bataille: An Intellectual Biography.* Trans. Krzysztof Fijalkowski and Michael Richardson. New York: Verso, 2002 [1992].

Sweedler, Milo. *The Dismembered Community: Bataille, Blanchot, Leiris, and the Remains of Laure.* Newark: University of Delaware Press, 2009.

Sylvester, David. "Bacon's Course." In *Francis Bacon: Figuribile*, ed. Achille Bonito Oliva, 19–86. Milan: Electa, 1993.

———. "Images of the Human Body." In *Francis Bacon: The Human Body*, 13–38. Los Angeles: University of California Press, 1998.

———. *Interviews with Francis Bacon.* New York: Thames & Hudson, 1987.

———. *Looking Back at Francis Bacon.* New York: Thames & Hudson, 2000.

Tasker, Yvonne. "Introduction: Action and Adventure Cinema." In *Action and Adventure Cinema*, ed. Yvonne Tasker, 1–13. New York: Routledge, 2004.

———. *Spectacular Bodies: Gender, Genre and the Action Cinema.* New York: Routledge, 1993.

Thislethwaite, Susan. "Mel Makes a War Movie." In *On The Passion of the Christ: Exploring the Issues Raised by the Controversial Movie*, ed. Paula Fredriksen, 127–45. Berkeley: University of California Press, 2006.

Thomas, Calvin. *Male Matters: Masculinity, Anxiety, and the Male Body on the Line.* Chicago: University of Illinois Press, 1996.

———. "Reenfleshing the Bright Boys; or, How Male Bodies Matter to Feminist Theory." In *Masculinity Studies and Feminist Theory: New Directions*, ed. Judith Kegan Gardiner, 60–89. New York: Columbia University Press, 2002.

Thornton, Gene. "Portraits Reflecting a Certain Sensibility." *New York Times*, November 11, 1982, H30.

Tinterow, Gary. "Bacon and His Critics." In *Francis Bacon*, ed. Matthew Gale and Chris Stephens, 28–39. London: Tate Publishing, 2008.

Trucchi, Lorenza. "The Delirium of the Body." In *Francis Bacon: Figuribile*, ed. Achille Bonito Oliva, 113–20. Milan: Electa, 1993.

———. *Francis Bacon.* Trans. John Shepley. New York: Harry N. Abrams, 1975.

Van Alphen, Ernst. *Francis Bacon and the Loss of Self.* London: Reaktion Books, 1992.

Vance, Carole S. "Misunderstanding Obscenity." *Art in America* 78, no. 5 (May 1990): 49–55.

———. "The War on Culture." In *Art Matters: How the Culture Wars Changed America*, ed. Brian Wallis, Marianne Weems, and Philip Yenawine, 221–31. New York: New York University Press, 1999 [1989].

Vander Stichele, Caroline, and Todd Penner. "Passion for (the) Real? *The Passion of the Christ* and Its Critics." *Biblical Interpretation* 14, no. 1–2 (2006): 18–36.

Vares, Tiina. "Action Heroines and Female Viewers: What Women Have to Say." In *Reel Knockouts: Violent Women in the Movies*, ed. Marth McCaughey and Neal King, 219–43. Austin: University of Texas Press, 2001.

Veen, Robbert. "*The Passion* as Redemptive Non-Violence." *Mennonite Life* 59, no. 2 (June 2004). http://www.bethelks.edu/mennonitelife/2004June/veen.php.

Wallis, Jim. "*The Passion* and the Message." In *On* The Passion of the Christ: *Exploring the Issues Raised by the Controversial Movie*, ed. Paula Fredriksen, 111–25. Berkeley: University of California Press, 2006.

Walls, Jerry L. "Christ's Atonement: Washing away Human Sin." In *Mel Gibson's* Passion *and Philosophy: The Cross, the Questions, the Controversy*, ed. Jorge J. E. Gracia, 25–39. Chicago: Open Court, 2004.

Walsh, Fintan. *Male Trouble: Masculinity and the Performance of Crisis.* New York: Palgrave MacMillan, 2010.

Walsh, Richard. "Wrestling with *The Passion of the Christ*: At the Movies with Roland Barthes and Mel Gibson." *Bible and Critical Theory* 1, no. 2 (2005): 1–16.

Warshow, Robert. "The Gangster as Tragic Hero." In *The Immediate Experience: Movies, Comics, Theatre and Other Aspects of Popular Culture*, 97–103. Cambridge, MA: Harvard University Press, 2001 [1948].

Watts, Rikk. "'Mirror, Mirror, on the Wall . . .': A Review of Mel Gibson's *The Passion of the Christ.*" *Journal for the Study of the Historical Jesus* 2, no. 2 (2004): 209–18.

Webb, Robert L. "*The Passion* and the Influence of Emmerich's *The Dolorous Passion of Our Lord Jesus Christ.*" In *Jesus and Mel Gibson's* The Passion of the Christ: *The Film, the Gospels and the Claims of History*, ed. Kathleen E. Corley and Robert L. Webb, 160–72. New York: Continuum, 2004.

Webb, Theresa, and Nick Browne. "The Big Impossible: Action-Adventure's Appeal to Adolescent Boys." In *New Hollywood Violence*, ed. Steven Jay Schneider, 80–99. New York: Manchester University Press, 2004.

Weiley, Susan. "Prince of Darkness, Angel of Light." *Artnews* 87, no. 10 (December 1988): 106–11.

Weinraub, Bernard. "Reagan Hails Move." *New York Times*, July 1, 1985, A1, A10.

Welsh, James M. "Action Films: The Serious, the Ironic, the Postmodern." In *Film Genre 2000*, ed. Wheeler Winston Dixon, 161–76. Albany: SUNY Press, 2000.

Wilkerson, Isabel. "Clashes at Obscenity Trial on What an Eye Really Sees." *New York Times*, October 3, 1990, A22.

———. "Jury Hears Passionate Arguments as Obscenity Trial Opens in Ohio." *New York Times*, September 29, 1990, 8.

———. "Obscenity Jurors Were Pulled Two Ways." *New York Times*, October 10, 1990, A12.

Willard, Dallas. "The Craftiness of Christ: Wisdom of the Hidden God." In *Mel Gibson's* Passion *and Philosophy: The Cross, the Questions, the Controversy*, ed. Jorge J. E. Gracia, 167–78. Chicago: Open Court, 2004.

Williams, Delores. *Sisters in the Wilderness: The Challenge of Womanist God-Talk.* Maryknoll, NY: Orbis Books, 1998.

Williams, Linda. *Hard Core: Power, Pleasure, and the "Frenzy of the Visible."* Berkeley: University of California Press, 1989.

———. "When Woman Looks." In *The Dread of Difference: Gender and the Horror Film*, ed. Barry Keith Grant, 15–34. Austin: University of Texas Press, 1996 [1983].

———. "Melodrama Revised." In *Refiguring American Film Genres: History and Theory*, ed. Nick Browne, 42–88. Berkeley: University of California Press, 1998.

Willis, Sharon. *High Contrast: Race and Gender in Contemporary Hollywood Film.* Durham, NC: Duke University Press, 1997.

Winnubst, Shannon. "Bataille's Queer Pleasures: The Universe as Spider or Spit." In *Reading Bataille Now*, ed. Shannon Winnubst, 75–93. Bloomington: Indiana University Press, 2007.

Wolf, Sylvia. "An Authentic Artlessness." In *Polaroids: Mapplethorpe*, 20–65. New York: Prestel Verlag, 2007.

Wood, Robin. "Ideology, Genre, Author." In *Film Genre III*, ed. Barry Keith Grant, 60–74. Austin: University of Texas Press, 2003 [1977].

Woods, Robert H., Michael C. Jindra, and Jason D. Baker. "The Audience Responds to *The Passion of the Christ*." In *Re-Viewing* The Passion: *Mel Gibson's Film and Its Critics*, ed. S. Brent Plate, 163–80. New York: Palgrave, 2004.

Wrathall, Mark A. "Seeing the World Made New: Depictions of the Passion and Christian Life." In *Mel Gibson's* Passion *and Philosophy: The Cross, the Questions, the Controversy*, ed. Jorge J. E. Gracia, 9–24. Chicago: Open Court, 2004.

Yates, Wilson. "Francis Bacon: The Iconography of the Crucifixion, Grotesque Imagery, and Religious Meaning." In *The Grotesque in Art and Literature: Theological Reflections*, ed. James Luther Adams and Wilson Yates, 143–91. Grand Rapids, MI: Eerdmans Publishing, 1997.

Yenawine, Philip. "Introduction: But What Has Changed?" In *Art Matters: How the Culture Wars Changed America*, ed. Brian Wallis, Marianne Weems, and Philip Yenawine, 9–23. New York: New York University Press, 1999.

Yingling, Thomas. "How the Eye Is Caste: Robert Mapplethorpe and the Limits of Controversy." *Discourse* 12, no. 2 (1990): 3–28.

Zimmerman, Jörg. *Francis Bacon: Kreuzigung.* Frankfurt am Main: Fischer Taschenbuch Verlag, 1986.

Index